CHRIS LEGASPI
LIFE DRAWING FOR ARTISTS

Understanding Figure Drawing Through Poses, Postures, and Lighting

Quarto.com

© 2020 Quarto Publishing Group USA Inc.
Text and illustrations © 2020 Chris Legaspi

First published in 2020 by Rockport Publishers, an imprint of The Quarto Group,
100 Cummings Center, Suite 265-D, Beverly, MA 01915, USA.
T (978) 282-9590 F (978) 283-2742

EEA Representation, WTS Tax d.o.o.,
Žanova ulica 3, 4000 Kranj, Slovenia.
www.wts-tax.si

All rights reserved. No part of this book may be reproduced in any form without written permission of the copyright owners. All images in this book have been reproduced with the knowledge and prior consent of the artists concerned, and no responsibility is accepted by producer, publisher, or printer for any infringement of copyright or otherwise, arising from the contents of this publication. Every effort has been made to ensure that credits accurately comply with information supplied. We apologize for any inaccuracies that may have occurred and will resolve inaccurate or missing information in a subsequent reprinting of the book.

Rockport Publishers titles are also available at discount for retail, wholesale, promotional, and bulk purchase. For details, contact the Special Sales Manager by email at specialsales@quarto.com or by mail at The Quarto Group, Attn: Special Sales Manager, 100 Cummings Center, Suite 265-D, Beverly, MA 01915, USA.

ISBN: 978-1-63159-801-2

Digital edition published in 2020
eISBN: 978-1-63159-802-9

Library of Congress Cataloging-in-Publication Data

Legaspi, Chris, author.
Life drawing for artists : understanding figure drawing through
 poses, postures, and lighting / Chris Legaspi.
ISBN 9781631598012 | ISBN 9781631598029 (eISBN)
1. Nude in art. 2. Figure drawing--Technique.
N7572 .L44 2020 | 704.9/421--dc23

LCCN 2019033851

Interior Page Design and Layout: Laura McFadden Design, Inc.
Photography and Illustration: Chris Legaspi

To anyone who has fallen in love with the human figure but also wants so badly to draw it well. I share that same desire, love, and pain with you. For anyone who shares this love and who wants to go on this journey with us, this book is for you.

Contents

Preface 6

Chapter 1 | Foundation 8
- 8 The Purpose of Figure Drawing
- 12 The Structure of a Life Drawing Session
- 14 Recommended Materials
- 20 Using Your Materials

Chapter 2 | Fundamentals of Life Drawing 24
- 24 Making Marks
- 27 The Concept of Gesture
- 37 Construction
- 40 Two-Dimensional Shapes
- 42 Three-Dimensional Shapes
- 46 Introduction to Shading, Light, and Shadow

Chapter 3 | The Drawing Process 54
- 54 Overview of the Drawing Process
- 62 Anatomical Landmarks
- 64 Starting with the Head
- 84 Drawing the Torso
- 94 How to Draw One- and Two-Minute Poses
- 102 How to Draw Three- and Five-Minute Poses
- 108 How to Draw Ten-Minute Poses
- 112 How to Draw Twenty-Minute Poses

Chapter 4 | Side View and Perspective 126
- 126 Side View Techniques and Strategies
- 138 How to Draw the Figure in Perspective

Chapter 5 | Exercises and Self-Study 150
- 150 Recommended Exercises
- 152 Part 1: Drawing from Life and Observation
- 158 Part 2: Dexterity Exercises
- 164 Part 3: Old Master Studies

Acknowledgments 172
About the Author 173
Index 174

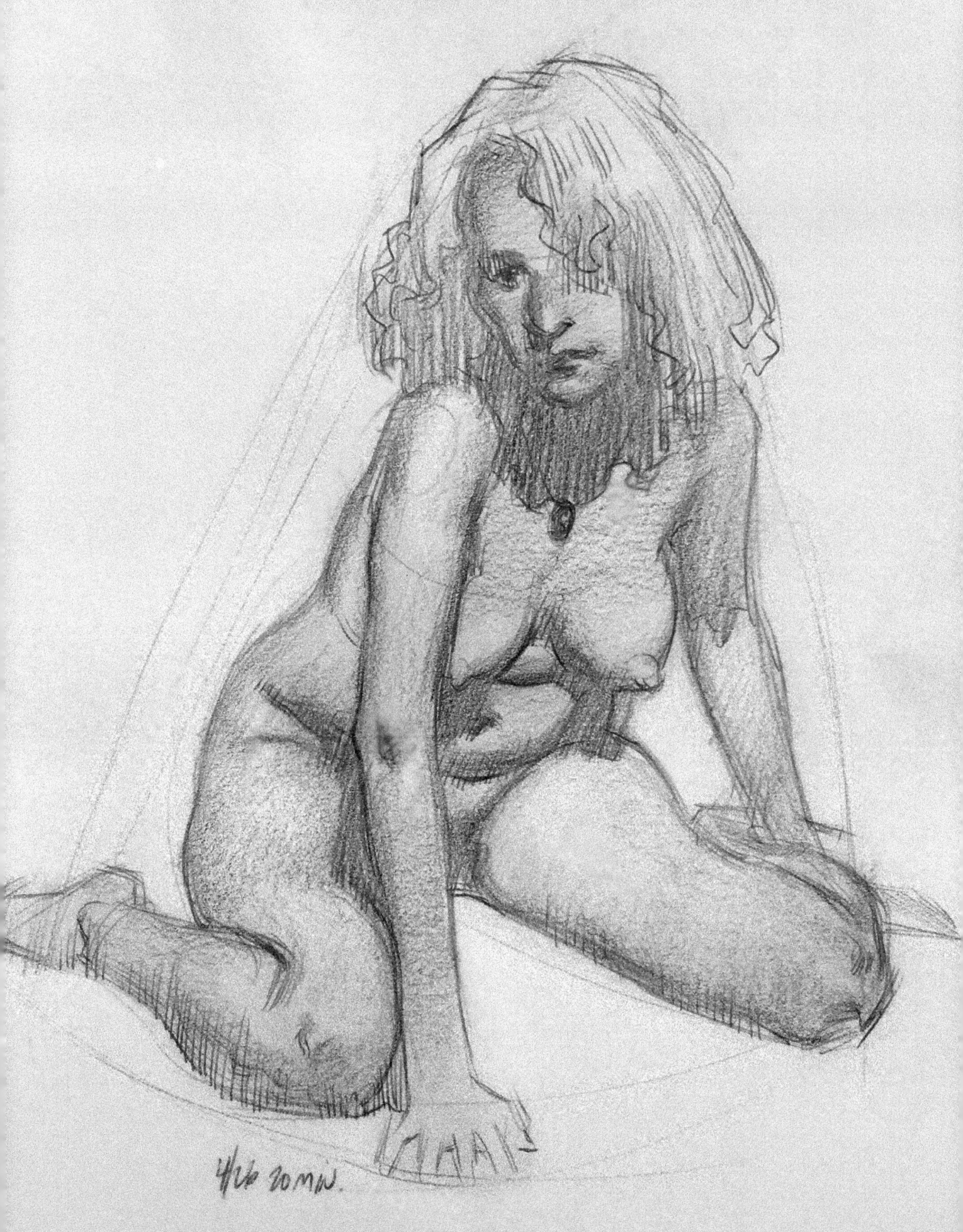

Preface

The purpose of this book is to provide guidance for one of the most difficult tasks in the known creative world—to describe, define, and capture a living human being on a flat piece of paper in a meaningful, compelling, artistic, and attractive way. This difficult and beautiful practice is known as figure drawing, and it is a subject that I and many, many, many of the great artists in history have fallen in love with and continue to practice and be obsessed with to this day.

In this book, I will humbly attempt to share some of my ten years of knowledge and experience on the subject. I say "some" because the topic is so complex and so deep that one book alone can never be enough. What I want to do with this book is provide support in one specific part of the figure-drawing journey, which is drawing from a live model.

Drawing from a live model, or life drawing, is, in my opinion, the most important aspect of the art. This is because life drawing allows us the opportunity to study the human body in its raw, natural, and often naked state. This gives us insight into the third dimension of visual space, and also the subtle nuances of a living, breathing human being that can never be seen in photography.

Because life drawing has time limitations (a human being can only pose for so long), it creates a unique structure to our drawing practice, along with a sense of urgency. This makes the drawing practice much more productive and effective if approached the right way. That is what this book will attempt to provide—an effective way to approach drawing the figure from life and achieve consistent results while making progress in both knowledge and skill.

WHO IS THIS BOOK FOR?

This book is designed for anyone who has either previously attempted to draw the figure from life or is willing to face the task. This book is for those who are prepared to spend hours in front of a live model with the intention or goal to achieve a level of realism and quality in their work.

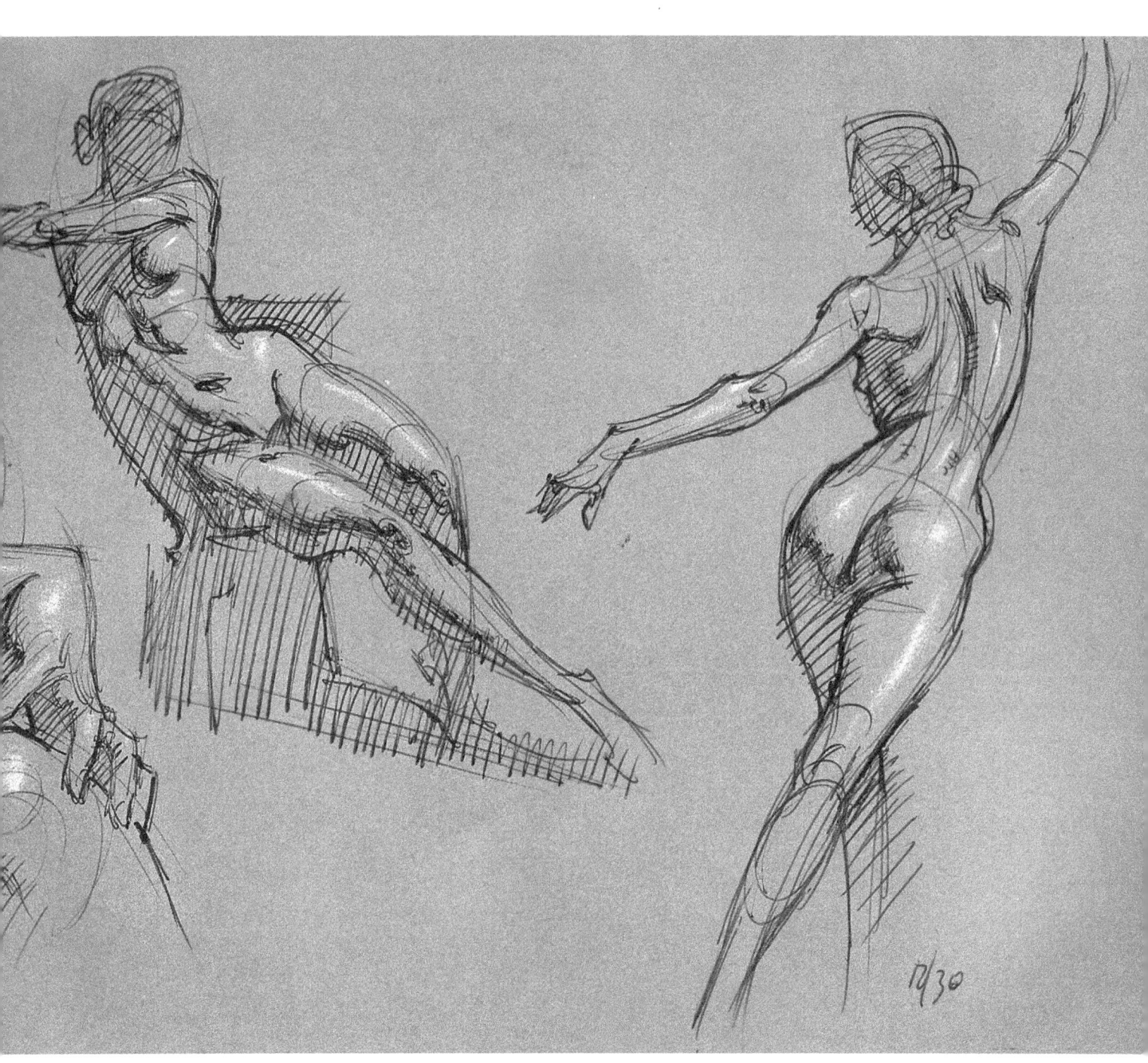

These five-minute poses, done with pen and white pastel on toned paper, are examples of figure drawings from a live model.

CHAPTER 1

FOUNDATION

The Purpose of Figure Drawing

Life drawing, or drawing from life, is the practice of drawing a living, breathing human being, live, in person, and in real time. Generally when a live model is drawn from life in an academic classroom or art studio setting, it is known as a life drawing session.

WHY DRAW THE FIGURE AT ALL?

The figure is merely a subject to study, but it is such an incredibly deep and complex subject. Because of this depth and complexity, every core fundamental of drawing, and of art itself, can be learned from studying and drawing the figure. Everything, from making quality lines to lighting to composition, is a necessary part of the figure drawing process. So, in short, if you want to become a better artist, drawing the figure can be a path to get there. This has been true for me and for many of the great artists throughout time.

WHY DRAW FROM LIFE?

The main benefit of drawing from life versus drawing from a photo, or even memory, is that the figure can be studied and observed in its natural state and in the round. This means that you can physically see the figure in all three dimensions. In a life drawing session, the poses are arranged with a time limit, which has many benefits for the art student.

The first benefit, and why it is so important, is that timed poses create a structure to the artist's practice. Having structure in any serious practice has many advantages. Setting a time limit forces the artist to fully concentrate on the model and the task at hand. For example, if I know I have only three hours to draw from a live model, then I will focus on and appreciate each pose in the time I have with the model. If each pose is limited in time (e.g., a one-minute pose), then I will be even more focused. If I want to make a meaningful drawing, I know I have to put maximum thought and concentration into each and every mark.

The second benefit is repetition. To learn any skill, especially a new motor skill that involves muscle and neural patterns (such as drawing with a pencil), many repeated attempts are required. In a three-hour life drawing session with timed poses, especially short times such as one, two, or five minutes, the model can make more than one hundred unique poses. Each pose is a new and fresh opportunity to practice a drawing skill.

Because there are so many unique opportunities (sometimes one hundred or more poses) in a typical three-hour life drawing session, there is less pressure or expectation to finish a drawing, or to make a good drawing. This frees up the mind to either focus on a specific skill or experiment and take risks because no matter how the drawing turns out, eventually there will be a fresh new pose, and there will be many new opportunities to try and try again.

The third benefit, and what I enjoy most, is the time pressure. With unlimited time for a drawing or a pose (or any task), the mind can easily become distracted and lose focus. When the artist has limited time, and knows that the pose will soon change, there is pressure, or a sense of urgency to accomplish the task. This sense of urgency imposes more focus on the pose and on every mark the artist makes, which makes each drawing, and the practice session as a whole, much more productive.

The purpose of life drawing is to study the human figure and learn as much as possible about the figure and the drawing process. The main goal of timed life drawing is practice and repetition. Like the gym or exercise, it is in a life drawing session where we get our "reps." The goal is not to make a finished drawing, a perfect drawing, or even a good drawing. In fact, the goal is to try to fail as many times as possible. This is especially true if you are new to life drawing, or if you are experienced and trying something new, experimenting, taking risks, or generally trying to improve.

In short, don't put any expectations or pressure on yourself when you are in front of a model. Instead, focus on the moment, focus on the task at hand. Focus on the materials you have, focus on the model, what the pose is giving you, and what you have to work with. Have your end goal in mind, but be fully present and absorbed in the process.

Opposite: A two-hour figure drawing from life. Pastel on newsprint.

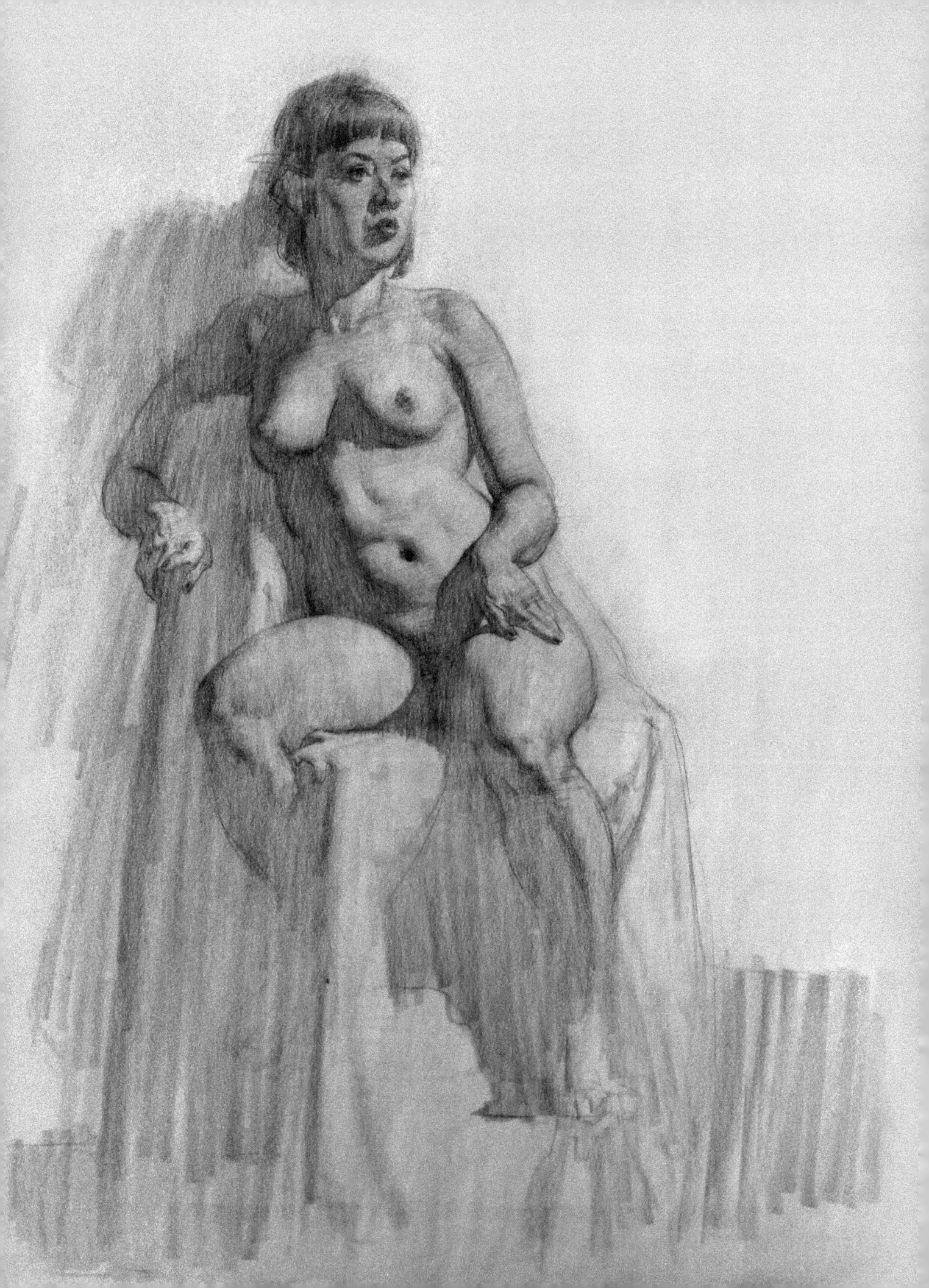

The Structure of a Life Drawing Session

Typical life drawing sessions in an academic (school or learning) model are two to three hours long. When I organize life drawings, I book a model for three hours and break up the time into various pose lengths.

Generally the session starts with short poses, which allow the artists and students to loosen up and warm up. Short poses have much lower expectations for the artist, freeing up the mind to simply draw and be in the moment and prepare the mind and body for more complex drawings

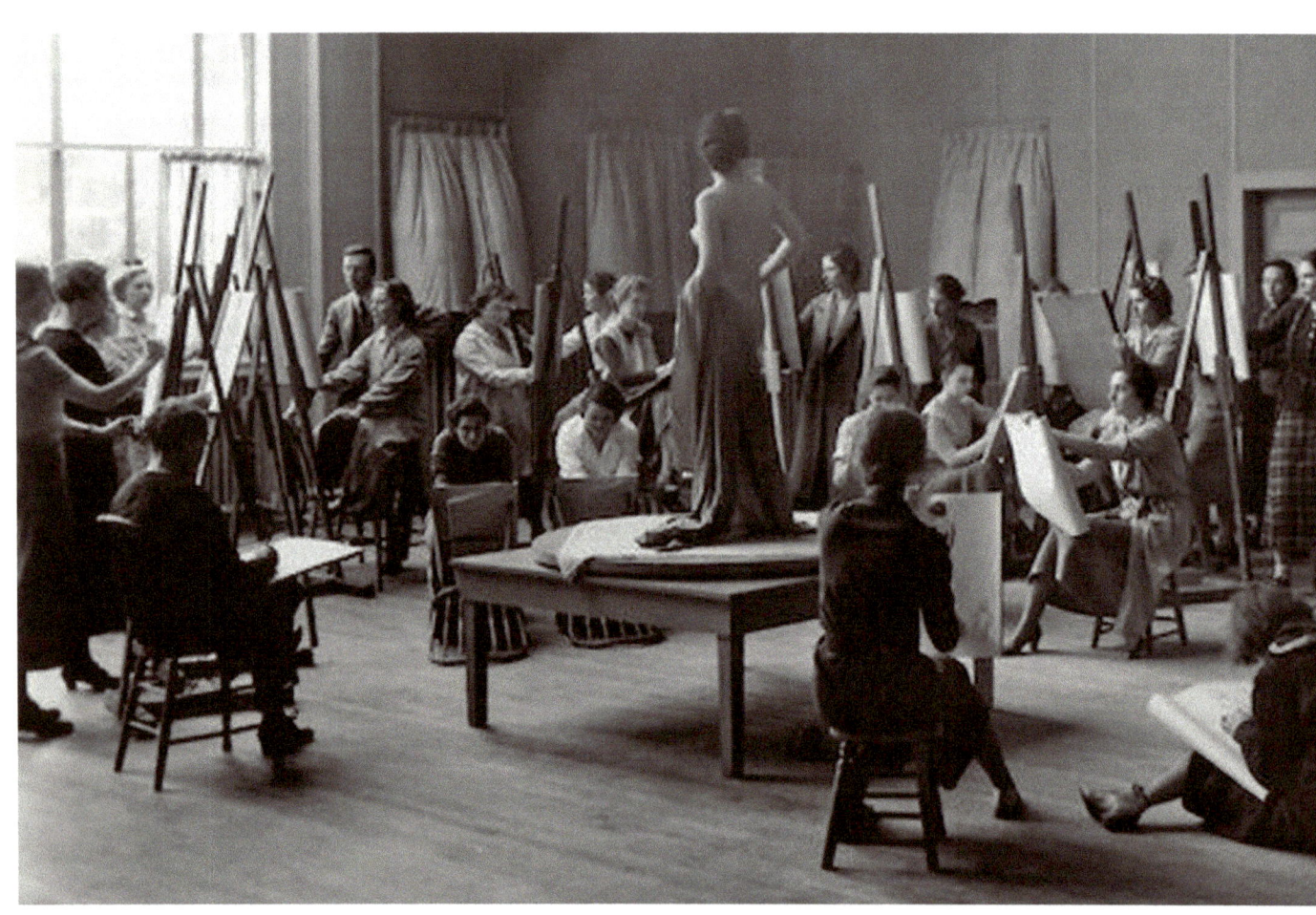

during longer poses. The first two hours typically consist of short poses of ten minutes or less. In the last hour, I like to include twenty- to twenty-five-minute poses. This gives the students an opportunity to practice and refine more complex tasks, such as proportion, anatomy, lighting, and shading.

Below is an example schedule of a life drawing session:

Total time with model = 3 hours

Hour 1
1. One-minute pose x 25
 (Five-minute break for model to rest)
2. Two-minute pose x 12
 (Five-minute break for model to rest)

Hour 2
3. Five-minute pose x 5
 (Five-minute break for model to rest)
4. Five-minute pose x 5
 (Five-minute break for model to rest)

Hour 3
5. Ten-minute pose x 2, five-minute pose x 1
 (Five-minute break for model to rest)
6. Twenty-five- to thirty-minute pose
 (or remainder of the three hours) x 1

This is not the only way to structure a life drawing session. This is simply one way that is commonly used.

Life drawing class, Vassar College, c. 1930. Courtesy of Archives and Special Collections, Vassar College Library.

Recommended Materials

To produce the best results and make practice time more productive, using the right set of materials is a must. The recommended materials on this list are designed to maximize your drawing time with the model and to teach good fundamental skills and techniques. When I was first exposed to this set of materials, I felt like my eyes were opened to a new world of possibilities. I was able to make new marks and use new techniques that were previously foreign to me. Over a few months and with consistent practice using these new tools, my dexterity and skill level improved dramatically. Because these materials are so effective and versatile, I, and many professionals, use and recommend them.

There are two sets of materials recommended for two different settings. The first set is for using in an art studio setting. This is the set I would bring to a life drawing session, regular life drawing class or workshop, or for use in my home studio. The second set is what I use for sketching out in the field, or any situation where portable, lighter materials are needed. For beginners or anyone new to life drawing, I highly recommend starting with the studio set of materials.

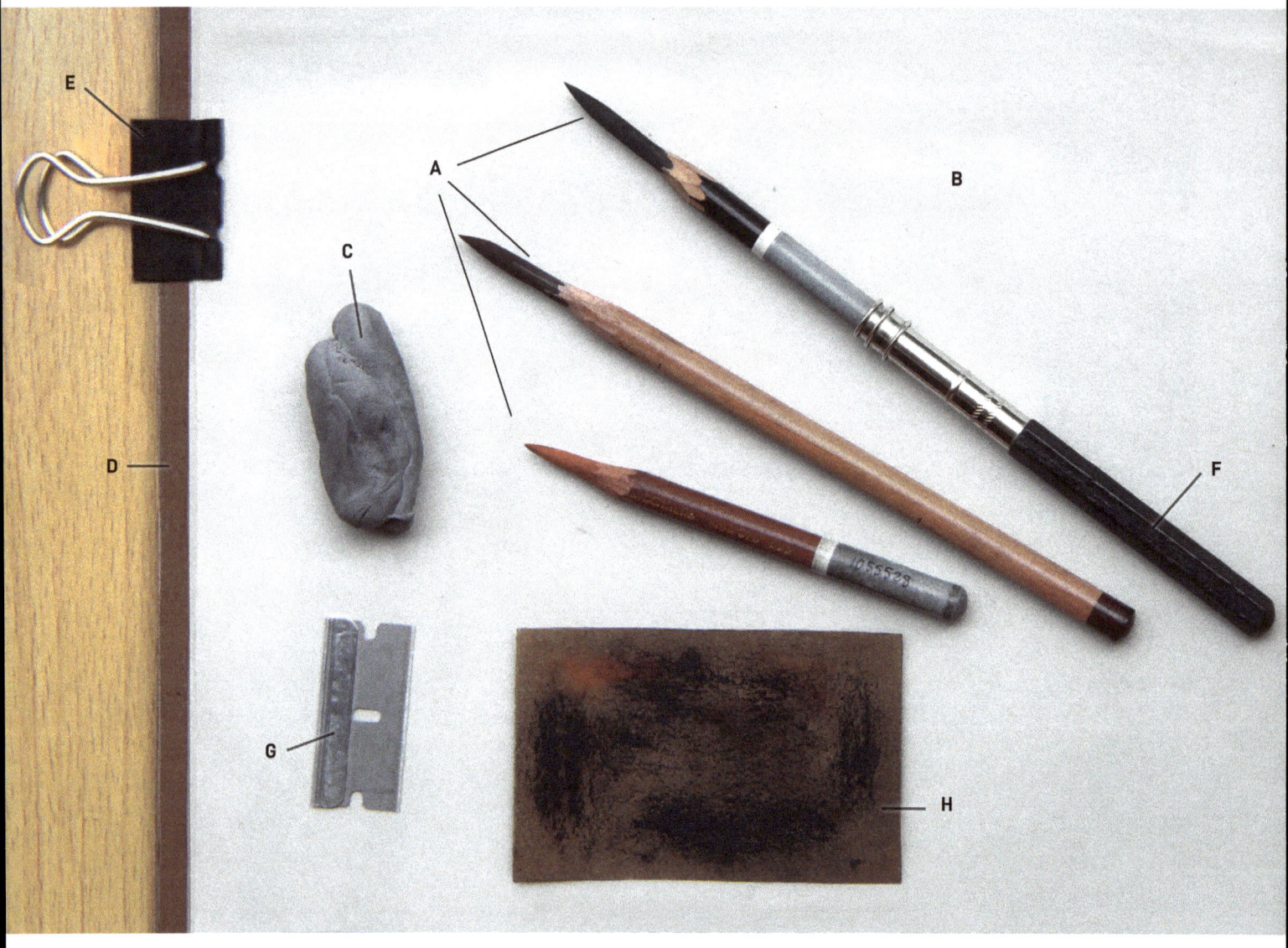

SET 1: STUDIO MATERIALS

Drawing Pencils (A)
The first and most important tool is the drawing pencil. The pencils I use and recommend come in three forms:

1. Pastel
2. Conté
3. Charcoal

Besides the material, the most important part of the pencil is how it is sharpened to a long lead point (more on this later). For pencil brands and grades, I recommend:

1. Wolff's Carbon, 6B
2. STABILO CarbOthello, black and earth tones (dark brown or dark red, pictured)
3. Conté à Paris, B
4. Faber-Castell Pitt Pastel, black

If these brands aren't available in your area, try to find a comparable brand and test them. As long as the material is either pastel or charcoal and produces the marks needed (see Making Marks, page 24) it will be suitable for life drawing. As a last resort, you can use the more commonly available sketching materials listed in Set 2 (see page 18).

Paper (B)

The paper I recommend is *smooth* newsprint. *smooth* newsprint. Yes, I mentioned *smooth* twice because it is that important. Newsprint is generally available in two textures: smooth and rough. Smooth produces the best result and is the best for practicing tones and edges. Rough newsprint will be very difficult to use and will lead to frustration. If you are already using newsprint and your marks look rough, it may be because of the rough paper texture.

The paper size I recommend is 18" x 24" (46 x 61 cm), or international size A2 (42 x 59 cm). This large format allows plenty of space to make long marks and strokes using your whole body and arm. With the larger-size paper, you can draw multiple smaller studies during short poses or larger drawings for longer poses.

Kneaded Eraser (C)

I recommend soft, pliable erasers. A soft eraser will erase and edit marks and still be gentle on the paper. I and most professionals use kneaded erasers (pictured).

Drawing Board (D)

To support my paper and give me a stable drawing surface, I use a wooden drawing board. The most common is masonite (pictured), but any thin and light hardboard will work. Pre-cut drawing boards are available at most art stores, and they easily accommodate 18" x 24" (46 x 61 cm) paper.

Clips (E)

To hold your newsprint paper on your board, I recommend large binder clips (pictured) and bulldog clips. These can be found in most office or stationery stores. Use the largest size available, which are approximately 2" (5 cm).

Other Accessories

Pencil Extender (F)

A pencil extender extends the life of a pencil when it becomes too short to hold comfortably.

Single-Edge Razor Blades (G)

To sharpen my pencils to a long point, I use single-edge razor blades and sandpaper. Single-edge blades are much safer to use than double-sided blades and are relatively inexpensive. If single-edge razor blades aren't available, I recommend a box cutter. How to properly sharpen a pencil will be covered later in this chapter.

Medium Sandpaper (H)

To smooth, sharpen, and refine my long pencil lead, I use a medium grade (80–120 grit) sandpaper. Most art stores also have pre-made pencil sanding blocks that also work well.

SET 2: PORTABLE/FIELD SKETCHING MATERIALS

For beginner students, or anyone new to life drawing, I recommend starting with the studio materials, especially the long-leaded pencils (see page 20). However, those materials may be difficult to find or may not be available at all in your area. Studio materials are also quite large, so they require more space and can be difficult to carry if you are traveling.

For cases in which smaller, portable sketching materials are needed, I use a separate set of more commonly found materials and tools.

Pencils (A)
The pencils I draw and sketch with the most are graphite pencils and colored pencils.

1. Graphite pencils are the most common and are readily available. I use mostly 2B and HB grades (pictured). For convenience, I often carry and use a mechanical pencil.

2. Colored pencils are very common and easy to find, but vary dramatically in quality. I use and recommend Prismacolor, black (pictured).

Ballpoint Pen (B)
Ballpoint pens are my favorite drawing tool. The large majority of my sketching is done with ballpoint because of its feel and versatility. Ballpoint, unlike gel or felt-tip pens, allows for more pressure sensitivity and is able to produce very light marks. In this way, this pen mimics drawing with charcoal or pastel pencil. Ballpoint pens come in many brands and colors. At the art store, I look for Bic or Pilot brand, size 0.5 or smaller, in black.

Markers (C)
I use markers mostly for tones. Because they can fill a shape or area quickly with a dark value, they are ideal for value and shadow studies. For some examples of shadow studies, see chapter 5. I use Sharpie brand for blacks and Prismacolor and Copic brand for grays.

Felt-tip and Brush Pens (D)
Unlike a ballpoint pen, felt-tip and brush pens make dark, uniform, and permanent marks. I use felt-tips mostly to practice my line drawing. Brush pens are great for sketching and practicing the undercup grip, which will be covered later in this chapter. The marks are dark, thick, and permanent, so there's no room for mistakes and no way to erase or undo a mark. This makes brush pen drawing a great exercise for practicing how to make careful and confident marks. The felt-tip brands I recommend are Faber-Castell Pitt Artist and Sakura Pigma. For brush pens, I like Sakura (pictured), Tombow, and Pentel.

Work with What You Have

These materials are recommended and helpful, but they're not necessary. If you can't find CarbOthellos or smooth newsprint at your local art store, don't worry. It's perfectly okay. Work with what you have. An ordinary writing pencil with the pink eraser at one end and a few sheets of whatever paper you can find is all you need to get started drawing. Don't use not having materials as an excuse not to draw. Work with what you have until you can find good pencils and paper. In the meantime, draw from life as much as you can and practice the drawing process and methods in this book.

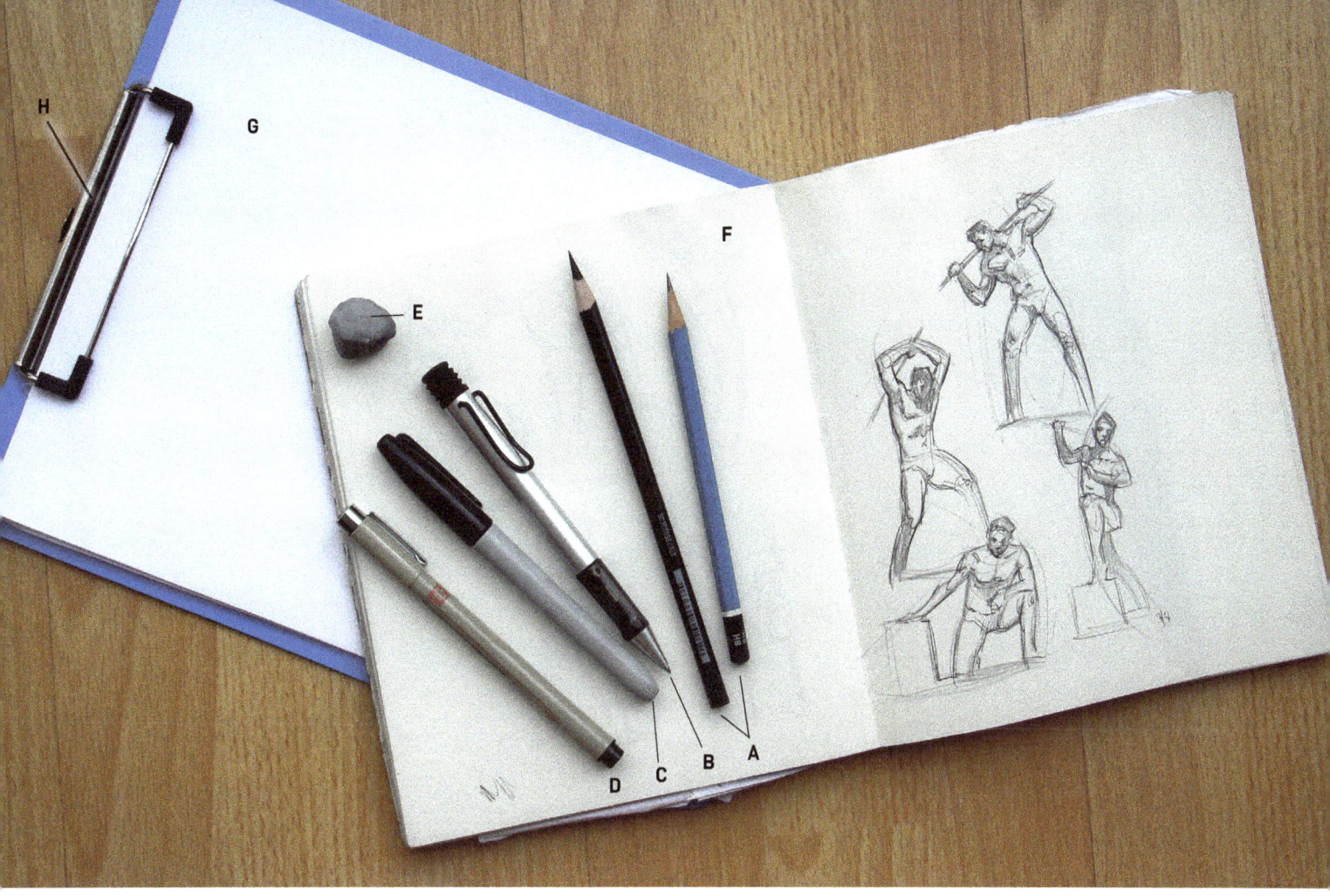

Erasers (E)
Kneaded erasers (pictured) will easily erase graphite and partially erase or lighten colored pencil. For erasing colored pencils, I recommend a Staedtler Mars eraser or any hard plastic eraser.

Sketchbook (F)
Sketchbooks come in many shapes, sizes, and paper types. There is an almost infinite range to choose from. The best way to find a sketchbook that is right for you is to try as many as possible, draw every day, and fill them up! For beginners, start by choosing a size that is comfortable and portable and has a neutral white paper with a smooth texture.

I bring my sketchbook everywhere with me, so most of mine are around 5" x 7" (13 x 18 cm) or 6" x 8" (15 x 20 cm) in size because they are easy to carry and store. Brands I have used include Strathmore and Moleskine, but even ordinary unlined journal books from a stationery store can be great for sketching and life drawing.

Copy Paper (G)
Besides drawing in my sketchbook, I use and enjoy ordinary copy paper/printer paper. I use U.S. letter size 8½" x 11" (22 x 28 cm) or A4 international size. Copy paper is great for drawing students because it is inexpensive and easy to find.

Clipboard (H)
To support my stack of copy paper, I use an ordinary clipboard. Most clipboards come in a standard size that supports letter-size (or A4) paper.

Using Your Materials

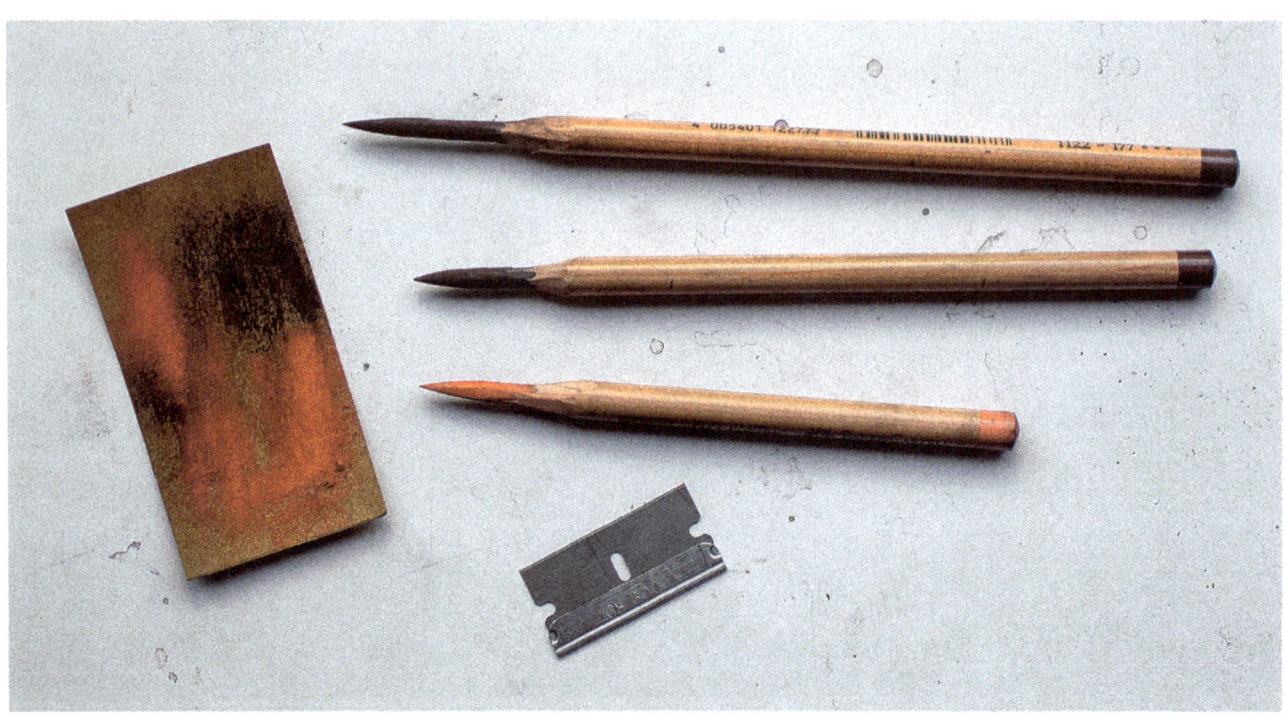

LONG-LEAD PENCIL

One of the most useful ways to draw the figure is with a long-leaded pencil. A long lead can be as long as 2" (5 cm), but for most artists new to drawing with long leads, I recommend sharpening and drawing with lead anywhere from ½" to 1" (1 cm to 2.5 cm) in length.

The beautiful thing about long lead is it allows for a wide variety and range of marks, specifically the ability to make sharp lines and also broad strokes of soft tones. This versatility is useful when drawing from life because it allows for line drawing and shading with a single tool, which saves time. A long lead also simulates a brush, which is great for preparing a drawing student for learning to paint. This variety of marks can also be achieved with drawing sticks such as charcoal or pastel, but pencil gives much more control for smaller marks and details if needed.

Needle Point and "Heel"

There are generally two shapes of long leads. The first is the long "needle" point **(A)**, and the second is the "heel" **(B)**. The needle point looks like a long needle while the heel has a flat surface. Both shapes can create the same marks needed for life drawing. I encourage you to try both until you arrive at a preference.

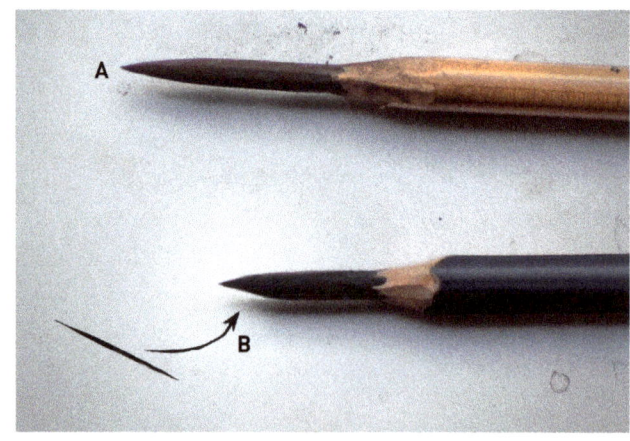

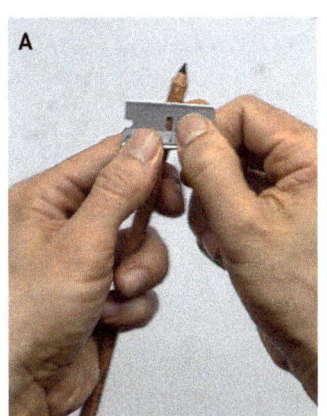 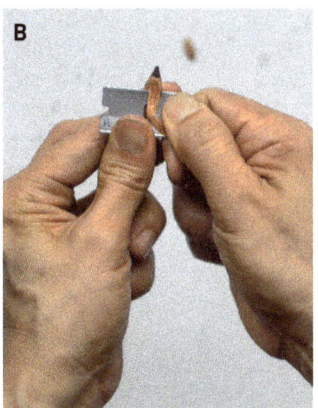 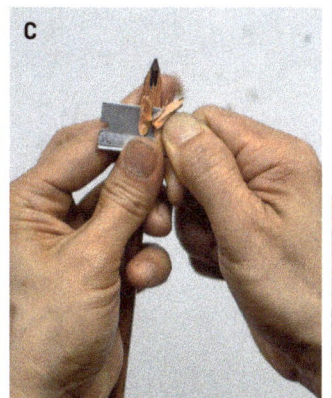 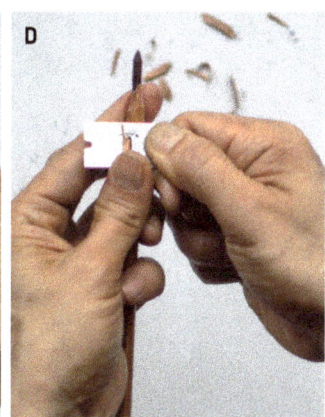

HOW TO SHARPEN YOUR PENCIL

Step 1: Expose the Lead
The first step is to slowly remove, or whittle away, the wood of the pencil to expose the lead. Using a single-edge razor blade, hold the blade with your thumbs on top **(A and B)**. Turn the pencil with your fingers as you shave the wood **(C)**. Once you have exposed enough lead (about ½" to 1" [1 cm to 2.5 cm]), shape the wood so that it tapers from the lead to the pencil **(D)**.

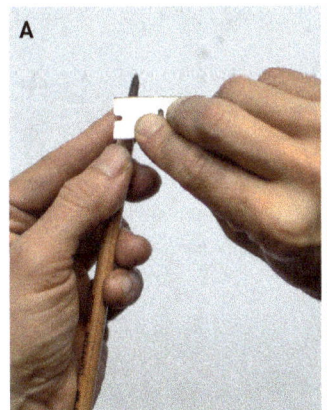 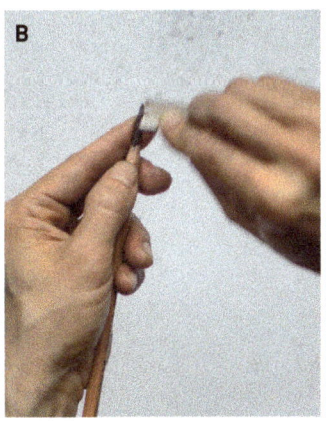 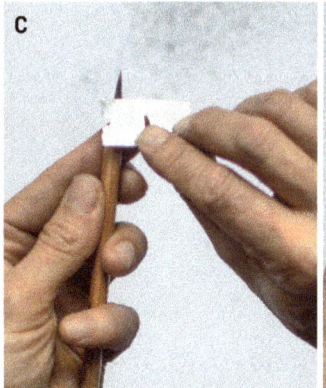 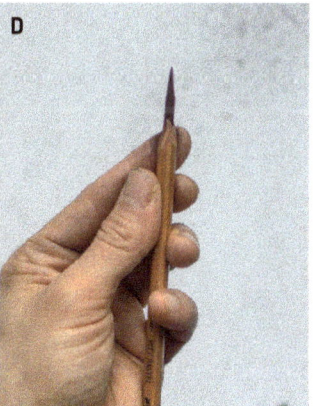

Step 2: Sharpen the Lead
The next step is to shape and sharpen the tip of the lead. This step takes a lot of practice, so if you're new to hand sharpening, proceed slowly and with caution. With a single-edge razor blade, start by holding the blade with your fingers on top and your thumb underneath **(A)**. Shave and whittle the lead to make a smooth and sharp point **(B)**. Continue to the shave the lead and turn the pencil with your fingers until you achieve a sharp point and smooth taper **(C)**. When finished, the shape should resemble a long needle **(D)**.

A Note on Electric Sharpeners

When you draw with a traditional graphite pencil or colored pencil, I recommend using an electric sharpener that creates the longest lead possible. Although an electric sharpener can never create a beautiful 1" (2.5 cm) needle point, there are sharpeners that can still produce a sharp point and long lead suitable for making tone and soft marks. There are many brands available, but the ones I have used are made by Foray and Panasonic.

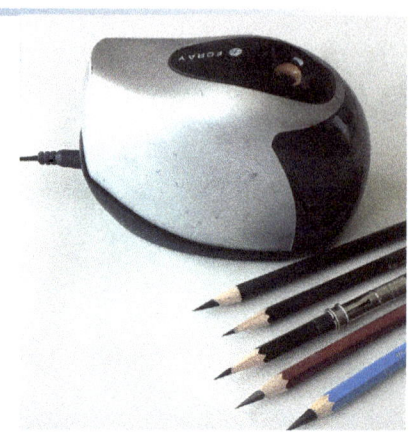

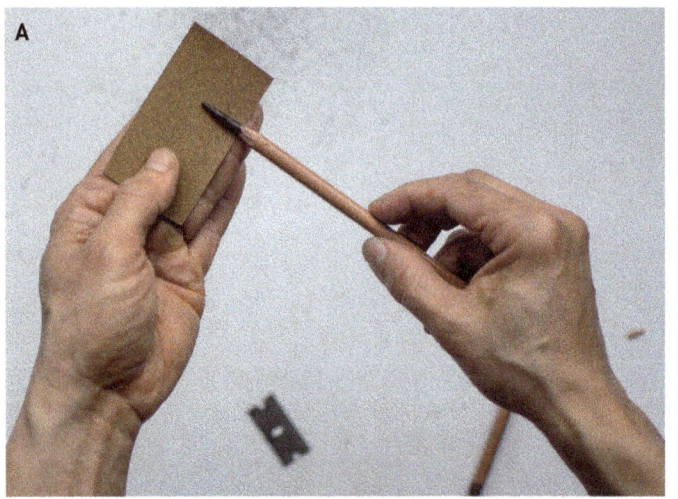

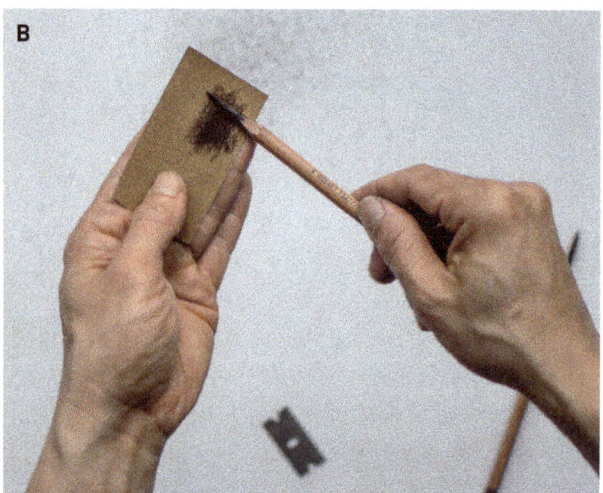

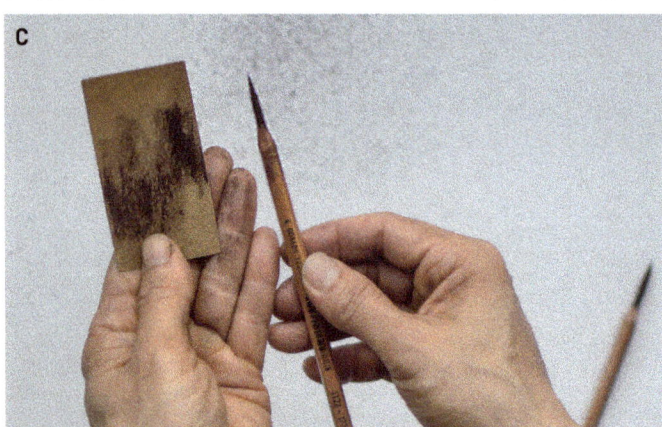

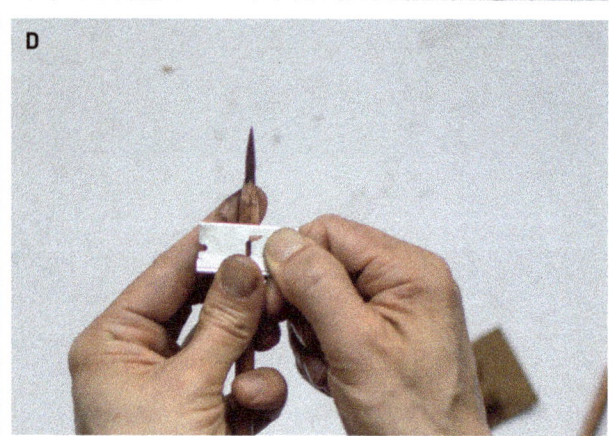

Step 3: Sand and Refine

To get the sharpest edge and smoothest lead, use a sanding block or medium-grain sandpaper. The goal in using sandpaper is to smooth out any bumps or irregularities on the lead and make the sharpest point possible.

Start by laying the lead flat on the sandpaper **(A)**. Move the pencil back and forth and turn the lead with your fingers as you sand **(B)**. After the lead is smooth and sharp **(C)**, I shave the wood again to make a smooth taper **(D)**. This allows you to lay the pencil flatter and use more of the side of the lead. Finish by wiping the lead with tissue paper to remove any excess dust.

HOLDING YOUR PENCIL

The common way to hold a pencil is with the thumb underneath and the fingers above. This is how most people hold a pencil to write and draw. For the purpose of figure drawing, and for any aspiring art students, we want to begin holding the pencil in a nontraditional grip known as the "undercup," or "painter's," grip.

To accomplish this, simply adjust the way you hold and use the pencil. For example, by using the side of the long lead you can make broad strokes and soft marks **(A)**. To make firmer marks, hold the pencil closer to the lead to get more pressure in your stroke **(B)**. To make fine lines, raise the pencil to use more of the tip **(C)**. Of course, when needed to draw small details, you can always go back to a traditional pencil grip.

If you are new to using the undercup grip, it will take a lot of practice to get used to holding a pencil in this way. With consistent practice, your control and marks will improve, and your overall dexterity will improve because you will have gained fuller use of your hand.

Later in this book, I share some drawing exercises to help improve dexterity and speed up the learning curve with undercup drawing.

Unlike the more common writing grip, the fingers are supporting, or "cupping," the pencil from underneath, and the thumb is on top. This is also how trained painters hold the long handle of a paintbrush.

With the undercup grip, you can make full use of the long lead of the pencil and achieve a wide range of marks, from lost and soft tones to sharp lines.

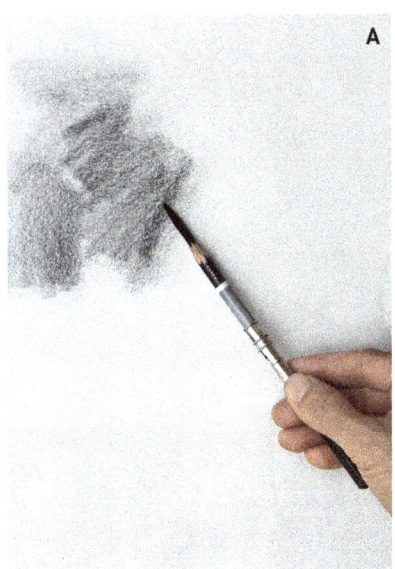

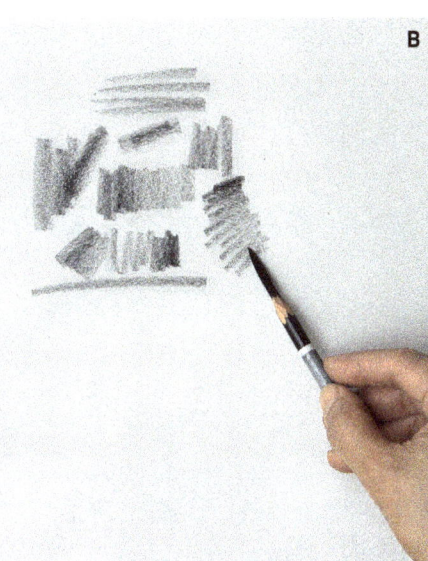

CHAPTER 2

FUNDAMENTALS OF LIFE DRAWING

Making Marks

THE THREE MARKS

The first and most simple statement in a figure drawing is the mark. Marks can take an infinite number of shapes or forms, and there is no right or wrong way to make a mark. For the purpose of drawing from life and becoming efficient and proficient, I like to simplify to three basic marks. These three marks are "straights," "C-curves," and "S-curves." I also call them "I, C, S," because their shapes resemble the three letters.

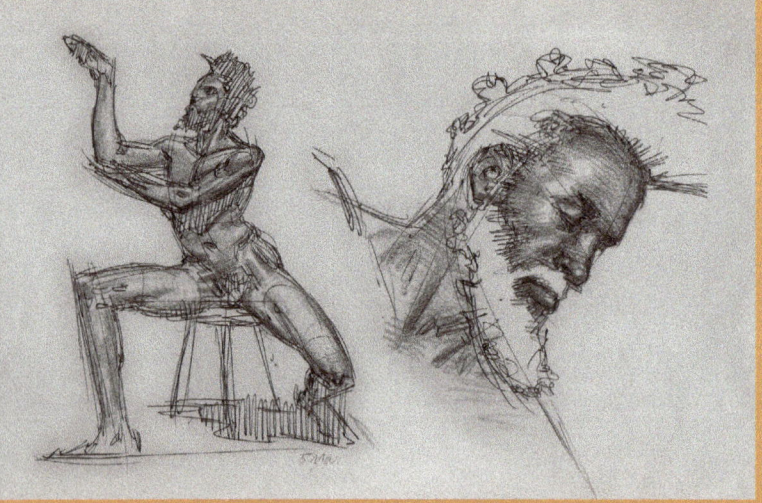

The figure and head can easily be drawn and constructed with straight, C-curve, and S-curve lines, especially in the beginning stages.

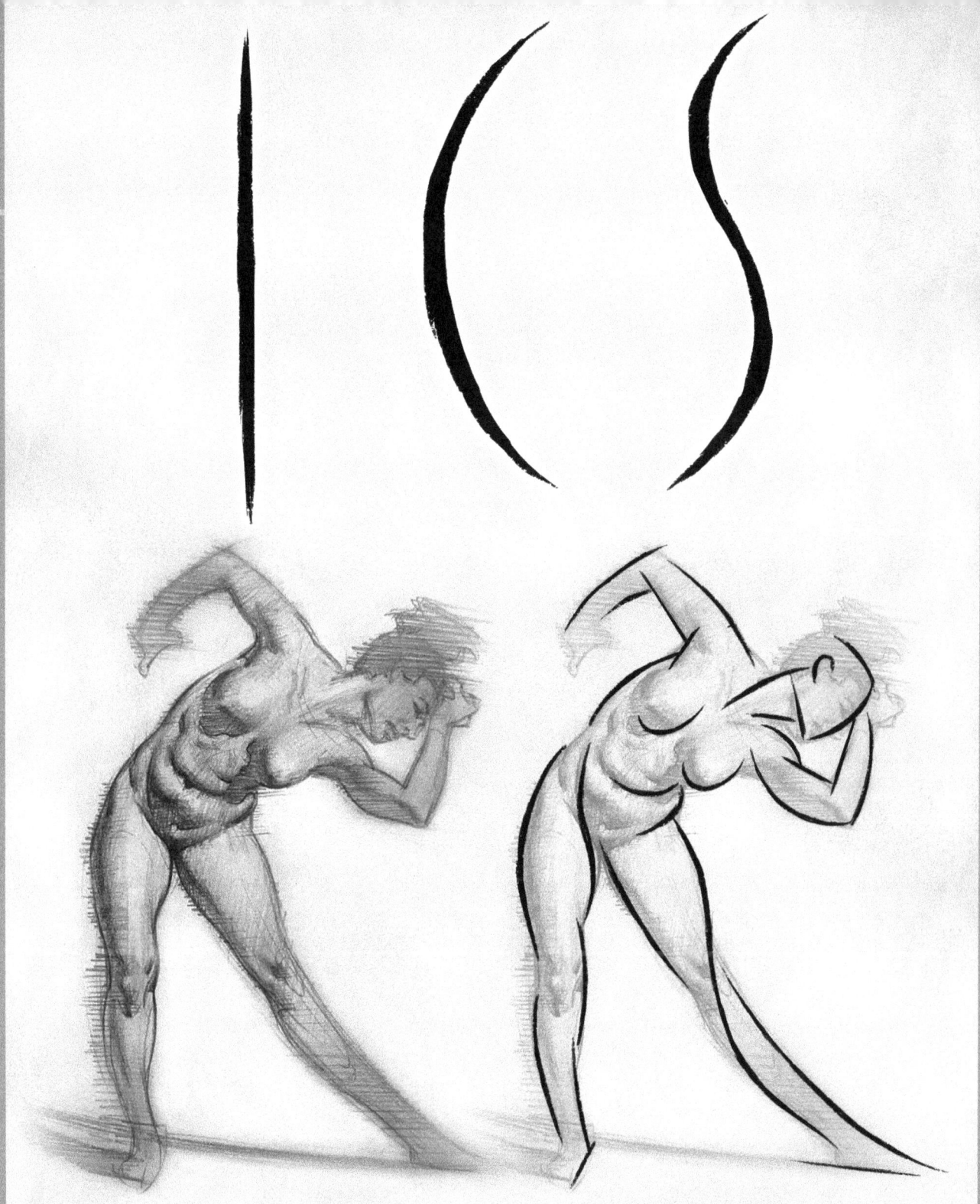

Straight marks don't really occur in nature or organic forms such as human beings, but as artists we can use them to great effect in our drawings. C-curves are everywhere. About 80 percent of a figure drawing consists of C-curves. S-curves occur when two C-curves oppose each other, meaning they flow or bend in the opposite direction. S-curves are commonly seen in twisting forms and poses. Later in the book we will examine how to use the three marks to start and build the drawing. Following are examples of how the three marks can be used in a drawing.

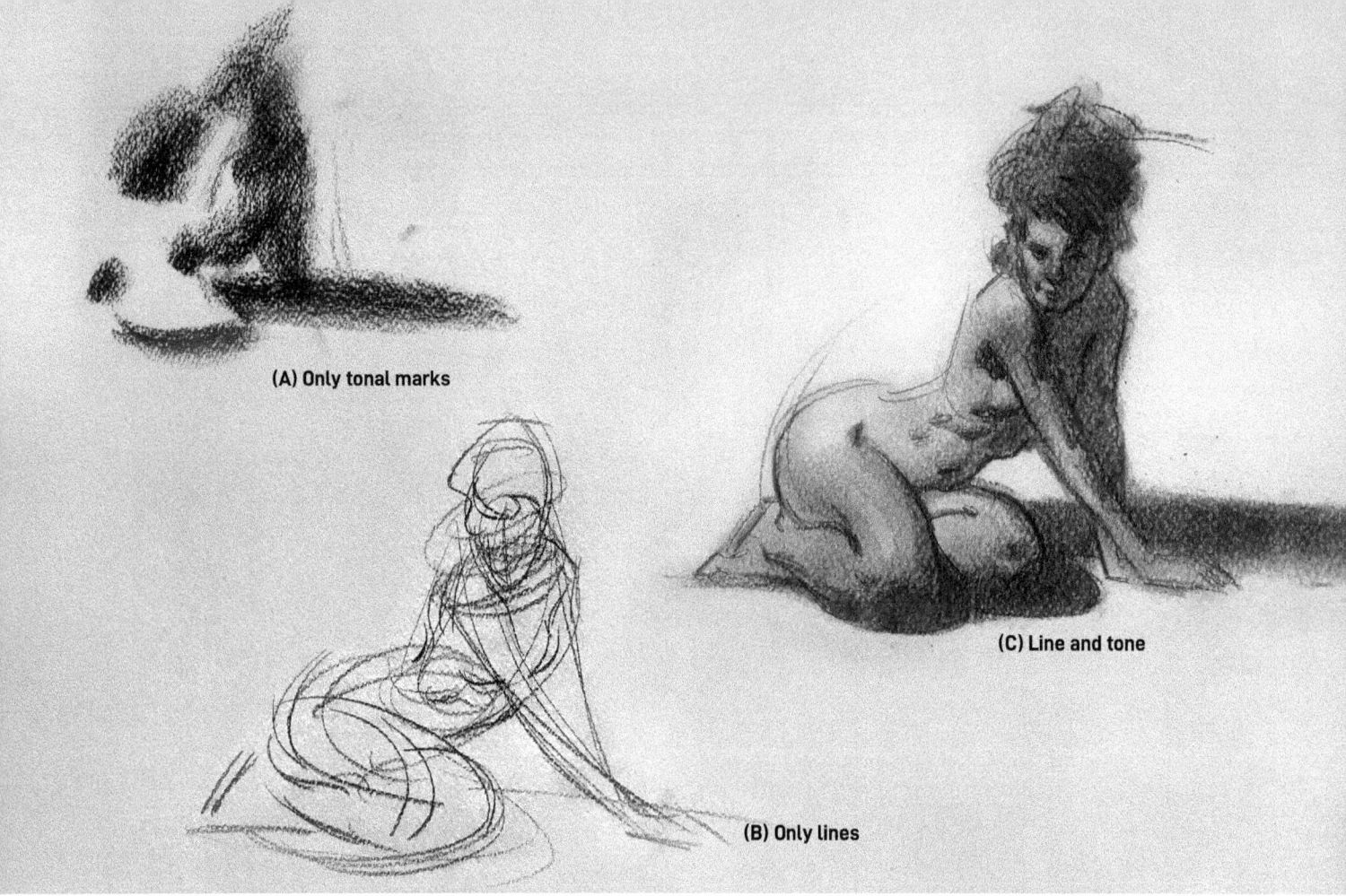

This example shows how a drawing begins with tone (A) or begins with line (B), and how both can be used together to create a beautiful drawing (C).

Line vs. Tone

In drawing, especially with dry mediums such as pencils, most of the marks made take the form of either lines or soft, tonal marks.

When we begin to draw the figure, lines are a natural choice. As we advance, we can also draw with tonal marks. I define a tonal mark as one that has a wide shape and softer look. Tones are generally used when shading or describing the light. As we advance, we can begin the drawing with tonal marks. Ideally, with practice, the trained artist will use both marks and flow between line and tone to create beautiful effects.

Again, there is no right or wrong way to make a mark. For the purpose of this book, the focus will be on line for the beginning stages of the drawing and tonal marks for the later stages.

The Concept of Gesture

The first and most important concept or idea in the art and practice of figure drawing is gesture. These are often the first marks made, and this is the foundation from which an entire drawing is built. So any book that attempts to teach figure drawing must include an examination of gesture.

Because gesture is so important, I will spend some time defining and explaining it and expand on this essential and fundamental concept.

WHAT IS GESTURE?

The concept of gesture and the word itself are often used and often misunderstood. Gesture is a mysterious concept that is almost impossible to describe or define in words because at its essence, gesture is an artist's attempt to capture life itself. Besides being a drawing method, gesture is also an action an artist takes and a way of drawing that expresses feeling and emotion in the moment.

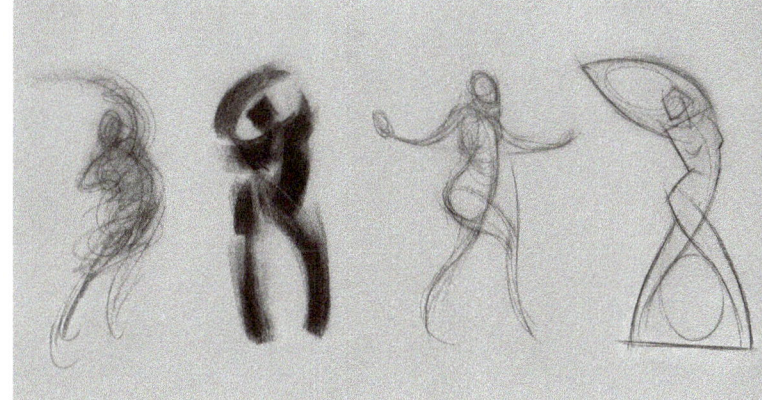

Above: There are many ways to draw gesture. Gesture can be controlled, rhythmic, chaotic, or all of the above.

Bottom: A page of one-minute gesture drawings from a live, costumed model. Short poses are great for practicing gesture.

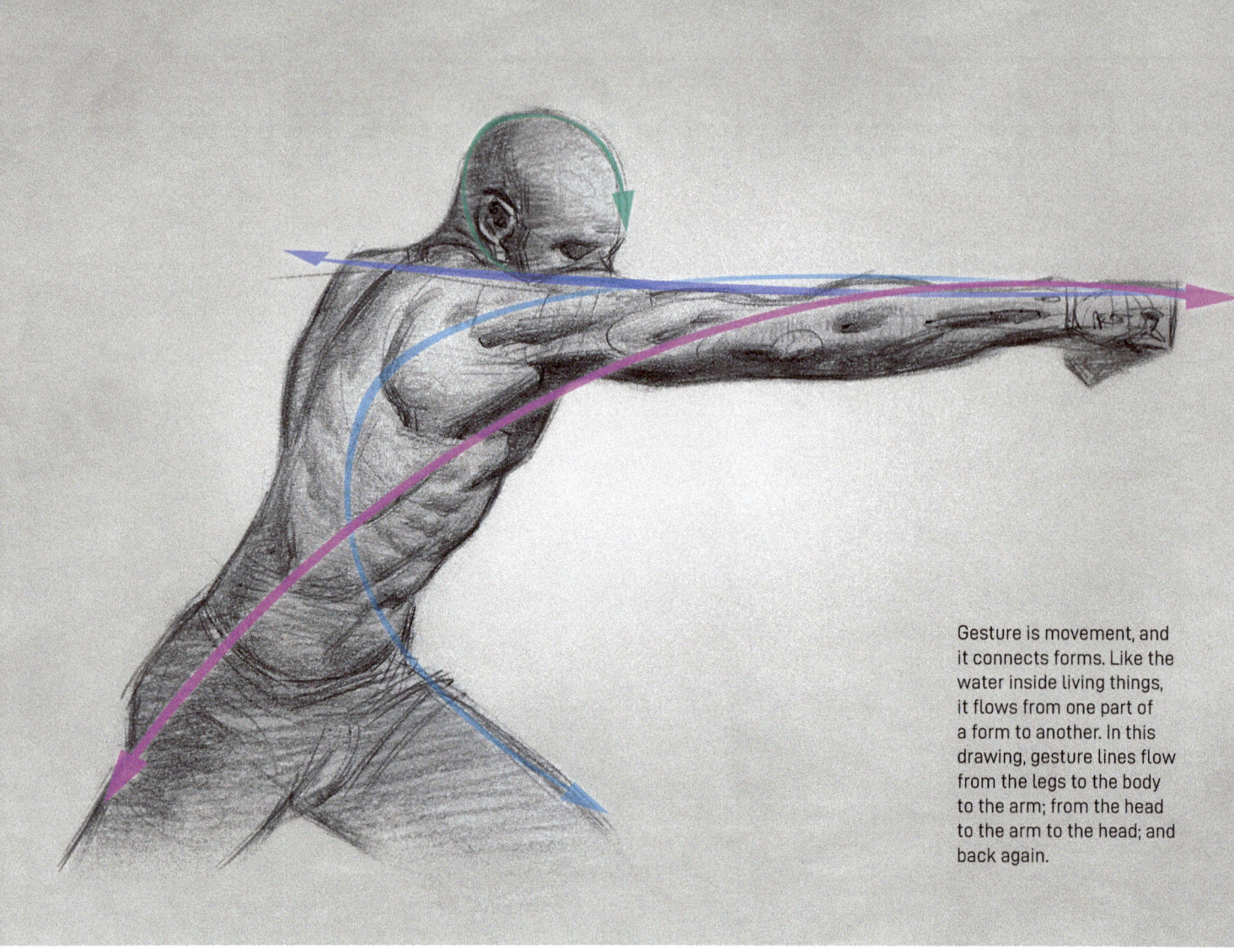

Gesture is movement, and it connects forms. Like the water inside living things, it flows from one part of a form to another. In this drawing, gesture lines flow from the legs to the body to the arm; from the head to the arm to the head; and back again.

For the purpose of this book, I define gesture as:

The fluid movement between two or more forms in space.

Gesture is fluid because organic, living forms are mostly made of water. This is especially true of human beings, which are 70 percent water. Like water, gesture can take many forms and shapes and is impossible to contain.

"Space" refers to the way gesture moves along and around the exterior or outer edges of forms, but also into, out of, and through forms.

Steve Huston, one of my great figure drawing teachers, describes gesture as the connection and relationship between parts or forms of a figure. For example, gesture connects and relates the head to the toes, the shoulder to the wrist, and the wrist to the fingers.

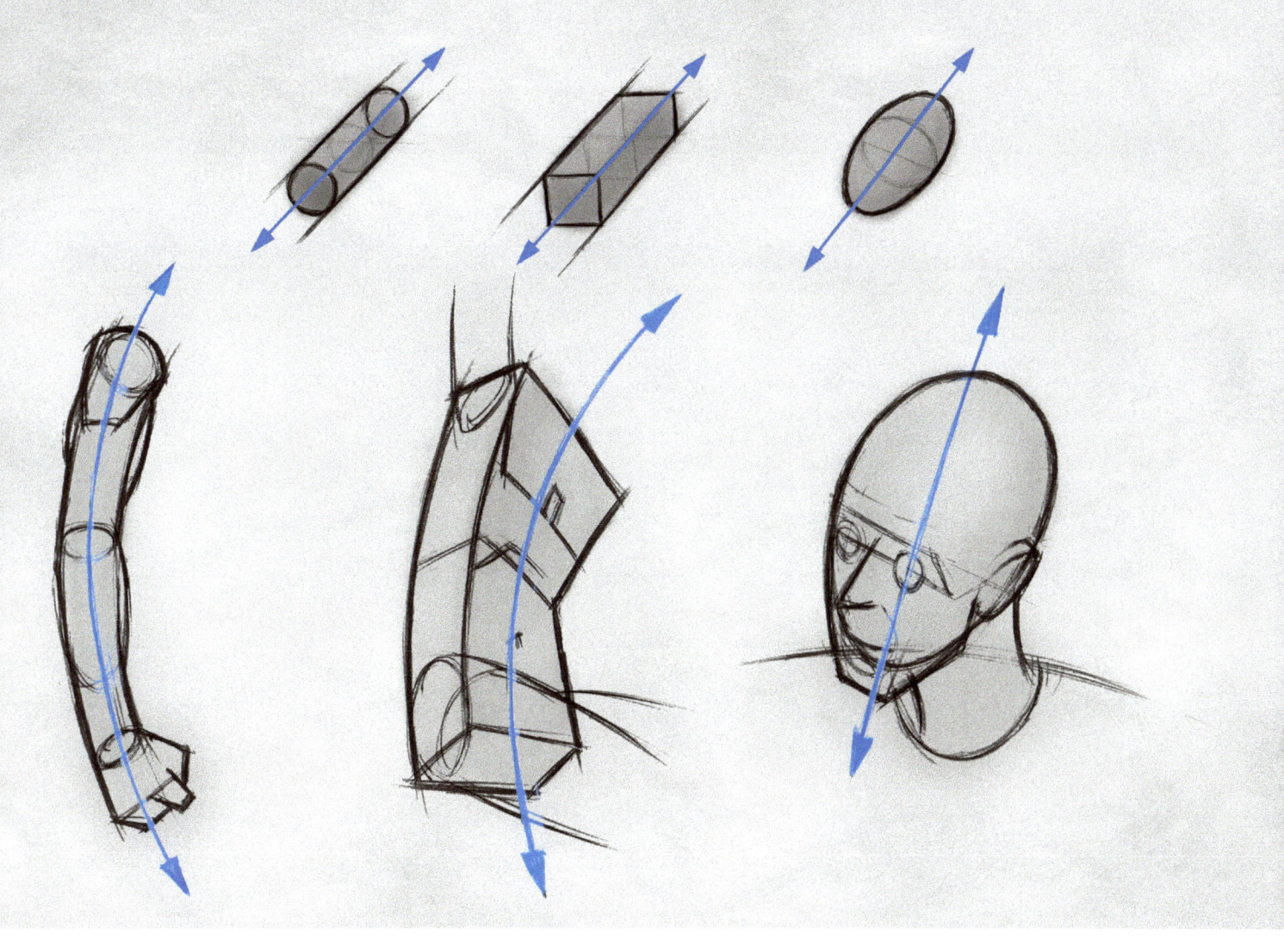

FORM AND FUNCTION OF GESTURE

Gesture has many functions and can take many forms in our drawing. Below are some of the important ways we can see and use gesture when we draw the figure.

Long Axis, Action Line, or "Thrust"

The first and most important gesture line to define is known as the "long axis." In a mathematical sense, the long axis is parallel to, or runs along, the longest side of a solid or form. In figure drawing, the "long axis" is the longest, most uninterrupted gesture line in the figure or form, because even the smallest forms have their own long axis.

The long axis is a mathematical term that describes the longest side of a form. In figure drawing, it is the longest, most uninterrupted gesture line. All forms, from largest to smallest, have their own long axis.

When drawing the figure, the long axis of a pose is also known as the "thrust" or the "action line" because it describes the fundamental action of the pose. If done right, the first few gesture lines can communicate the primary action of the pose. The action line answers the question: "What is the pose (figure) doing?" Communicating the action of a pose is one of the most important responsibilities of an artist and should be the goal for any student of figure drawing.

I almost always start with the action line because it adds a sense of movement, but it also is a great foundation for building the rest of the drawing.

Stretch and Pinch

To move the human body, our muscles and bones work in a pulley-lever-type system. This means that when a muscle or muscle group contracts, another must elongate or stretch. For example, when the arm is flexed, the bicep muscle contracts and the tricep muscle on the opposite side of the arm stretches.

In figure drawing, this action of muscle contraction and elongation is known as "stretch and pinch."

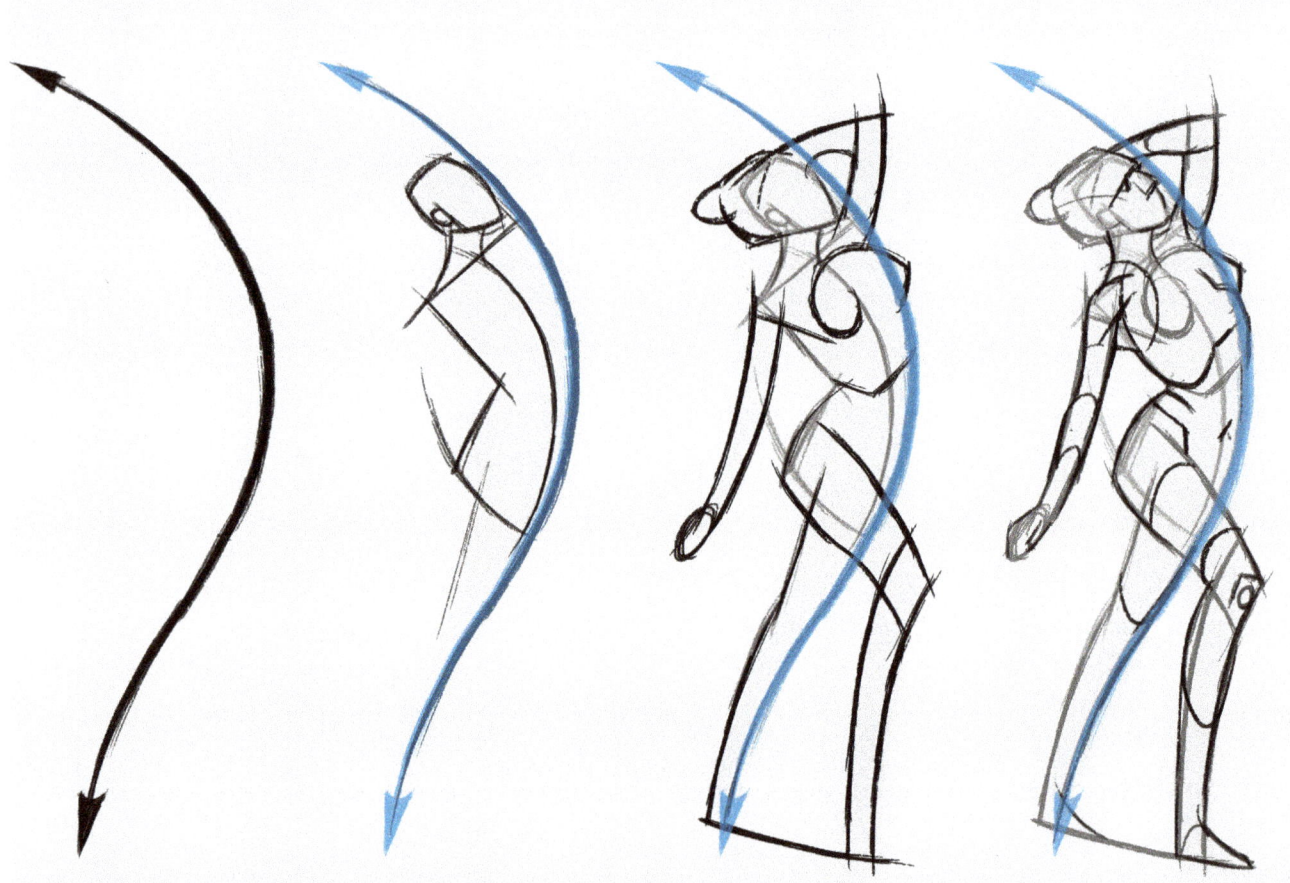

The action line is a great way to start a drawing. Not only does it define the movement and action of the pose, but it serves as a design line from which the entire drawing can be built.

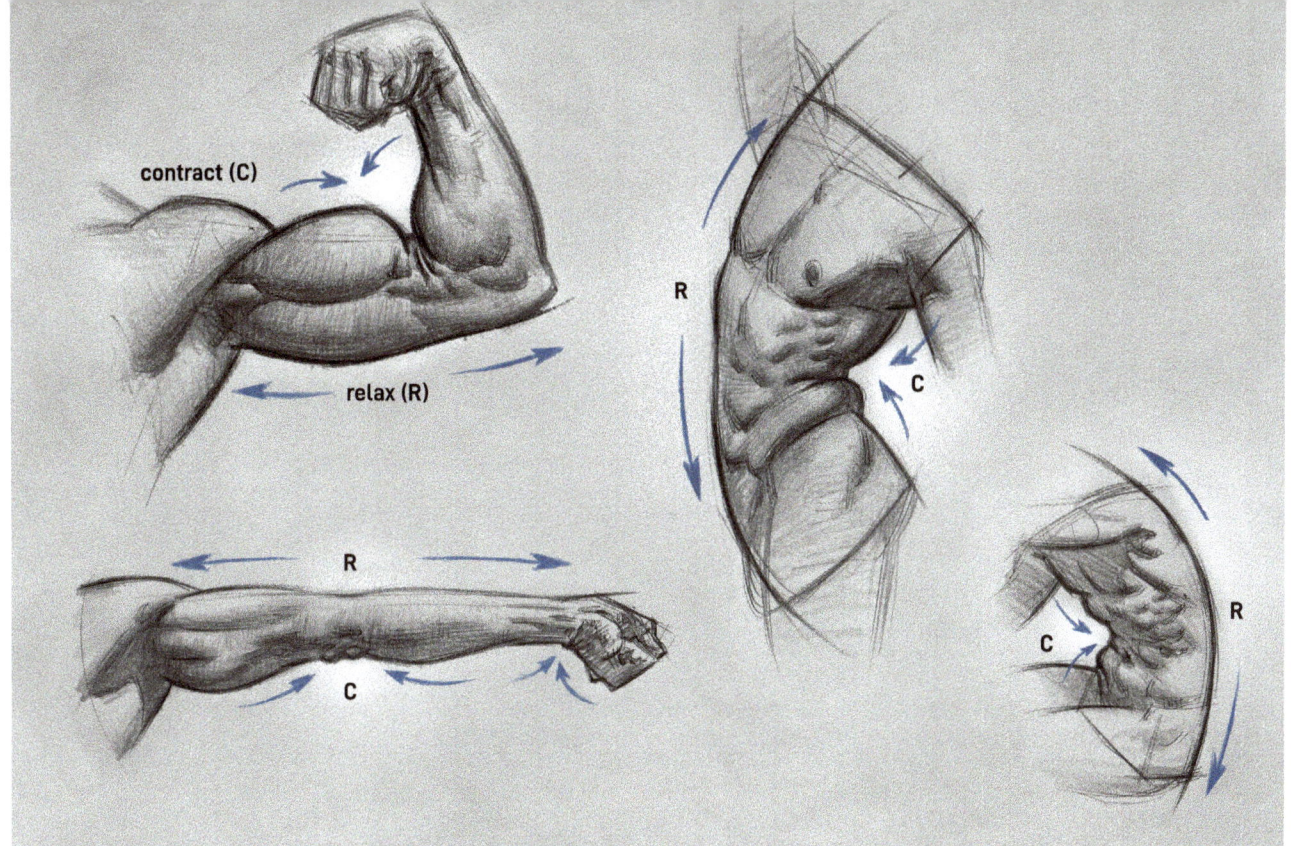

When one muscle or group of muscles contracts (pinches), another group (usually on the opposite side) must elongate or relax (stretch). This is how the human machine is built and is true throughout the body.

Stretch is long; it is a curve. It serves as the action line of the form. Pinch can appear as small, curved forms, bunching, or groups of small forms.

When drawing, I keep the stretch side as simple as possible. I use long curves and try to leave the curve smooth, without adding bumps or details if possible. The pinch side is where I add detail. This is where I can have fun drawing small muscles and interesting curves and shapes.

When done correctly, the combination of long, smooth curves in some areas and lumps, bumps, and details in others adds contrast to a drawing. Contrast is a simple and effective way to make the drawing feel more sophisticated, polished, and beautiful.

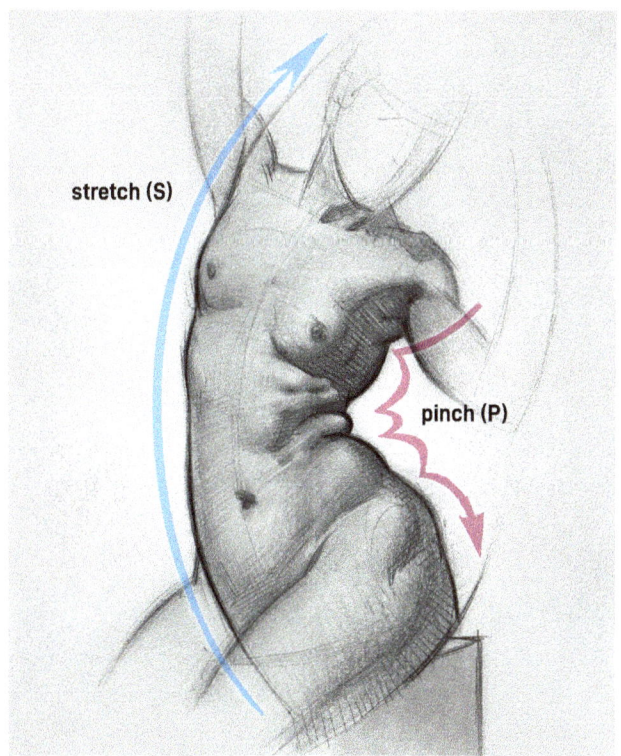

Stretch and pinch are opposite, contrasting forces. I keep the stretch as simple as possible, using long, simple curves. This suggests muscles stretching and elongating. In contrast I draw the pinch with short, aggressive strokes that suggest muscles contracting and overlapping. This contrast makes a drawing feel more sophisticated, dynamic, and lifelike.

FUNDAMENTALS OF LIFE DRAWING

Stretch and pinch typically happens on the sides of the form and moves along the form. Another way that gesture can move is over forms, which we'll explore next, is "structure."

Structure

When we draw the long axis of a figure or the curved stretch of a form, these gesture lines occur along the form, meaning they are generally drawn on the sides, or outer edges. When a gesture moves over the form, it is known as structure. For example, a line drawn from the left side of the rib cage to the right is structure.

Structure is what creates a feeling of volume. It turns a flat rectangle into a solid cylinder. In fact, it makes any flat, two-dimensional shape into a three-dimensional solid or volume.

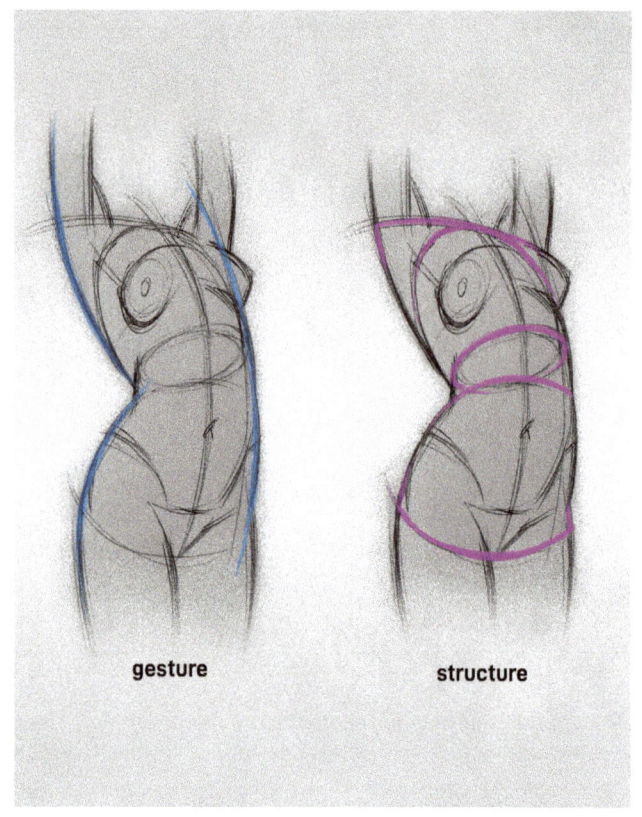

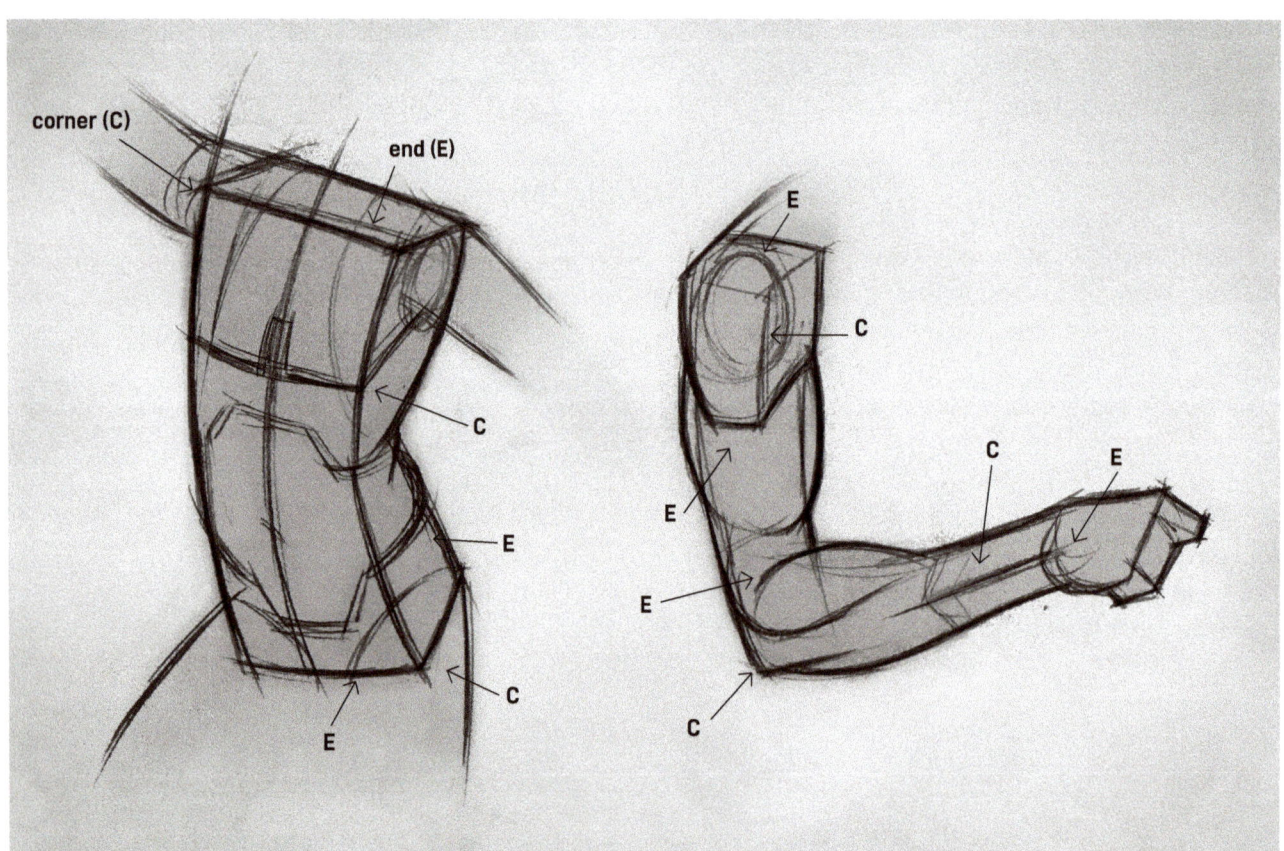

Top: Gesture runs along the form and structure runs over the form. Bottom: Adding corners and ends gives structure to forms. Corners and ends help contain and create a rigidity that balances the fluid, watery design of a gesture drawing.

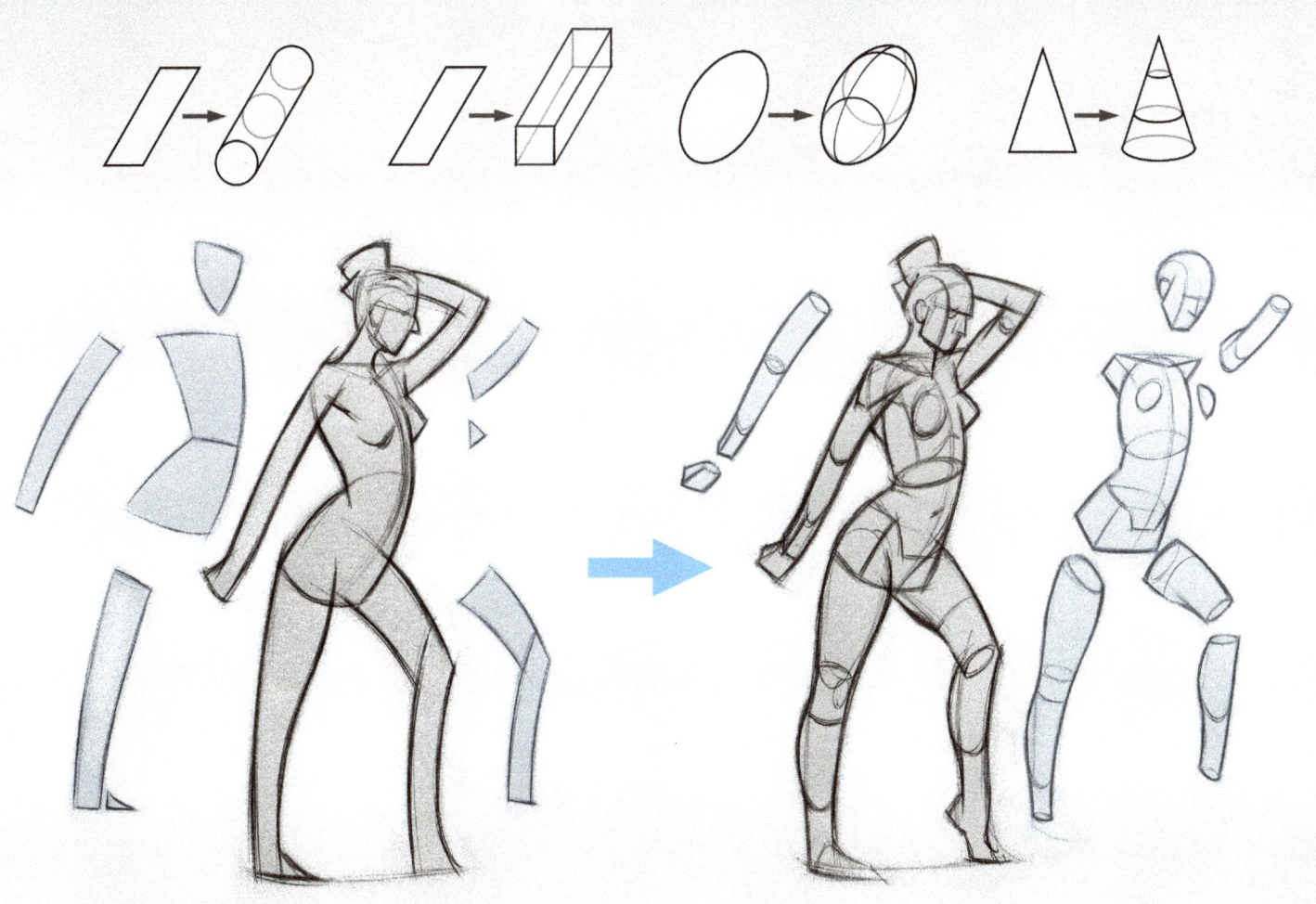

Structure turns 2-D shapes into 3-D solids. In figure drawing, structure becomes a great tool to make flat figures feel more full, solid, and volumetric.

Structure is necessary because gesture lines alone are fluid, whereas structure gives a drawing form and solidity by creating a way to contain the fluid nature of the body.

One way structure can be used is at corners and at the ends of forms. Corners happen when a shape ends and changes direction. Corners also occur on the front side of the form. A simple bulge or bump in anatomy can be a corner. Also, when we add light and shadow, we can use shadow shapes and highlights to define corners.

Whenever I want more structure, I simply terminate a form and add a corner, and therefore structure.

FUNDAMENTALS OF LIFE DRAWING

Rhythms

Rhythms are one of the most important forms of gesture. Like gesture and structure, rhythms move along and over the forms, but rhythms also go through forms. Rhythms are naturally occurring gesture lines that often follow the natural flow of the anatomy. For example, a line drawn from the ear flows rhythmically to the shoulder, and a line from the shoulder can flow to the chest, ribs, and all the way down to the legs.

Because rhythms often follow anatomy, they are a great way to simplify the anatomy when drawing. This makes rhythms ideal for drawing and sketching from life.

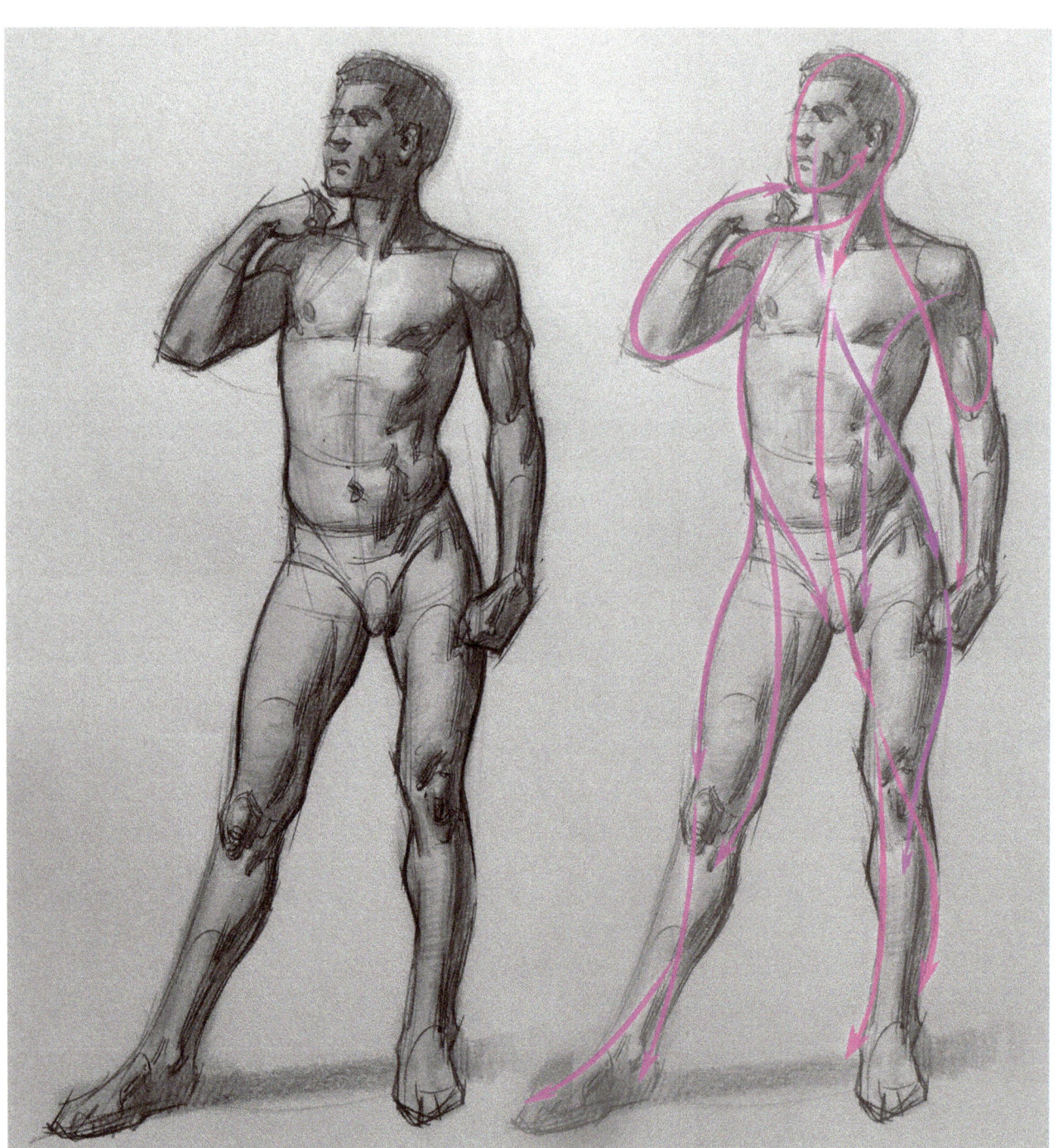

Rhythms are everywhere. They can be seen in the natural flow of human anatomy, but a trained artist can also invent rhythms to make a drawing come to life.

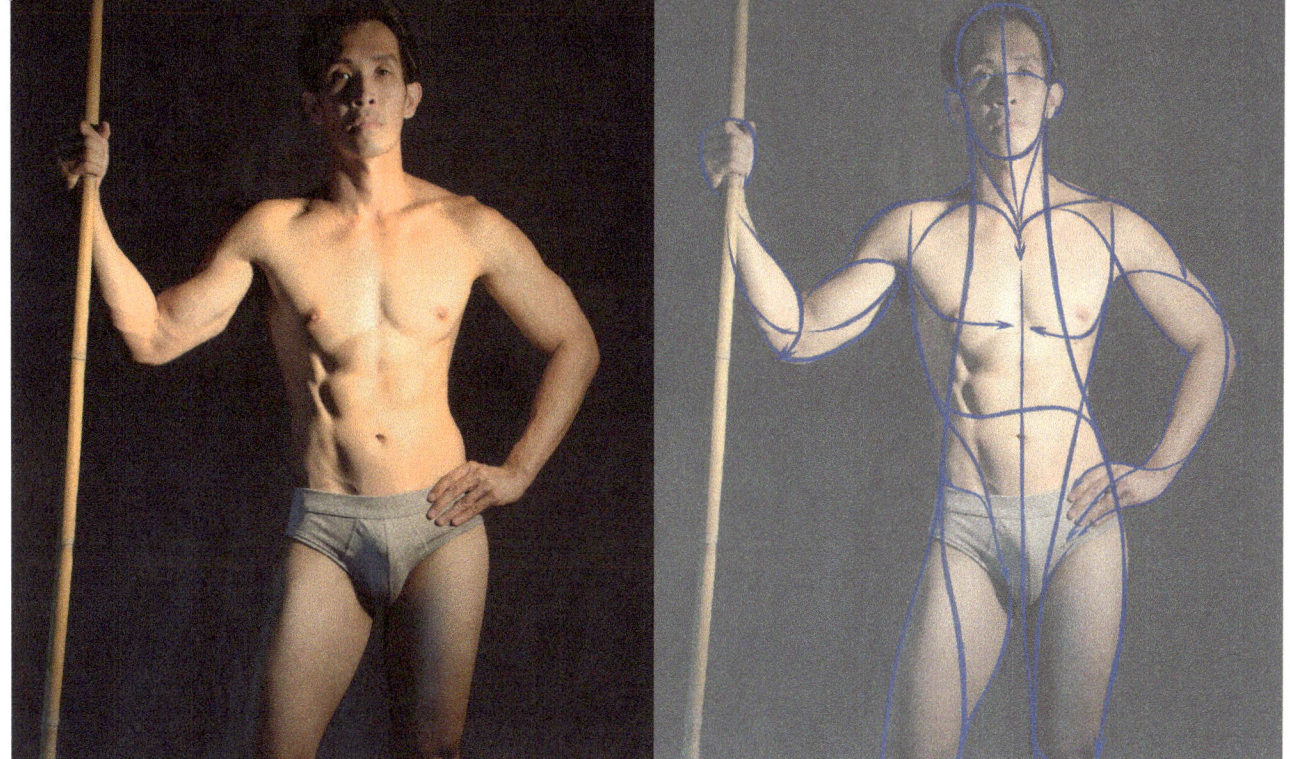

Because muscles and joints naturally flow from one to another, they can be quickly described and simplified with rhythm lines.

One of the main functions of rhythm is to extend a gesture line. For example, you can extend the stretch side of the torso to flow from the hand all the way to the toe, or go in any number of directions.

Drawing in this way also leads the viewer's eye through the drawing. This is known as "eye-flow." Having good eye-flow is a more advanced compositional idea, but by using rhythms you can add another dimension to your figures and make them much more eye-catching and appealing to the audience.

These are just some of the ways gesture can be used in drawings; there are many more ways to use and apply gesture. To describe them all would take an entire book on the subject alone.

For the beginning of this figure drawing journey, the forms and concepts defined here can build a foundation for a process that you can use in your figure drawing practice.

The process of drawing will be examined in detail later in this book.

Rhythm lines flow up, down, left, right, and around. They create movement by keeping the gesture alive. This movement creates a beautiful eye-flow, which keeps the viewer engaged in a drawing. How many more rhythm lines can you see in this example?

FUNDAMENTALS OF LIFE DRAWING

35

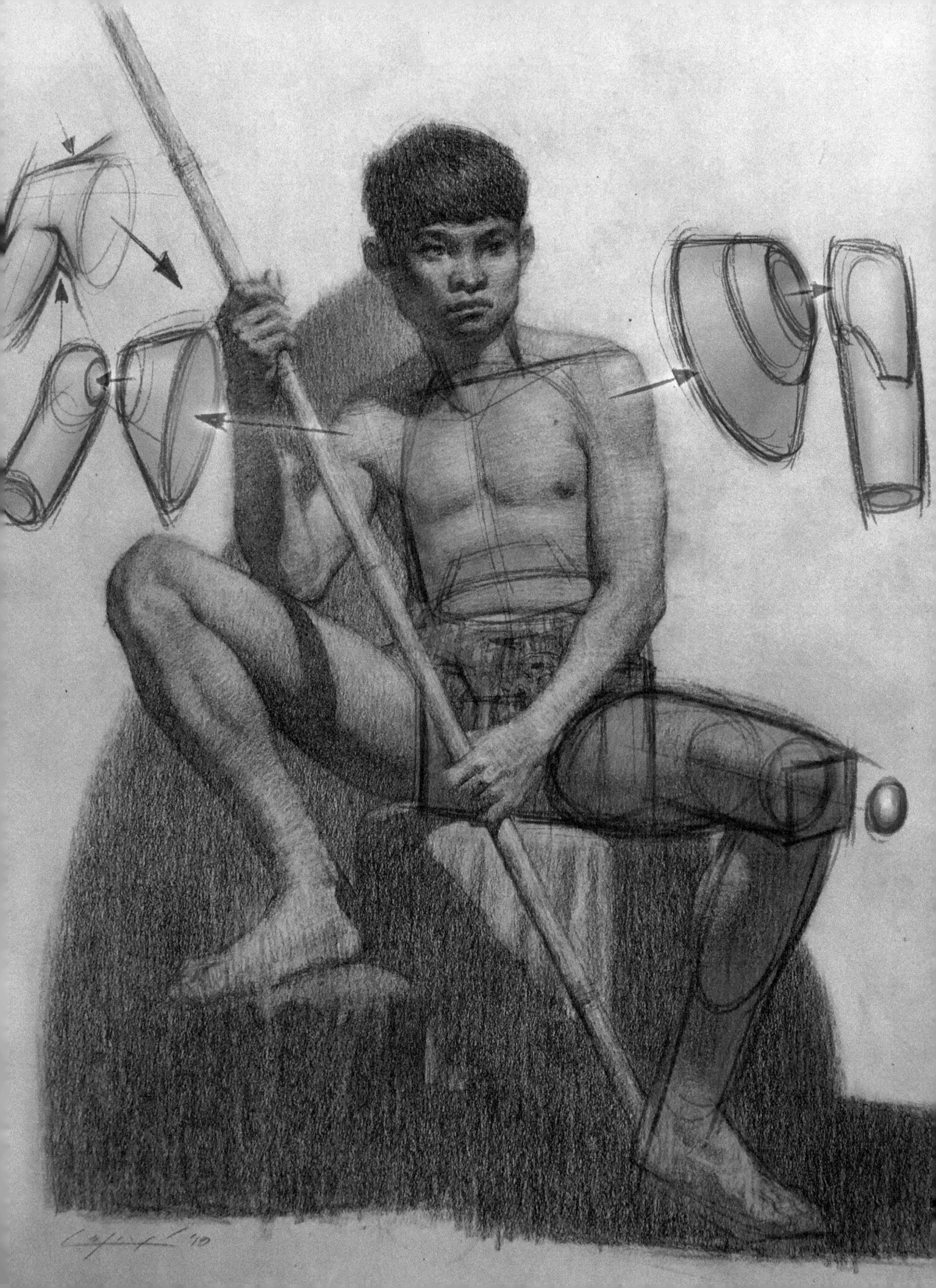

Construction

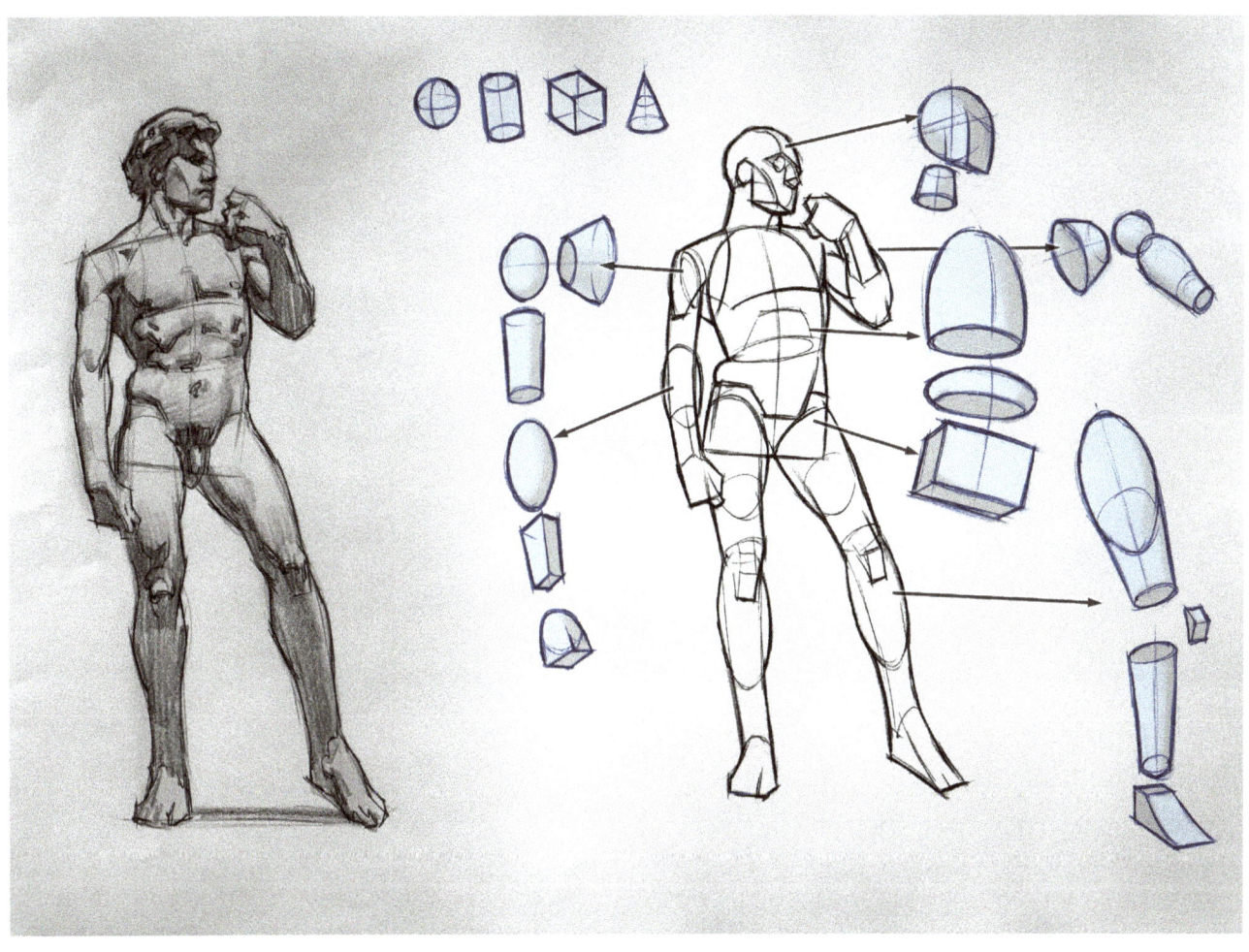

Cylinders, boxes, spheres, and cones are the simplest and most basic geometric forms.
They are great tools for simplifying the figure when drawing from life.

WHAT IS CONSTRUCTION?

Like gesture, construction is a term often associated with figure drawing. For the purpose of this book, I define construction as:

A method of drawing a complex subject using simple solids (geometric forms).

Simple solids, also known as geometric forms, "base forms," or volumes, is a mathematical term that refers to cylinders, boxes, spheres, and cones.

FUNDAMENTALS OF LIFE DRAWING

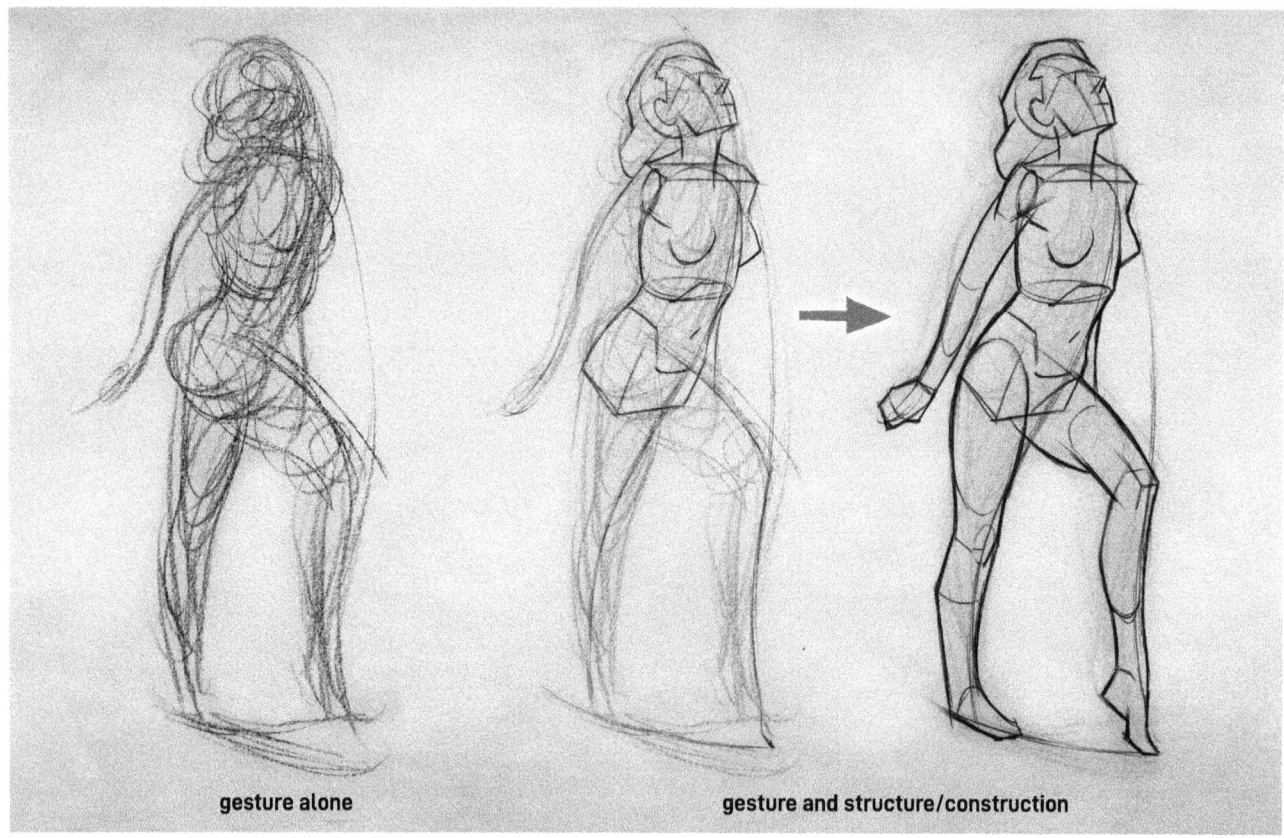

Gesture adds fluid movement to figures, but gesture alone can be too fluid, too watery. It feels weak and unstable. When balanced with construction, figures feel solid, three-dimensional, and more lifelike.

WHY DRAW CONSTRUCTION?

The primary purpose of construction is to help create the illusion of three-dimensional form. Because paper (or any drawing surface) is essentially flat, or two-dimensional, an artist must use tools and strategies to create the illusion of three-dimensional form. Construction and form drawing are among the first and primary tools an artist can use to suggest depth, which is the third dimension. The concept of two-dimensional and three-dimensional drawing will be explored in further detail later in this chapter.

Construction is also necessary because it adds solidity and weight to figures. With gesture alone, figures feel very loose, light, and unstable. With construction and geometric forms, figures start to feel full, solid, and volumetric.

But of course, you don't want to use only geometric forms or rely too much on form drawing without gesture. If you do, your figures can become very stiff and mannequin-like. This is one of the main criticisms and dangers of construction drawing. The solution is to begin with gesture, then add construction, and then work to maintain a balance between movement and form, gesture and construction.

CONSTRUCTION IS STRUCTURE

In "Form and Function of Gesture" (see page 32), I made the case that structure is gesture that moves over a form. By moving over the form, two-dimensional shapes become three-dimensional volumes. Squares become cylinders and boxes, and circles become spheres. This means that when we add structure to our gesture drawings, we are using construction.

In essence, construction is still gesture. If drawn correctly, construction can add movement, depth, and life to a drawing. This process of balancing gesture with structure and construction drawing will be explored in great detail later in this book.

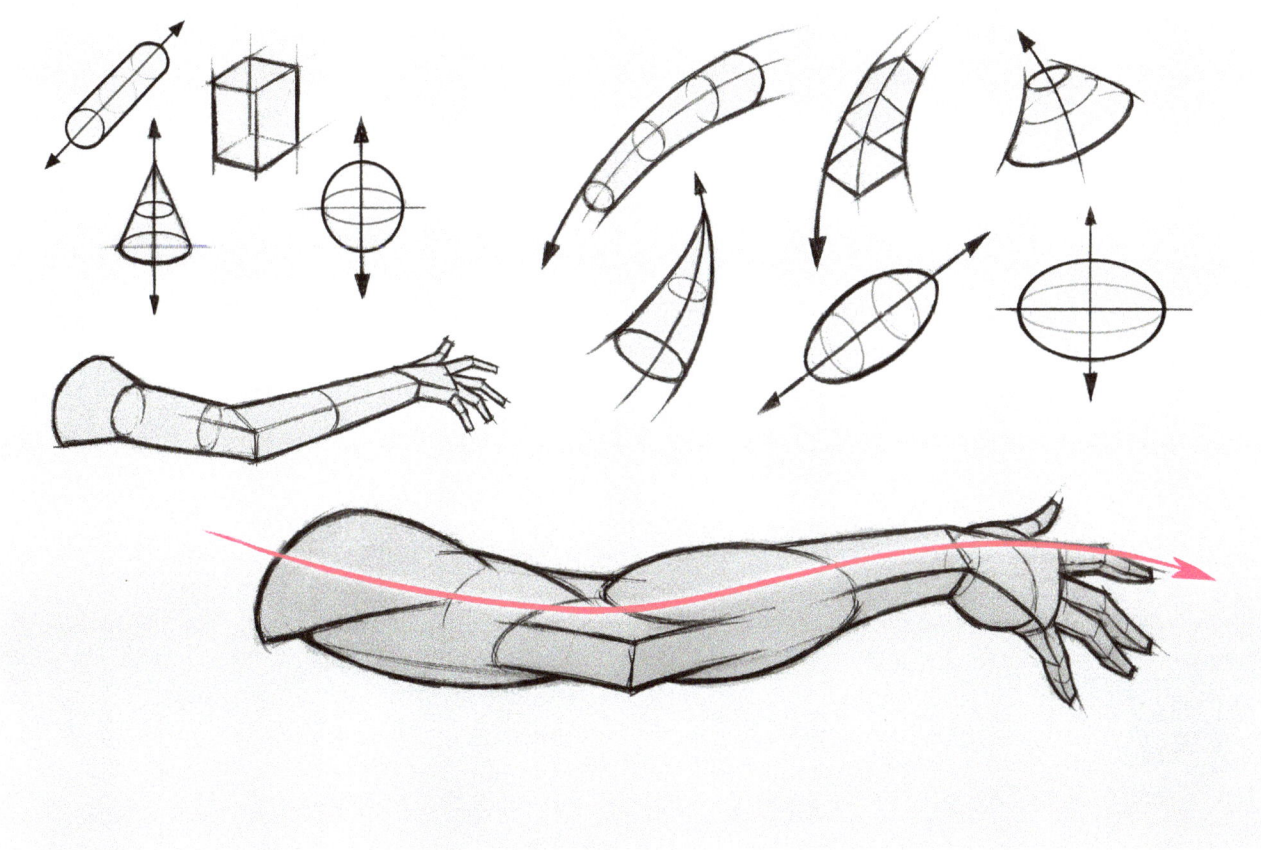

Construction is structure and therefore gesture. Construction doesn't have to be stiff. If drawn correctly, with long lines and curves, construction can be fluid and add movement, as well as create depth and structure.

Two-Dimensional Shapes

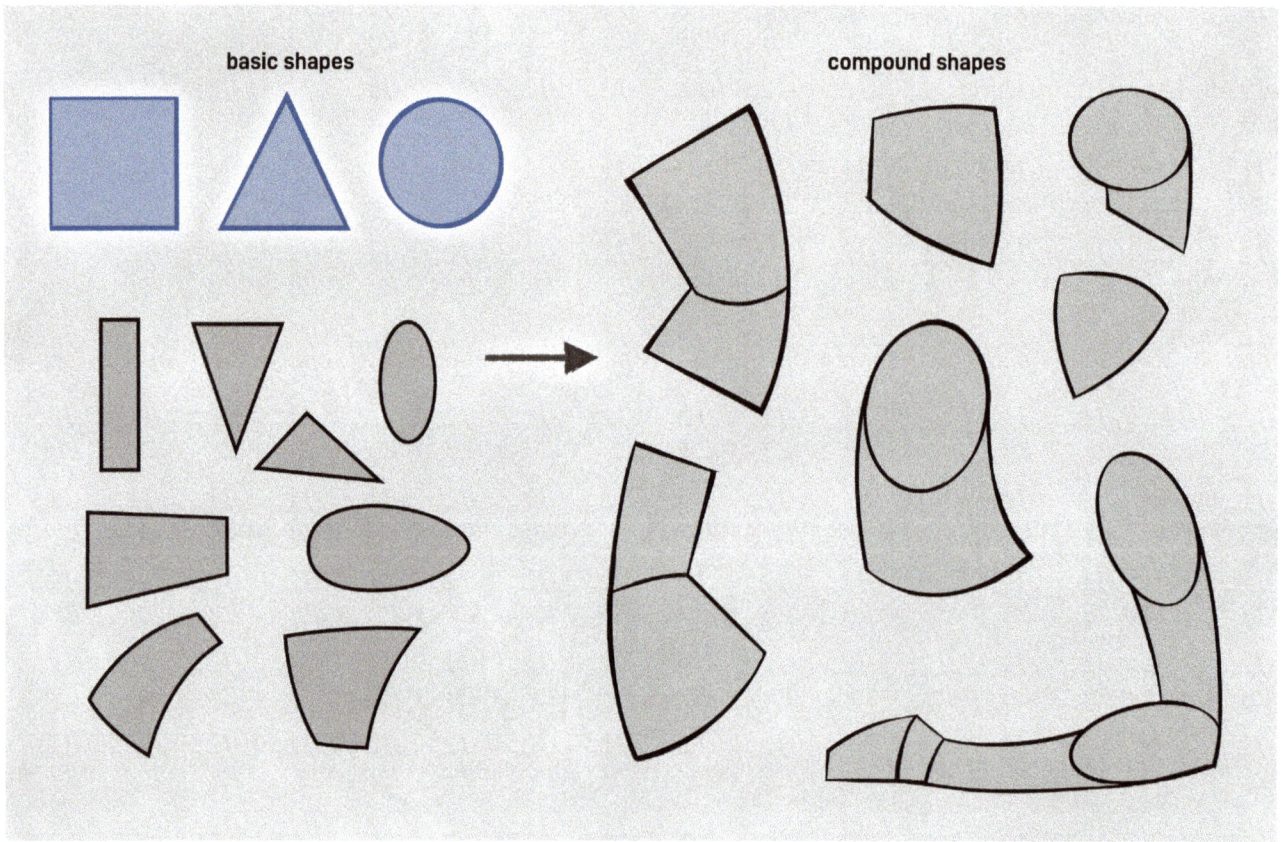

WHAT IS SHAPE?

Shapes are objects that have an outer boundary. In figure drawing, this boundary is also known as a contour. In a picture, plane shapes represent the visual space an object occupies. This visual space is also known as a silhouette.

In the drawing process, shapes are the logical evolution of line because lines combine to create the outer boundary of shapes. I refer to them as two-dimensional shapes, because they have only two dimensions: length and height. This means shapes are flat, like the surface we draw or paint on. The most basic shapes are squares, triangles, circles, rectangles, and ovals. In figure drawing, the most common shapes are rectangles and ovals.

WHY ARE SHAPES USEFUL?

Shapes are helpful because they can be used as symbols for more complex objects. They can indicate or describe something more complex. Because they can be drawn quickly, they work well for the initial stages of a figure drawing, especially if the pose is timed. For example, an oval can be used to symbolize, or indicate, a head. A rectangle can be used to indicate a torso, arm, or leg. A triangle can indicate a hand or foot.

The other reason shapes are useful is design. Drawn well, a shape can quickly communicate a pose. By designing an appropriate shape, the artist can better communicate the idea, pose, or form they are drawing. Because shapes can be quickly drawn and edited, they are very effective for using in a life drawing setting.

OBSERVING SHAPES

Shapes are everywhere on the figure. To see shapes, look for the outer boundary of the figure, then the outer boundary of all the other forms. For example, the outer points of the pose below create a triangle-like shape **(A)**. The interior forms also create secondary shapes **(B)**. Even the smallest forms have outer boundaries that can be seen and defined as shapes **(C)**.

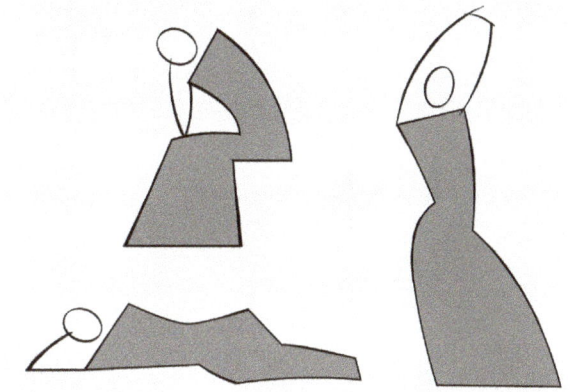

A shape that is designed well can communicate a pose. Even with no details, the shapes in this diagram start to communicate a standing, sitting, and reclining pose.

USING SHAPES

When drawing the figure, I always start with the largest shapes possible. These are the large masses and major shapes. Once I see and design large shapes that work well, I can then look for and begin to design secondary shapes. I can also evolve flat, two-dimensional shapes into three-dimensional shapes, which we'll examine next.

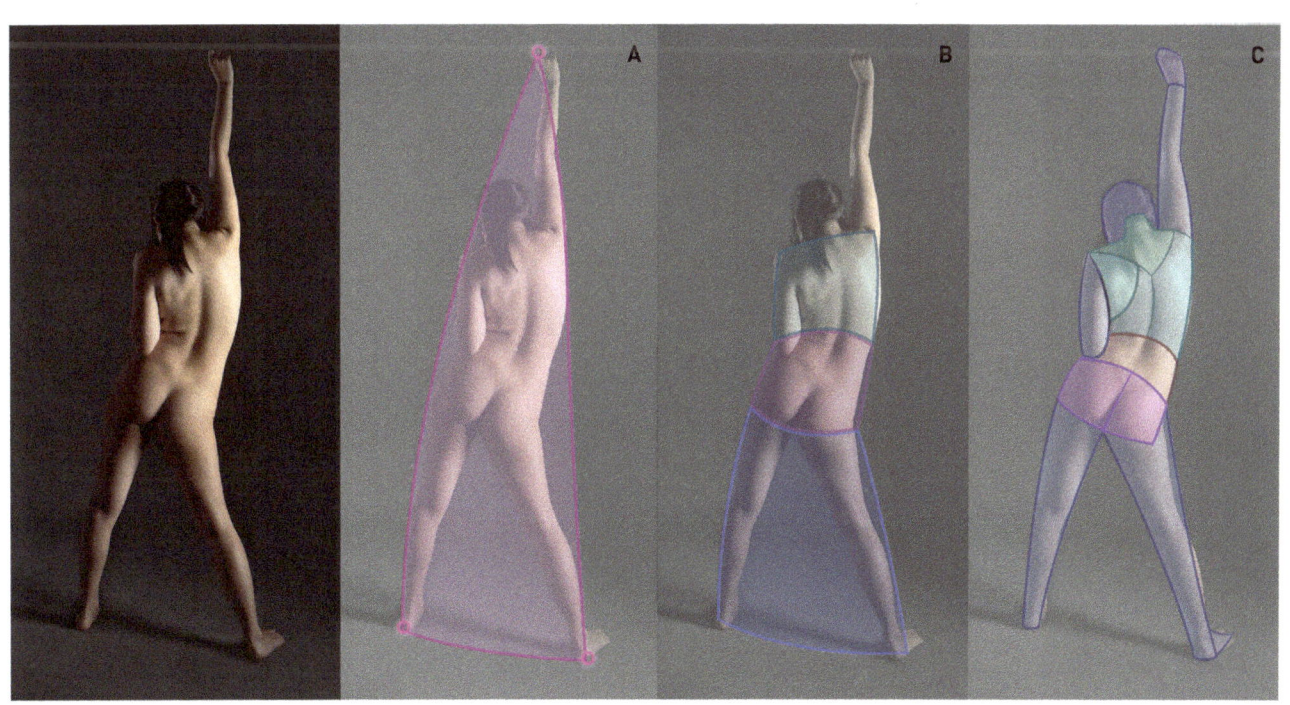

FUNDAMENTALS OF LIFE DRAWING

Three-Dimensional Shapes

The next evolution of shapes are simple solids, or volumes, also known as three-dimensional (3-D) shapes. Three-dimensional means the shapes imply length, height, and depth, which is the third dimension. Three-dimensional shapes can only suggest depth, because of course, drawings and the drawing surface still exist on flat, two-dimensional (2-D) surfaces or planes. Because the drawing surface is flat, the artist must use every tool necessary to create the illusion of depth, and 3-D shapes are one of the first and simplest tools to accomplish this task.

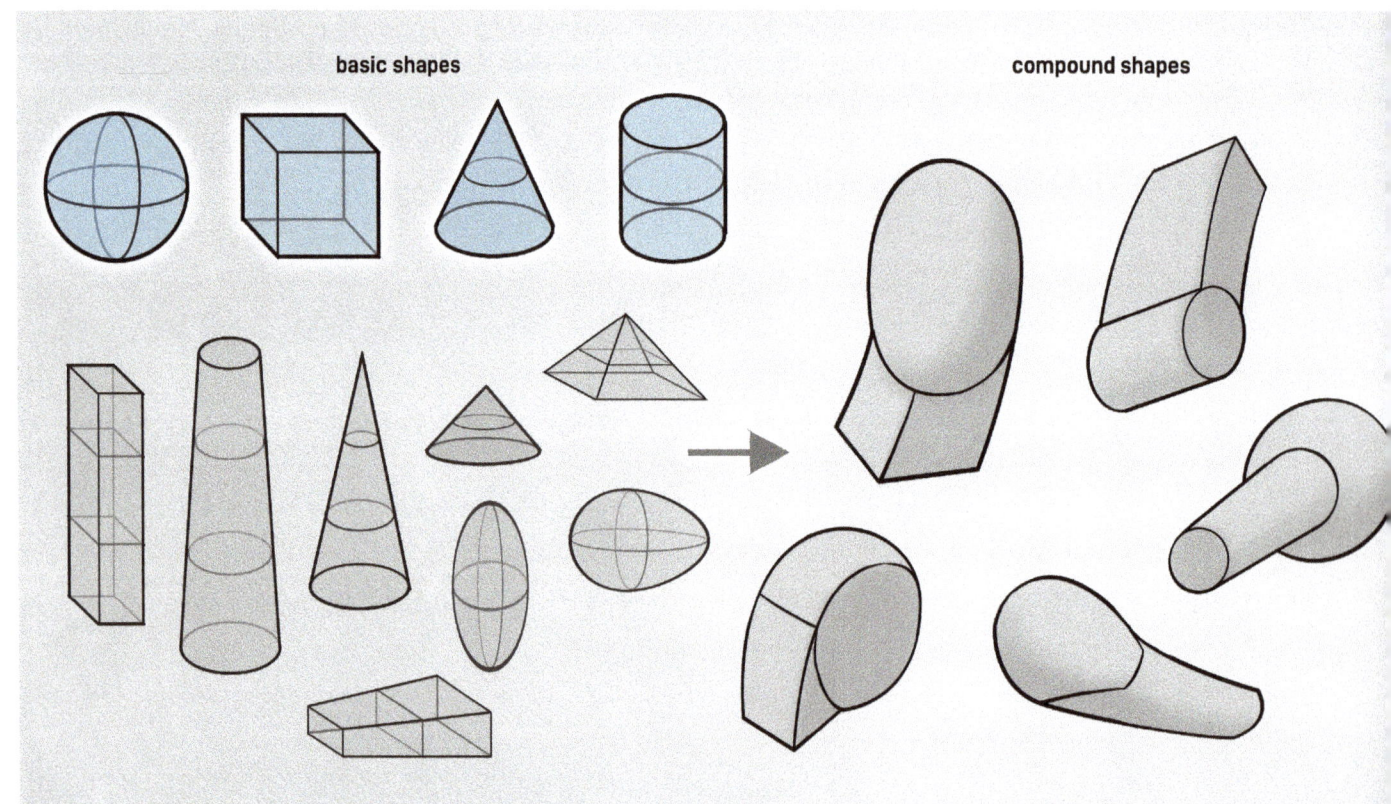

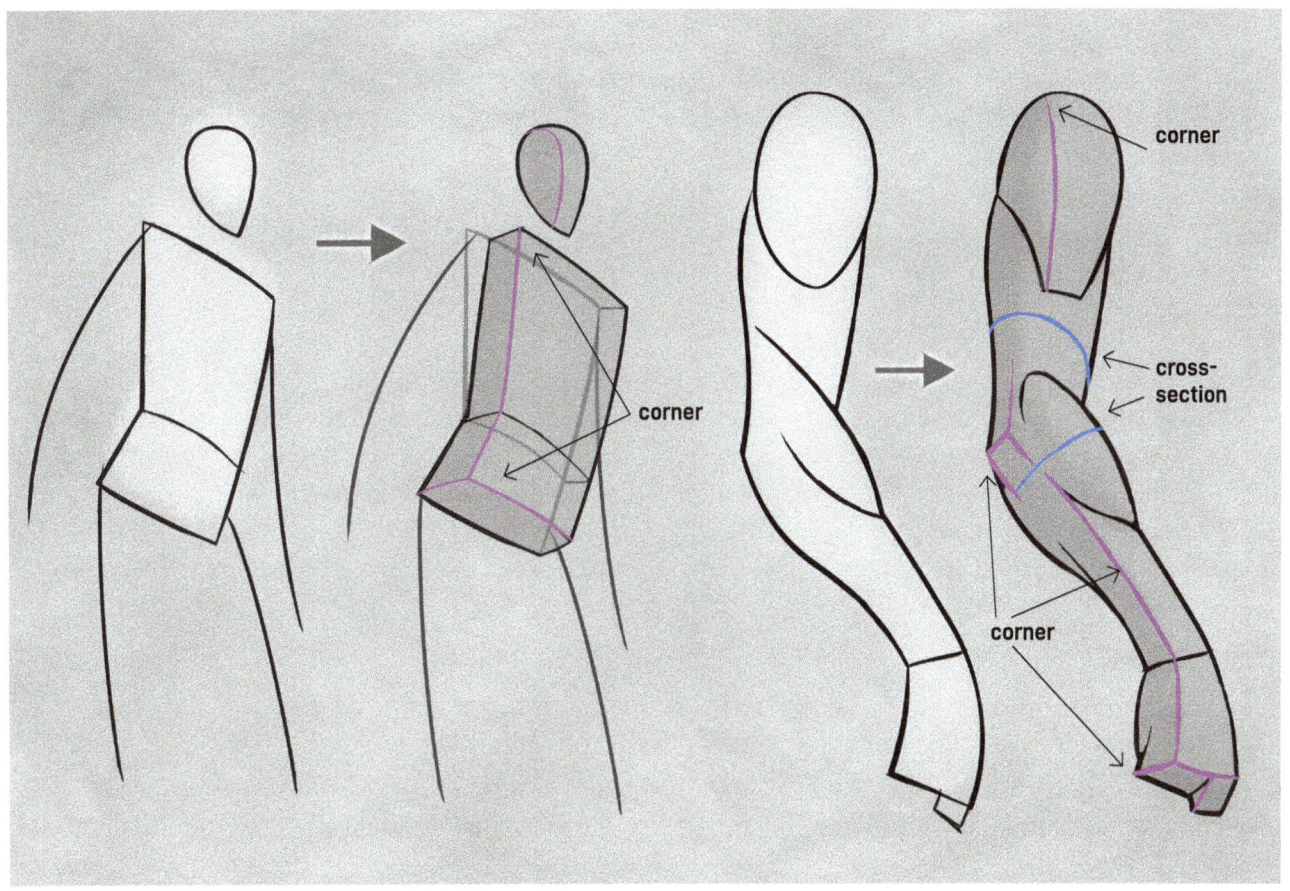

Adding corners to a 2-D shape quickly creates structure and volume and helps suggest depth.

WHAT ARE 3-D SHAPES?

A 3-D shape or volume is essentially a 2-D shape that has corners and multiple surfaces, or planes. The most common 3-D shapes are cubes, cones, cylinders, and spheres, which are derived from squares, triangles, and circles. Three-dimensional forms can be stretched, elongated, and compressed to create endless variety. They can also be combined to create compound 3-D shapes.

WHY DRAW WITH 3-D SHAPES AND VOLUMES?

The primary function of 3-D shapes is to create structure. If a figure is drawn with only line and shapes, it can feel "watery'" or flat. With 3-D shapes and volumes, a drawing starts to feel more rigid and solid. For example, when a square becomes a cube, a corner is added, which adds structure. When a rectangle has curved ends and cross sections, it becomes a cylinder, which adds a feeling of volume and mass.

HOW TO DRAW 3-D SHAPES

Three-dimensional shapes and volumes are useful for structure and depth, but they can feel stiff and "robotic" if drawn excessively or carelessly. One way to make 3-D forms more lifelike is to draw tapering forms and curved lines. Tapering means that the sides of a form gradually converge at one end, making that end smaller. This makes the drawing feel more natural because it mimics the way organic forms, such as the human body, naturally curve and taper.

Tapering lines are also helpful because they suggest perspective, as the lines appear to converge to an imagined vanishing point. This is especially useful for drawing foreshortened forms and defining their movement into and out of 3-D space. We will examine foreshortening in detail later.

Another useful 3-D tool is cross sections. Cross sections define an end of a form. They naturally occur at the joints, or where one body part meets another. If I want more structure and volume, I can also add cross sections in the middle of a form. For example, the bulge of the leg muscles or the pinching of a contracted bicep are opportunities to add cross sections and more volume.

The diagram opposite shows how tapering and curved forms feel much more natural than symmetrical forms **(A)**. When I draw a form, such as a leg **(B)**, I start with tapering lines **(1)** and then add cross sections at the ends of forms such as the knees and ankles, but also where forms bulge or pinch **(2)**. These cross sections help me place anatomy and detail and make my lay-in, or foundation, drawing feel more volumetric **(3)**.

Three-dimensional forms are the first tool I use to suggest depth because they are made up of lines. Another powerful tool is to add light and shadow to drawings, which we will examine next.

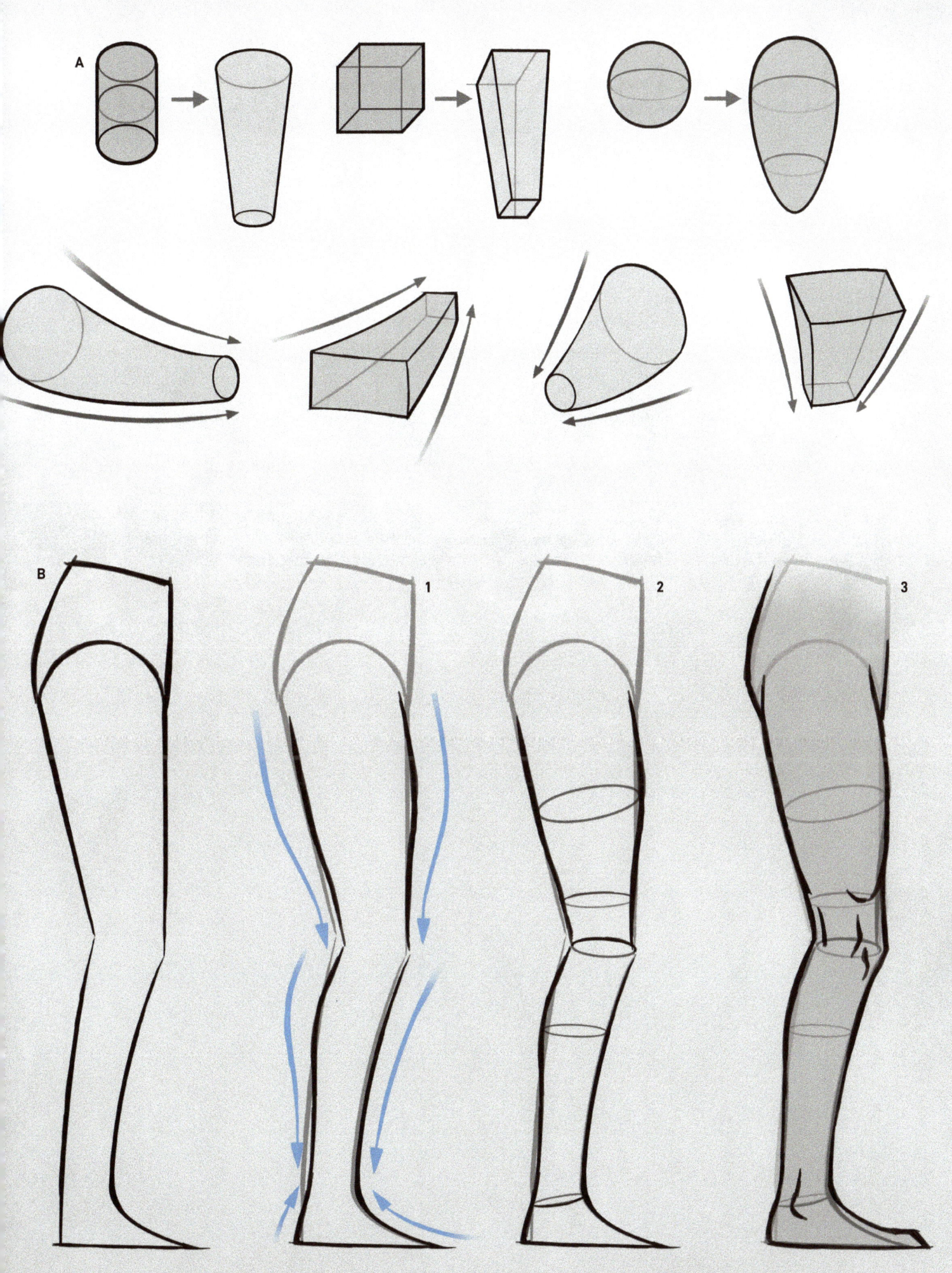

Introduction to Shading, Light, and Shadow

Lighting and shading are among the most beautiful and exciting parts of realistic drawing. When I first learned how to shade, I felt like I had a superpower. My drawings took on a whole new dimension and started to come to life.

However, I didn't learn shading overnight and I didn't learn it from a single book. In fact, I didn't learn from a book at all, the topic is so massive and complex.

Here I present an overview of this awesome technique, and also how you can begin to use light and shadow in your drawings. Even though this chapter is only an introduction, there are many examples throughout that demonstrate a shading process that I use when drawing from life. Before you draw, I must first lay the foundation by introducing the three core principles of shading: value, shape, and edge.

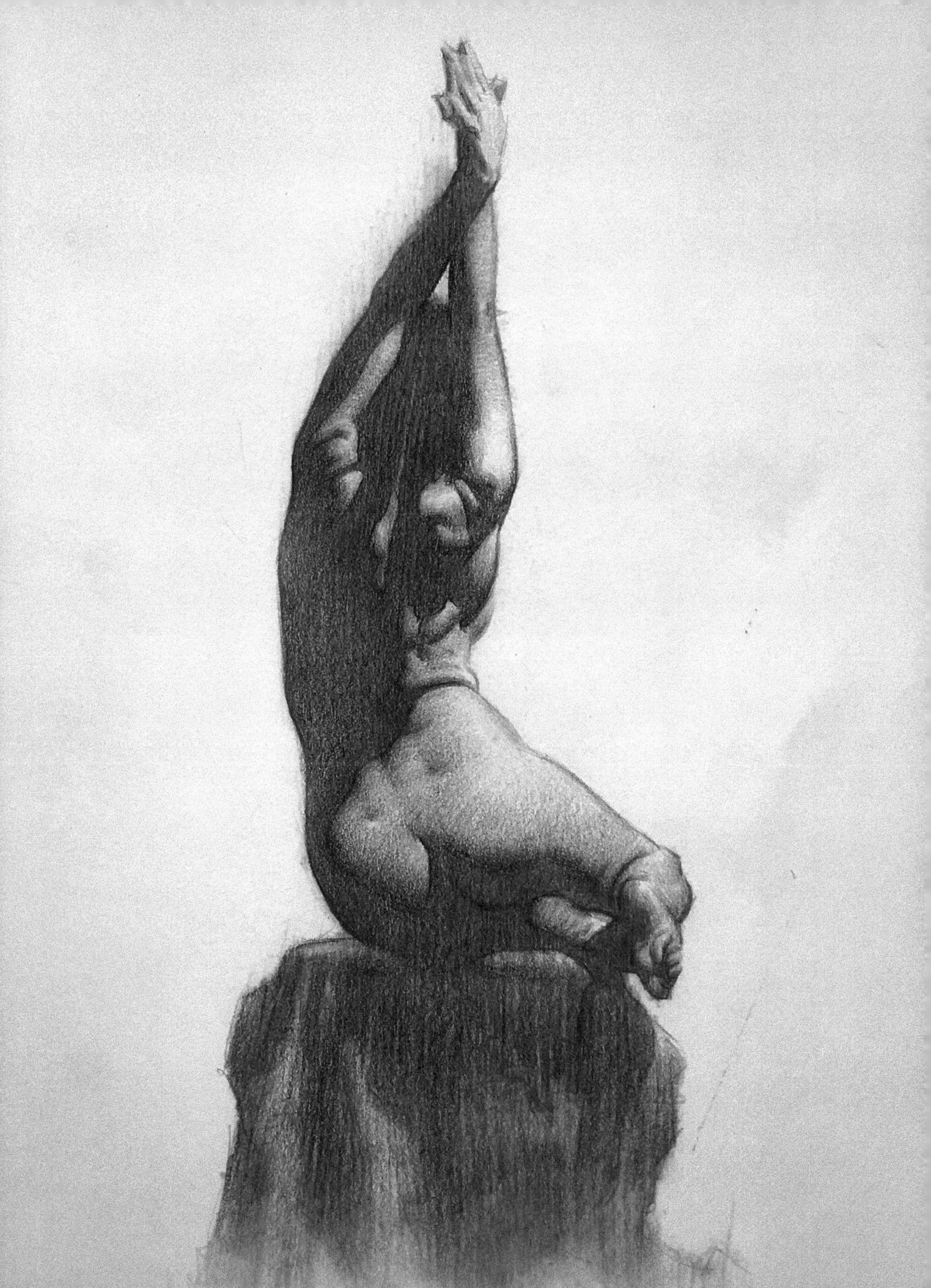

PRINCIPLE 1: SIMPLIFIED VALUES

The first concept to understand in light and shadow is value. Values are lights and darks. They are pure black, pure white, and all the grays in between. The range of values visible to the human eye is infinite and complex. With our crude drawing tools of pencils, paint, and paper, and with our time limitations, it is not possible to copy or match the infinite values that we see in nature. To begin using values, the artist must first control value. To control value, we first simplify.

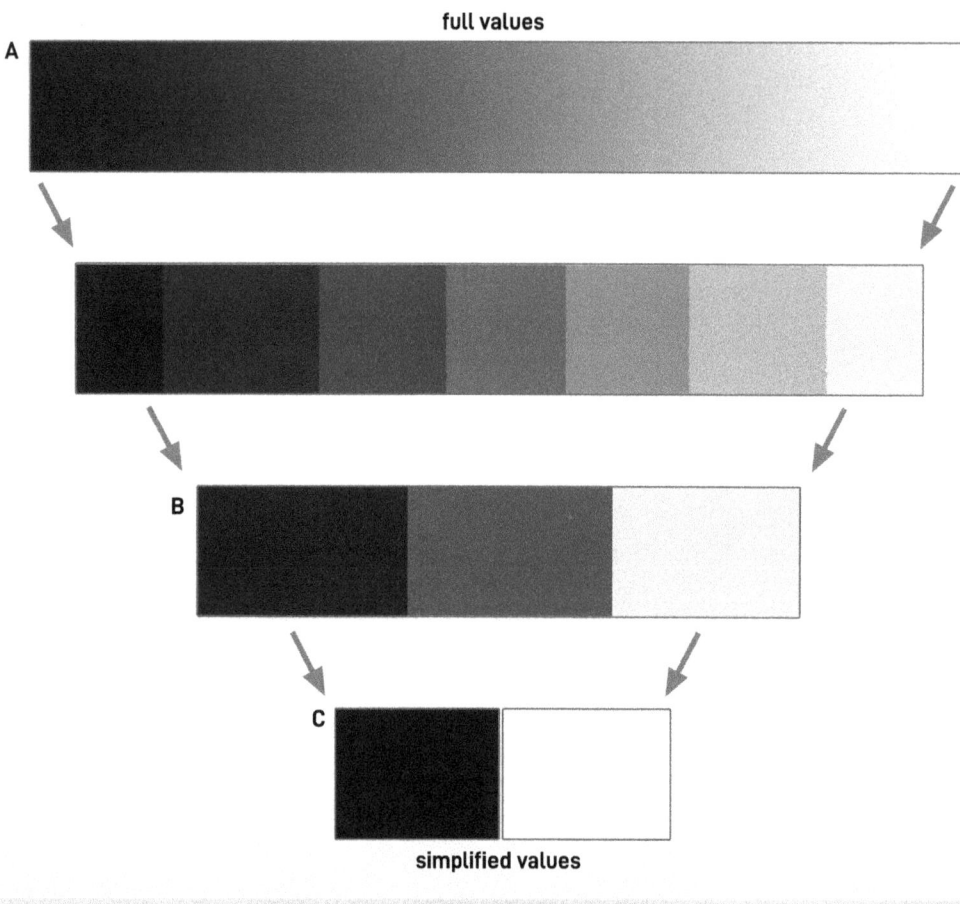

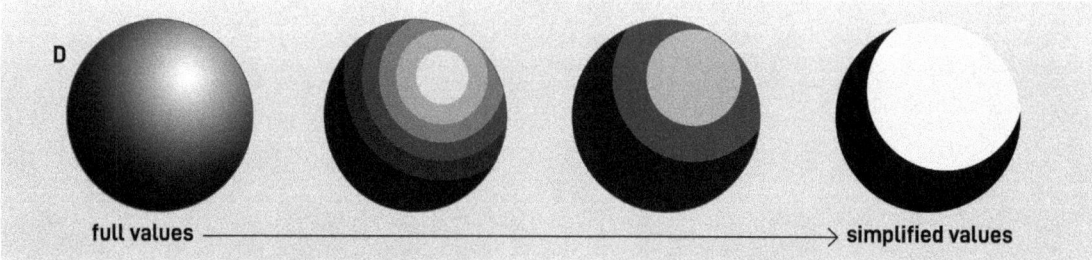

The value bar at the top of the diagram (A) represents the full range of visible values, from pure black to pure white. To control values, you must first learn to see and limit the values you use. The most simple value palettes are three-value (B) and two-value (C). The spheres (D) show how limited values can look on a simple form.

To begin shading, start with the simplest value range of two values: one value for light and one for dark.

Limiting yourself to two values may seem impossible, but a lot can be accomplished with only two values. This is done with good design and using shape to begin communicating.

Of course, there are many more values the artist can use, especially to achieve the illusion of realistic form. The next logical value range is the three-value system of light, dark, and halftone, which is also known as midtone.

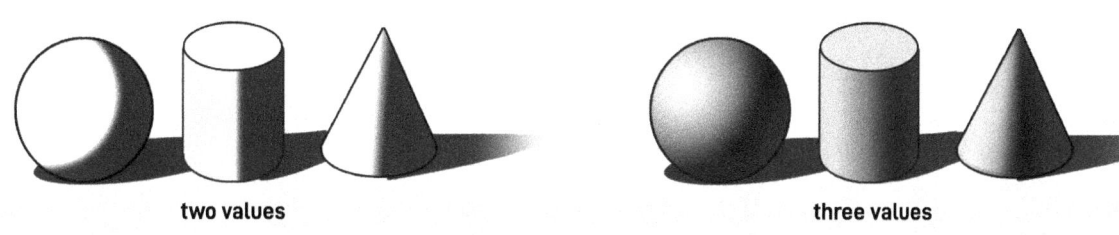

The beautiful thing about a three-value system is that it allows for another value group to model the form. Modeling form means to make forms feel round and three-dimensional. Halftones allow the artist to make a more modeled form by providing smoother transitions. This means you can use the tones to help transition from a dark shadow to a lighter area. Along with value, this transition can be accomplished with edge (see page 51).

The demonstrations in this book are limited to two- and three-value drawings. For beginner artists, I recommend practicing with a two-value system first and then adding a third value as you gain experience. Later in the book there are more value exercises for practicing and learning limited values.

FUNDAMENTALS OF LIFE DRAWING

PRINCIPLE 2: LIGHT AND SHADOW SHAPES

As you previously learned, shape is the boundary around an object or form. Shapes aren't just on the outside of a figure; they can be seen everywhere on the body. The figure and its forms have shapes, but when there is light on a form, the shadow is also a shape. I call this the "shadow shape" or "shadow mass."

Shadows have shape. The shapes are clearer when there is a strong, bright light source (see diagram opposite). Along with learning to see limited values, identifying shadow shapes is the first and most important skill to master when drawing from life.

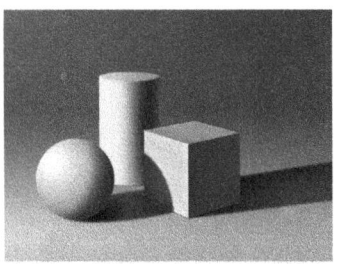
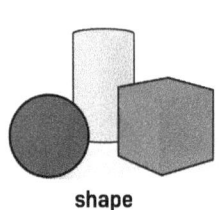
shape
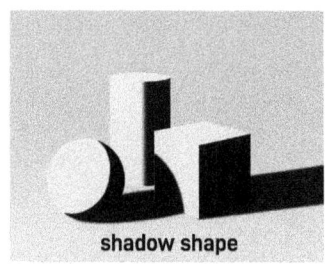
shadow shape

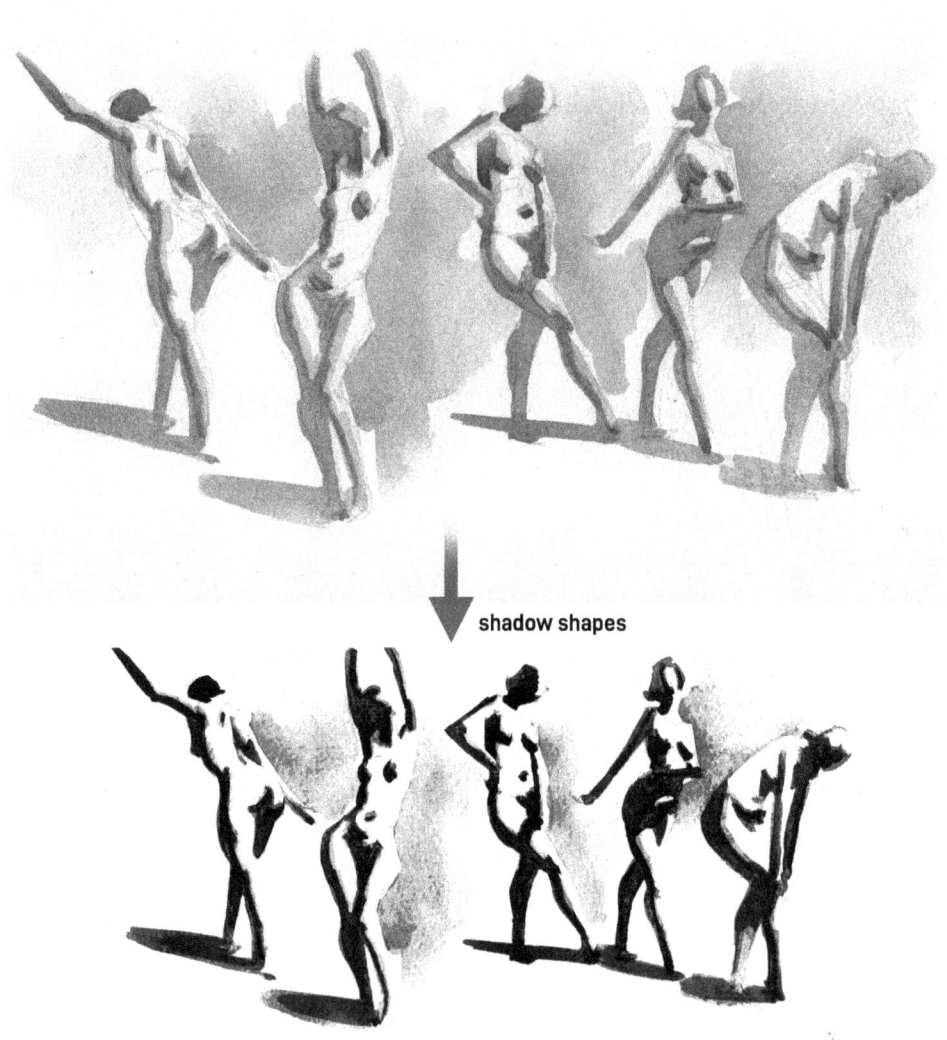
shadow shapes

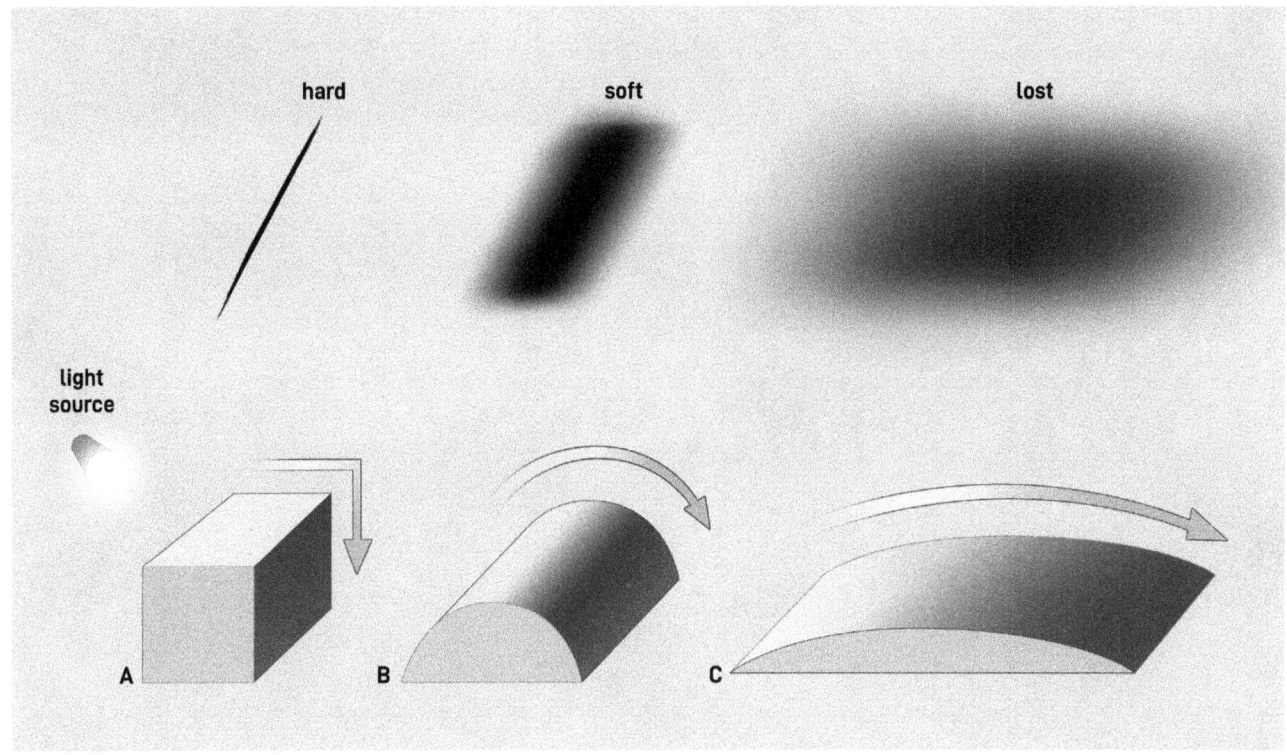

PRINCIPLE 3: EDGE

Edges describe how a form in light transitions from one side or surface of the form to another. Edges can take many forms and like value there is an infinite range, from hard to soft and everything in between. To help me control edges, I first simplify and limit the edges I use to only three: hard, soft, or lost.

Hard edges communicate a rapid surface change. This can be seen in the box above as the top surface in light quickly transitions to the side plane in shadow, as a sharp corner or hard edge **(A)**. In organic forms, hard edges don't exist except at the contour and cast shadow.

Soft edges are slower, softer transitions. Soft edges occur on rounded, curved forms. When drawing living, organic forms such as a figure or portrait, 80 percent of the edges will be soft. This can be seen in the curve of a cylinder, as the light gradually transitions into shadow **(B)**.

Lost edges are slow and subtle transitions. Forms that are almost flat or have very little curvature have a lost edge **(C)**. Lost edges mostly occur in halftones and gradients.

The best way to understand edges is to study examples of edges in nature and in works of art. Before observing edges, you must first understand the anatomy of light and shadow, which is also known as the form principle.

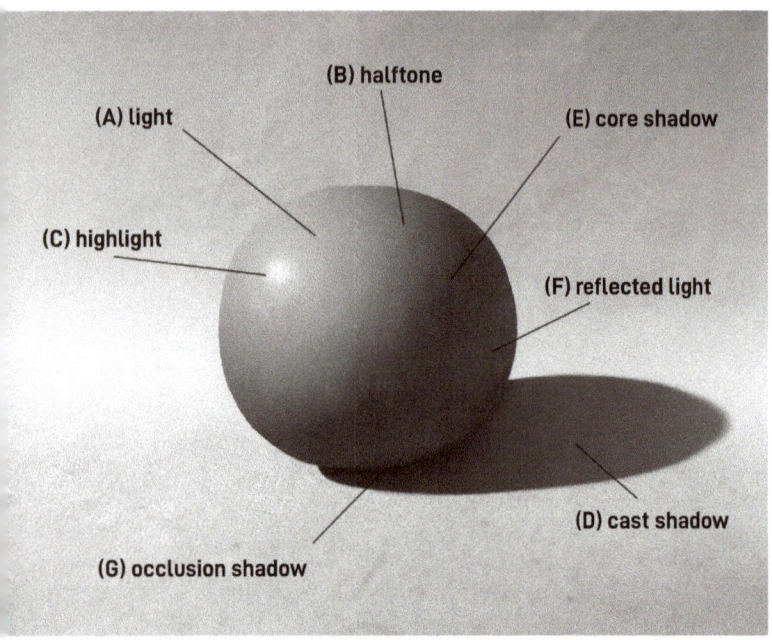

(A) light
(B) halftone
(E) core shadow
(C) highlight
(F) reflected light
(D) cast shadow
(G) occlusion shadow

THE FORM PRINCIPLE

The form principle is the anatomy of light and shadow. When light is on a lit object it produces a light side and a shadow side. Both sides have parts or components the artist must know and understand to begin shading.

Parts of the light:

Light: the form in full light **(A)**
Halftone: also known as "transition tone," this is where the form transitions from shadow to light **(B)**
Highlight: the form that is closest to the light **(C)**

Parts of the shadow:

Cast shadow: the projection of the object's shadow onto a surface **(D)**
Core shadow: the border where light and shadow meet **(E)**
Reflected light: also known as "bounce light," this is light from the surrounding environment that bounces (or reflects) back into the shadow **(F)**
Occlusion shadow: also known as "contact shadow," this is where the form contacts a surface or another form, creating a deep, dark shadow where bounce light does not penetrate **(G)**

HOW TO OBSERVE SHADOW SHAPES

The first step in observing and identifying shadow shapes is to squint. Squinting helps the eye lose color and detail information and see only the value information **(H)**. This helps the artist to better see all the values as value groups.

Next look for the border that is the terminator, or core shadow **(I)**. The shadows are clearer if there is a strong single source light like in this example. If the light source is bright enough, the shadows are clearer. Once you clearly identify the shadow shape and its border, look to the light side and identify the brightest area **(J)**. This is often at the part of the form that is closest to the light or has a large surface area. Below, the top of the glutes and its highlight receives and reflects the most light, making it the brightest area.

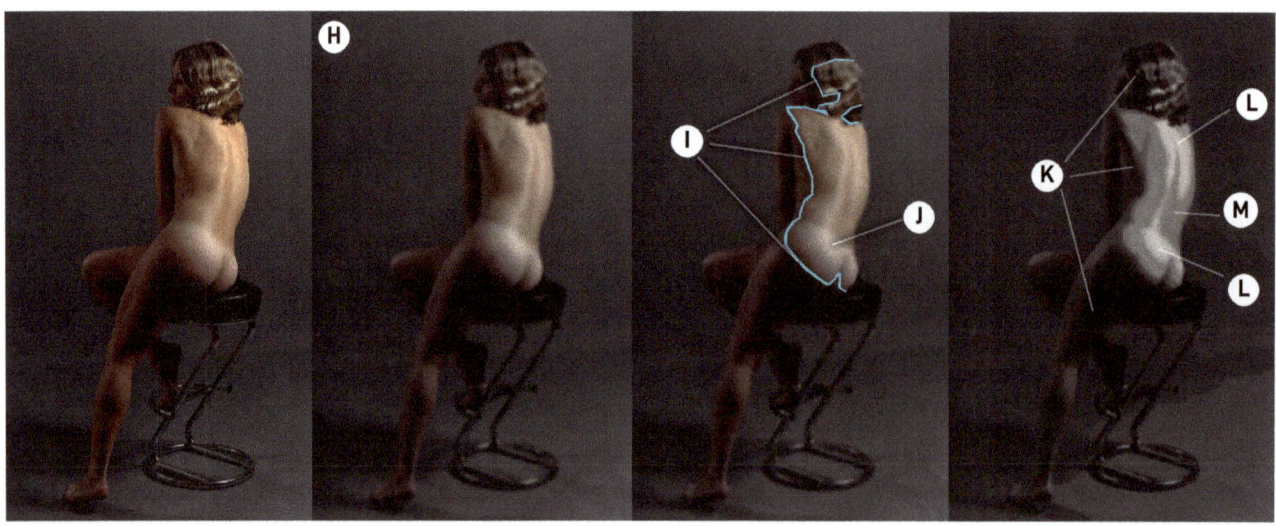

For the value variations and halftones, squint and make a decision on which values to group with the shadow and which to group with the light. In this pose, the entire left side of the figure is in shadow **(K)**. The lights and highlights are at the glutes and the upper back, along with bright highlights in the hair **(L)**. This leaves the large mass of the model's back as a halftone **(M)**.

INTRODUCTION TO THE SHADING PROCESS

Below is an example of how I use these principles when drawing the figure. This is not a fully finished drawing. This level of "finish" is an example of what can be accomplished in a ten-minute timed pose.

1. Once I have a lay-in, or foundation drawing, I define the shadow shape. To help me see the shadow shapes, I squint at the model.

2. I fill, or mass in, the shadow shape with a medium dark. This clearly separates light and shadow and establishes a two-value system.

3. I add a wash of halftones and leave the light areas. I also start to darken and soften the core shadow, which helps model and turn the form from shadow to light.

4. With the remaining time I refine my values and edges. I darken the shadows and parts of the halftones to push the contrast. I soften core shadow edges and reinforce cast shadows.

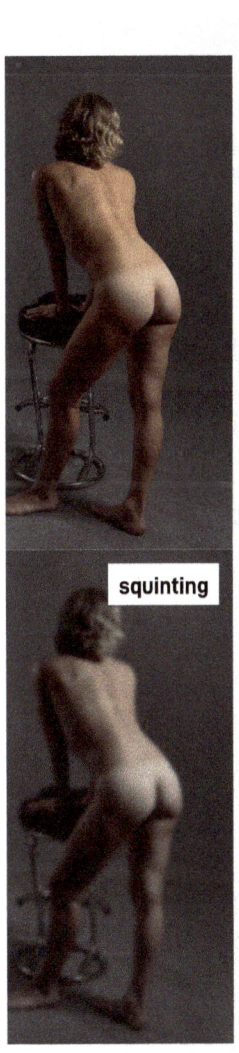

squinting

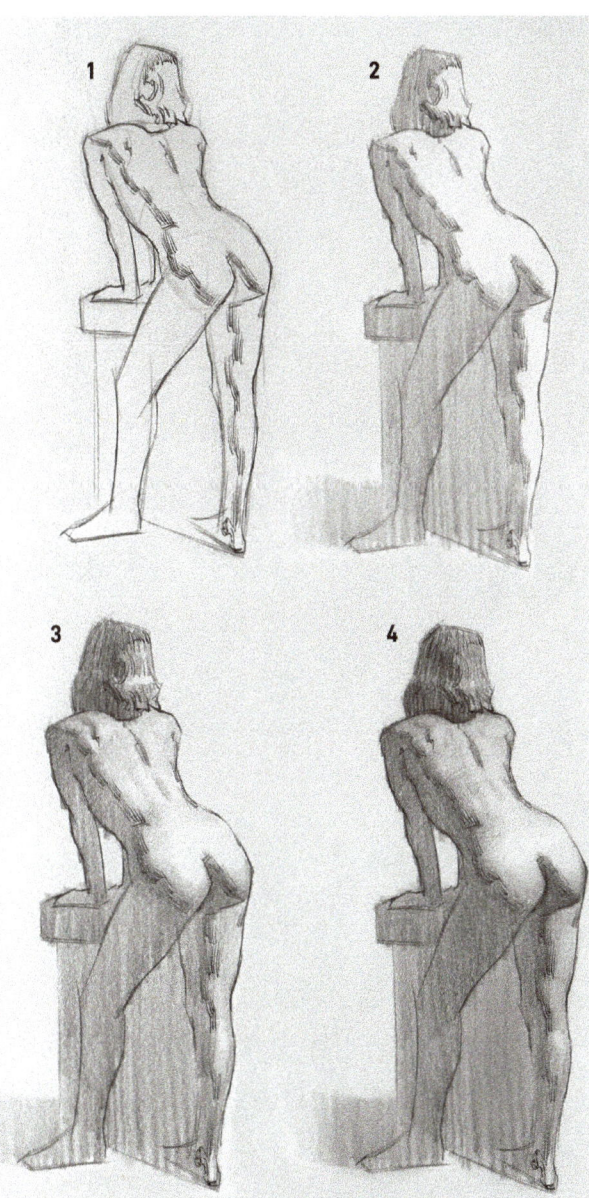

This chapter is only a brief introduction to the enormous topic of shading. There is much, much more to learn about this topic. For the purpose of this book and learning to how to draw from life, the information presented here can get you started in shading your figure drawings. Later in the book there are many examples of shaded drawings that can be copied and studied, along with other recommended exercises.

CHAPTER 3

THE DRAWING PROCESS

Overview of the Drawing Process

The drawing process is the core of my philosophy, and the most important aspect of this book. With a reliable and effective process, I can consistently and repeatedly apply the drawing fundamentals. Repetition is the key to gaining knowledge, understanding, and a perfection of the skills needed to draw the figure.

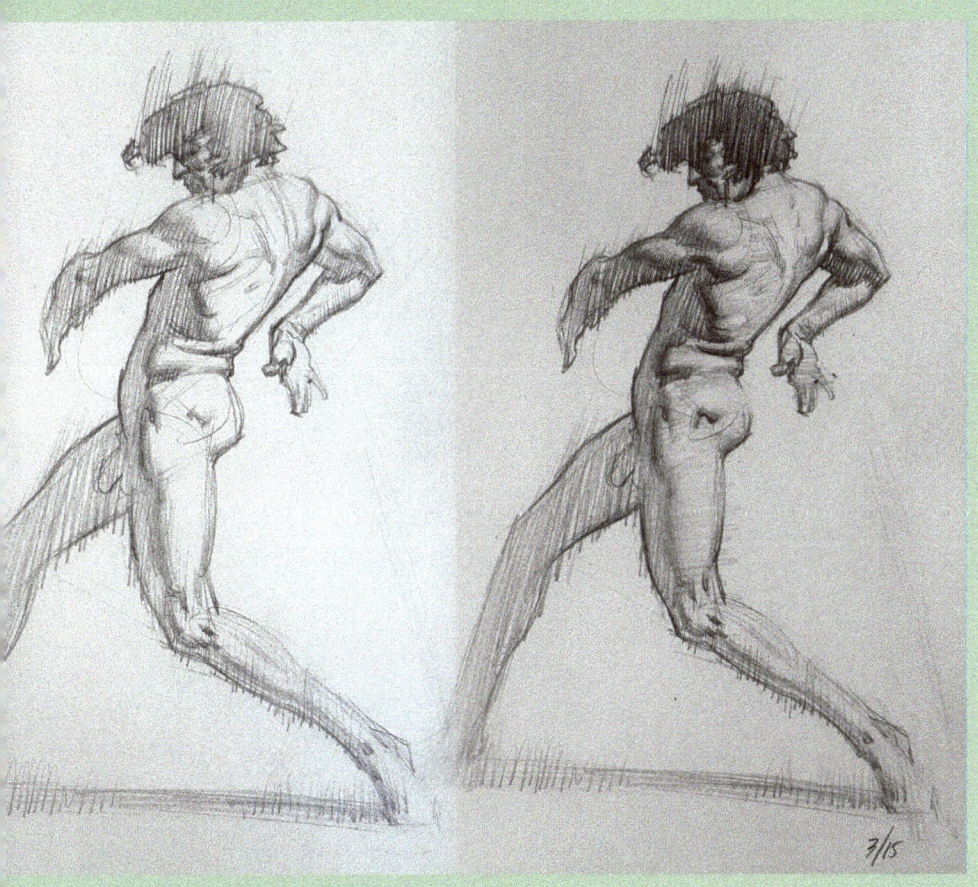

The drawing process can be summed in three words: simple to complex.

This means I start with simple marks, then use marks to design shapes, then turn shapes into 3-D volumes, and eventually add more complexity, such as light, shadow, anatomy, and other details.

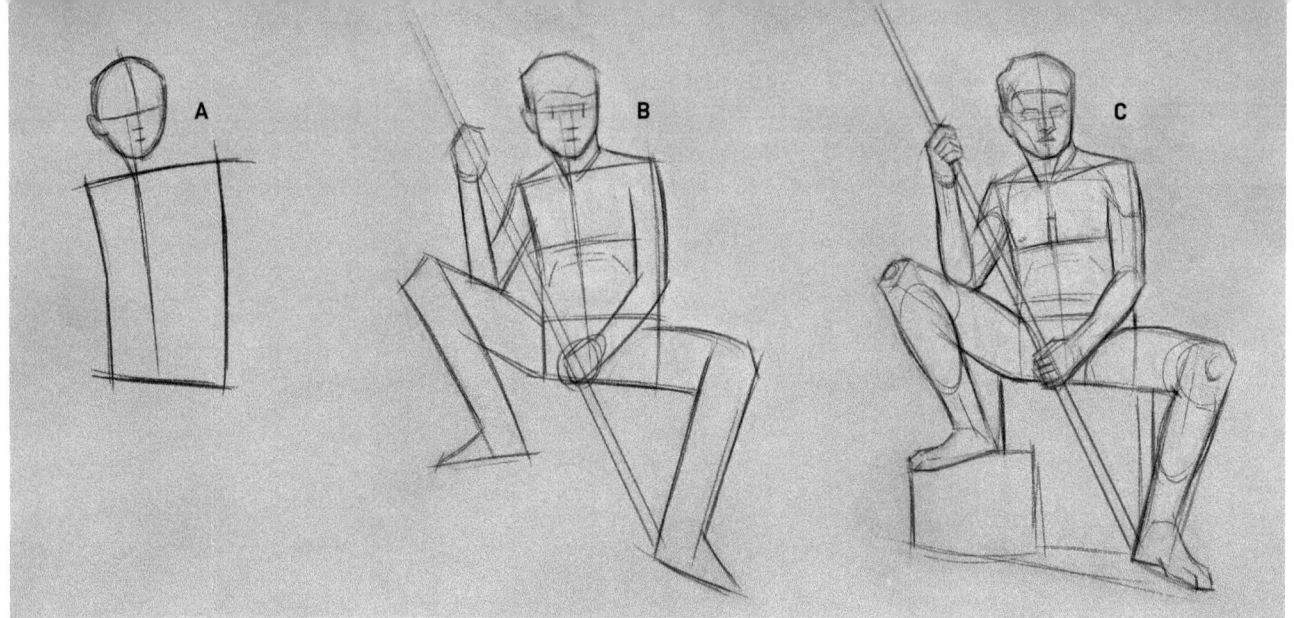

This example is a lay-in of a three-hour pose. It starts with the gesture and an indication of the head and torso (A). Next I design 2-D shapes (B) and then construct the figure with 3-D volumes, or compound shapes (C).

STAGES OF LIFE DRAWING

Stage 1: The "Lay-in"

The first stage is foundational drawing. It starts with a combination of lines, shapes, and solids that clearly describes the pose and acts as a foundation from which the drawing can built. This is known as a "lay-in." The lay-in begins with gesture and the action of the pose. Next simplify the figure into 2-D graphic shapes, and then construct the figure with 3-D volumes, which add structure and an implied three-dimensional quality.

In shorter poses, the lay-in generally doesn't have much information and detail. It has just enough information to help begin the lighting and modeling process, which is the second stage of the drawing.

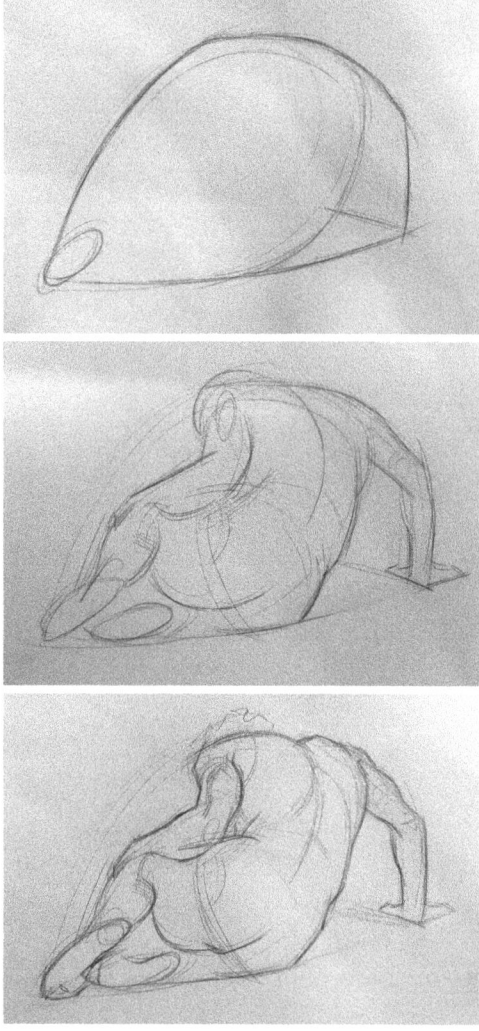

This example is a lay-in of a ten-minute pose. The finished lay-in (bottom), doesn't need a lot of detail, but it provides just enough information for me to begin the next stage of the drawing.

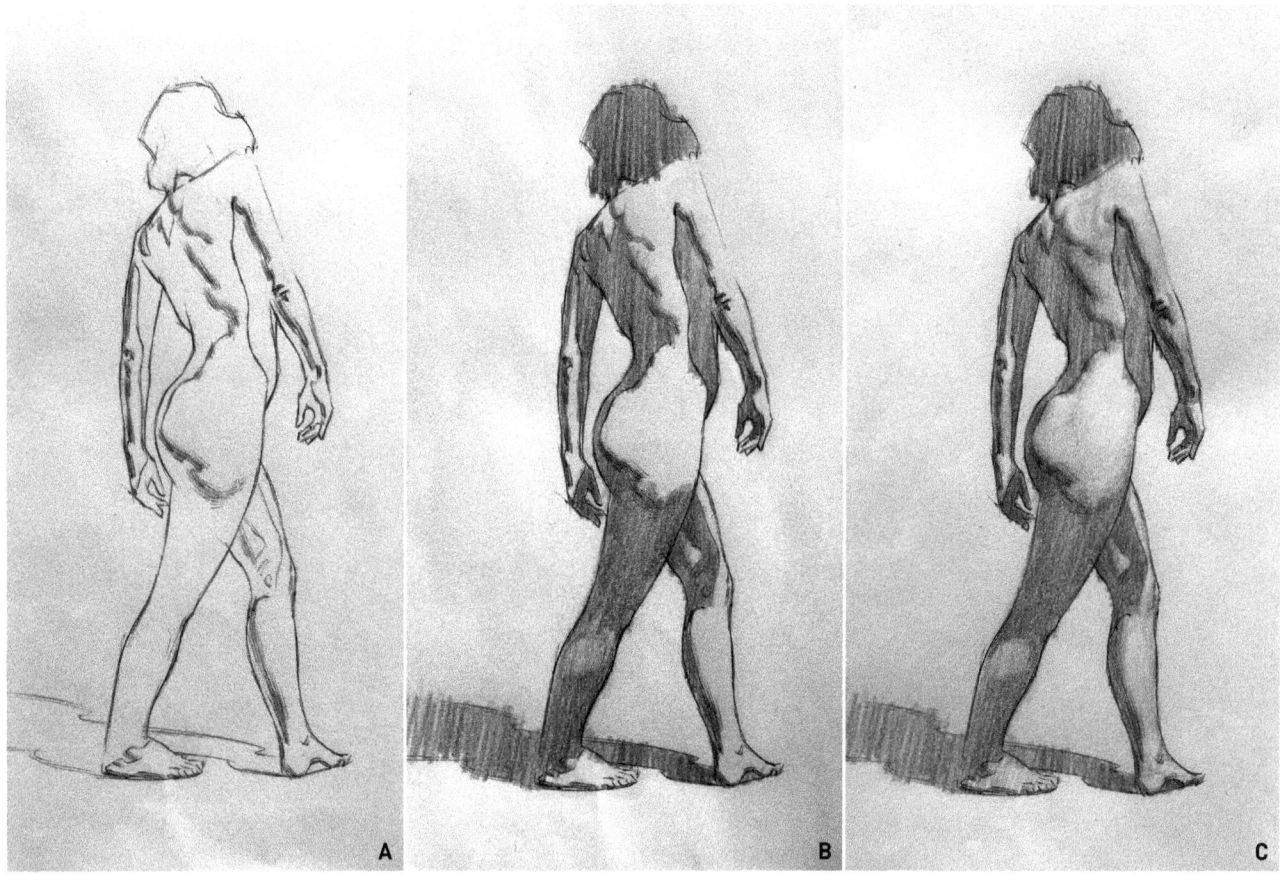

I begin the lighting stage by first defining the shadow into a shape (A). Next I fill the shadow shape with a medium-dark tone (B). This establishes a simplified, two-value system. With the shadow established, I can add halftones and then edge variation (C).

Stage 2: Lighting and Modeling

The second stage of the drawing is where you describe and define the light and shadows you see on the figure and begin to model the form. "Modeling" means creating the illusion of three-dimensional form. The lighting and shading process begins by first establishing a clear value pattern. This is done by grouping the values into either light shapes, dark shapes, or a value in between. This first stage of lighting and shading is also known as a "value block-in."

Once you have the blocked-in values, add a variation of edges to help describe the form. Depending on the time limitation of the pose, you can start to refine the values, value shapes, and edges, which is the beginning of the rendering stage.

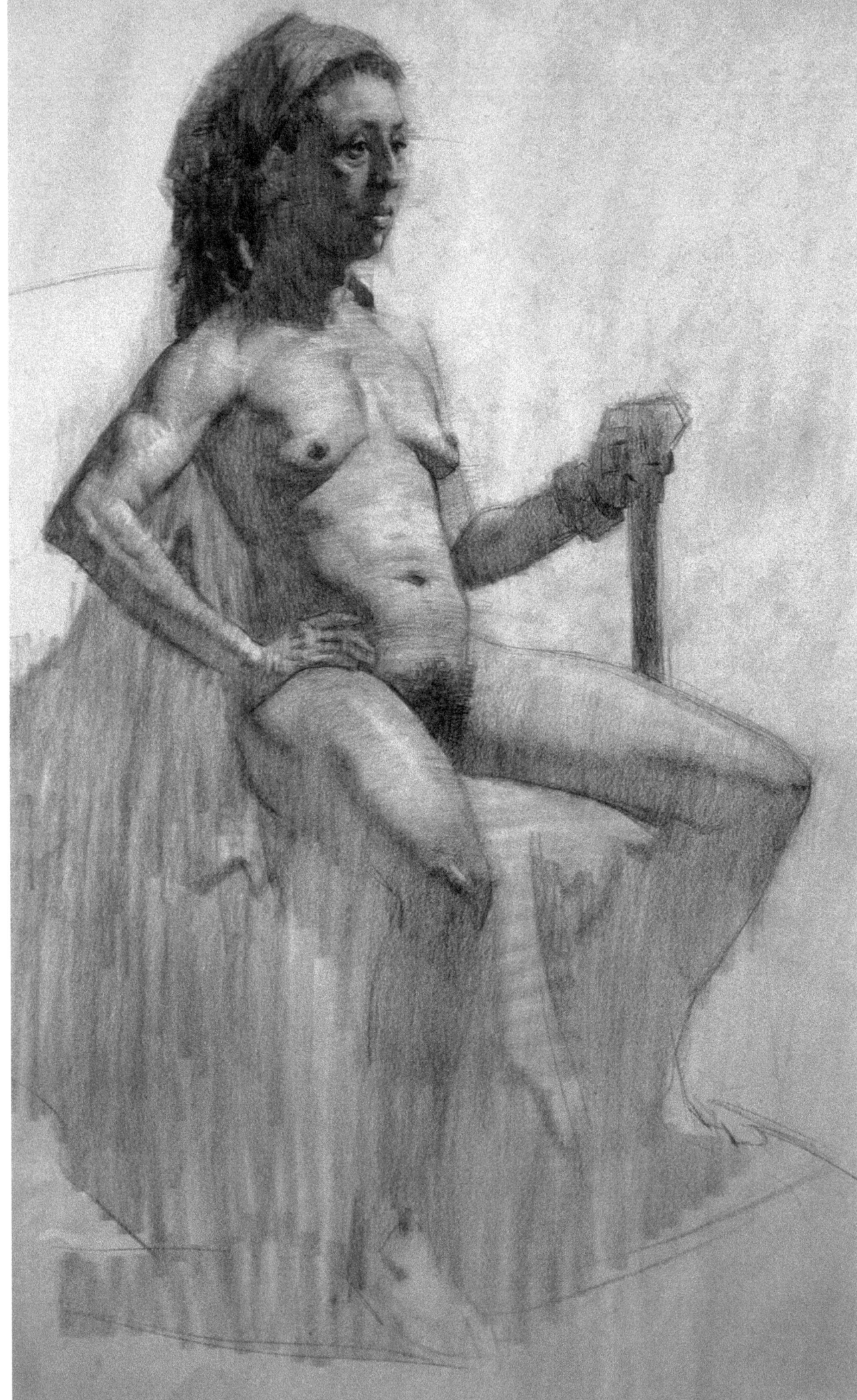

Stage 3: Refinement and Rendering

The final stage is where you refine all aspects of the drawing, such as proportion, anatomical detail, and lighting and shading.

In this first example of a three-hour pose (see opposite), I was able to render and refine most of the figure. The head and upper body are rendered and read well. With more time, I would have continued the rendering with the hands and then the lower body and other secondary areas, such as the fabric.

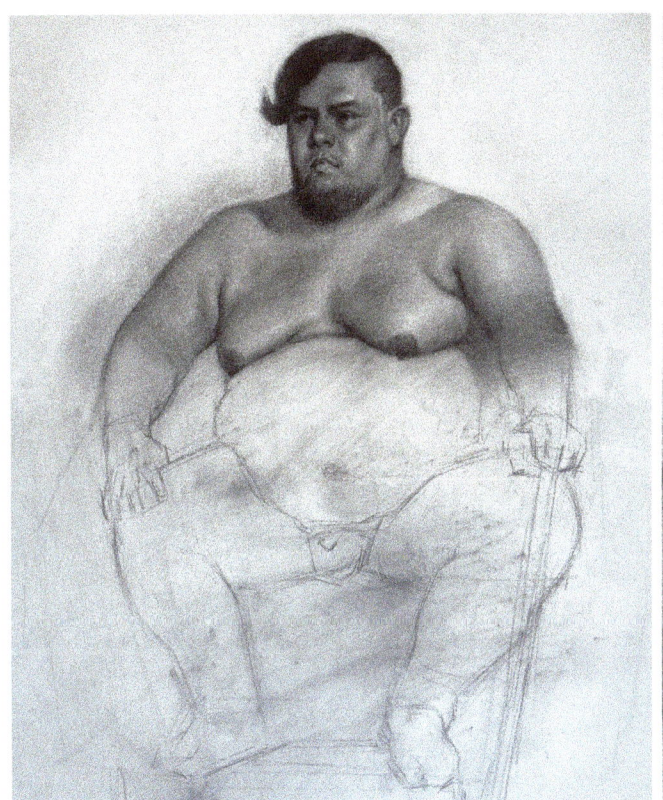 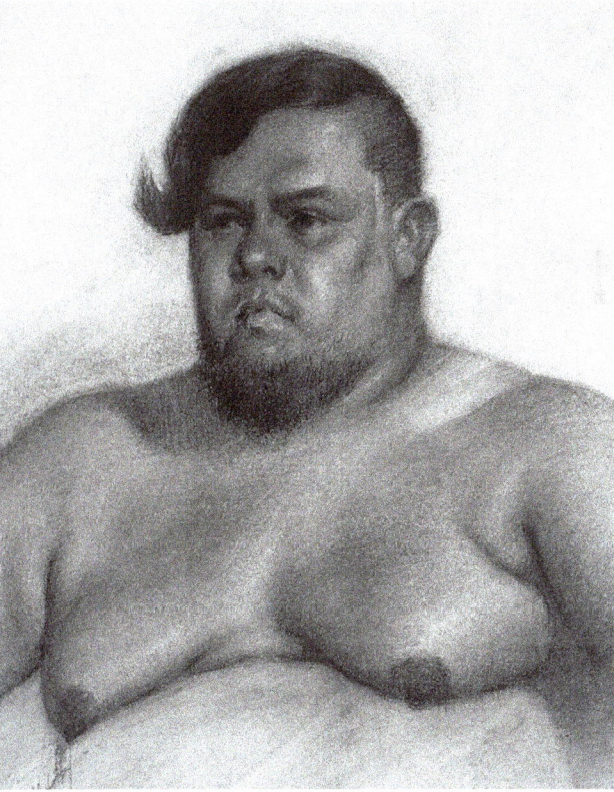

In this second example from a three-hour pose (above), I decide to finish the head and then work down the body.

Stage 4: Finish

In the final stage, I attempt to complete and resolve the drawing. This stage is also referred to as "polishing," because you add the final marks, tones, accents, and any other small details and finishing touches that make the drawing feel as complete as possible.

In general, a truly high-quality rendered, finished, and polished drawing requires many, many hours. Even during shorter poses, you can try to finish and resolve a drawing. This means that the drawing reads well and feels complete at whatever stage it is in.

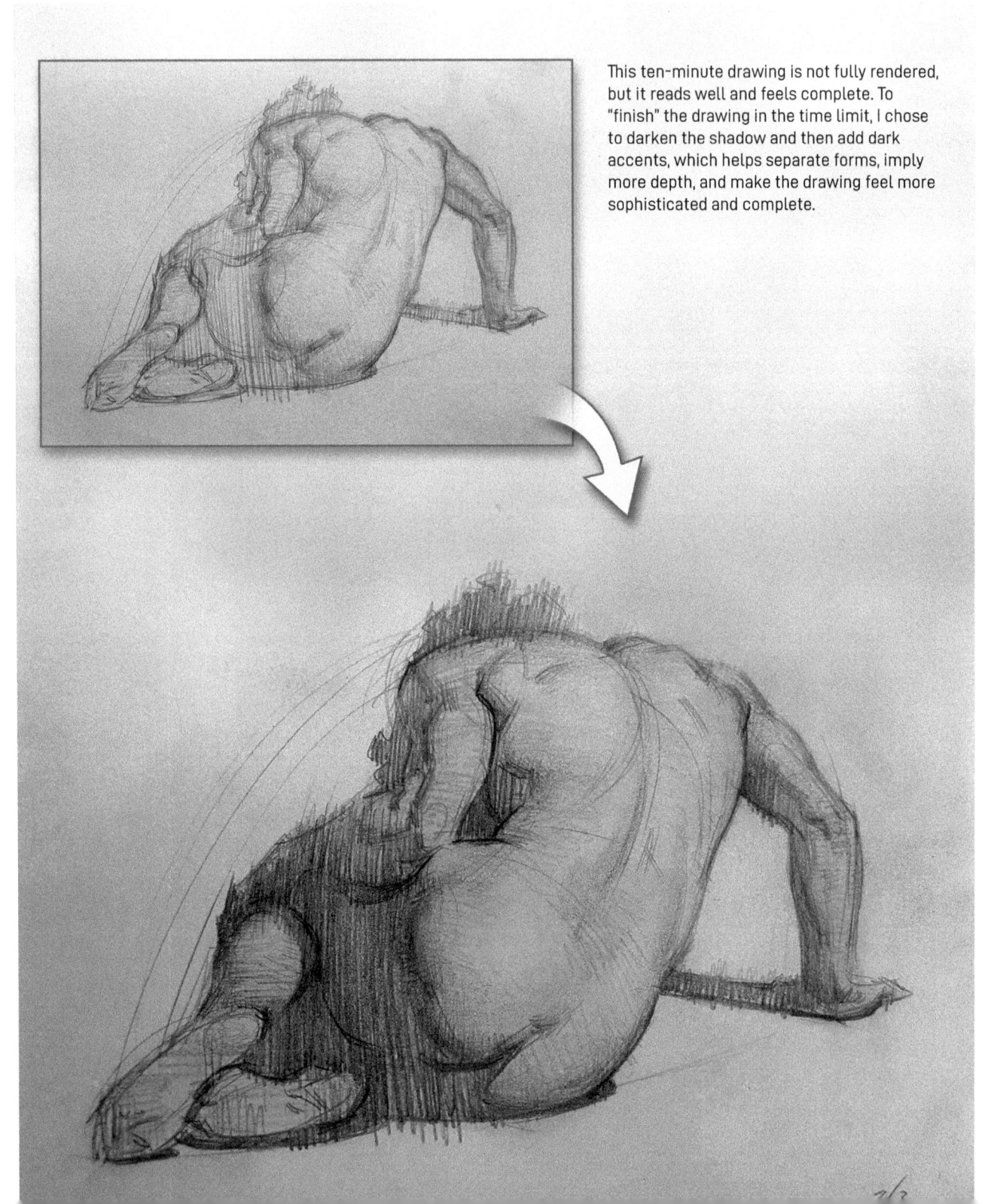

This ten-minute drawing is not fully rendered, but it reads well and feels complete. To "finish" the drawing in the time limit, I chose to darken the shadow and then add dark accents, which helps separate forms, imply more depth, and make the drawing feel more sophisticated and complete.

TIMED POSES AND PROGRESSION

When you draw from life, there are time limitations. A pose will be anywhere from thirty seconds to three or more hours. Short poses are the best way to practice and learn the fundamentals and the first two stages of the drawing process. Longer poses are where you can practice rendering and the finish.

Life drawing and timed poses are great for learning because they allow for many opportunities to practice every stage of drawing. For example, when the model is posing for only one minute, there will be sixty opportunities to draw and practice gesture in one hour. If the poses are ten minutes, there will be at least five unique opportunities to practice shading. If I draw from life for three hours a day, imagine how much practice I would get in a week, a month, or a year!

Thirty-second and one-minute poses
- Gesture
- Mark making
- Using simple, 2-D, geometric shapes (circles, boxes, and triangles) and design

Two- and three-minute poses
- Refining shapes and using compound shapes
- Beginning construction by using 3-D volumes (cylinders, boxes, spheres, and cones)

Five- and ten-minute poses
- Refining construction and 3-D volumes and using compound shapes and volumes
- Beginning the light and shadow process by observing shapes and limiting values
- Practicing using a two-value system of light and dark
- Applying edges and practicing edge control
- Practicing using three values by adding a halftone (light, dark, and halftone)
- Refining values with dark accents and bright highlights

Twenty-minute poses
- Practicing more accurate line drawings
- Refining proportions and shapes
- Continuing to refine values
- Continuing to refine edges

Two-hour or more poses
- Thumbnailing and value composition
- Practicing placement of the figure
- Continuing to refine proportions and anatomy
- Continuing to refine values and edges
- Practicing the process of "finishing" a drawing

These are just a set of guidelines, not a set of hard rules. As you draw from life with timed poses, you will naturally know and understand what can be accomplished in a set amount of time.

Anatomical Landmarks

Before you can draw, you must first learn how to see. The figure is very complex, so you must not only learn to simplify how you draw, but also how you see. When observing the human body, there is a lot of visual information to process. It is easy to get lost in the complexity, so you must focus your attention on key parts of the body that will be the most helpful to the drawing process. These key points are what I call major anatomical landmarks.

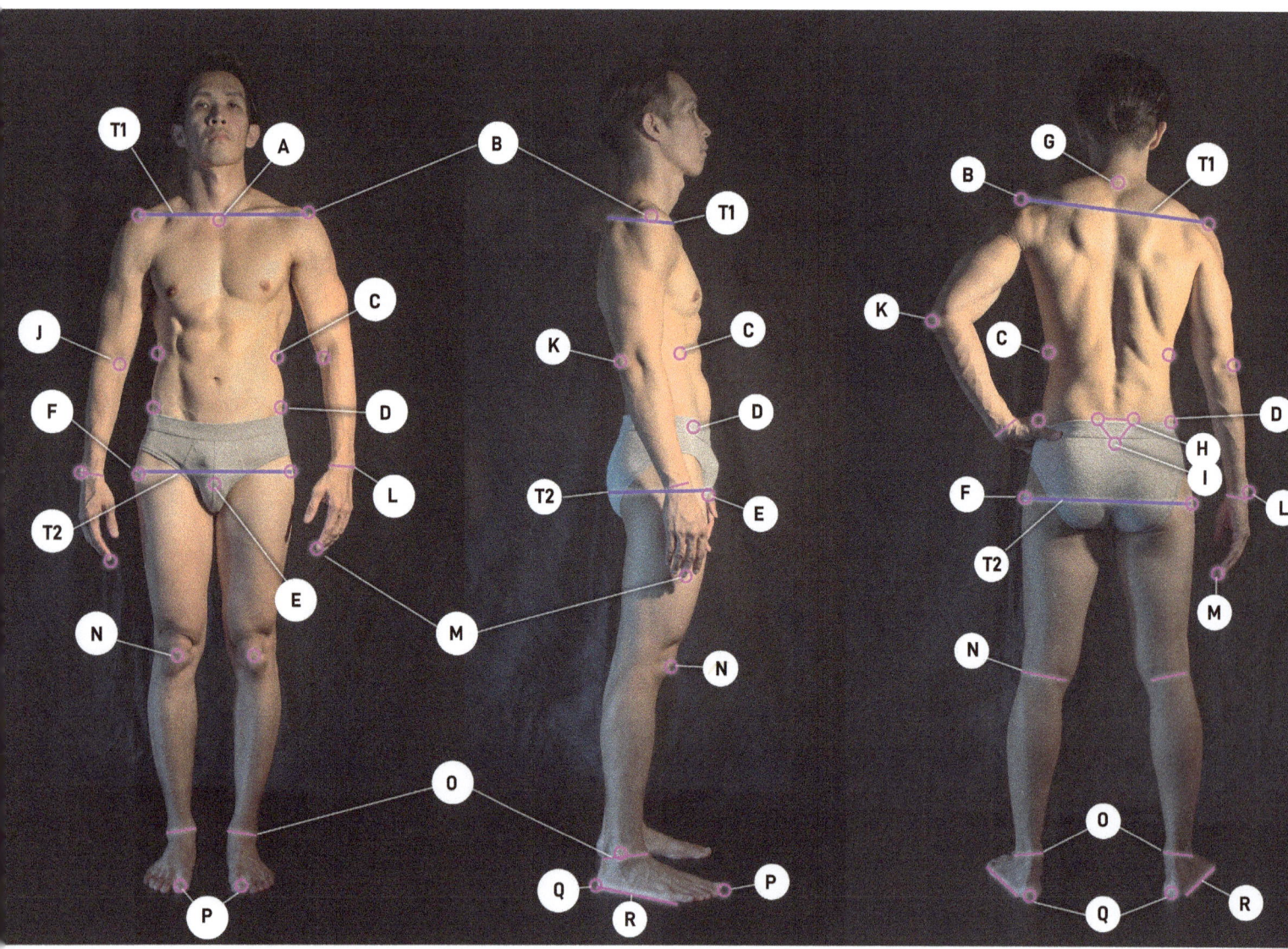

These landmarks are mostly bones and bone structures that are generally visible on the surface of the body. Because these structures drive and support the movement of the body, learning how to see and identify them will greatly improve your ability to make good decisions and good marks when drawing from life.

If you have never studied anatomy or are new to life drawing, the names of these bones and anatomical terms may be unfamiliar. This chapter is not meant to be a lesson on anatomy; it is a lesson on observation. Knowledge of anatomy is not required to begin learning figure drawing, but it will become necessary as you advance. If you are new to anatomy, use this observation guide as a starting point for further self-study.

LANDMARKS OF THE TORSO

In general, the first and most important landmarks are in the torso. The torso is the largest mass of the body and all the limbs originate from the torso. The torso also contains the two largest and most important bone structures, which are the rib cage and the pelvis (hipbone).

Starting with the top of the torso **(T1)**, I look for the pit of the neck **(A)**, which is located at the base of the neck between the clavicles (collarbones). The pit of the neck marks the top of the torso and also the centerline. The points of the shoulders **(B)** are the bony protrusions that make up the shoulder joint.

Next, look for the bottom of the rib cage **(C)**, which can usually be seen when the model bends to one side. The bottom of the abdomen **(D)** is marked by the iliac crest in both front and side view. This bony protrusion is two spines of the pelvis. In lean and muscular models, this can be seen easily because the lower obliques (part of the abdominal muscles) rest on top of the iliac crest. These bony spines are even more visible in females because of their larger pelvises.

The bottom of the torso **(T2)** is marked by an imaginary line that runs through the bottom of the glutes and through the genitals **(E)**. The great trochanter **(F)** (head of the upper leg bone) marks the beginning of the legs and acts like an axis point for the movement of the legs.

In the center of the upper back is the seventh cervical vertebrae **(G)**. This works like the pit of the neck in the front. It marks the centerline and is just above the top of the torso **(T1)**, which connects the points of the shoulder **(B)**. The other important landmark in the back is the sacrum triangle. This is marked by the two dimples in the lower back **(H)** and the bottom of the sacrum **(I)**.

MAJOR LANDMARKS OF THE LIMBS

When observing the limbs, first look at the joints. The pit of the bicep **(J)** and the elbow **(K)** mark the end of the upper arm. The outer wristbone and a line drawn through the wrist **(L)** marks the end of the arm. To mark the end of the hand, look for the longest or outermost finger **(M)**. The kneecap at the front of the knee and the line drawn through the back of the knee **(N)** mark the bottom of the upper leg. The ankle bones and a line drawn through the ankle joint **(O)** mark the end of the leg. For the feet, look for the longest visible toe **(P)** and the heel **(Q)**. If the feet are making contact with a surface, look for the contact line, which marks the bottom of the foot **(R)**.

These landmarks will help you draw the body, but the head has its own set of landmarks, which are outlined next.

Starting with the Head

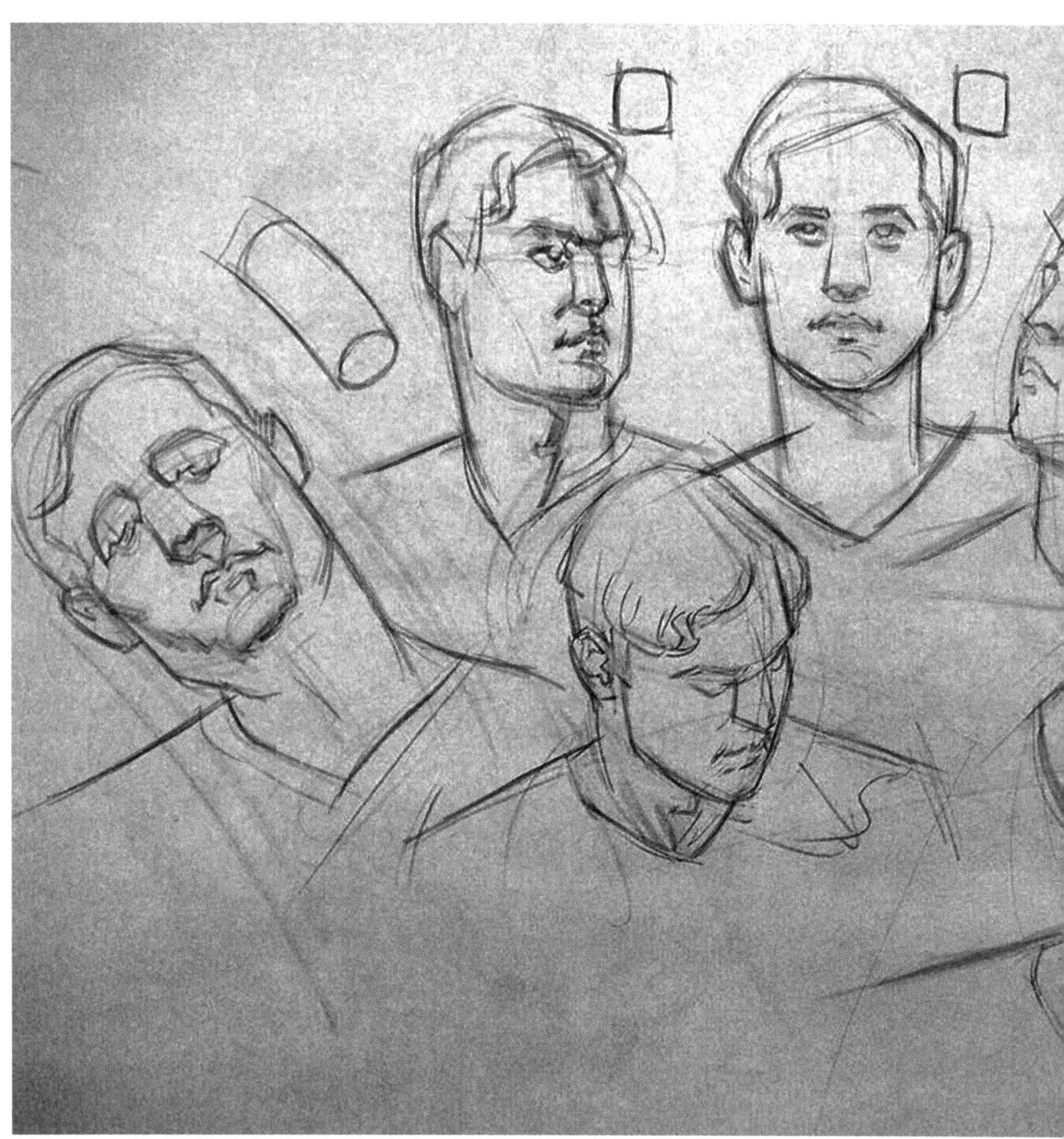

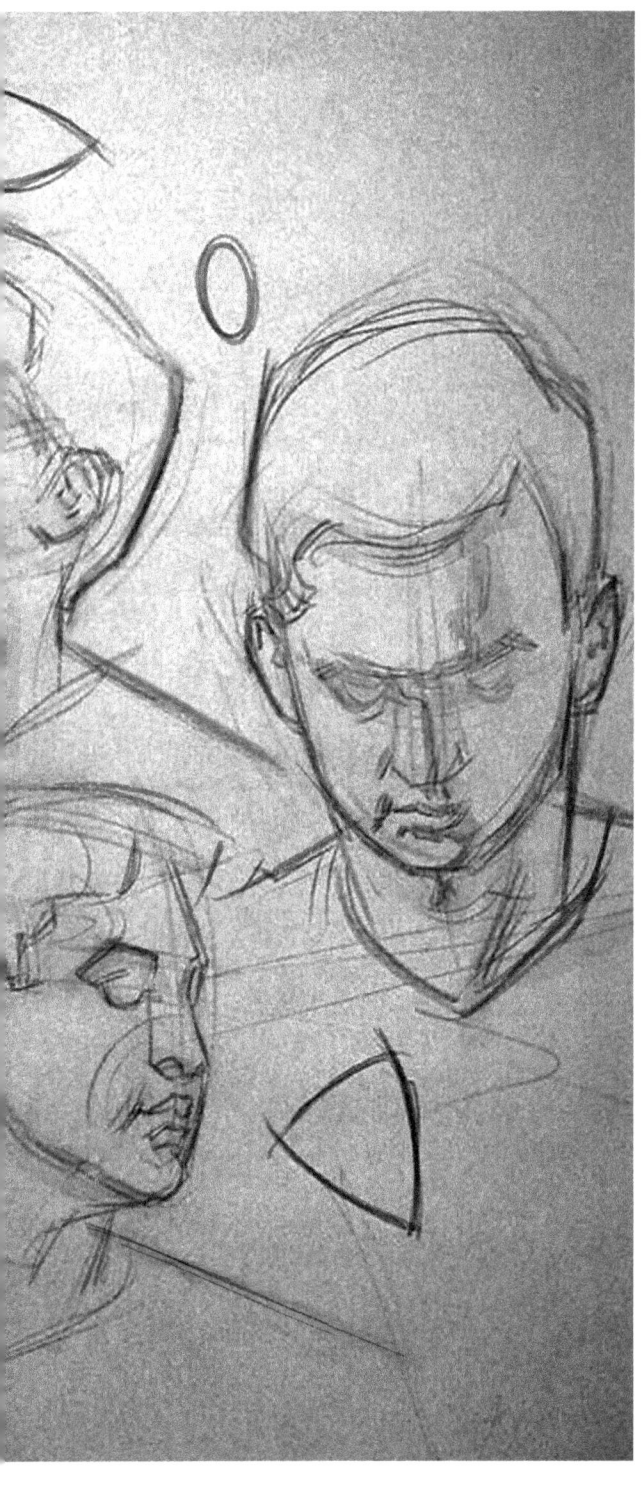

Starting with the head is an effective way to begin a figure drawing. However, the head is an incredibly complex structure.

For the purpose of this book, I show a process that is effective and functional in the setting of a life drawing session with timed poses. Even though it is not possible (or effective) to draw a fully finished or complete, head with very limited time, this process contains the foundational skills and tools needed to begin a longer and more finished head drawing.

In short, the goal is not to draw the head, but instead to *indicate* the head. Indicating accomplishes two main goals:

Goal 1: It clearly communicates the head and its basic nature, size, shape, and position. This is known as the "read."

Goal 2: It gives us enough information to proceed to the next stage of the drawing.

The next stage is generally proceeding to the torso and then the rest of the figure. Of course, if you are doing a head study, the next stages could be adding more complexity, such as details and lighting and shading.

Before drawing, the first step is to learn how to correctly observe and interpret the model's head.

PART 1: WHAT TO LOOK FOR

Before drawing the head, take a few moments to observe the pose. Because the head is so complex and there is so much information to interpret, it is important to limit your focus, especially when drawing under a time limit. Careful observation also helps you make a mental game plan of the task ahead.

Anatomical Landmarks

Just like the figure, there are key landmarks and anatomy to describe, suggest, or define in the drawing in order to get the read. The most important parts of anatomy to look for are the centerline, eyeline, ears and ear attachments, bottom of the nose, and hairline.

The diagram opposite shows the major landmarks at various head angles. The first and most important features to look for are the "crosshairs." These are imaginary lines that run through the vertical and horizontal center of the head. The vertical center is known as the "centerline" **(A)** and the horizontal center is the eyeline **(B)**. These crosshairs are important for many reasons, but you can rely on them to define the position, which is how much the head is turning left or right, or tilting vertically up or down. The centerline is the foundation for placing the features. It is also where to look to see the gesture of the head. The eyeline helps define the tilt and also leads to the ears, which are another important tool for defining position.

The next important landmarks are the hairline **(C)**, which is the top of the face, and the bottom of the chin **(D)**, which lies at the bottom of the face. To indicate eyes, observe the brow line **(E)**, which is the bone that makes up the top of the eye socket. As you observe and draw the brow line, focus more on the bone and eye socket, instead of the eyebrow hair. The center of the eyes and eye sockets **(F)** start at the brow line and end at the bottom of the eye socket, which is just below the eyeballs. The bottom of the nose **(G)** is at the base of the nose and nostrils. Use this line along with the brow line to define the nose position, which is helpful in side views and when the model is looking up or down.

The final important landmark is the ear and ear connection **(H)**. In life drawing, you can use the ear and ear connection to define position. This is because the ear connection not only lines up the eyeline (horizontal center), but lines up the vertical center in side view. This means that the ear connection is a central axis point where the head tilts up or down. Because of the ear's location, and because it is so prominent, it can be used to define the proportion of the head, especially the ratio and size of the cranium, or back of the skull, to the face.

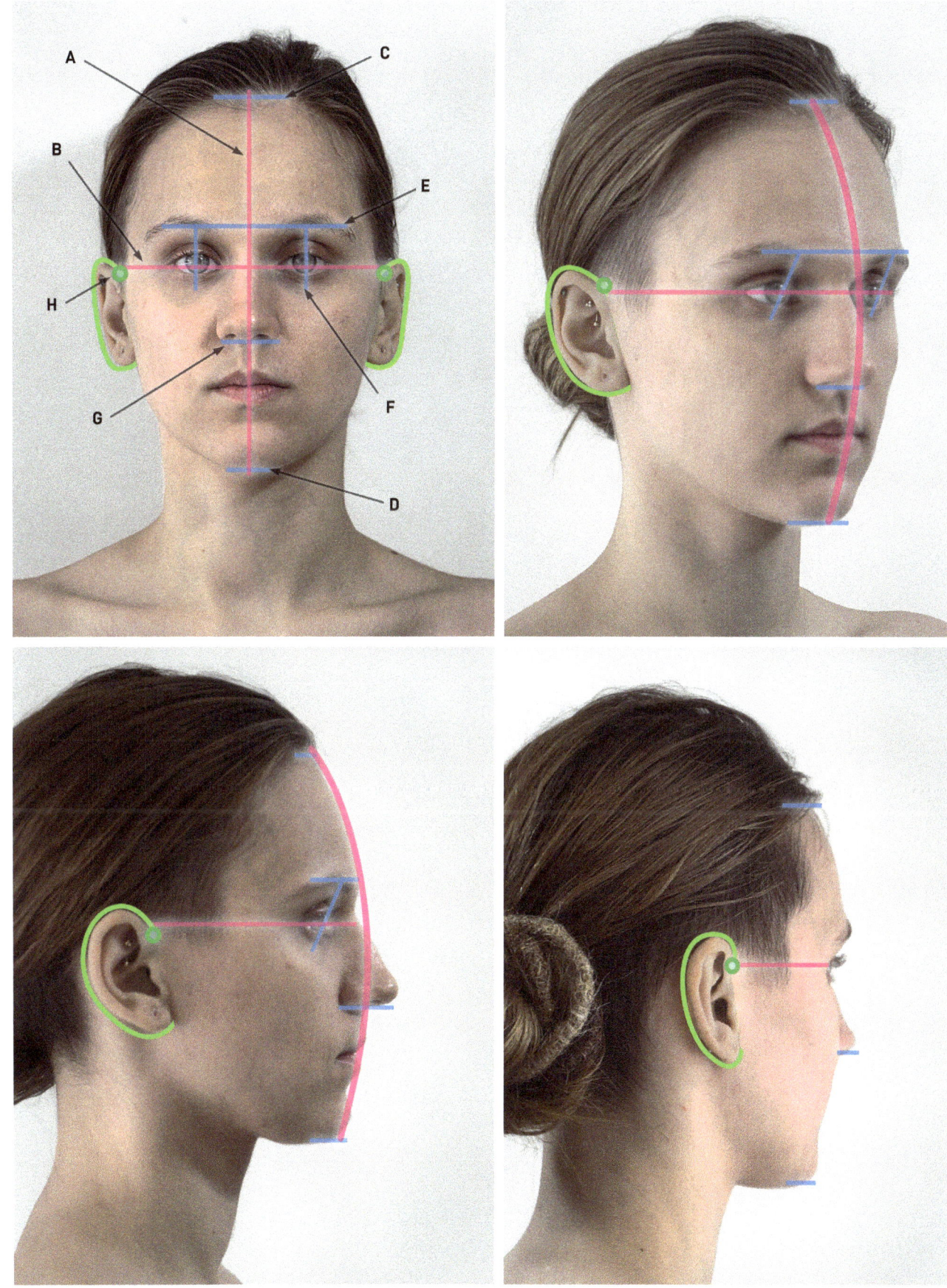

67

THE DRAWING PROCESS

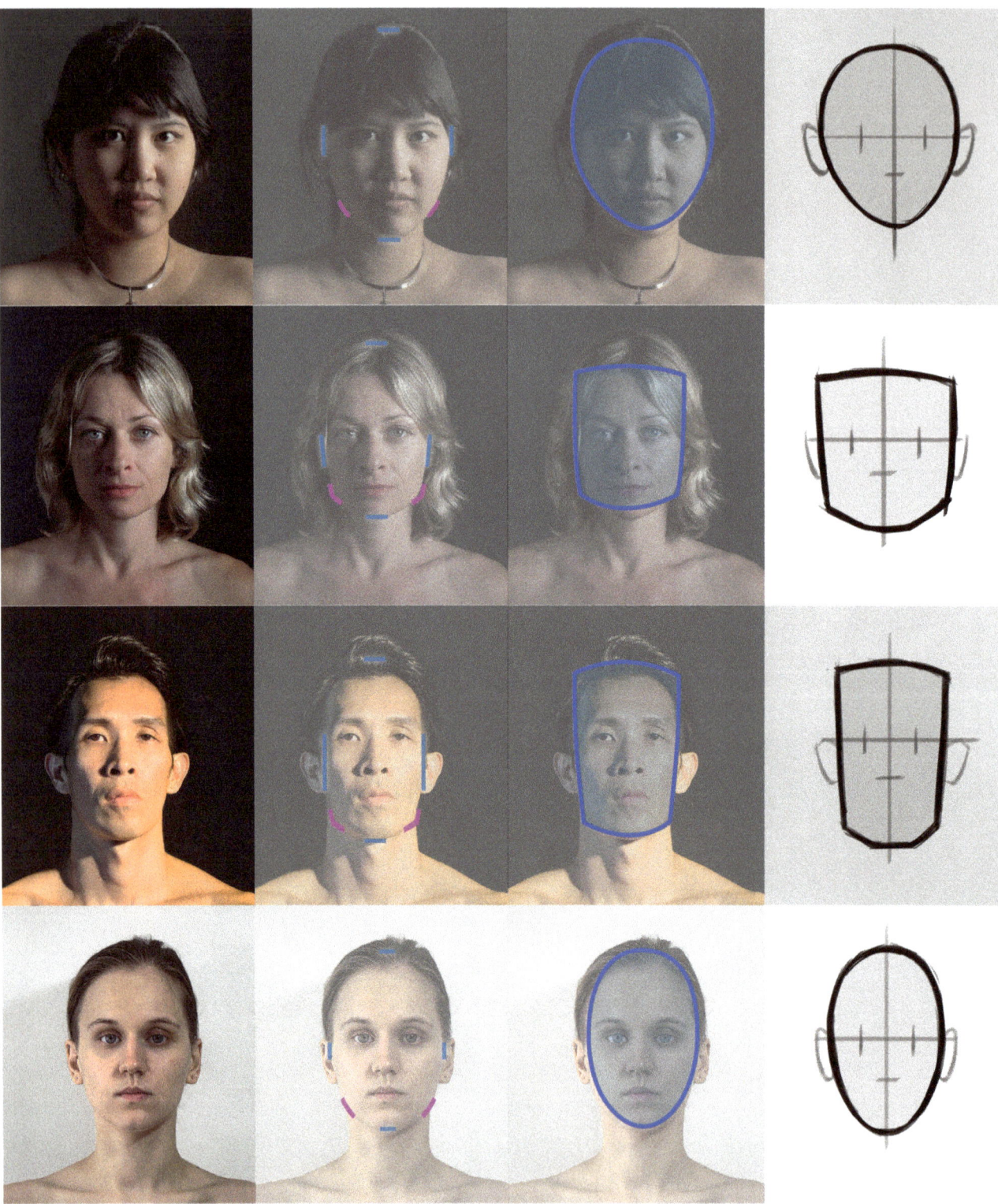

Outer Shape
To simplify the head, look at the outer shape of the model's head. Like all complex forms, try to see the head as a round, oval-like form, as square and rectangle shapes, or even as triangle shapes, which can be seen more clearly in side and three-quarter views.

To see the shape, it helps to look at the contour, or outer edge, of the model's face and cranium. The main points to look to are the top of the hairline or skull, if visible, the bottom of the chin, and the sides of the face or head. Studying these points will help you see the nature and character of the face shape.

For example, if the model has soft and curved features, a circle or oval is an obvious choice. If the model has sharper, or angular features, start with a box-like, or rectangular, shape. If the jawline is defined, use that as a starting point to help define a shape.

When I begin to draw, I'll often exaggerate the shape, making it more round, square, or pointed, wider, thinner, or longer, etc. This helps add life to the beginning stages of the drawing and better communicates the nature of the model's head and face.

A Note on Hair

When it comes to drawing hair (or costume pieces such as hats), simplify as much as possible into graphic shapes. Like the face, look at the outer contour to define the shape. The main things to look for are direction changes and corners. These corners will help you imagine the shape that best captures the hair. As you begin to draw the hair, use a very simple and general shape. If time permits, add smaller hair shapes.

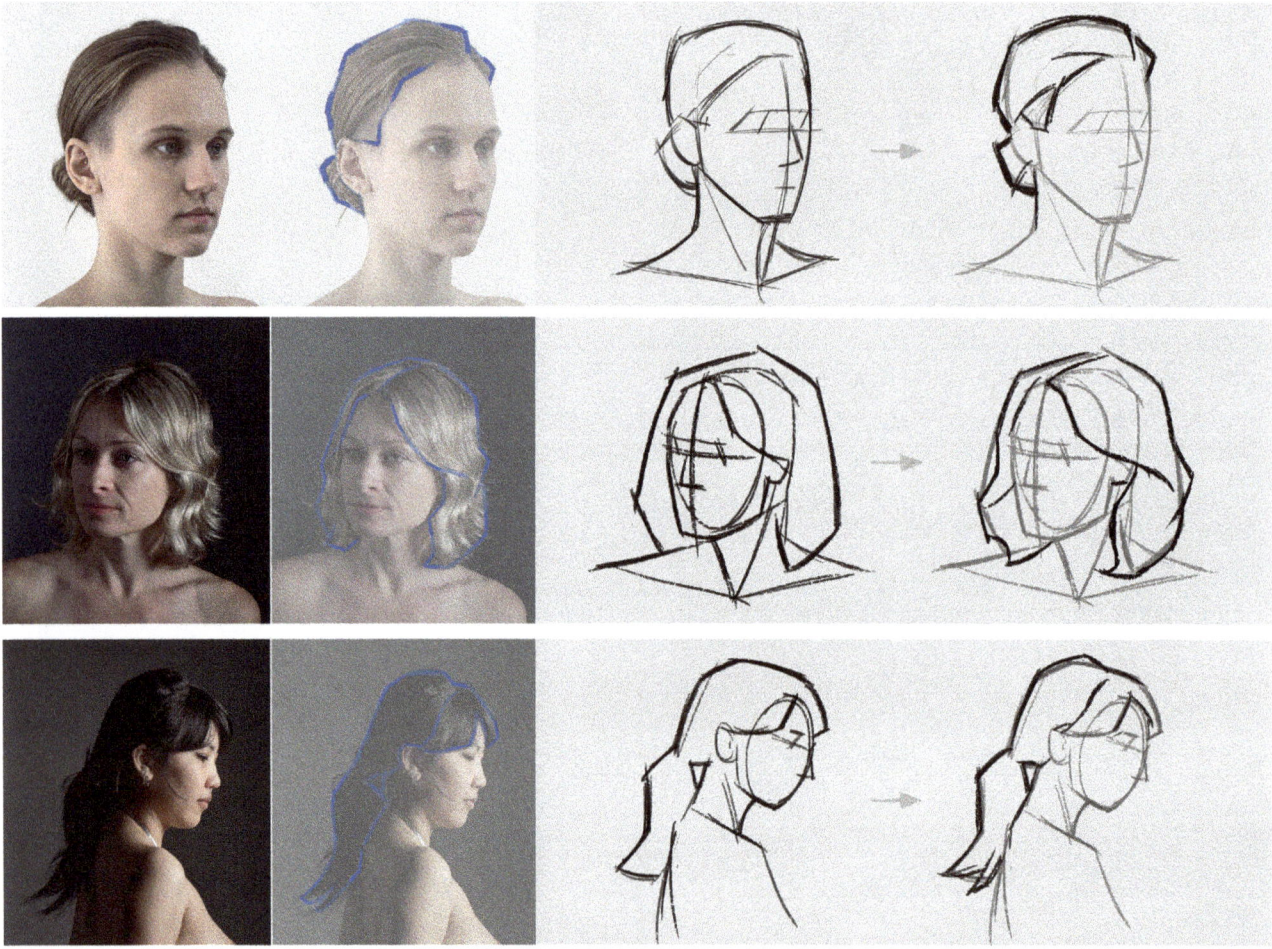

Note how the direction changes help to see the hair as a simple shape. As I draw, I start with the big shapes and then add smaller hair shapes if time permits.

If you are new to drawing, this can take some practice, because the tendency is to see and draw individual strands. This is very common, but with practice in observation, your eye will be trained to see shapes in the hair. Throughout this book are many examples of how to simplify hair details, which can be copied for reference and further study.

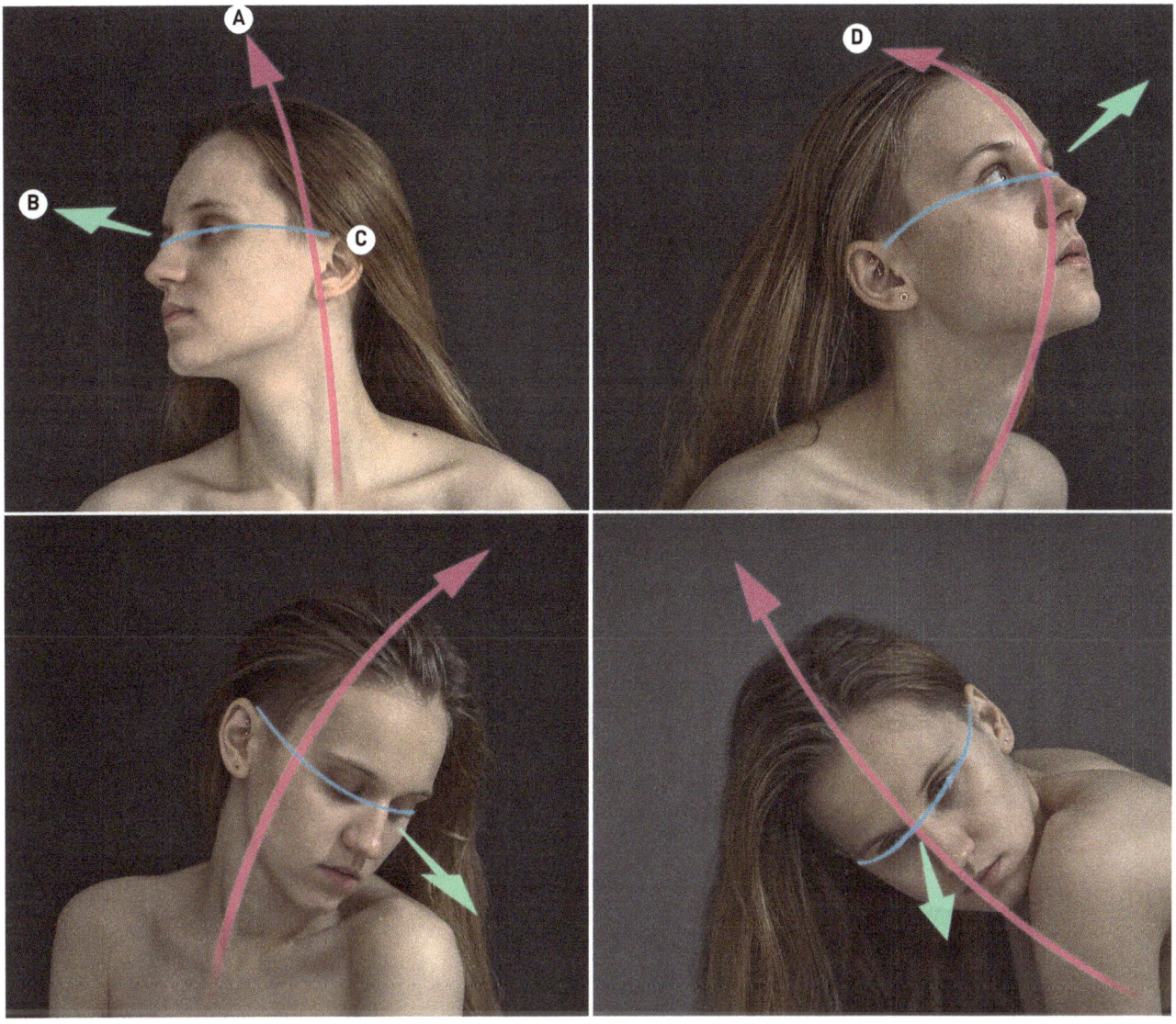

The action flows from the body through the head (A). The centerline of the neck is where I look to see the action (D). The gaze (B) and eyeline (C) are vital in defining the amount of rotation.

Action of the Head

The other important thing to look for is the action. Action is gesture and gesture is life. If you correctly observe and communicate the action, then the head indication will feel much more alive. To do this, first ask the question: "What is the head doing?" Other questions to ask are: "How much of the face do I see?" "Is it a side view or three-quarter?" "Are they looking up, or looking down?" Carefully observing the amount of rotation and tilt helps tremendously when it comes time to draw and define the position.

Structures of the Neck

The neck is an important structure because it supports the head and determines the action of the head. To correctly transition from the head to the body, you must first see and understand the key anatomical landmarks of the neck, which are the centerline, sternocleidomastoid, and trapezius.

The first landmark to look for is the centerline of the neck **(A)**, which is an imaginary line that runs through the center of the front and back of the neck. The next major structures are the sternocleidomastoid muscles **(B)**, which run along the side of the neck. These tube-like muscles flow from behind the ear and converge at the pit of the neck **(C)**. The large trapezius muscles **(D)** make up the back of the neck and also transition to the shoulders. In the back view, the seventh cervical vertebrae is the center of the neck at its base, directly between the shoulders and trapezius muscles **(E)**.

It's not important to memorize these names or be an expert on anatomy, especially if you are new to life drawing. The important thing is to learn how to see them and how they connect the head to the body. When the connections are defined correctly, the process of drawing the figure will be much smoother.

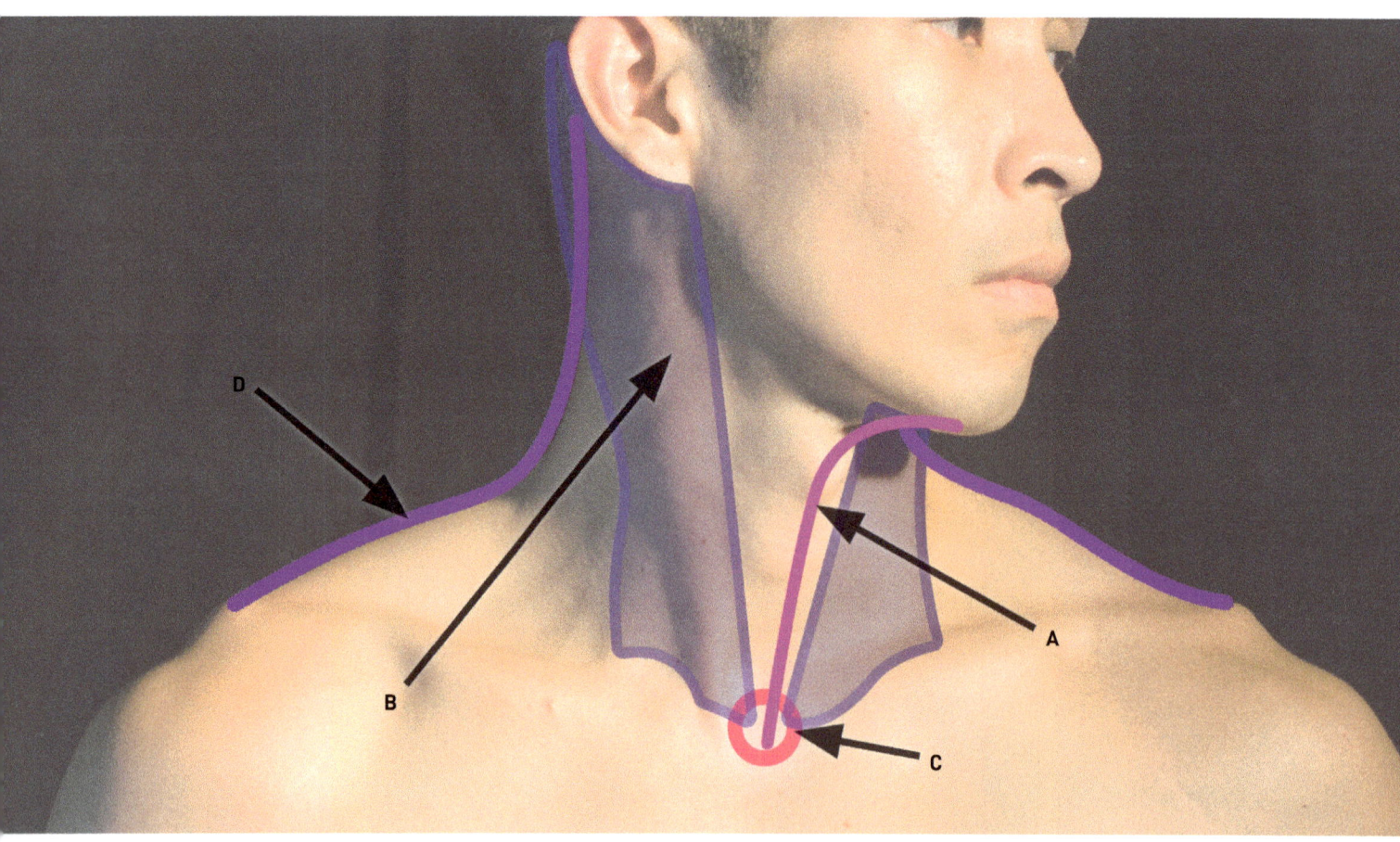

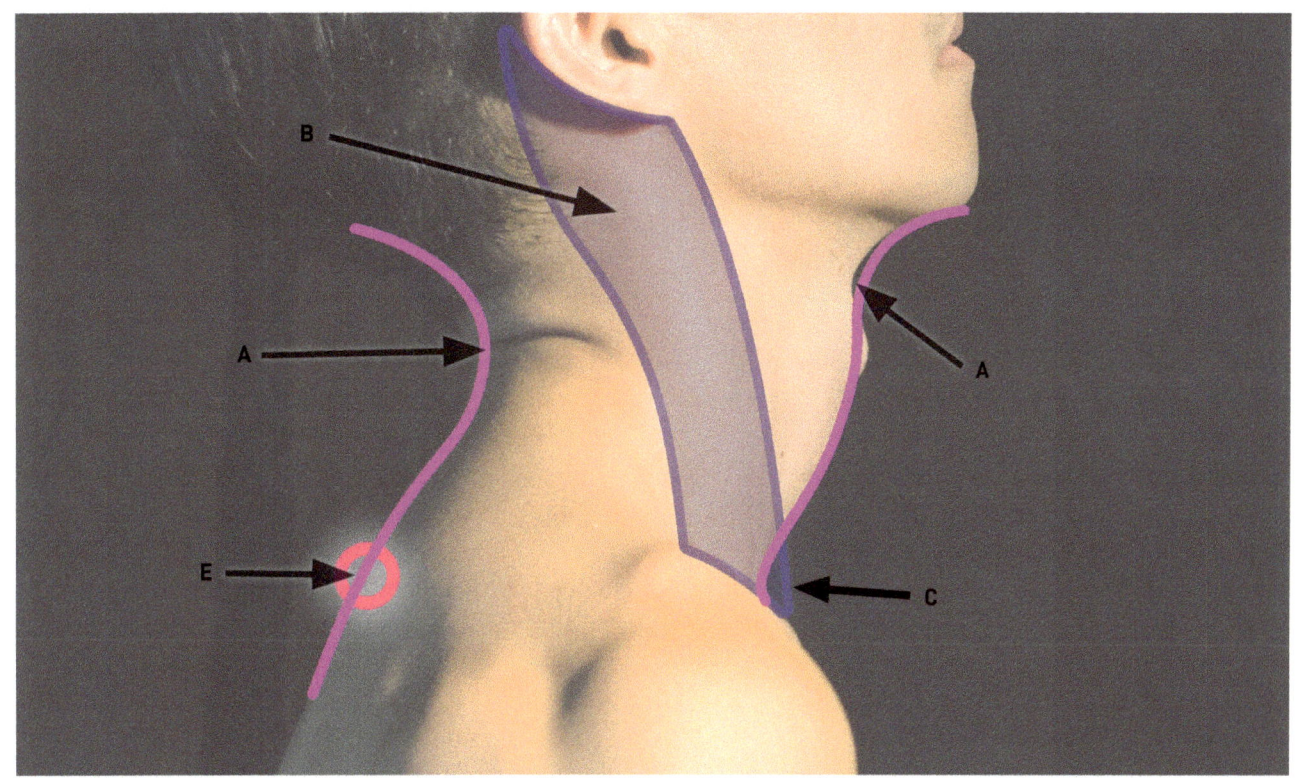
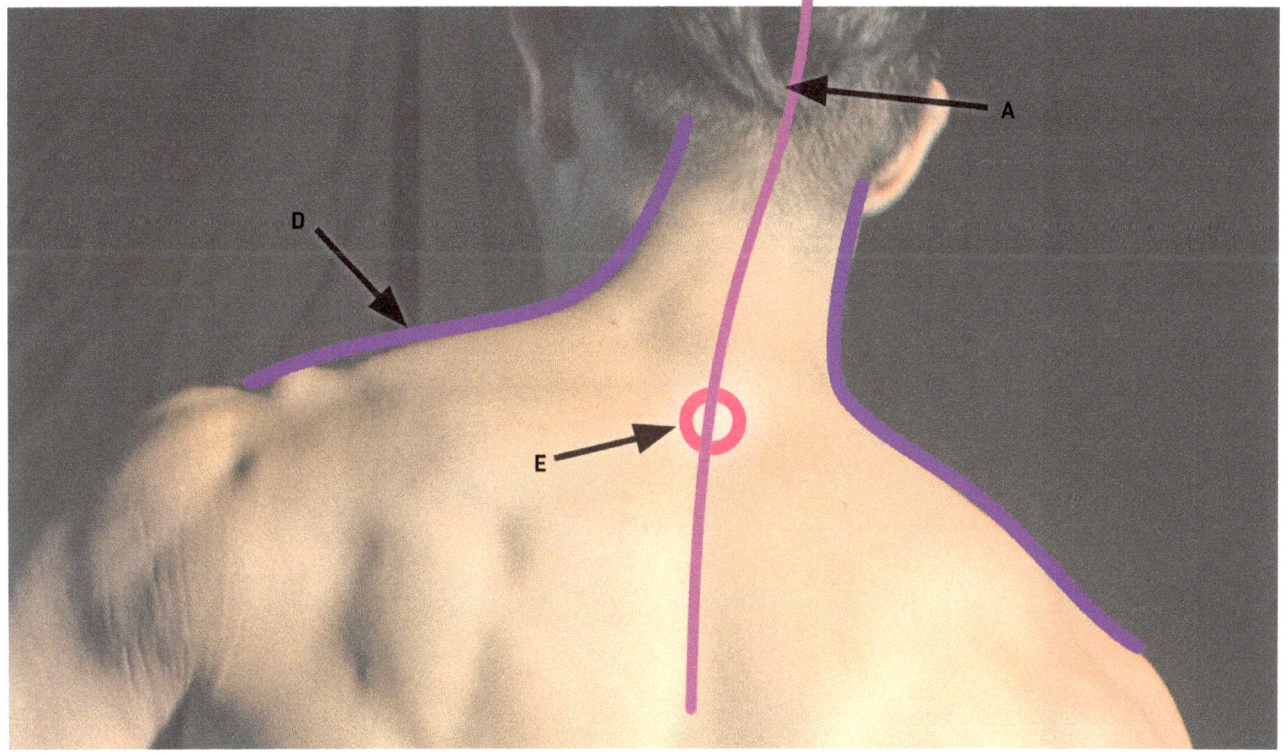

THE DRAWING PROCESS

73

PART 2: HEAD INDICATION PROCESS

If you take the time to observe and understand the head and its action, the drawing process is relatively simple. Again, because of time and size limitations, the goal is not to draw a fully finished head, but instead to indicate the head and define enough information so that the head reads well and you can transition to the body.

Like drawing anything, the head follows the same process of drawing simple to complex, lines to shapes, gesture to structure. To demonstrate the process, I use several examples of heads in various angles and positions.

Example 1: Front View, Male

Observation Process
The first things to look for are the crosshairs, which comprise the centerline of the face (vertical center) and the center of the eyes (horizontal center). Also note the top of the head, the hairline, brow line, bottom of the nose, and bottom of the chin. Finally, look for the anatomy of the neck, specifically the sternocleidomastoid and trapezius **(A)**. The next things I look for are the shapes, starting with the major, outer shape of the head and face, and then the secondary shapes such as hair and other costume details, if any **(B)**.

Drawing Process
Step 1: Gesture and Action
Start with an oval, drawn in a gestural way with long, fluid marks. Also define the centerline, which in most front views is the action line of the head.

Step 2: Crosshairs and Feature Indication
Draw the eyeline to complete the crosshairs, which helps define the head's position. Next, draw simple marks to indicate the brow line, center of the eyes, bottom of the nose, and bottom of the chin. Also indicate the ears, which are connected to the eyeline.

Step 3: Shapes
The most important shape is the general shape of the model's face and head. In this example, I use a rectangular shape that closely resembles the nature and character of the model. Next simplify the hair into a shape.

Step 4: Connecting to the Shoulders
Use the natural flow of the neck anatomy to transition to the body. The sternocleidomastoid flows to the pit of the neck, and the trapezius leads to the shoulders. These simple marks are all you need to begin drawing the torso and the rest of the figure.

Step 5: Hair and Other Details
Once the head is reading well, and if time permits, add secondary details. I usually begin by refining the hair shapes and then start to further indicate the features. In the early stages of a life drawing, the most important features to define are the eye sockets and the nose, followed by the eyes and lips. You can also start to add structure to the face by adding cheekbones, which begin to define the sides of the head and face.

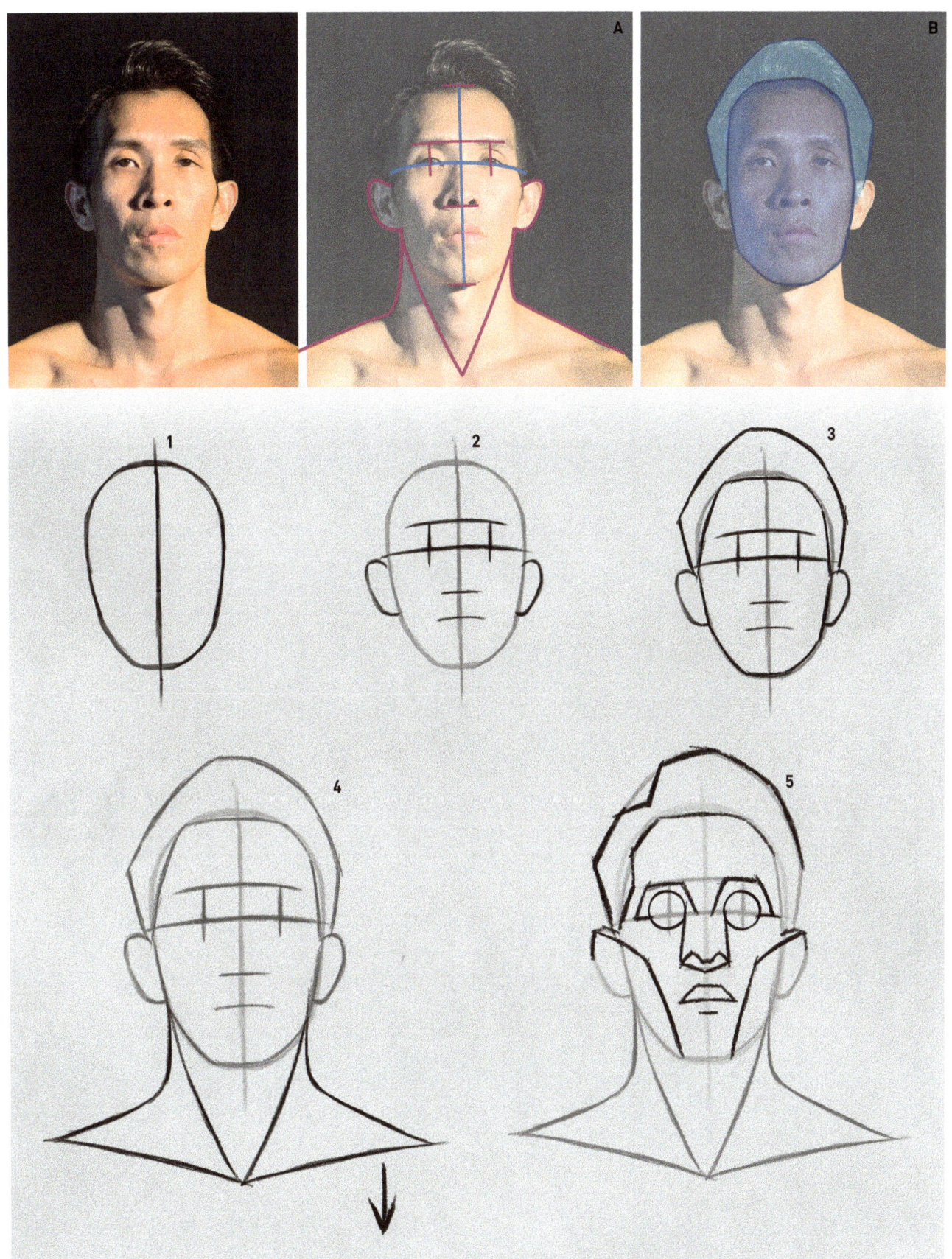

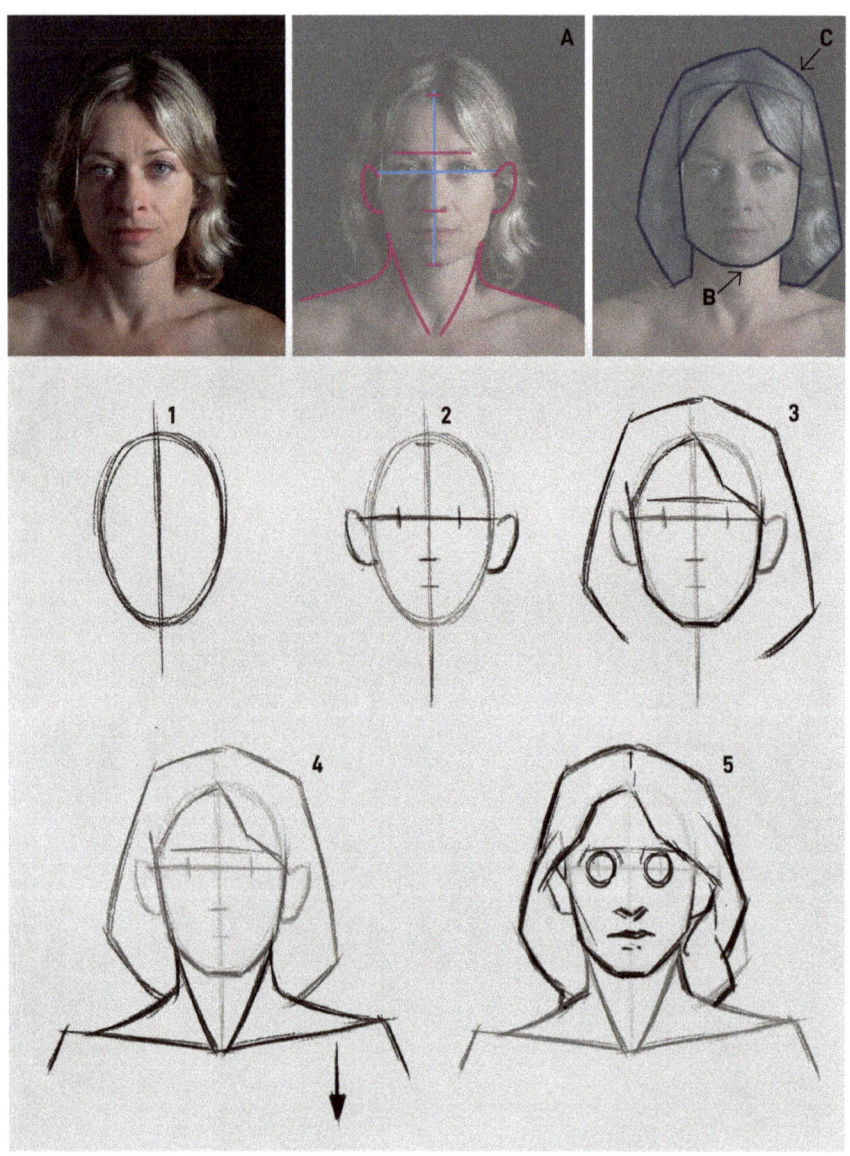

Example 2: Front View, Female

Observation Process

In this example of a female model, the process begins the same. First observe the key anatomical landmarks **(A)** and then the shapes. The most important shape is the head and face, which I interpret as square/rectangular **(B)**. For the model's hair, look for corners and direction changes that help you simplify the hair into a large graphic shape **(C)**.

Drawing Process

Begin the drawing with the gesture and action **(1)** and then feature indication **(2)**. Next, block in the head shape and a simplified hair shape **(3)**. Then indicate the neck and transition to the shoulders and body **(4)**. If time permits in the pose, add more details to the head. In this example, I further indicate the eyes, nose, and mouth and refine the face shape. Finally, refine and add more details to the hair, such as secondary shapes and direction changes that communicate the smaller masses of hair **(5)**.

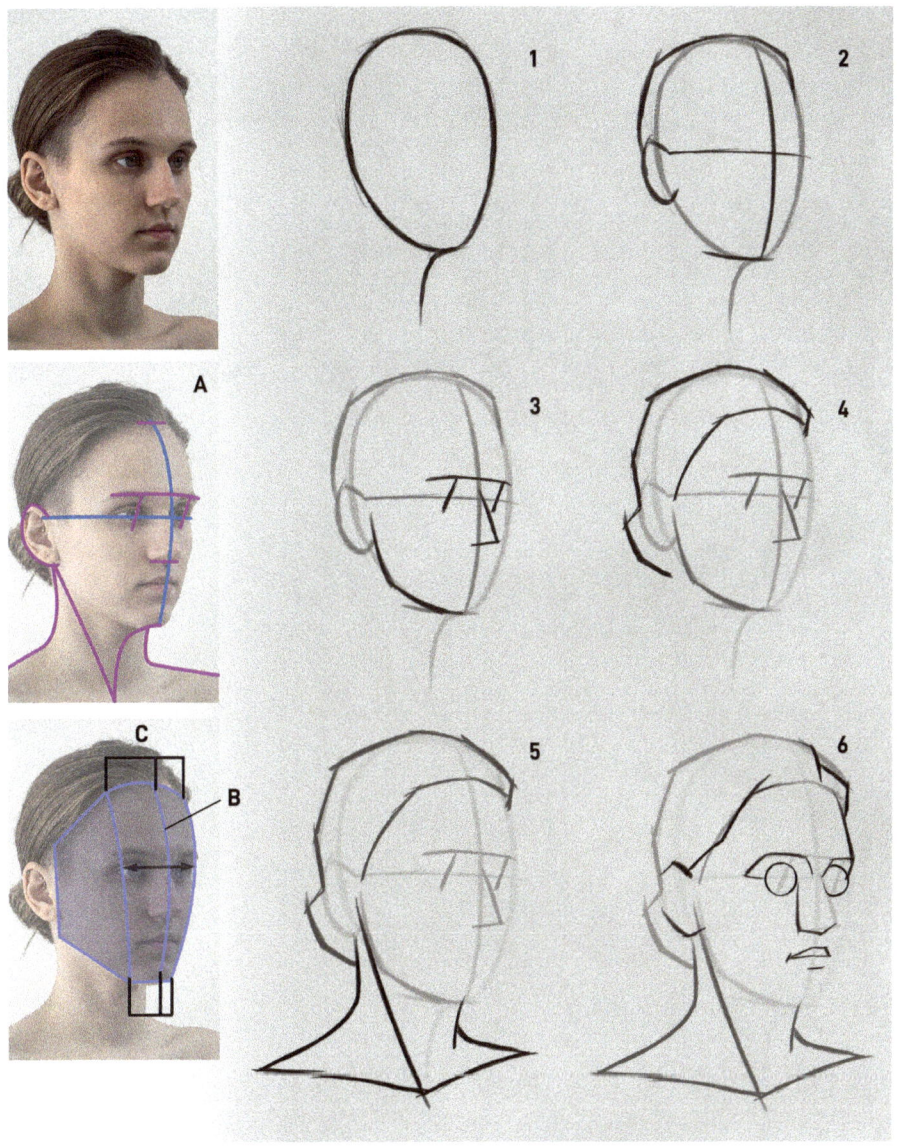

Example 3: Three-Quarter View

Observation Process
As the head starts to turn, as in this example of a three-quarter view, carefully observe the amount of rotation. Along with noting the major anatomical landmarks **(A)**, take a moment to carefully observe how much of the front of the face you see. Do this by first looking to the centerline **(B)** and then noting the distance to the left and right sides of the face **(C)**. Defining the correct ratio of left to right is critical to clearly communicating the amount of head turn.

Drawing Process
Start with the gesture **(1)** and then the crosshairs **(2)**. For the features, especially note the brow and nose, because they are more prominent as the head turns **(3)**. Complete the head indication with a simplified hair shape **(4)** and then transition to the neck **(5)**. If there is more time, refine the shapes and begin to add more features and details **(6)**.

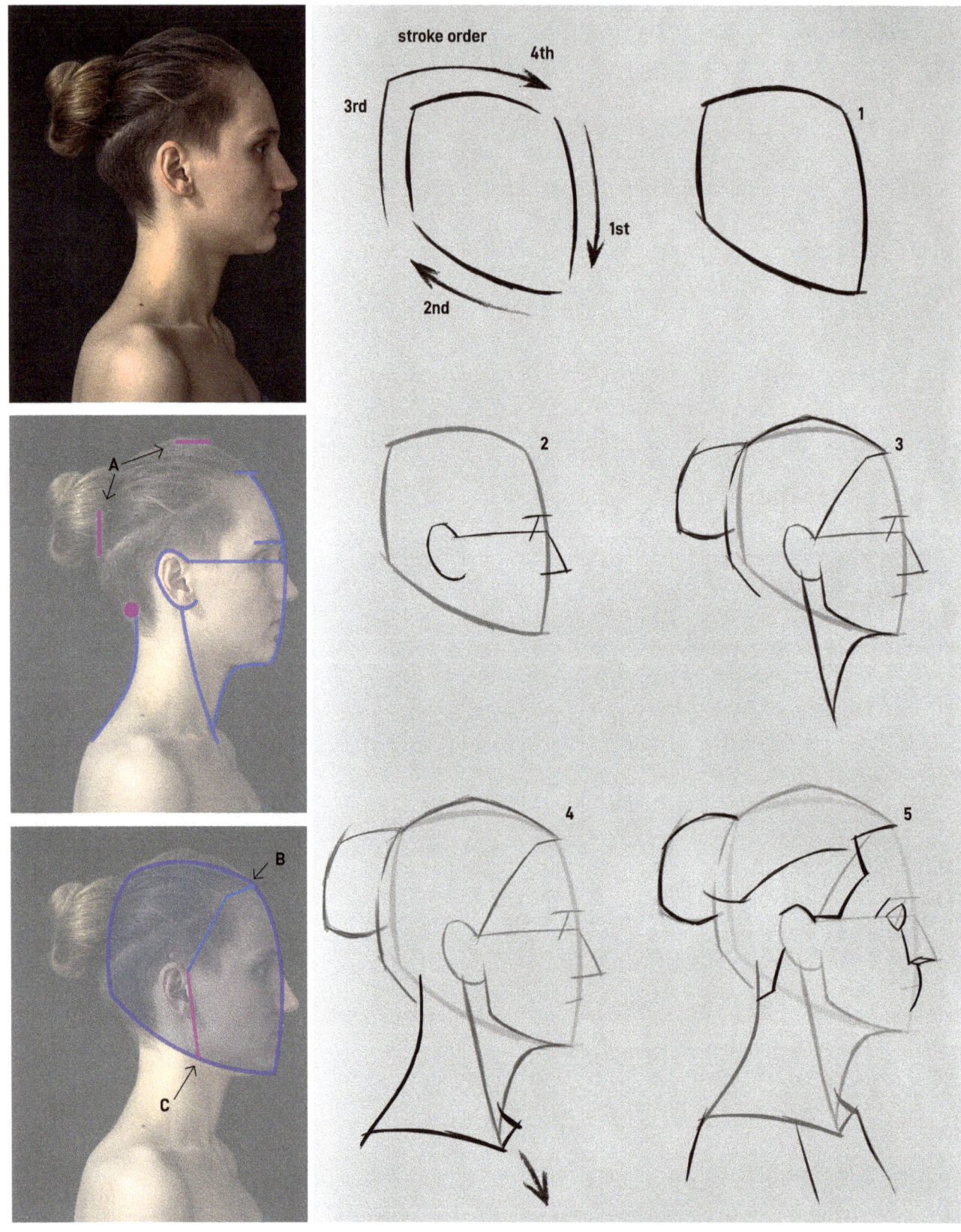

LIFE DRAWING FOR ARTISTS

78

Example 4: Side View, Female

In a side view, also known as "profile view," the front of the face is barely visible or not visible at all. Generally side views are less challenging to draw because there is less information and fewer features to describe. Instead, the front of the ear and more of the back of the head (the cranium) are visible. The cranium is a large mass of the head. Measure from left to right; it is at least as large as the facial mass. Drawing the cranium too small is a common mistake for beginner artists; drawing the cranium with enough size in proportion to the face helps make a side view read with more clarity.

Observation Process

Along with all the major anatomical landmarks and crosshairs, look at the top and back of the head and the base of the skull **(A)**, because these points define the cranium. For the shape, look at the hairline, which is at the top of the face, the bottom of the chin, the base of the skull, the back of the head, and the top of the head **(B)**. To separate the face from the cranium look to the back of the jaw and ear connection **(C).**

Drawing Process

In a side view, you can often combine gesture and shape in one step. Starting with the gesture of the face, then flowing to the jaw, and then to the back and top of the head **(stroke order)** creates a triangular or curved box-like shape **(1)**. The most important features are the brow line, eyes, and nose. Draw the center of the eyes at an angle, which suggests the eye socket receding and the brow line coming forward. A simple triangle shape quickly indicates the nose **(2)**. Next separate the facial mass by defining the jaw and a simplified hairline. Then simplify the hair shape. Follow the gesture of the front of the neck and the sternocleidomastoid muscle to the pit of the neck **(3)**. Complete the transition to the body by indicating the side of the neck and the collarbone, which connects the shoulders to the pit of the neck **(4)**. If you have more time, continue to refine the head and add details such as the eye socket, eyeballs, and nose **(5)**.

Head Looking Up or Down

One of the more difficult positions to draw is when the head is looking up or down. This is known as "up-view" and "down-view." This also occurs if your eye level is above or below the model.

In an up-view or down-view, perspective and foreshortening are involved. This means that the head and features appear to get smaller as they go away in space (up-view), or appear to get larger as the head comes toward you (down-view).

One simple way to draw the head with foreshortening is to use a cylinder as a base shape. A cylinder has straight lines on the sides, which help suggest perspective, meaning the lines appear to eventually converge at a distant vanishing point. The curve of the cylinder also helps indicate the features because the human head (and all organic forms) is naturally curved.

Example 5: Up-View, Male

Observation Process
The first areas to observe are the top and sides of the head and bottom of the chin. These points will help you imagine the cylinder form to use as the base shape of the drawing **(A)**. The horizontal feature lines, especially the eyeline and brow line, are curved like a cylinder. Also look for the curve of the head, forehead, and the jawline **(B)**. The bottom planes, or undersides of head, will help you communicate an up-view. The most important bottom planes to look for are the eye sockets, bottom of the nose, upper and lower lips, and the underside of the jaw **(C)**.

Drawing Process
Start a curved rectangular shape and the action of the head, which is also centerline **(1)**. Next, establish the crosshairs with the eyeline, mark for the eyes, bottom of the nose, and center of the mouth. Indicate the ears **(2)**. Refine the shape of the head, also add the hair shape, and then follow the neck structures to transition to the shoulders and torso **(3)**. Finally, describe the underplanes, especially the eye sockets, bottom of the nose, lips, and the bottom of the jaw **(4)**. If you have enough time, continue to refine the head and add features and details as needed to reinforce the feeling of a head looking up.

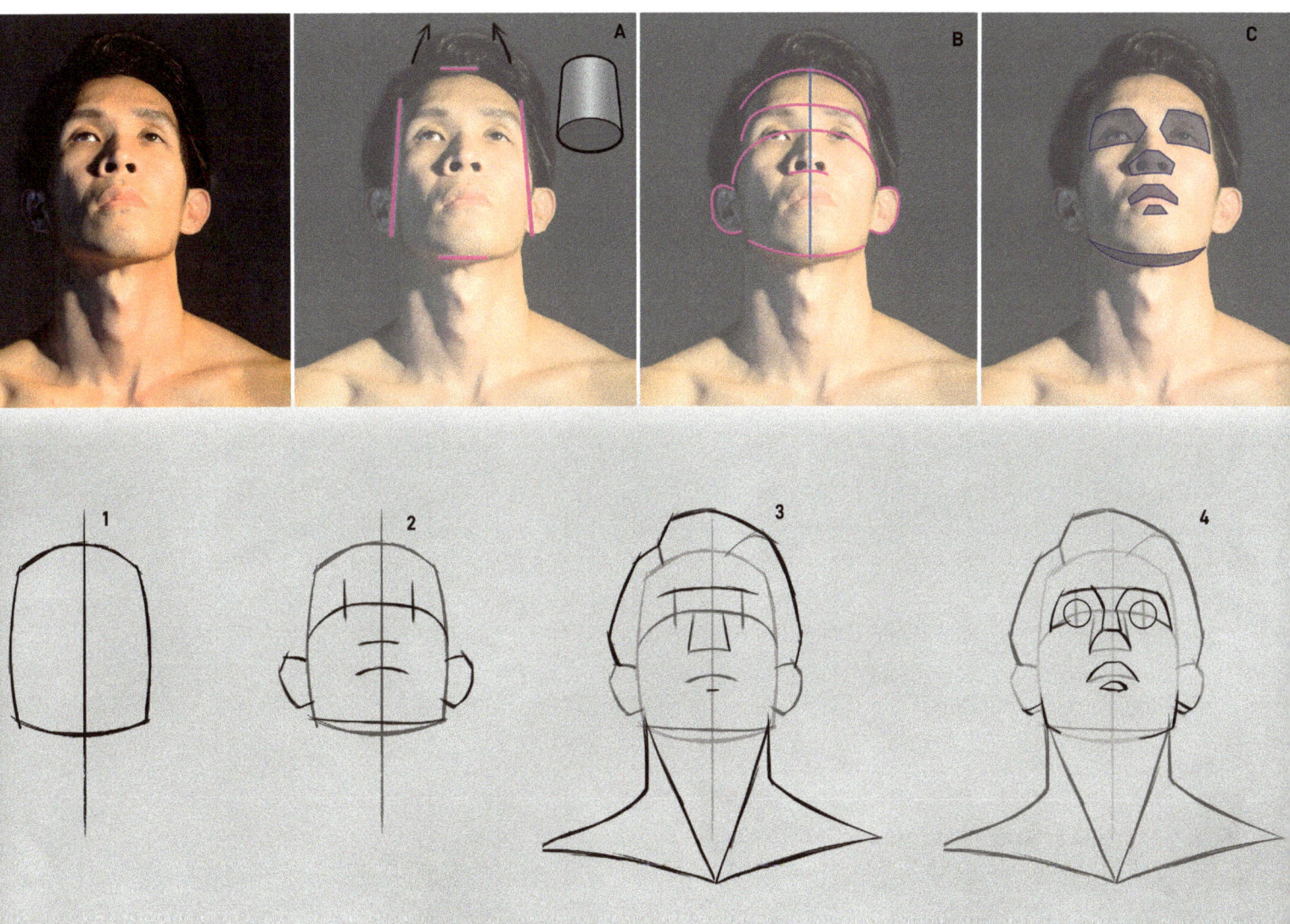

THE DRAWING PROCESS

81

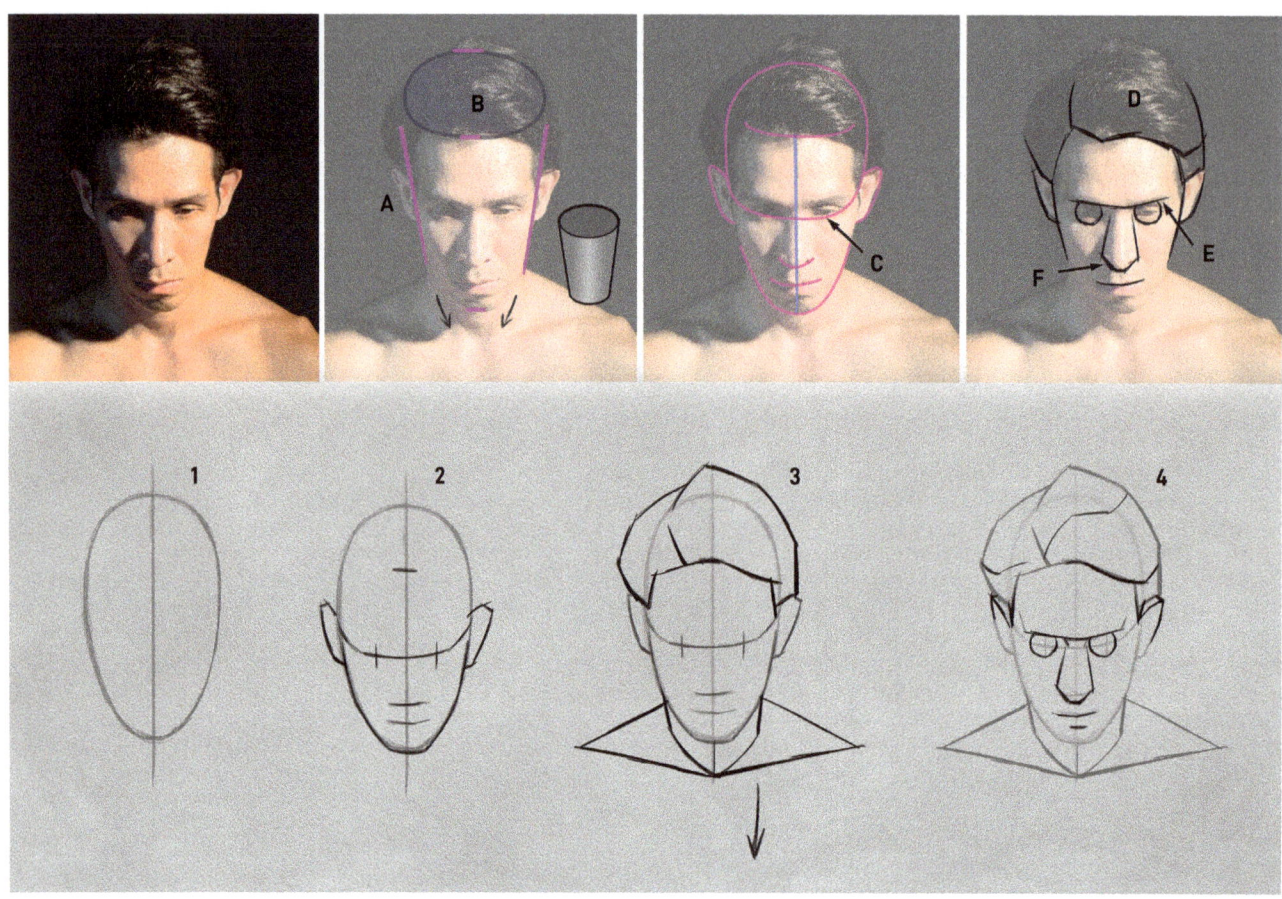

Example 6: Down-View, Male

A head looking down is very common in life drawing. Using the cylinder as a base shape works just like an up-view pose, except in reverse. This means the front of the cylinder curves downward and the sides of the cylinder converge at the bottom of the form.

Observation Process

Like an up-view, first look for the sides of the head and the bottom of the chin **(A)**. At the top of the head look for the hairline and the back of the head. These points will help you visualize the top of a cylinder **(B)**. The anatomical landmarks to look for are the eyes, bottom of the nose, center of the mouth, and the curve of the jaw. Visualize the eyeline as a long circular line that follows through the eyes and around the back of the head **(C)**. To help communicate a down-view, look for areas of overlap. For example, the hair overlaps the forehead **(D)** and the brow bone overlaps the eyes **(E)**. Note how the nose overlaps the mouth structure **(F)**.

Drawing Process

Begin with a curved shape that resembles a cylinder and centerline **(1)**. Next, lay in the eyeline and ears and mark the center of the eyes, bottom of the nose, and center of the mouth **(2)**. Because the hair is closest to the viewer, define it as a simple shape. Then follow the visible neck structures along with the collarbones, which transition to the torso **(3)**. Finally, add as many overlaps as possible to reinforce the feeling of a down-view. Use the brow to overlap the eyeballs and block in a simplified shape for the nose, which overlaps the mouth. Refine the jaw shape and begin to block in the mouth and lips **(4)**.

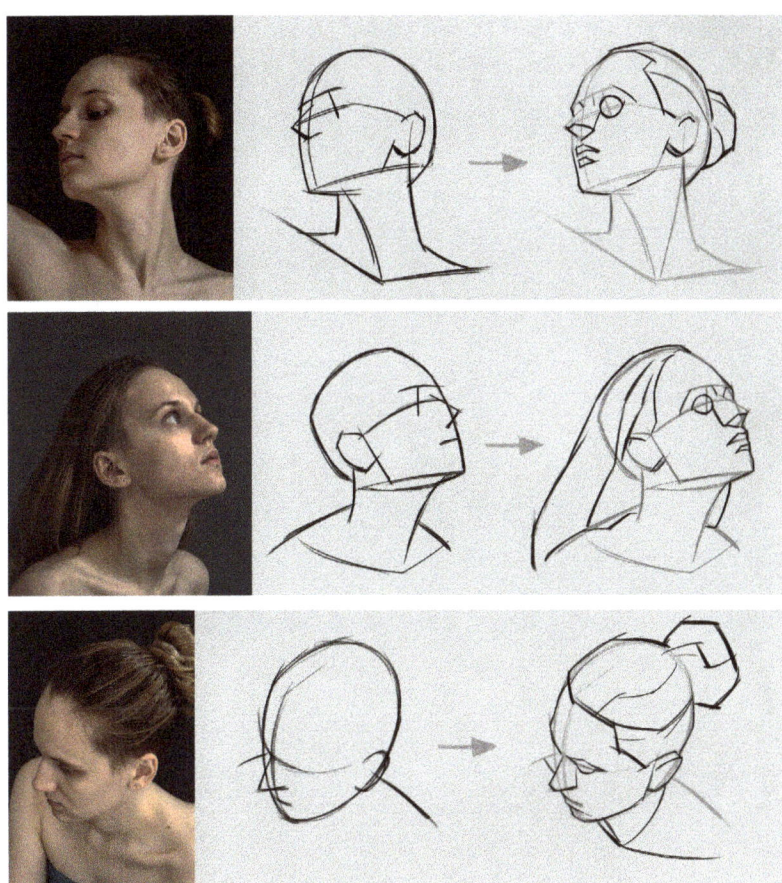

Once the head structure reads well, it creates a solid foundation to which I can add more details.

Example 7: Various Up- and Down-Views

In these examples, the head is turned and looking up or down, which can seem more difficult. For up-views, emphasize the curved jawline, which suggests the underside of the cylinder form. Take advantage of every other bottom plane you can use, especially the eye socket, bottom of the nose, and lips. In a turned down-view, there is often very little facial information available. This means you must carefully observe and define the shapes of the head and features that you do see. Take advantage of all the overlaps available, especially the browline and the nose. If available, use the hair as much as possible to create overlaps of layering forms, which suggests depth.

Throughout the book there will be many more examples of the head at various angles and more opportunities to study, copy, and observe how I indicate the head and transition to the figure.

Drawing the Torso

After the head, the next major form to define is the torso. Learning to draw the torso is like learning to draw any form. The process of gesture to construction, 2-D to 3-D, is exactly the same. The torso also acts like a limb. It can bend, move, and twist like an arm or a leg. Like the limbs, the torso has an upper structure, the rib cage, and a lower structure, the pelvis, with a flexible area in between that acts like a joint. In short, once you can draw the torso, you can apply the same principles and process and draw any limb or other part of the body.

THE THREE SECTIONS

The torso is a beautiful and complex structure. To simplify the torso, look for and draw it as three sections: the upper torso, the abdominals (or mid-back), and the hips. These sections relate to the three bone structures: rib cage and shoulder girdle, spinal column, and pelvis.

The upper torso starts at the top of the shoulders and the base of the neck, and ends at the bottom of the rib cage **(A)**. The mid-section starts at the bottom of the rib cage and ends at the top of the pelvis. The abdominal wall is seen in the front view **(B)** and the lower back muscles can be seen in the back view **(D)**. The hips start at the top of the pelvis and end at the center of the crotch **(C)**. Drawing in sections will help you group all of the complex anatomy and simplify it into shapes. Sections are also very helpful for drawing a torso that is bending forward or backward.

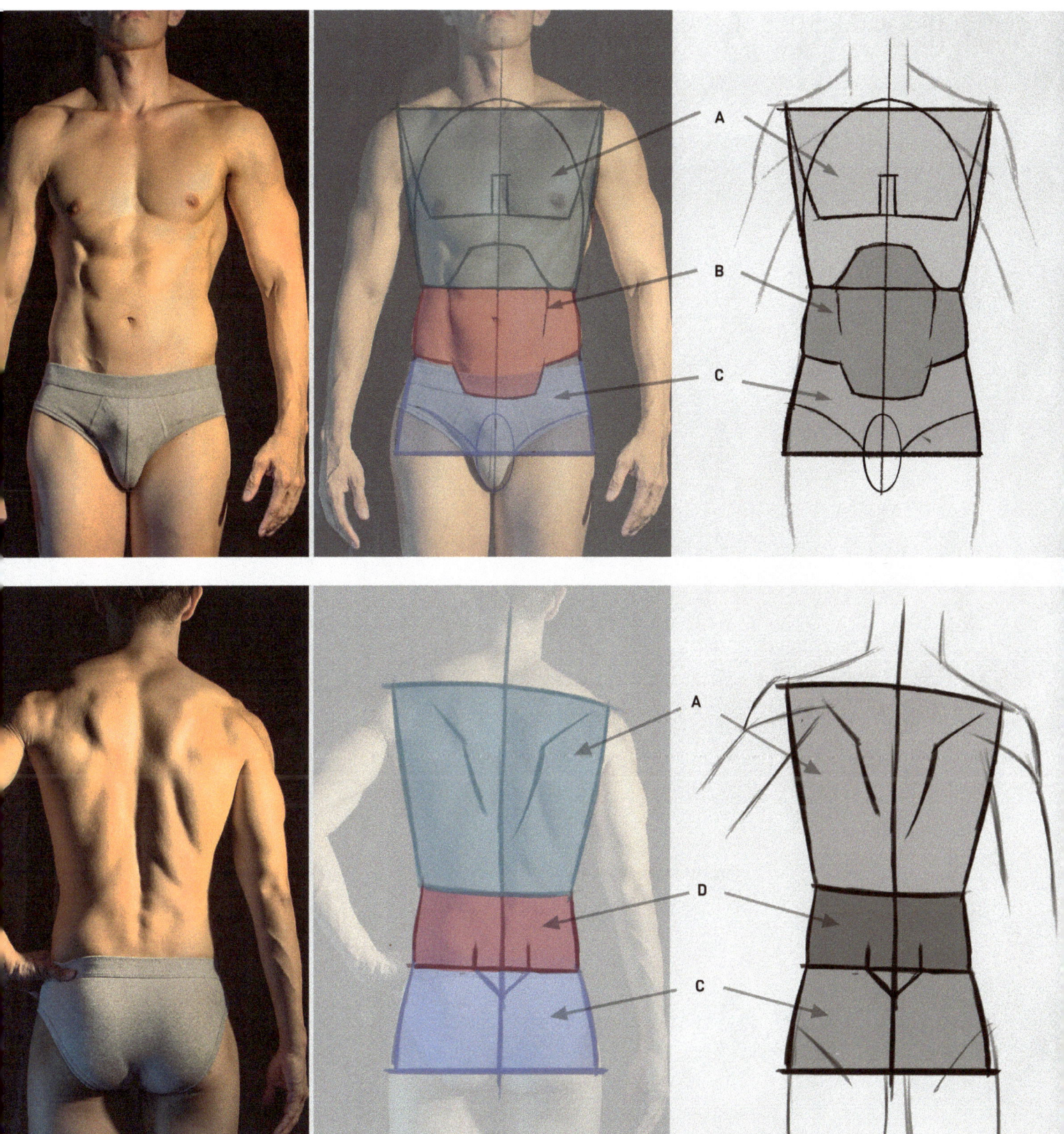

CHARACTERISTICS OF MALE AND FEMALE MODELS

The two main differences between the male and female body are the proportion of the bone structures and the genitals. In males, the upper torso will be much wider than the hips; in females, it is the exact opposite, with the hips being much wider. In a drawing, these inverse proportions can be quickly suggested with basic shapes. For the breasts and male genitals, a simple oval shape is enough to indicate them.

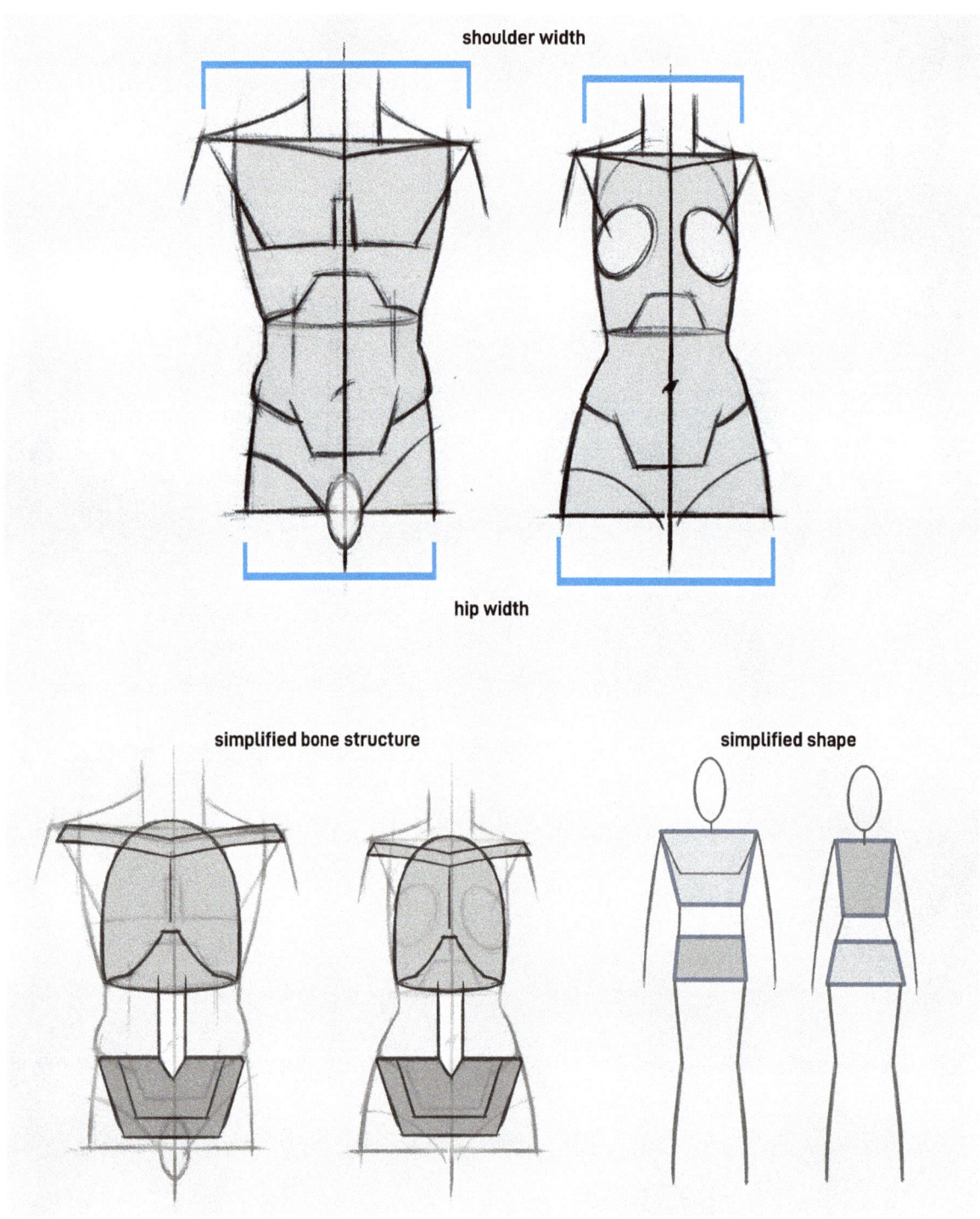

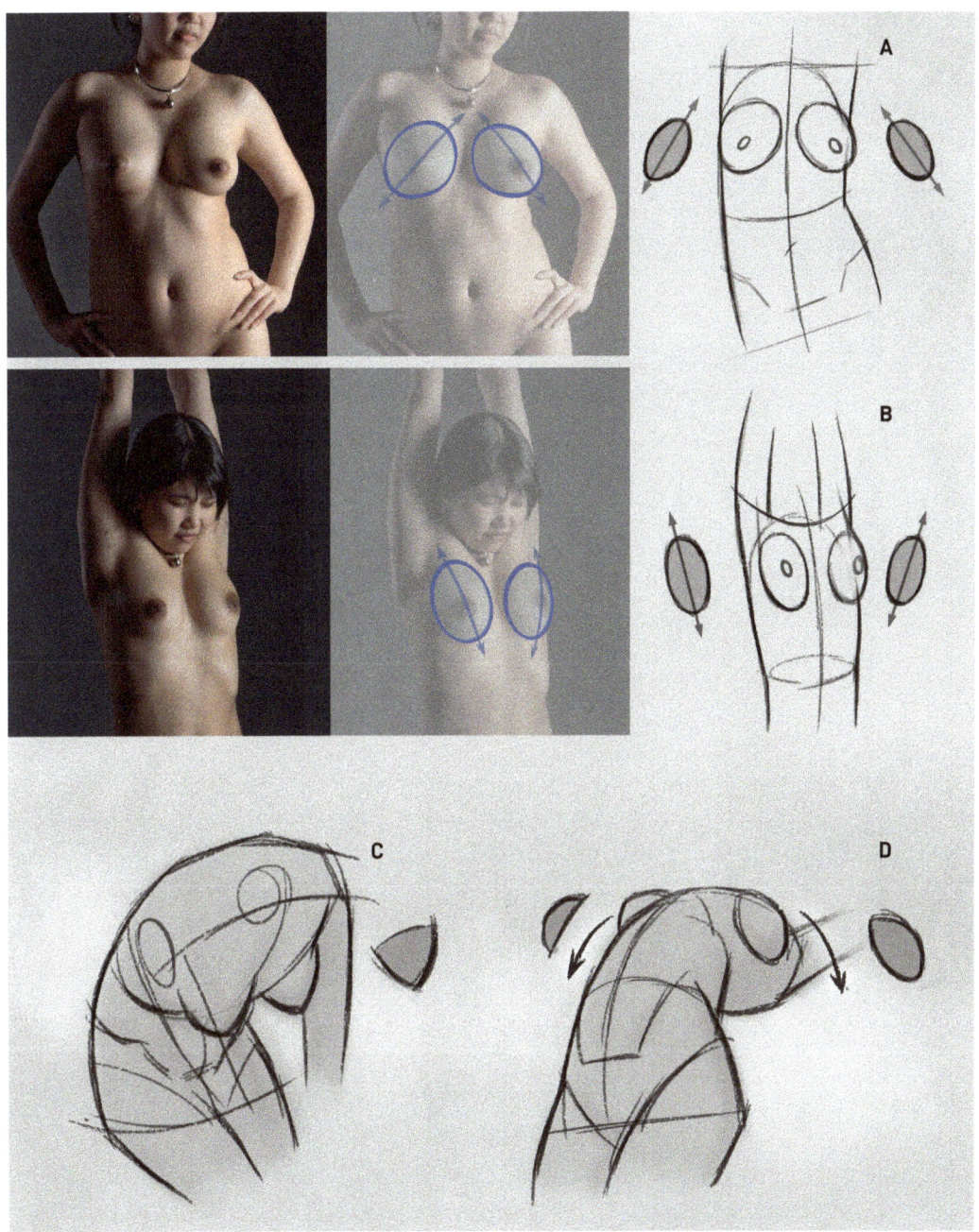

To block in the breasts, use a simple oval shape. In a neutral pose, the long axis generally angles down **(A)**. If the arms are raised, the angle reverses as the mass of the breasts rises with the arms **(B)**. If the pose is bending forward, the breast appears to have a more triangular shape **(C)**. If the model bends back or the torso is in a horizontal position, the mass of the breasts slightly moves to the side, which increases the distance, or gap, between them **(D)**.

These shapes work for indication. Every model is different and with more time in a pose, you want to eventually refine the shapes to match the model's individual shape and character.

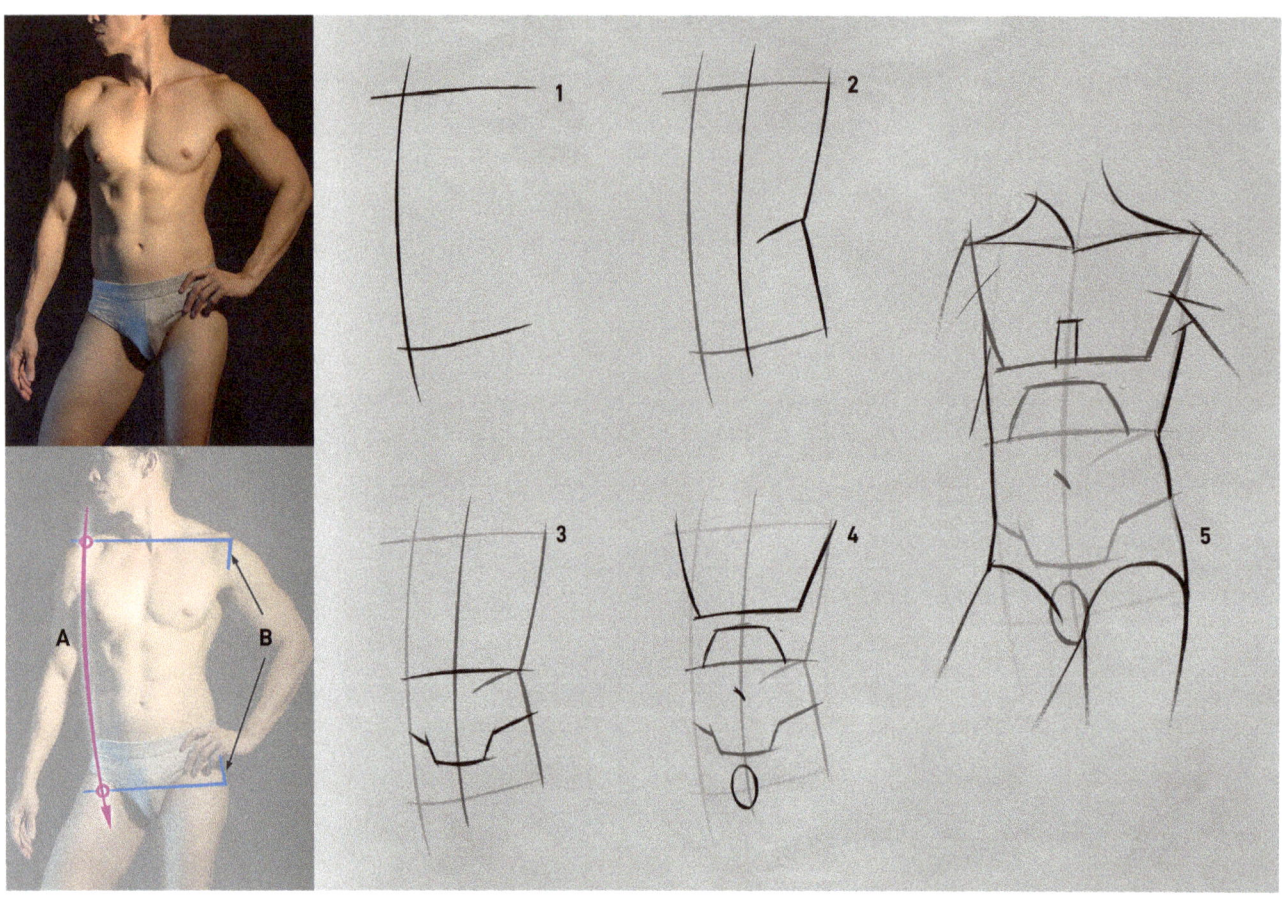

Example 1: Front View, Male

Observation Process
Before you begin, look for the gesture and action of the pose. In this example, the torso is slightly bending to the left, which creates an obvious stretch and pinch. The top of the left shoulder and bottom of the left hip are the points to look for and connect in the mind's eye to define the action or thrust of the pose **(A)**. The other important landmarks to identify are the shoulder line and the hip line, which give you the top and bottom of the torso **(B)**.

Drawing Process
The drawing begins with a long C-curve for the action line at the stretch side and then two lines to define the top and bottom of the torso form **(1)**. Next define the centerline and indicate the pinch, which begins to separate the top and bottom of the torso **(2)**. Define the three sections **(3)**. Begin to add detail and simplified anatomy **(4)**. With more time, add more detail and simplified anatomy. Also refine the contour and add any overlaps to help create structure **(5)**. At the this stage, the torso has a lot of information to help you proceed with the drawing by adding limbs, more details, or light and shadow.

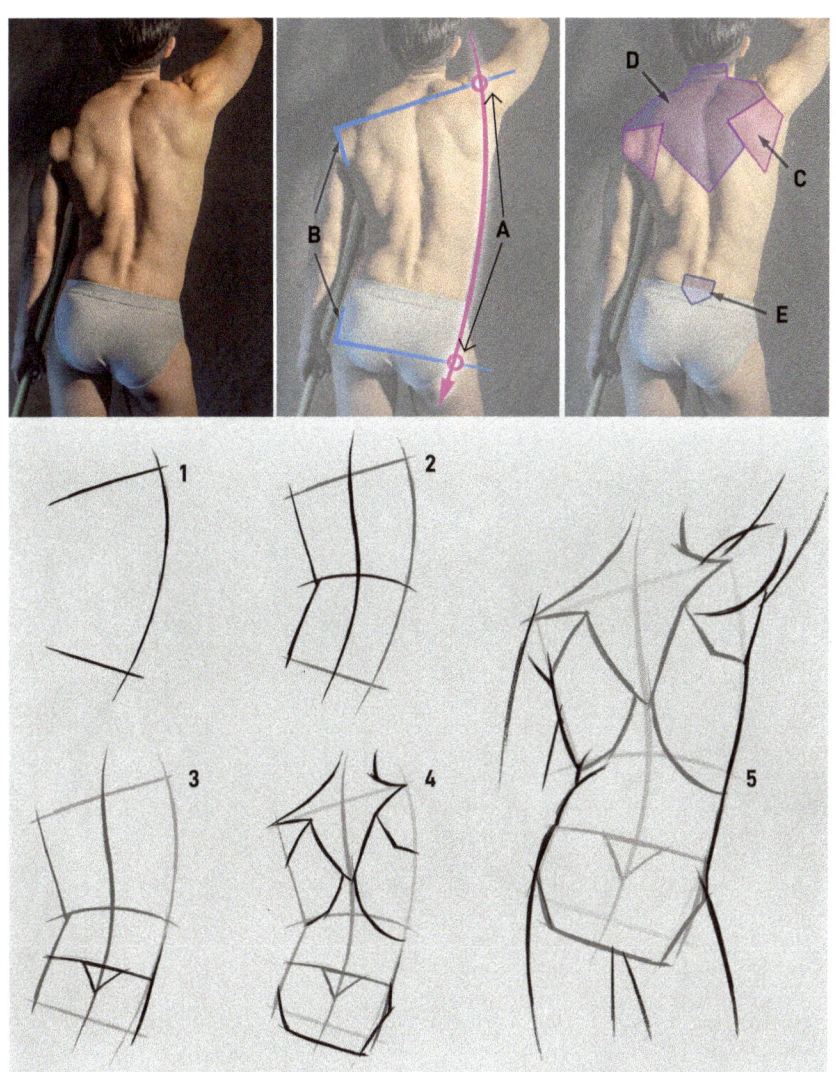

Example 2: Back View, Male

Observation Process
Like the front view, first look for the action and any helpful landmarks. The top of the right shoulder and bottom of the right hip help you identify the action line **(A)**. These points also help you identify the shoulder line and hip line **(B)**. The upper torso has a lot of complex anatomy. The first landmark to look for is the triangular-shaped scapula **(C)**. In this model, the large trapezius muscle **(D)** can be easily seen. In the lower back, look for the dimples at the side of the triangular-shaped sacrum **(E)**. Identifying these key landmarks will help as you draw and construct the torso.

Drawing Process
Start with the action line, shoulder line, and hip line **(1)**. Continue with simple marks to define the pinch and the right contour of the torso. An S-curve defines the centerline **(2)**. Next separate the three sections **(3)**. Simplify the complex anatomy of the back using basic shapes **(4)**. For example, triangle shapes can quickly describe the scapula and the trapezius muscle. If there is more time, continue to refine the shapes and the contour, and begin to draw the limbs **(5)** or add light and shadow.

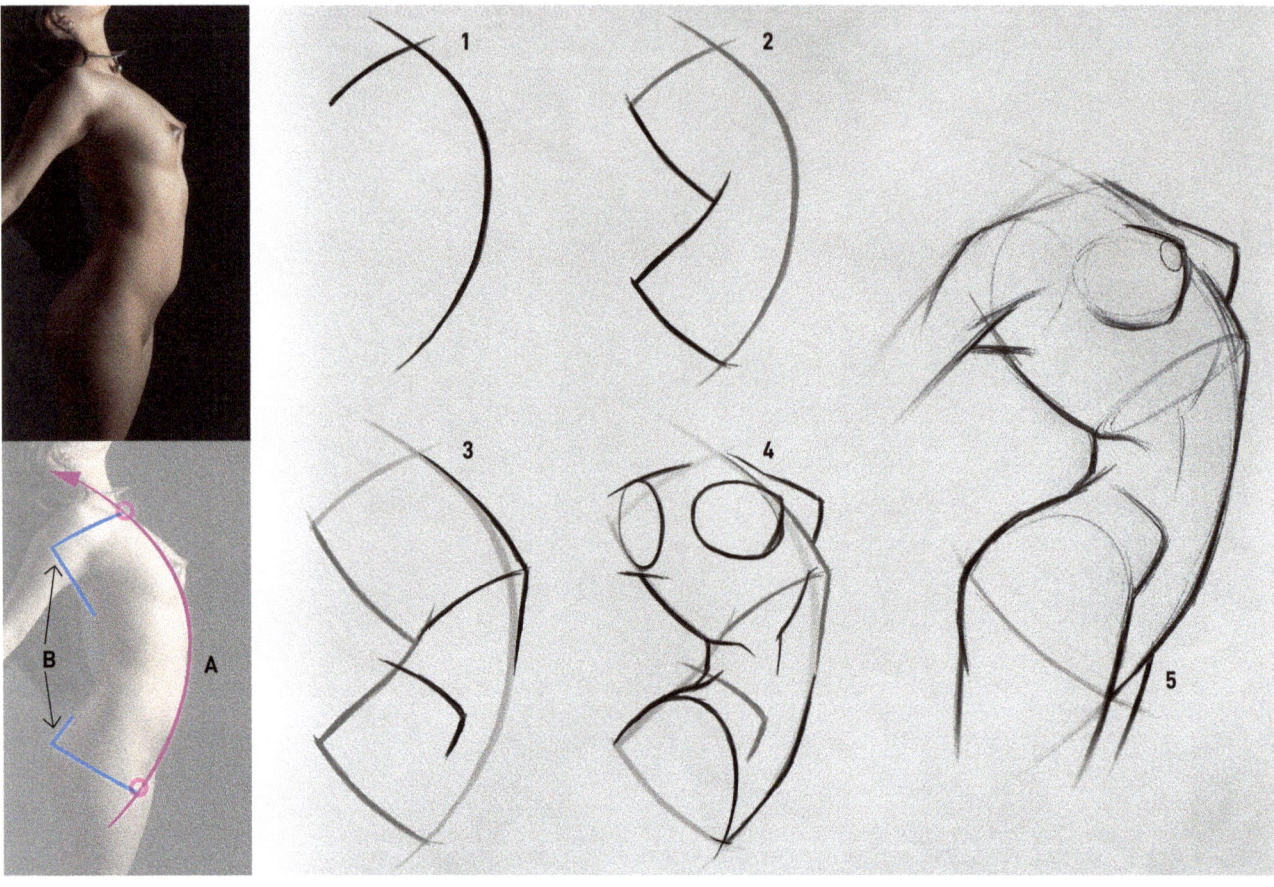

Example 3: Side View, Female

In a side view, many anatomical landmarks may be hidden. This means there is less information to draw and that it can be more difficult to get a clear read. Side views require more use of the anatomy to help describe forms. Along with the anatomy, you can use overlapping forms and overlaps as much as possible to help you get a stronger read.

Observation Process

In this pose, the action line is clear **(A)**, so you can use it to help locate the pit of the neck and the bottom of the crotch. These points will help you see the top of the shoulder and bottom of the hips **(B)**.

Drawing Process

A long C-curve defines the gesture, and then define the top of the torso at the shoulder line **(1)**. Close the torso form by defining the contour of the back and the pinch **(2)**. Next separate the three sections by indicating the rib cage and drawing a partial box-like shape to indicate the iliac crest, which separates the abdomen from the hips **(3)**. Next add simplified anatomy such as the pinching muscles, breasts, and the beginning of the shoulder joint **(4)**. With more time, you can either refine the drawing, add more anatomical details, draw the limbs, or start the shading process **(5)**.

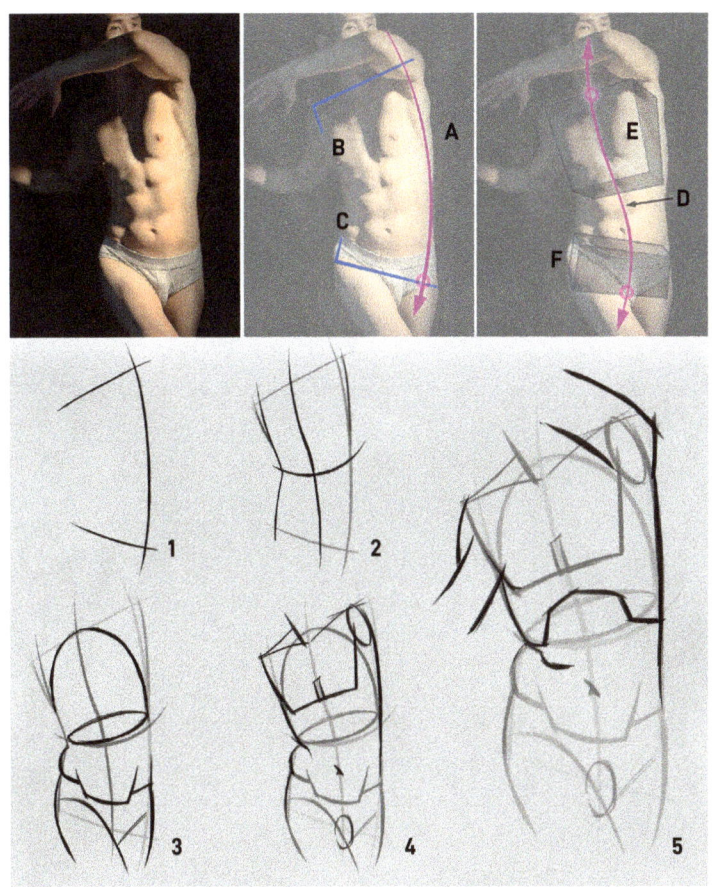

Example 4: Twist, Male

What makes a twisting pose unique is that the upper torso and hips turn or rotate in opposite directions. This causes the centerline to have an S-like curve and makes for a very dynamic and interesting pose.

Observation Process

In this twisting pose, look at the stretch side to see the action line **(A)**. The shoulder line **(B)** is clear, but to help yourself see the hip line **(C)**, follow the stretch side to the bottom of the groin and draw an imaginary line through the leg to the outer edge of the glutes. The centerline is an important part of a twisting pose, so look for it by drawing a line through the pit of the neck, navel, and groin **(D)**. Because the centerline marks the front of the upper body **(E)** and the front of the hips **(F)**, it defines the direction these structures are facing, which helps communicate a twisting action in the drawing.

Drawing Process

Start with the action and the top and bottom of the torso **(1)**. Next define the pinch, which separates the upper torso and the hips **(2)**. Separate the three sections by indicating the bottom of the ribs, the obliques, and the iliac crest, which defines the box-like shape of the hips **(3)**. Add simplified anatomy to help the torso read **(4)**. With time remaining, add more detail at the pinch and the contour, and then transition to the next stage **(5)**.

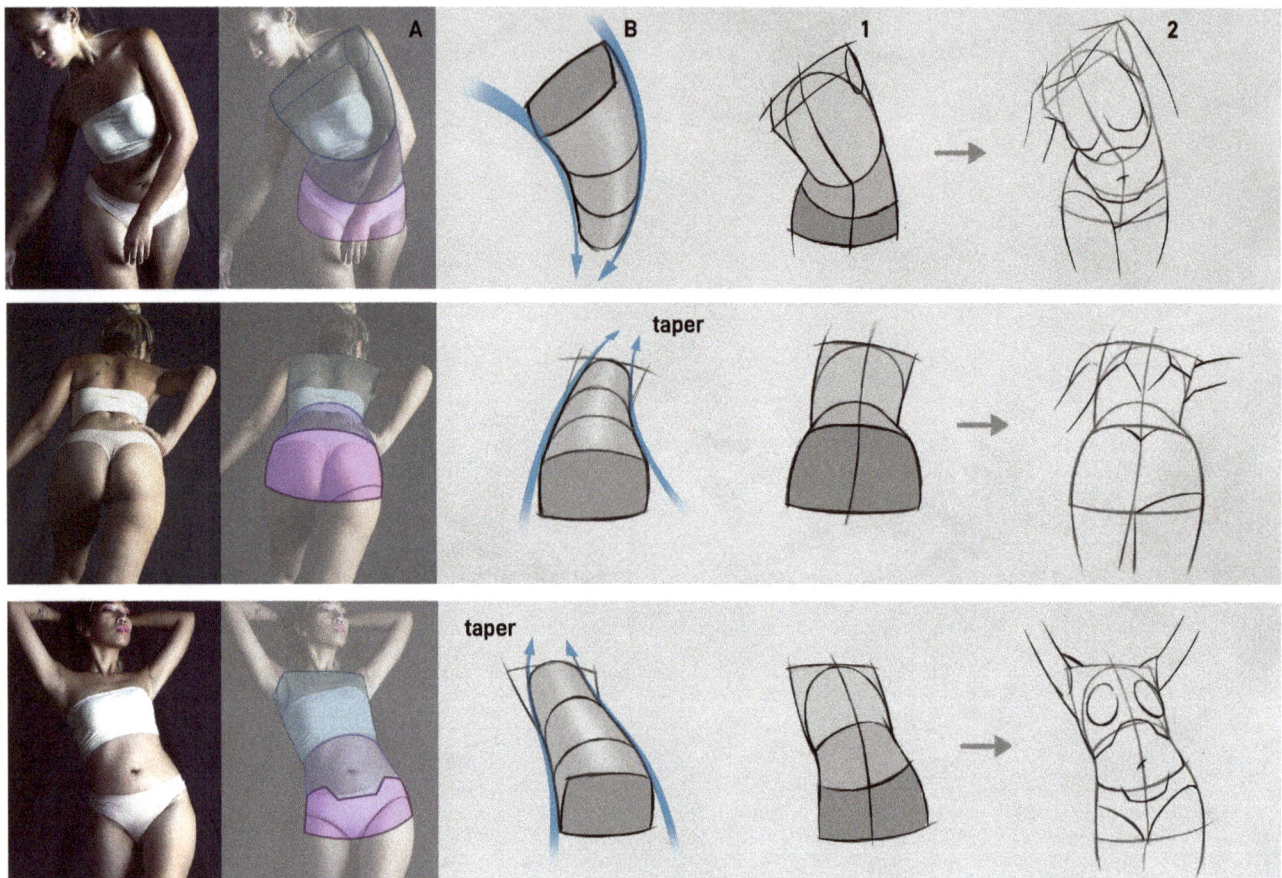

FORESHORTENED POSES

When the model bends forward or backward, the torso either comes toward you or moves away from you. To communicate this in your drawing, use the three sections and take advantage of their natural overlaps. Drawing in this way mimics the way the torso structures naturally overlap each other.

For example, if the figure bends forward, the rib cage will be in front of the abdomen and the abdomen will be in front of the hips. If the figure bends backward, the inverse is true and the hips will be in front. Each section will create overlaps, so take full advantage and emphasize the overlaps in your drawing.

Another tool to use when drawing a foreshortened form is tapering lines. Tapering means that the lines slightly converge, or come together, as the forms move away from the viewer. This helps suggest perspective and an imagined vanishing point. Whenever possible, try to exaggerate the tapering of forms to help emphasize the feeling of foreshortening.

To foreshorten the torso, look first for the three sections and how they overlap each other **(A)**. When you draw, make the forms taper as much as possible **(B)**. Start the drawing by drawing the sections and consciously try to emphasize as many overlaps as possible **(1)**. Once the sections and foreshortening are reading well, continue to further develop the torso **(2)**.

TORSO AND FORM STUDIES

During a life drawing session, I often isolate and draw only the torso, or any other limb or structure that interests me. Torso, form, and limb studies allow the artist more time to study and practice complex aspects of figure drawing such as anatomy and shading. I encourage anyone who is new to figure drawing to do many torso studies along with drawing the full figure. See opposite page for an example of five-minute torso and form studies.

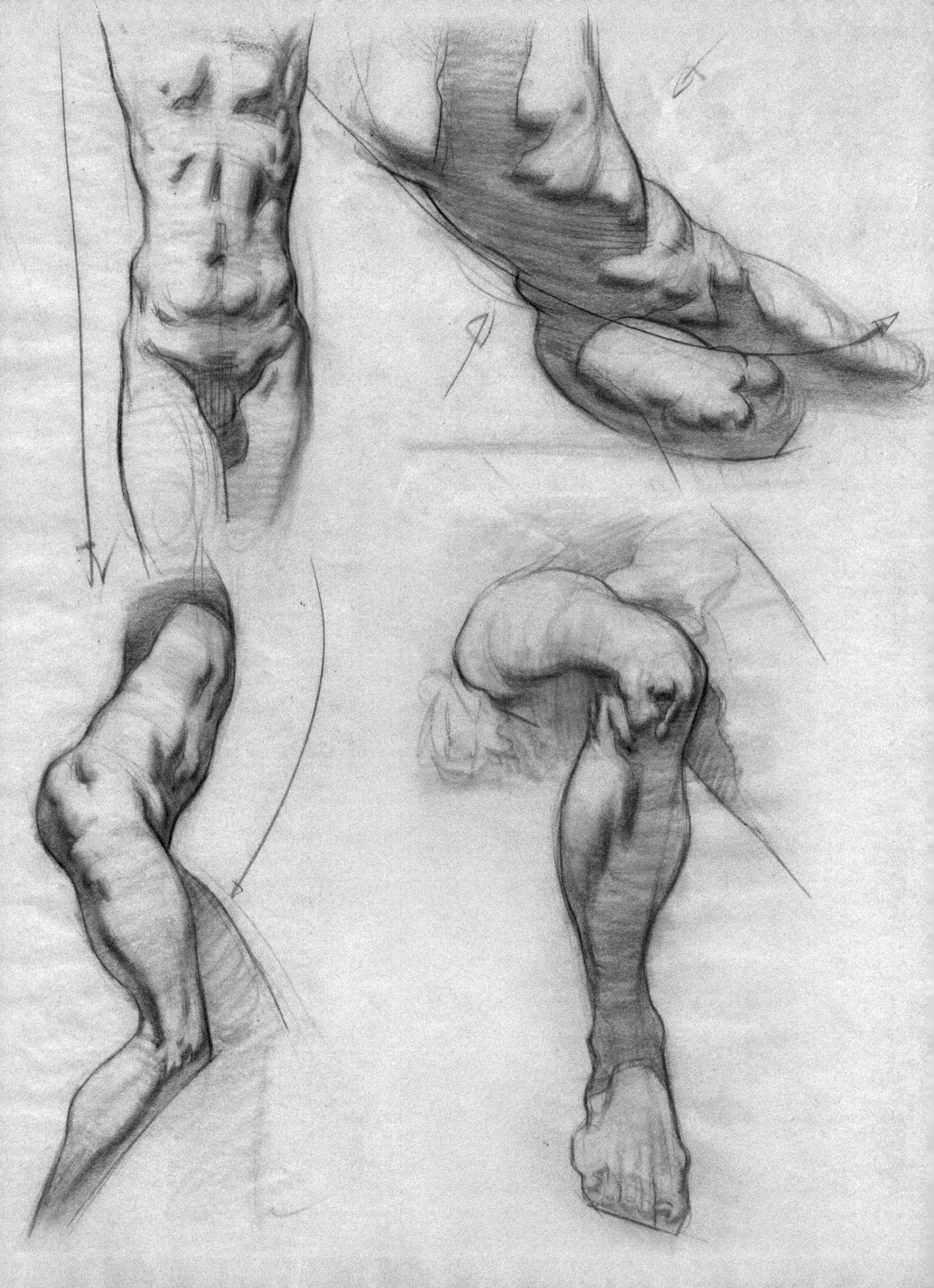

How to Draw One- and Two-Minute Poses

Now that you know how to start a drawing with the head and torso, you can draw the full figure. Life drawing sessions generally start with very short poses. They can be as quick as thirty seconds, but one- and two-minute poses are more common practice. These are sometimes called "gesture poses" because that is the main focus.

One- and two-minute poses are great ways to start a drawing session because they allow you to warm up your hand and mind. The poses are so fast, there is little time to add details or complexity. In addition, they provide many poses to draw and many opportunities to practice, experiment, and make mistakes. Having an abundance of opportunities frees the mind from the pressure of being perfect or "getting it right" or finishing a drawing.

That's very important to remember at any stage of the drawing. The goal is not to finish a drawing.

One minute is not enough time, and neither is ten or twenty minutes. The goals are to:

1. Communicate the action of the pose
"What is the model doing?" is the question I always ask when I draw gesture poses, and I want my drawing to clearly communicate and answer this question.

2. Indicate enough information to progress to the next stage
For one- and two-minute poses, the next stage would be construction, 3-D forms, and simplified anatomy.

A page of one-minute poses from life.
Ballpoint pen on toned paper.

TIPS AND BEST PRACTICES

Tip 1: Exaggerate the Gesture
Gesture adds movement and life. The more you exaggerate the gesture, the more dynamic the pose will be. Over time, as you add detail and anatomy and complexity, the pose will get stiff. So the gesture must be as dynamic as possible from the beginning. Short poses are the best opportunity to practice exaggeration.

Tip 2: Draw with Long, Fluid Lines
Make all lines as long as possible. To help accomplish this, look at the extremities, the outer points, and try to draw the lines from one end of the figure to another. For example, I draw the extended arm to the feet, or the top of the head to the toes. I also look for and use rhythms to connect landmarks and elongate my gesture lines.

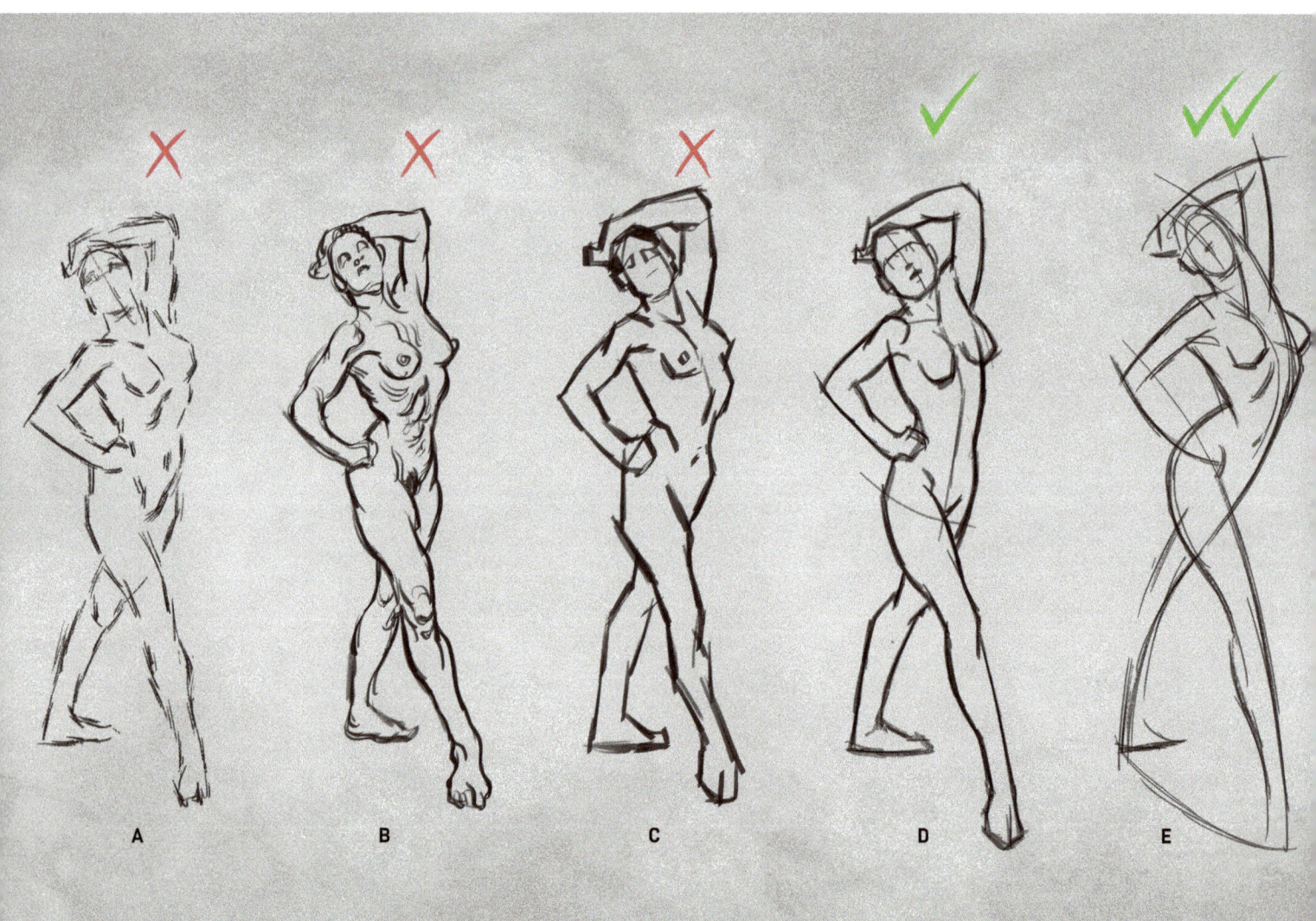

A B C D E

Tip 3: Draw with the Whole Body and Arm

This may seem strange if you are new to gesture drawing and drawing with long lines. As most drawing (and writing) is done with the hand and wrist, it becomes habitual to draw short, choppy strokes. To get the most movement and gesture in your drawing, move your whole body when you make gesture lines. The drawing will feel much more alive when the lines have more life in them.

See diagram shown opposite for an example of these best practices.

(A) Drawing with only the wrist produces short, choppy, and sketchy strokes.

(B) Focusing too much on the anatomy and details, all the subtle curves and bumps, makes the drawing feel lumpy and stiff.

(C) Drawing with short strokes and too many straight lines makes the drawing very stiff. Straight lines can be used, but they must be well balanced with curves.

(D) This drawing is on the right track. There are smooth curves, not too much detail, and a nice balance of marks. The only thing that would make the drawing better is exaggeration.

(E) The curves are long and fluid in this drawing. There are very few breaks or bumps in the contour, if any at all. The anatomy and forms are simplified but still read well. Most important of all, the gesture and action are exaggerated. Look how the chest and ribs are pushed forward, the is hip pushed out, and the angle of the pinch side is more dramatic.

This is not the only way, or the right way, to draw a gesture pose, but these best practices will definitely help make the drawing much more dynamic. Starting a figure drawing with good gesture and good marks builds a good foundation for the rest of the drawing.

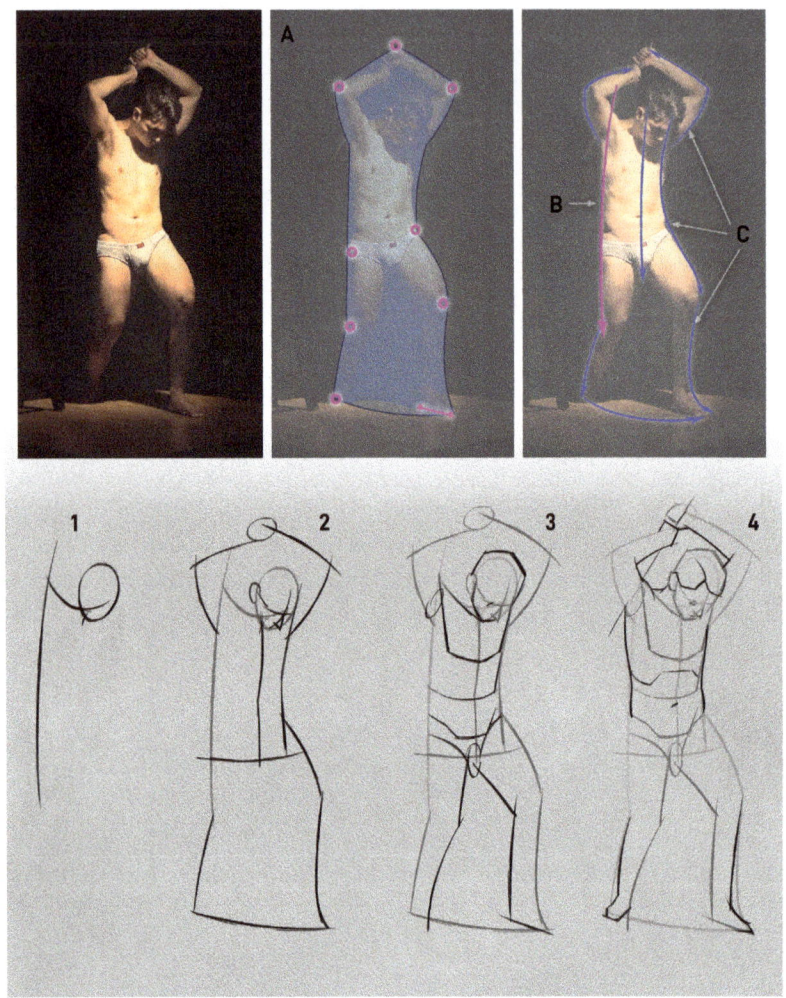

Example 1: Front View, Male

Observation Process

The first thing I notice is the dramatic action of the pose and the interesting silhouette. To identify the silhouette, I look at the outer points of the top hand, elbows, hips, knees, and feet **(A)**. The gesture runs along the stretch side of the pose **(B)**. Following the contour from one landmark and outer point to the other creates opportunities for rhythm and movement **(C)**.

Drawing Process

1. Begin by defining the action line and indicating the head shape and then the shoulder line.

2. Close the torso with the hip line and then add the centerline. Follow the outer contour, which defines the gesture of the limbs and the outer silhouette. Start to indicate the head to define the gaze.

3. Separate the sections of the torso and add simplified anatomy. Refine the head shape and then block in the shape and gesture of the limbs.

4. Block in the arms and simplified hand shapes. Refine the contour of the torso as well as the shape of the lower legs and feet.

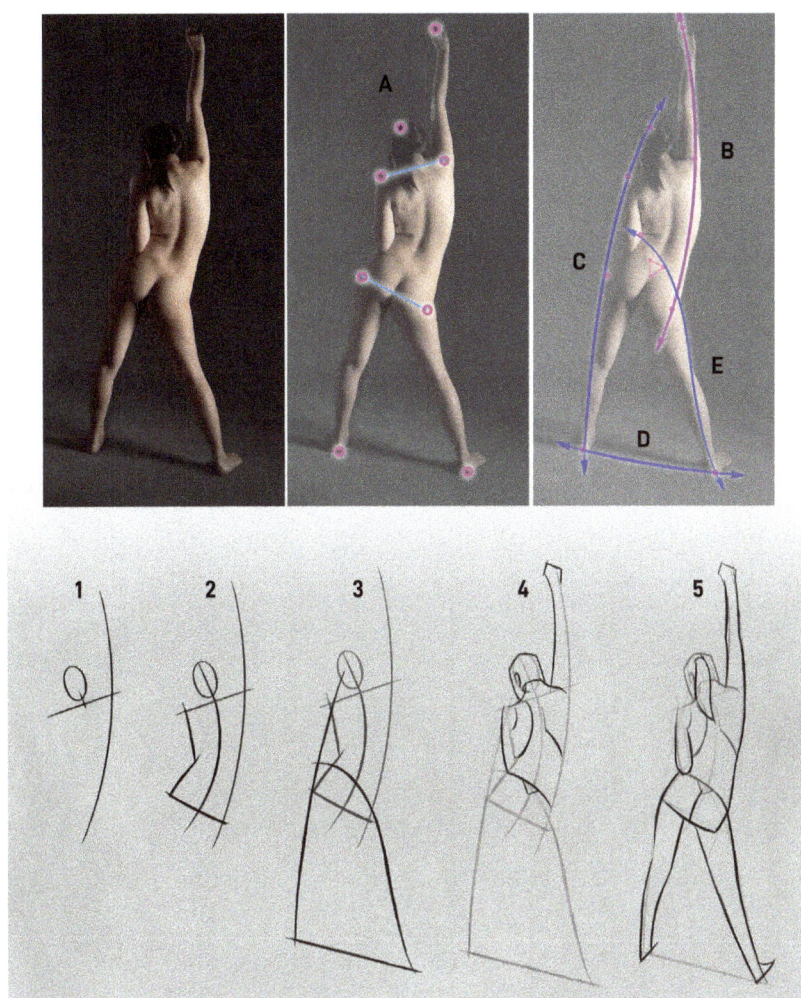

Example 2: Back Pose, Female

Observation Process

In this pose, the first landmarks to notice are the outer extremities. They are the hand, head, left hip, and heels of the feet. Also look for the shoulder and hip lines **(A)**. Identifying landmarks helps you see the action line **(B)** and the many possibilities for gesture and rhythms. In addition to the action line, the longest gestures lines are at the left outer edge **(C)**, the ground plane **(D)**, and the rhythm the runs through the right leg and hips **(E)**.

Drawing Process

1. Establish the action, indicate the head, and define the shoulder line.

2. Close the shape of the torso at the hips, define the pinch side, and define the centerline.

3. Use long gesture lines to establish the outer edge and gesture of the legs.

4. Add simplified anatomy of the upper back, separate the hips, and indicate the shapes of the head, arms, and hand.

5. Define the glutes and hips. Draw the limbs as long, tapering rectangles by following the contours of the limbs with long, tapering lines, closing the shapes at the bottom of the feet and hand.

Example 3: Side Pose, Female

Observation Process

The first thing I notice about this pose is the dynamic action of the arms and of the body. The action line runs along the front of the torso but can also be extended from the head to the right foot **(A)**. The other landmarks I look for are the hip and shoulder lines **(B)**, which gives me the top and bottom of the torso.

Drawing Process

1. Begin by defining the action line and draw the curve as long, fluid, and continuous as possible. Indicate the head and define the shoulder line.

2. Close the torso shape by defining the pinch side and the bottom of the hips. Then define the gesture of the front leg and relate the front foot to the back to establish a ground plane.

3. Indicate the facial features and describe the gesture and shape of the limbs. Add simplified shapes for the breasts and hands.

4. With the time remaining, continue to indicate the head with a simplified hair shape. Refine the shape of the contour, starting with the torso and then the legs and feet.

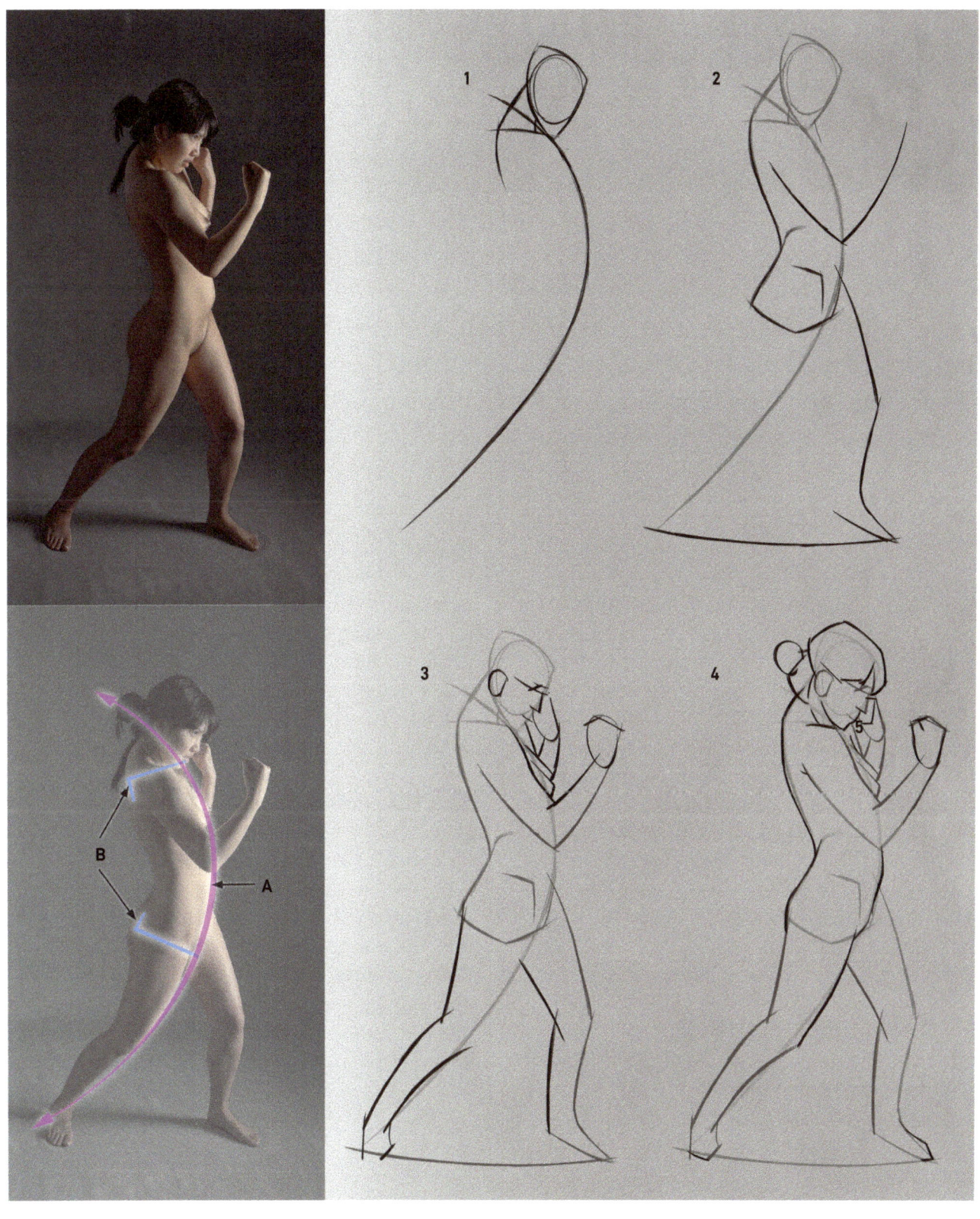

How to Draw Three- and Five-Minute Poses

After gesture poses, the next set of poses will be three or five minutes each. Five-minutes poses, or "5s," are my personal favorite because they give me just enough time to add structure, construction, and even start the shading process, but they're not long enough to add too much detail or "finish." This balance between time and time limitation keeps my drawing feeling fresh and spontaneous and makes the drawing process fun.

WHAT TO FOCUS ON

For five-minute poses, the primary goal is still the same: communicate the action of the pose and define enough information to progress to the next stage of the drawing process. This means you develop the lay-in by turning your marks and 2-D shapes into 3-D forms and volumes by adding structure lines, corners, and cross sections where needed to make the forms feel more solid and volumetric. You can also add anatomical detail as needed to help get a better read. If the pose is relatively simple and there's not too much information to define, you'll likely have enough time to start the shading process by defining the shadow shape and blocking in simplified values.

TIPS AND BEST PRACTICES

Tip 1: Learning How to Edit

Five-minute poses are the best time to practice the skill of editing. Editing means you don't attempt to draw everything you see. Instead you only draw what is essential to communicate the pose and get the read. Because the time is so short, it's impossible to draw or define every single detail you see. Instead of rushing to finish and obsessing over every little detail, use the limited to time to think and make good decisions about what to draw and what to leave out. This means if a piece of anatomy or detail is not essential to getting a good read, leave it out.

Tip 2: Don't Rush

Even though three or five minutes is not a lot of time, don't rush the drawing. Most beginners want to rush to get to the next stage, or finish the drawing. With a three- or five-minute pose there is a temptation to rush to the shading. When you slow down and take the time to think and make good decisions, the more effective and efficient your marks, shapes, and details become. Being more efficient is what makes you draw faster, and of course, makes the quality of the drawing better.

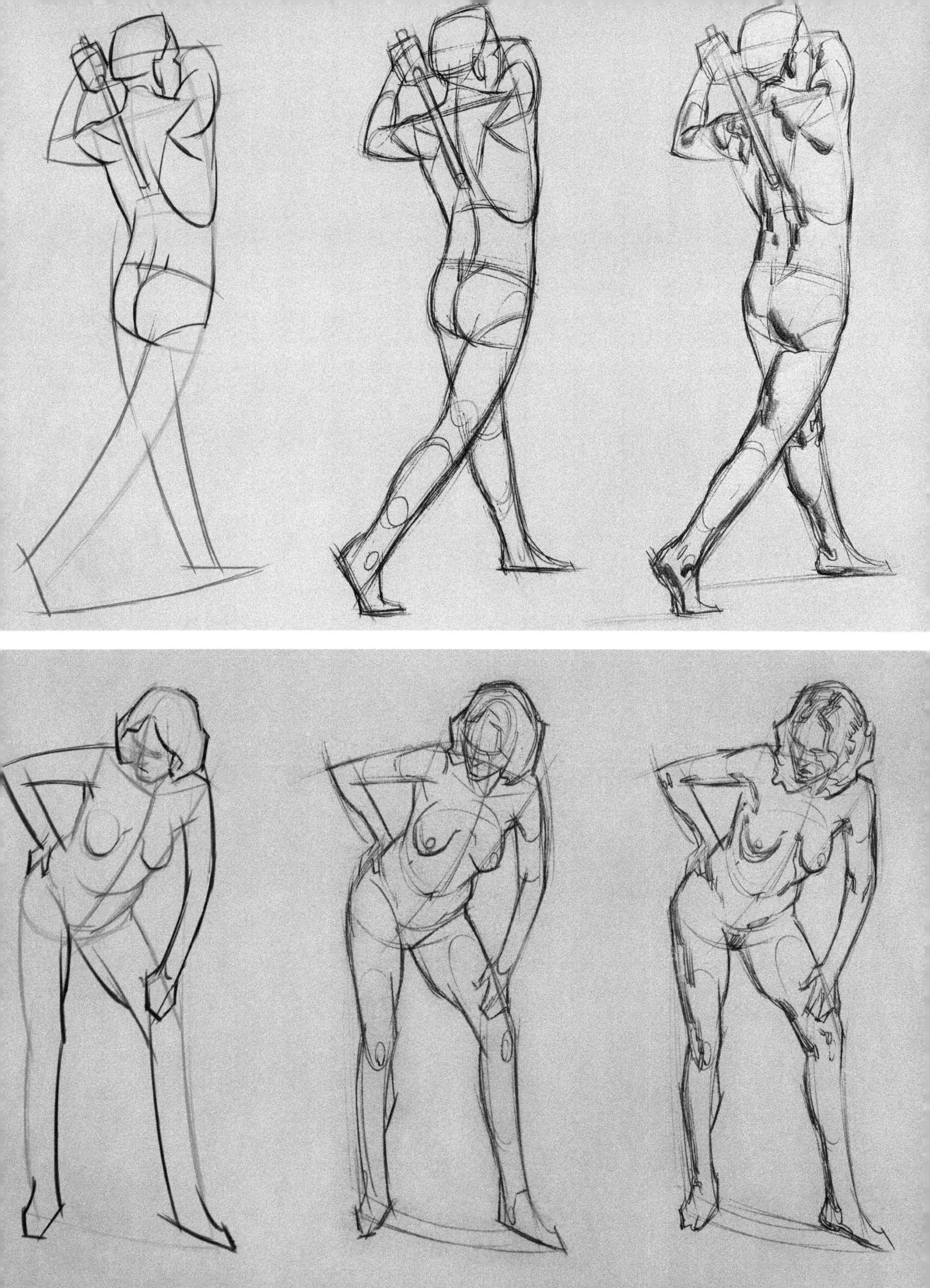

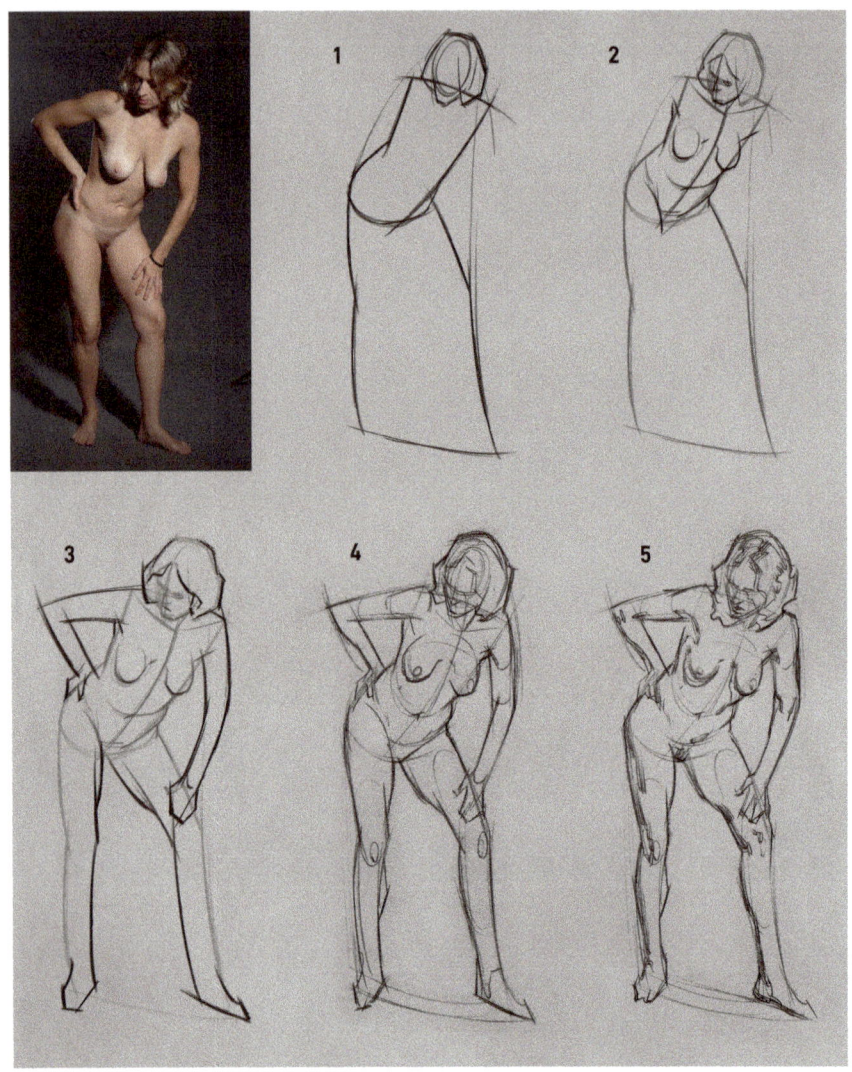

Example 1: Front View, Female

Drawing Process

1. Begin by defining the action of the pose, indicating the head, defining the shape of the torso and the outer contour and gesture of the legs.

2. Because the torso is foreshortened, separate the sections and use overlaps. Also indicate the facial features.

3. Define the limbs with long gesture lines and 2-D shapes.

4. Add mass and volume to the cylinders of the arms and legs with cross sections and compound forms.

5. With the time remaining, start the shading process by first defining the shape of the shadow.

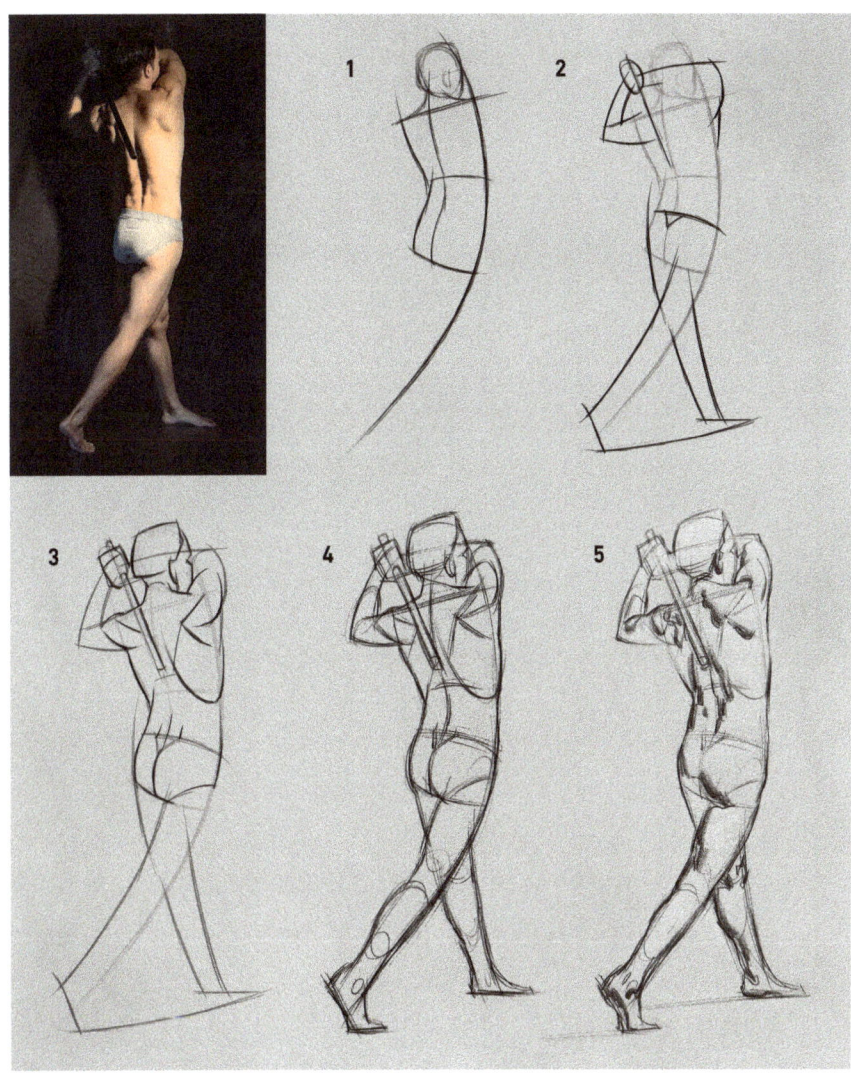

Example 2: Back Pose, Male

Drawing Process

1. Start with the gesture and action of the pose. Then relate and connect the outer points with long gesture lines.

2. Separate the sections of the torso to create overlaps and then limbs with long curves and 2-D shapes.

3. Begin constructing the cylinders of the upper back and the limbs.

4. Draw more construction, cross sections, and compound forms to add mass to the limbs.

5. Begin the shading process by defining the shadow shapes.

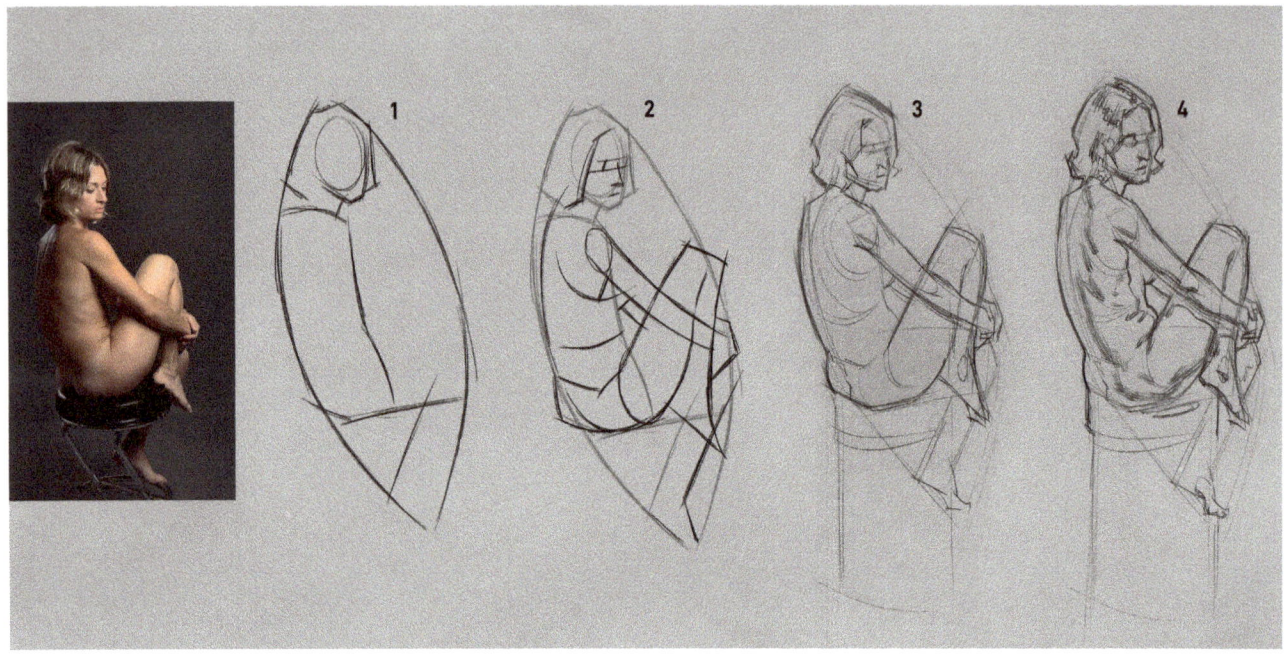

Example 3: Seated Side Pose, Female

Drawing Process

1. Define the action of the pose, indicate the head, define the torso shape, and connect the outer points using long curved lines.

2. Separate the torso sections, define the limbs with gesture lines and 2-D shapes, and indicate the facial features.

3. Construct the figure by using corners and cross sections and adding simplified anatomy.

4. Begin the shading process by defining the shadow shapes.

Take Your Time

With enough practice and experience, a five-minute pose can start to feel like a lot of time. If you make good decisions and become skilled at editing information, you can get a clear and strong read with very few marks and shapes. If you are new to figure drawing, don't set too many expectations at the beginning. If it takes the full five minutes to clearly define the torso, that's okay. If it takes five minutes to get the gesture and structure of the legs to look right, that's okay too. It's not a race. The best use of the time is to slow down, observe, and practice the drawing process. The set of five-minute sketches from life below is an example of making good decisions and efficient marks and carefully following the process. In these five-minute sketches, I was even able to add shadow tones and highlights, which I will demonstrate next with ten-minute poses.

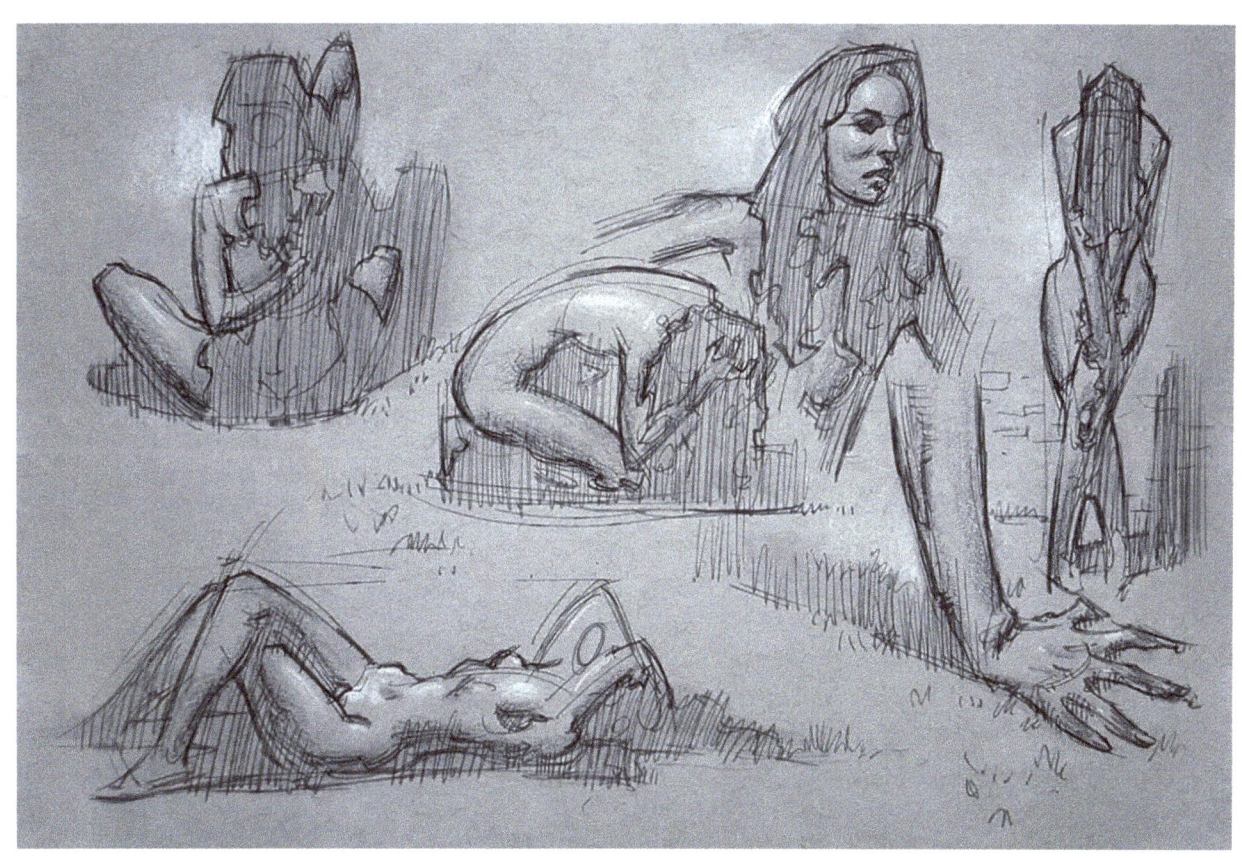

How to Draw Ten-Minute Poses

I like ten-minute poses because I have a little more time to refine my lay-in and I get a chance to practice the beginning stages of the shading process. Generally by the first ten-minute pose in the session, I'm warmed up, feeling loose, and in a good drawing rhythm.

The process, goals, and expectations are the same as for a five-minute pose. With a ten-minute pose, you can be more careful with the lay-in. Take the time to correct proportions, angles, shapes, and the contour. Sometimes, if the pose is complex, I will spend the entire ten minutes with a lay-in and not start shading at all.

That is okay. If the pose is less complex, you may have more time to develop the shading. Life drawing is not a race and the goal is not to finish. So don't rush to the shading. Instead use the time to practice the process and make the drawing feel complete, no matter what stage you are at.

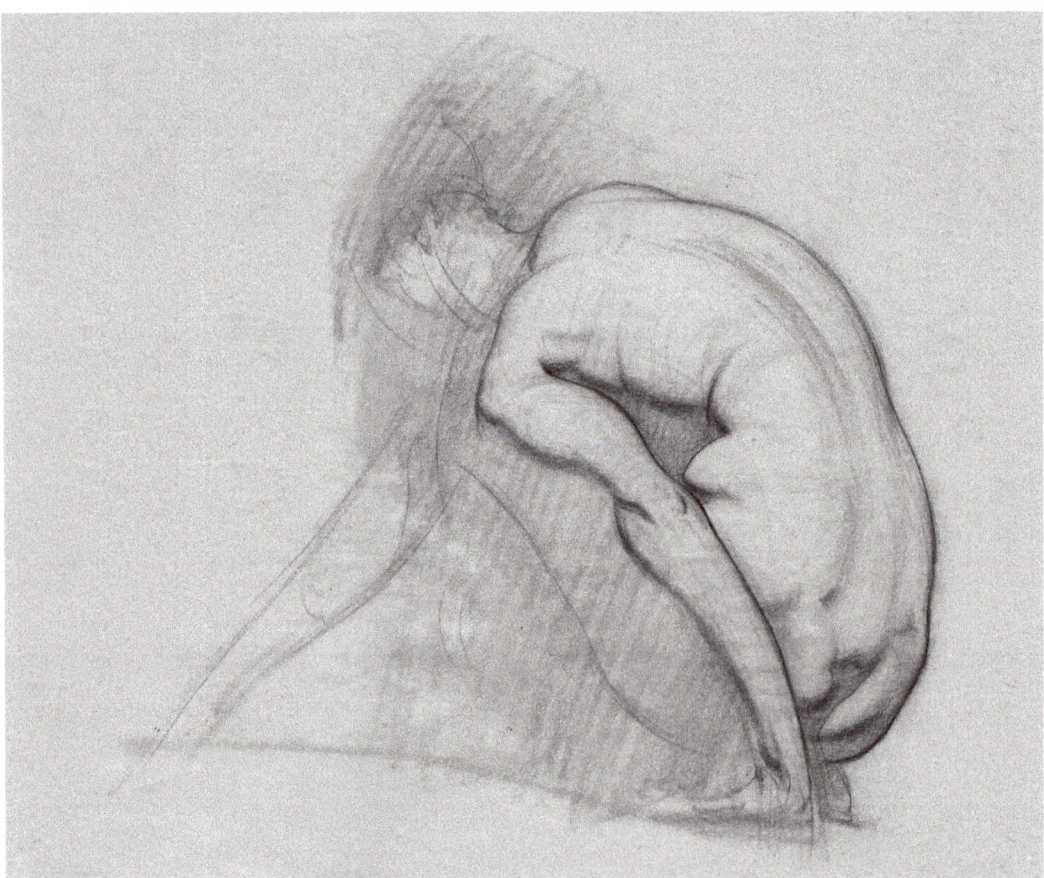

This is a ten-minute pose from life. Pastel pencil on newsprint. This is an example where the pose was relatively simple so I had time to add shading and tones. With the limited time, I decided to prioritize the forms of the back.

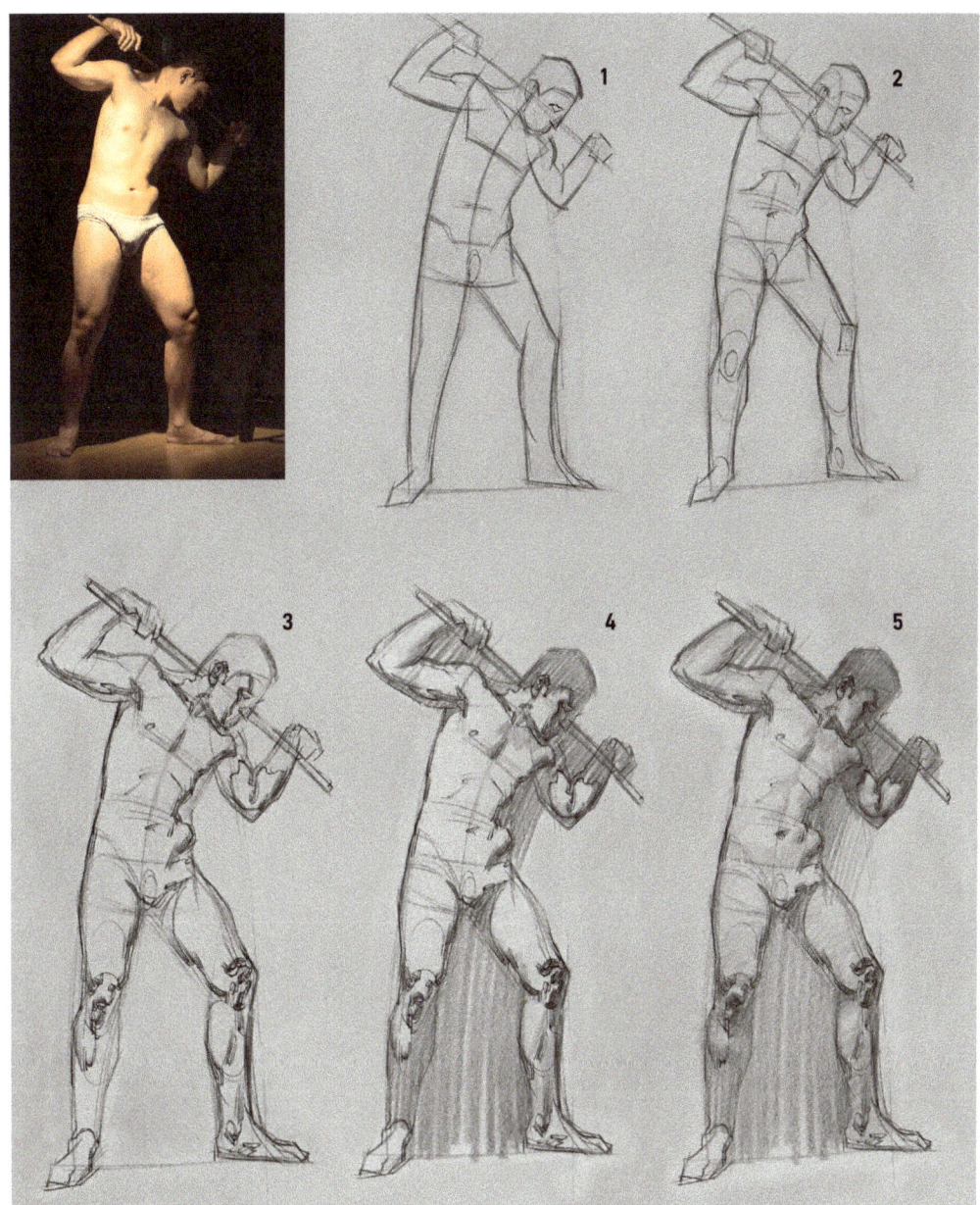

Example 1: Front View with Interesting Shadow Shapes, Male

Observation Notes

These type of poses are my favorite to draw. The pose is intruiging and the light is dramatic, producing clear shadows with very interesting shapes. There is also a nice balance of light and dark shapes. The face is hidden, but there is still a lot of anatomy to see and draw. With only ten minutes, focus on the shadow shapes, especially at the core shadow, and practice communicating form with clear shapes and limited values.

Drawing Process

1. Begin the lay-in with gesture and 2-D shapes.

2. Finish the lay-in by constructing with 3-D forms and adding cross sections, corners, and simplified anatomy.

3. Define the shadow shapes.

4. Fill the shadow shapes with a medium dark tone, which establishes a clear two-value pattern.

5. With the time remaining, add halftones and start to refine edges.

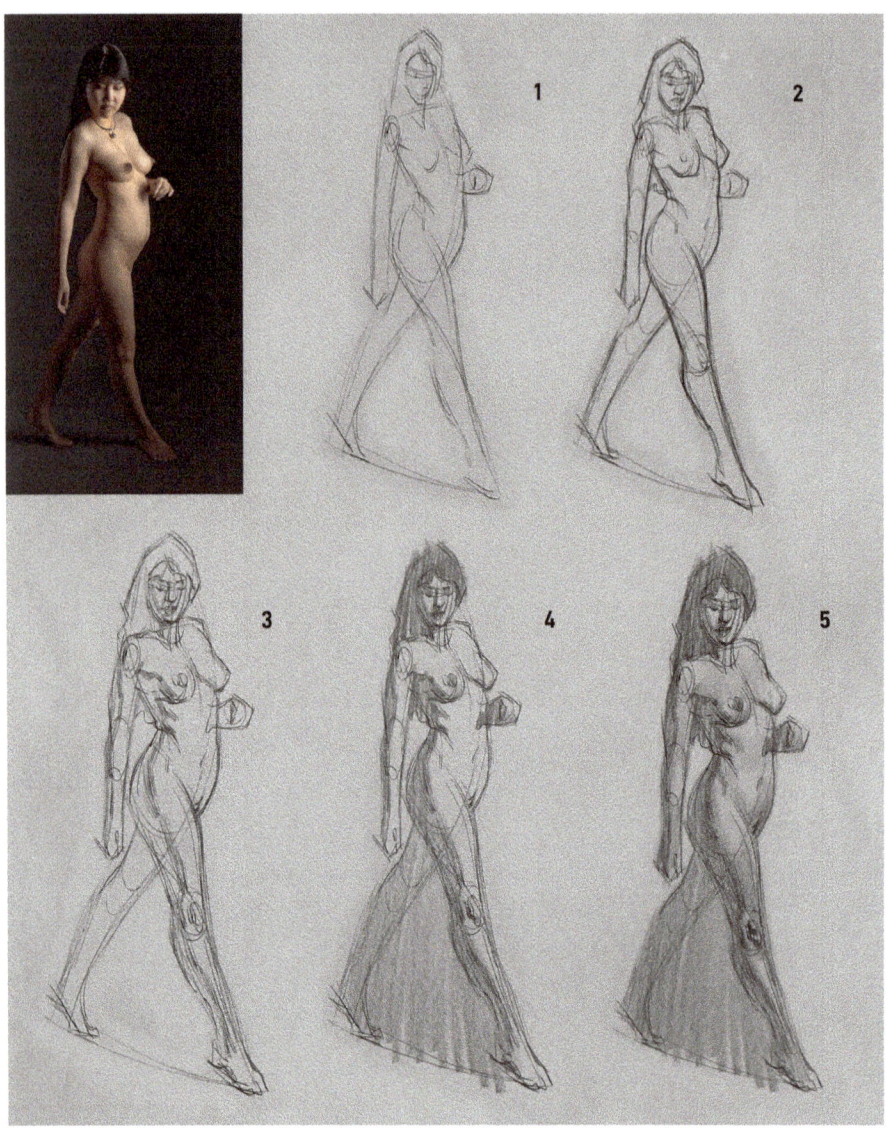

Example 2: Side View, Female

Observation Notes

The first thing I notice about this pose is the beautiful gesture and movement. The action line is a lovely S-curve that runs from the head all the way to the left toe. Because the face and both hands are visible, you will need to spend more time on the lay-in. Also, because the model is a young female, you need to be more mindful of the core shadow edge.

Drawing Process

1. For the initial 2-D lay-in, emphasize long curves and especially exaggerate the beautiful S-curve action line that runs from head to toe.

2. Complete the lay-in by constructing the limbs with cross sections. Add anatomical detail and simplified facial features, and refine the contour.

3. Define the shadow shapes.

4. Mass in the shadow with a medium dark tone and create a clear two-value pattern of light and dark.

5. With the time remaining, start to add half-tones and soften the core shadow areas.

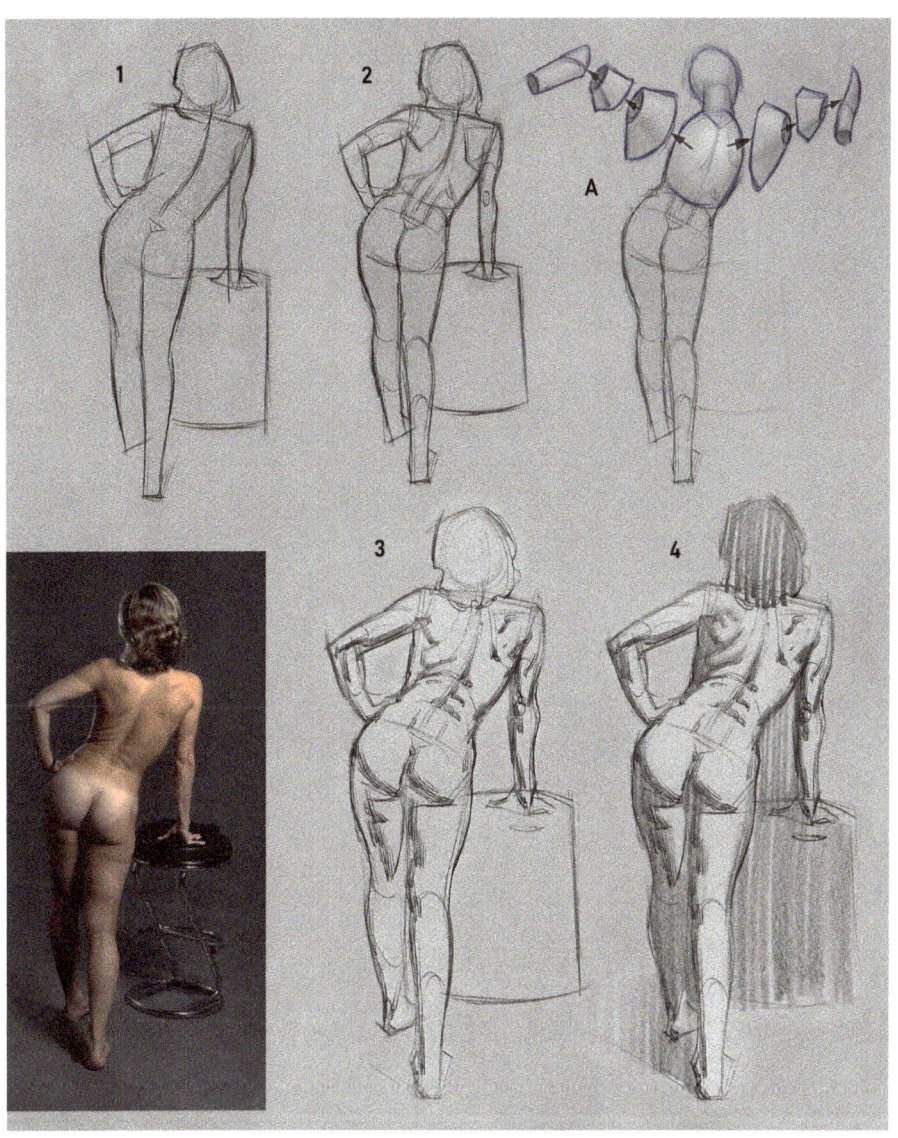

Example 3: Back View, Female

Observation Notes
The first thing I notice in this pose is the anatomy of the back and arms. There are so many interesting shapes that I decide to focus on the anatomy as much as I can in the ten minutes. For the anatomy to read clearly and be in the right place, you need to refine the proportions as much possible. This means the lay-in drawing and defining the initial shadow shapes will take up most of the time.

Drawing Process
1. Use 2-D shapes and curves to define the action of the pose and the limbs. The shapes are mostly simple rectangles, so much of the work will be done with 3-D forms and construction.

2. Add cross sections and structure to turn the torso, arms, and legs into cylinders. Also use cylinder construction to indicate the scapula and upper back muscles **(A)**. Clearly separate the torso sections to create overlaps.

3. Carefully define the shadow shapes, making sure each shape and core shadow also define a piece of anatomy.

4. With the time remaining, fill the shadow shapes with a medium dark tone to create the initial two-value system.

How to Draw Twenty-Minute Poses

The last set of poses in a life drawing session will be twenty- or twenty-five-minute poses. In a typical two- or three-hour session, the last two or three poses will be "20s."

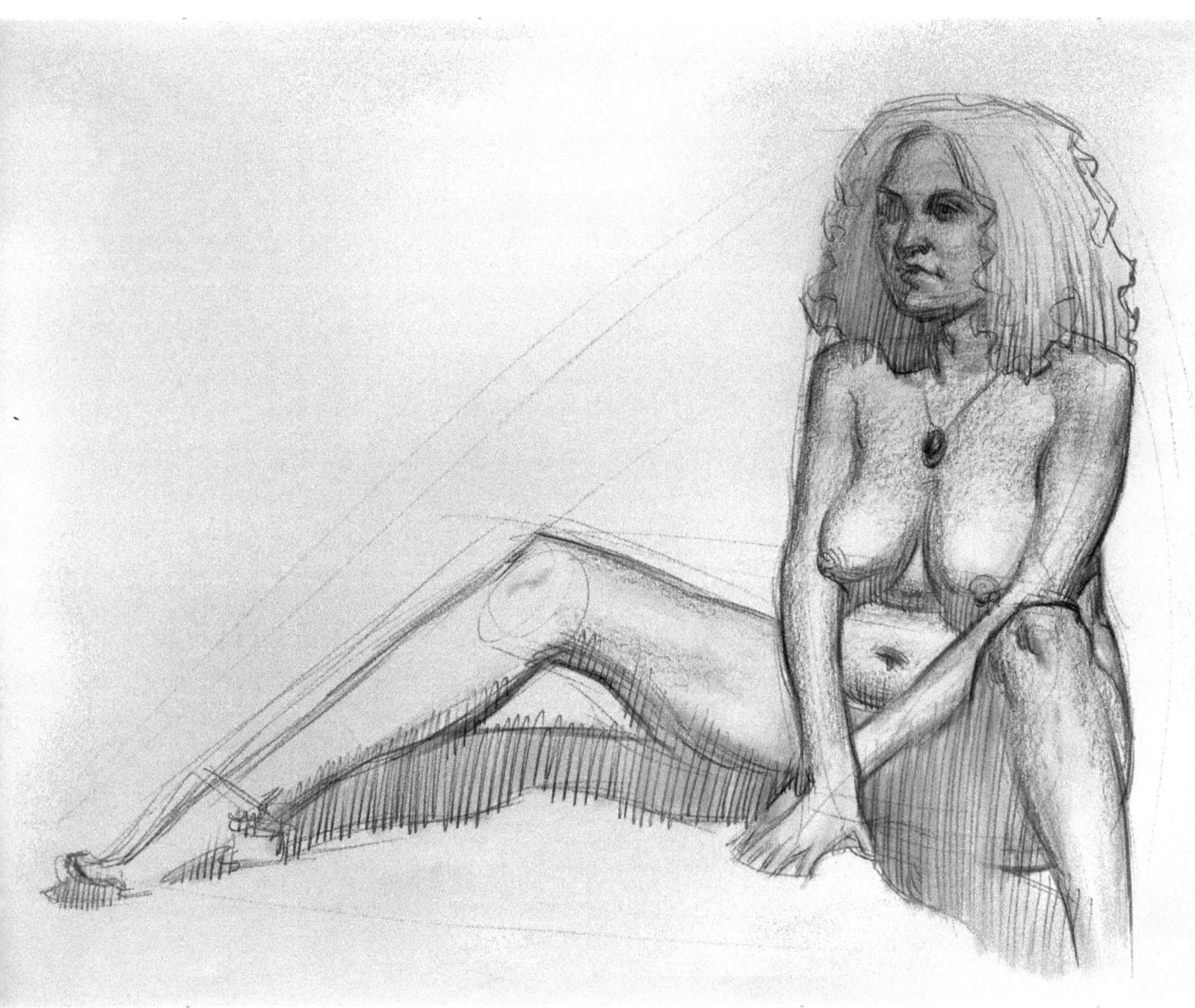

This is a twenty-minute pose from life. Ballpoint pen and colored pencil on paper.

Twenty-minute poses can be very challenging, especially for artists new to life drawing. With more time, there is often more pressure and expectation to "finish" a drawing. There is pressure to have something nice to show your friends and family.

I like twenty-minute poses because they give me a chance to slow down, think more, and be more thoughtful with every mark. When I approach a twenty-minute pose, what helps is to start with a goal.

TIPS AND BEST PRACTICES

Tip 1: Start with a Goal
Before you start drawing, take a moment to decide what part of the drawing to focus on. For example, you may focus on the lay-in and really take your time to get good proportion and structure. Or you may focus on anatomy. Whatever stage or experience level you are at, having a goal in mind will help you focus and make the drawing time more productive.

Tip 2: Get a Better Viewpoint
If your view of the model is not favorable, or if the pose is not attractive or interesting, move seats and change your vantage point in some way. Of course, moving is not always possible because of factors such as the size of the room and number of artists in the workshop. Sometimes moving to one side of the room or farther away in the back row allows you to get a better viewpoint without disturbing the other artists in the room.

Focus on the Process

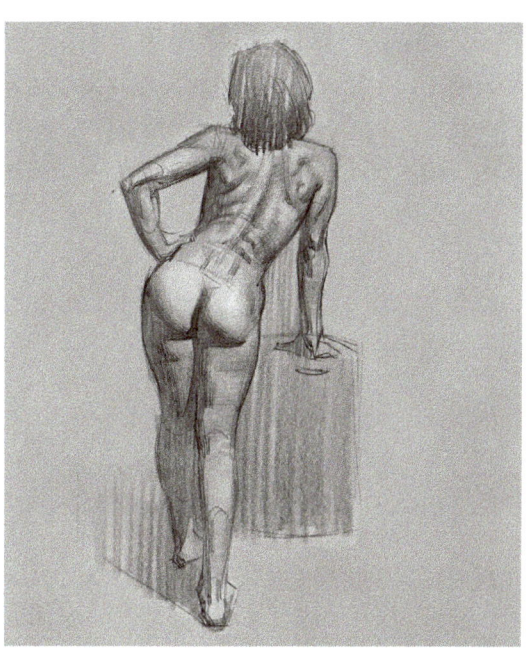

In the previous example, I ran out of time before I could add more shading to the drawing. That is okay. It's very tempting to rush the drawing, skip steps, and get to the shading or try to finish the drawing as fast as possible. Again, life drawing is not a race. The goal should always be to communicate the action of the pose and define enough information to progress to the next stage of the drawing process, whatever it is. The more time you spend with each stage of the process, especially the lay-in and shadow blocking, the more skilled you will become, which will eventually translate into efficiency and better-quality drawings.

If you really like a drawing, you can always continue the drawing after the pose or during breaks. That is perfectly okay too.

I continued to work on the drawing above after ten minutes expired and the pose was finished. Here I continued shading by adding halftones and softening core shadow edges.

Tip 3: Focus on the Process

No matter what experience level you are at, the best use of the time in front of a model is to practice the drawing process. If you are still at the lay-in and gesture stage, it is okay to practice gesture and shapes for twenty minutes. If it takes you twenty minutes to do a good construction drawing with accurate proportions and positioning of forms, that is a success. Just because the pose is twenty minutes or more and the person sitting next to you is shading their drawing, don't feel that you also have to shade your drawing. Make the most of the model time and practice the drawing process at whatever stage you are in.

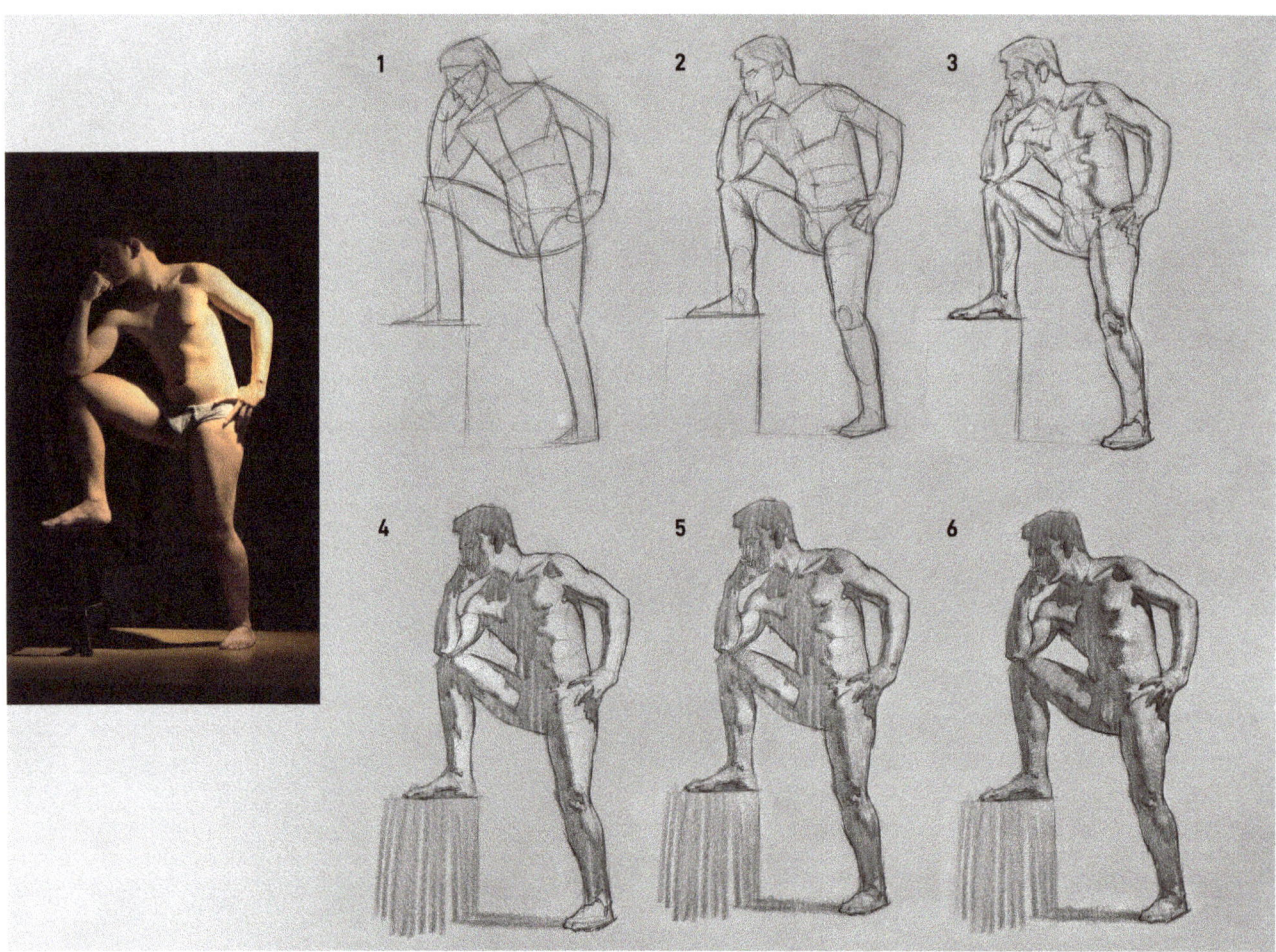

Example 1: Front View, Male

In this example, the lighting is dramatic and there are interesting light and shadow shapes. The goal is good craftsmanship. This means you should try to make your marks and tones as clean possible and establish good values.

Part 1: The Lay-In

The lay-in is the beginning of the drawing process and the foundation of the entire drawing. It's so important that 80 percent of this book is about the lay-in. In the pose below, and for every twenty-minute pose in general, take your time with the lay-in, try to be as accurate as possible, and be true to the pose.

1. The first part of the lay-in is the gesture and 2-D shapes. Draw with long, fluid lines and try to make your marks and the gesture as dynamic as possible. Because of this, don't focus too much on proportions and angles.

2. When you start to refine the initial lay-in and add construction, be more mindful of the shapes and proportions. Start constructing the head and torso and adding sections, 3-D forms, and simplified anatomy, making necessary adjustments as you work. In my drawing, I notice right away the angle of my initial head indication is off. I correct the angle and refine the shapes **(A)**. Start to construct the arms and refine the shapes of the hands. For the model's left hand, use simple rectangle shapes to suggest the fingers **(B)**.

3. Complete the lay-in by constructing the legs. To do this, add cross sections and compound forms to thicken the legs and suggest a volumetric cylinder form. Refine the shapes of the feet to suggest toes, heels, and ankles. The last correction I make in my drawing is at the model's right knee and arm **(C)**. First I shortened the length of the upper leg and corrected the angle of the front of the knee. Then I refined the shape and length of the upper arm, especially the point of the elbow and how it transitions to the forearm.

Taking as much time as needed to do a good lay-in will give you a solid foundation from which you can build the drawing.

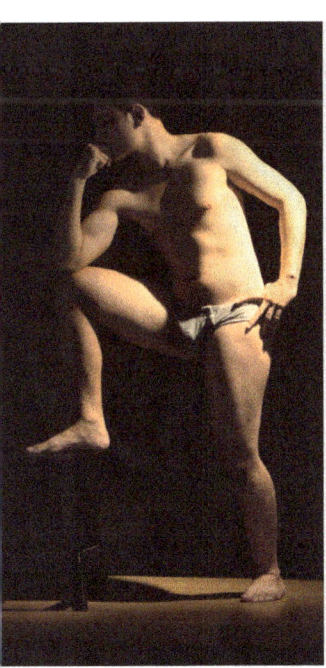
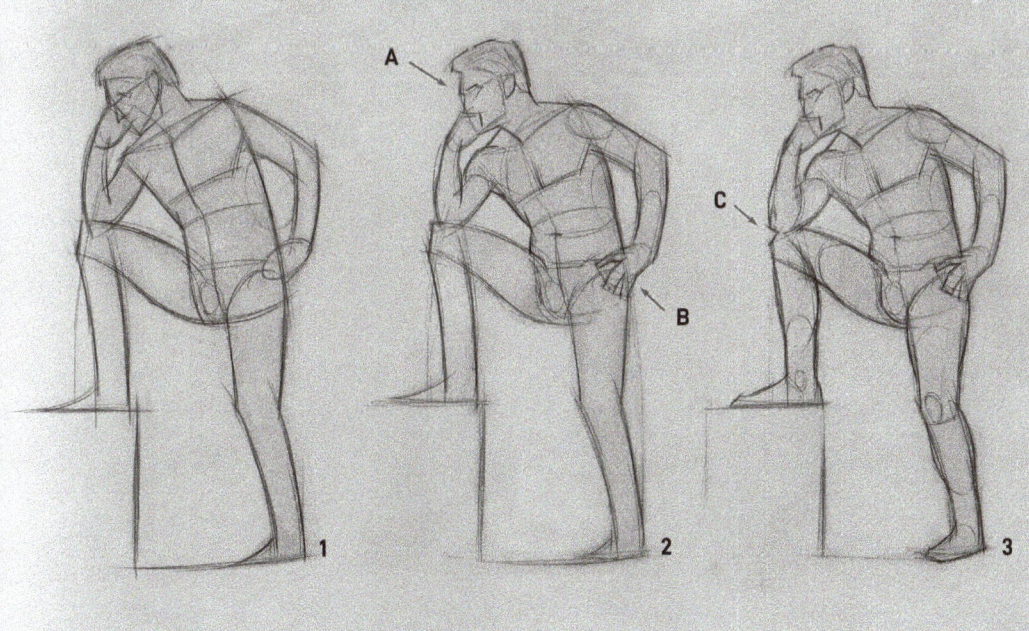

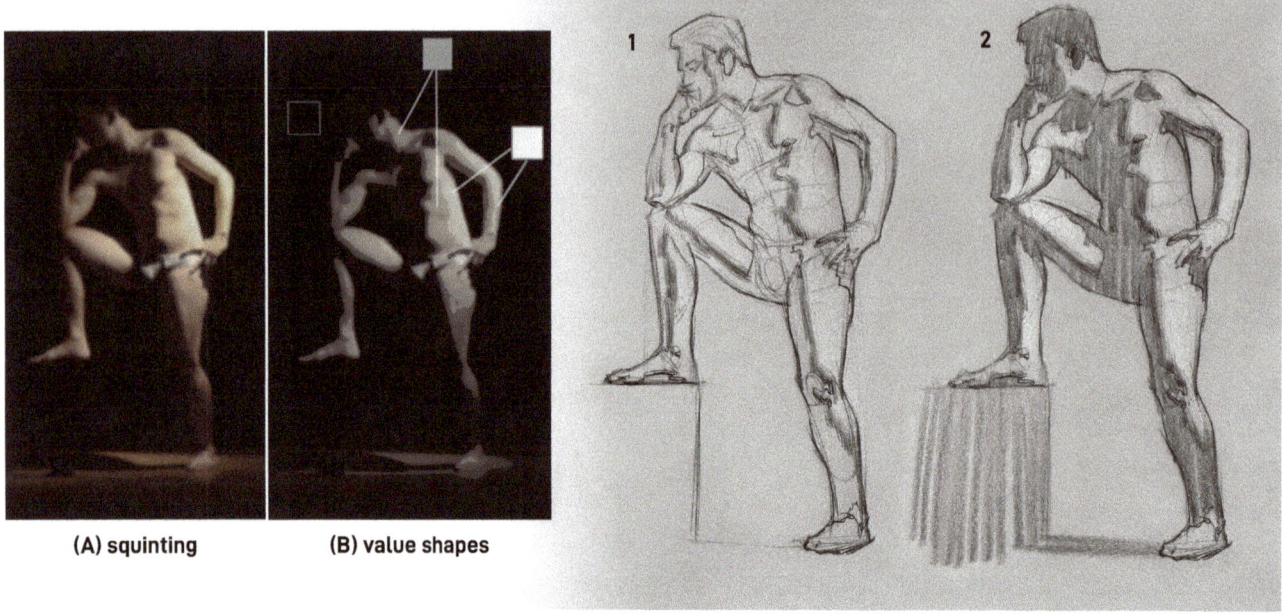

(A) squinting (B) value shapes

Part 2: Starting the Shading Process

Observation Notes

Before you shade the drawing, take some time to observe the light and the values. Squint at the model to help see the value shapes **(A)**. Because the lighting at this drawing session is done correctly, the light and shadow shapes are very clear. For the value shapes **(B)**, first look to the left side of the figure, which is entirely in shadow, and use this as your dark value. The right rib cage and arm receive a lot of direct light so they are the brightest areas and highlight areas, which is the light value. This leaves the figure in light, which you can group as your halftone value.

1. Start the shading process by first defining the shadow shapes. Because there is almost no bounce light, the border is very clear. As you draw the core shadow, make sure to follow the anatomy and the forms.

2. To clearly separate light and shadow and establish a two-value pattern, fill the shadow shapes with a medium dark tone. To make the drawing feel cleaner, try to make the tone as even as possible.

Part 3: Shading and Resolution

1. To complete the shading process, start to add halftones everywhere except the right rib cage and arm. Leaving these areas bright establishes the three-value shapes. As you add tones, use the side of the pencil to also start softening the core shadow edges.

2. Continue to add halftones throughout the figure, using slightly darker tones at the lower parts of the figure, like the legs and hand. Add very light tones at the right rib cage and arm to help show forms and create a highlight.

3. With the time remaining, continue to refine values and edges. To add more contrast, darken the shadows overall, especially the core shadows near the shoulder and right rib cage which will be the focal point of the drawing. Darken the halftones, especially at the legs, feet, arms, and any area away from the bright highlight areas.

Finally, make dark accents at the occlusion shadow areas. In this pose, these are at the armpits and the fingers on the left. Also reinforce and darken the cast shadows at the chest, shoulder, and arms.

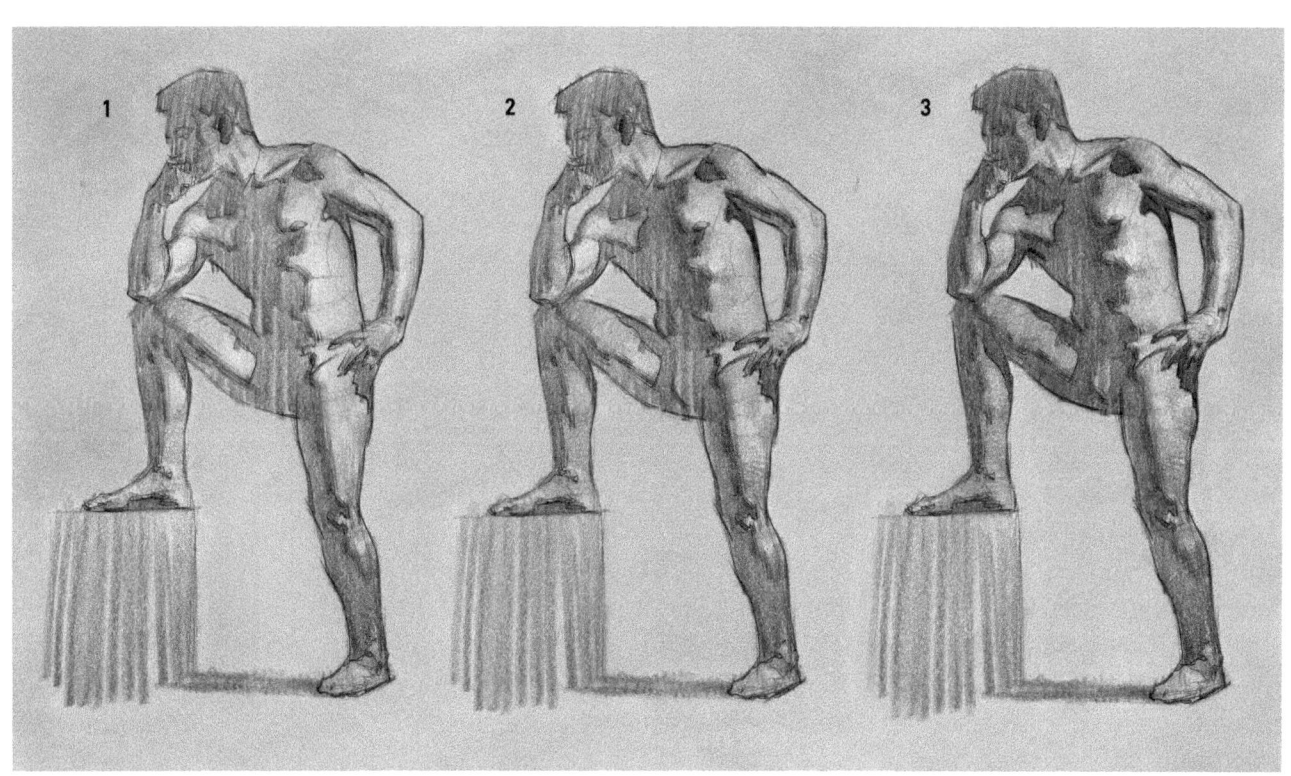

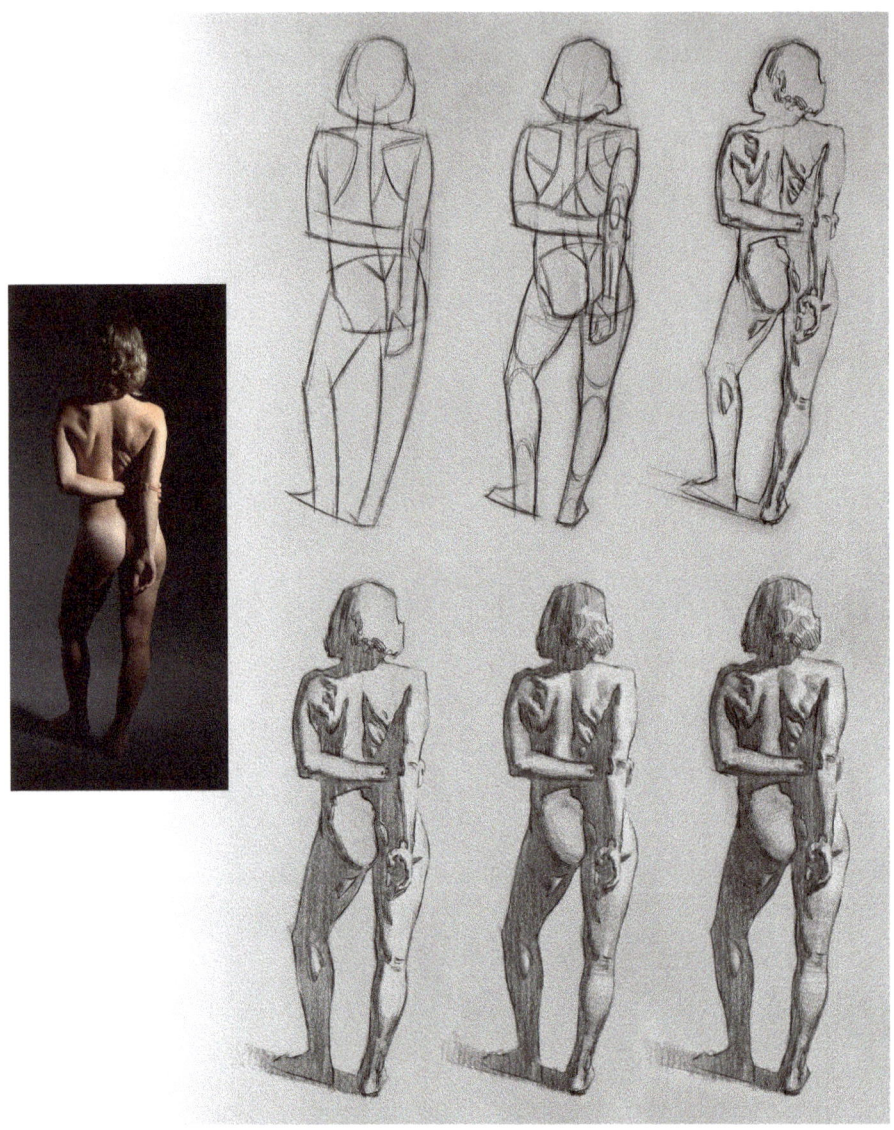

Example 2: Back View, Female

In this example of a back view, the lighting is also dramatic and there are clear light and shadow shapes. The upper back has very interesting and beautiful shapes. For this pose, focus on anatomy and communicating form with tones and edges.

Part 1: The Lay-In

1. Start the drawing with the action line and the long curves. This creates an envelope around the figure and adds rhythm. Block in the head with a simple shape and then block in the torso shape, separating the upper body from the hips. Make sure to exaggerate the angle of the shoulder line and hip line to communicate the beautiful contrapposto (asymmetrical position) of the pose. To block in the limbs, use long curves that flow along their outer contours.

2. Define the shape of the torso, separate the hips to indicate the pinch, and then draw the centerline. Follow the gesture along the outer edge of the arms to define their gesture and shape. Indicate anatomy with a triangle shape for the scapula and the sacrum, which also separates the hips from the abdomen. Simplify the hands with a simple square shape.

3. To complete the lay-in, use construction to add more volume to the shapes. Construct the upper back by using a series of cylinders to simplify the anatomy and add thickness to the scapula (see diagram on next pages). Add cross sections and egg-like forms to the limbs to give them thickness and volume.

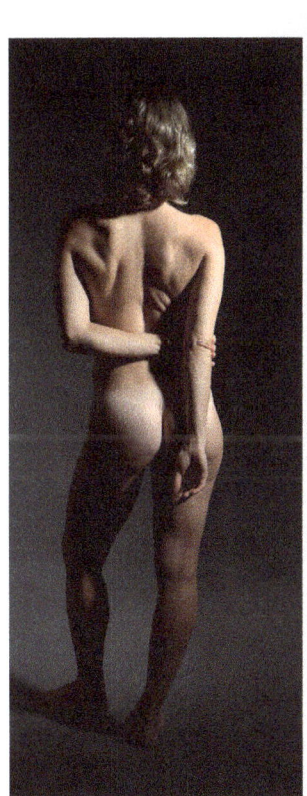
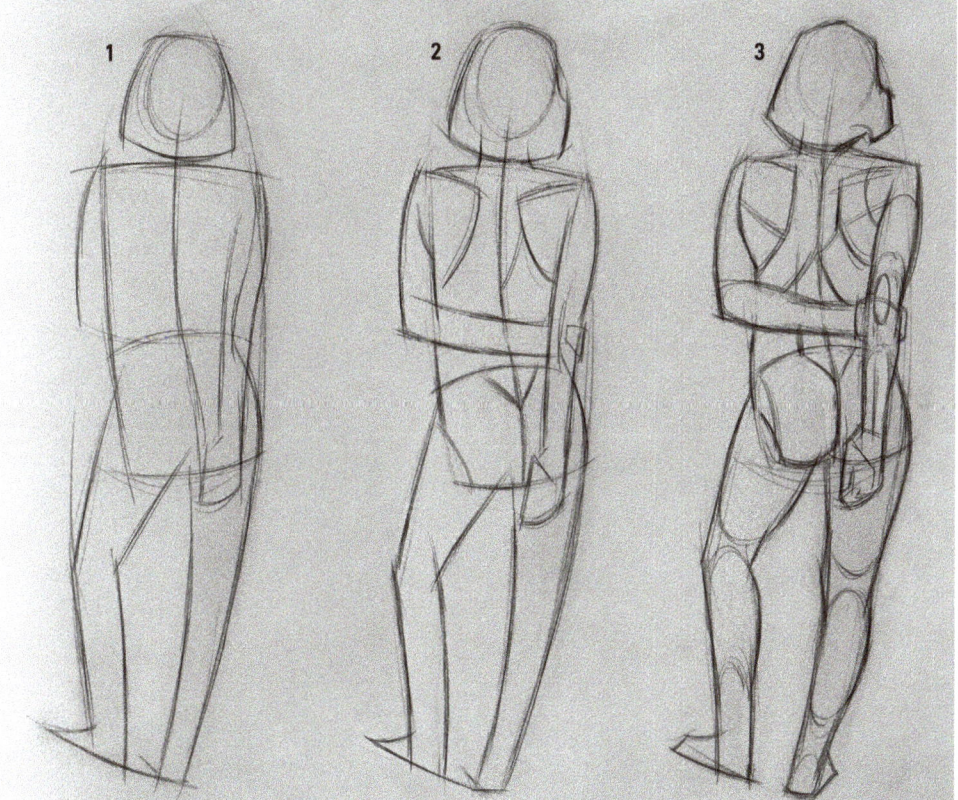

Constructing the Upper Back

The upper back is a beautiful but very complex region because there are many layers of anatomy and detail. Following are some notes on the process I suggest to construct the upper back in this pose.

Observation Process

The upper back is a complex area that requires careful observation. The most important landmark is the scapula. To help see the scapula, look for highlights and corners. In this pose, a long, thin highlight runs along the spine of the right scapula **(A)**. The upper corner of the left scapula is also in highlight **(B)**. The bottom corners of the scapulas can be seen in shadow **(C)**.

These corners will help you see the triangular shape of the scapula through the skin and muscles **(D)**. Once you identify the scapula, look for the group of muscles that surround scapula. These muscles support the scapula and movement of the shoulder and upper arm **(E)**.

Drawing Process

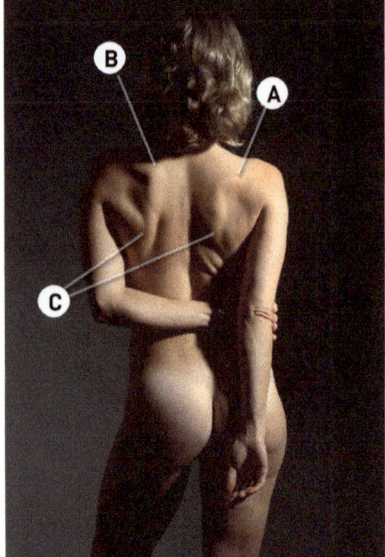

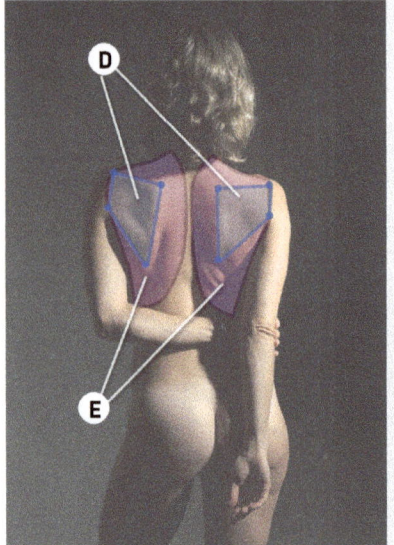

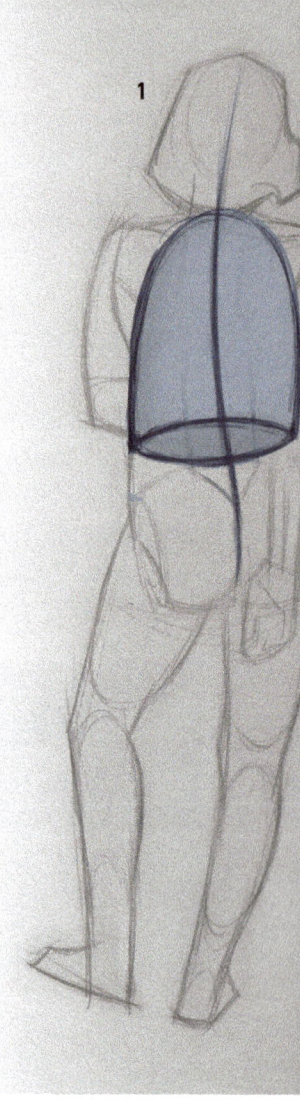

1. To simplify and draw the upper back anatomy, visualize the forms as layers. The first layer is the rib cage. To construct the rib cage, use a compound shape that resembles the shape of a birdcage or bullet.

2. The next layer comprises the muscles underneath the scapula. There are many layers of muscles here, both large and small. The most obvious is the large trapezius muscle, which attaches to the top and interior spine of the scapula. To simplify, use a wide, tapering cylinder shape. The opening end is where the arm will attach.

3. The final layer is the scapula bone itself. It is triangular in shape, but also adds thickness and corners to this shape. This shape also groups and simplifies the muscles that sit on top of the scapula.

To have a true understanding would require a proper study of the anatomy. Although it is not required to be an expert on anatomy to start drawing from life, it is extremely helpful, especially if your goal is more realism and to achieve a higher quality of drawing. Once I studied the anatomy of the scapula and the major muscles

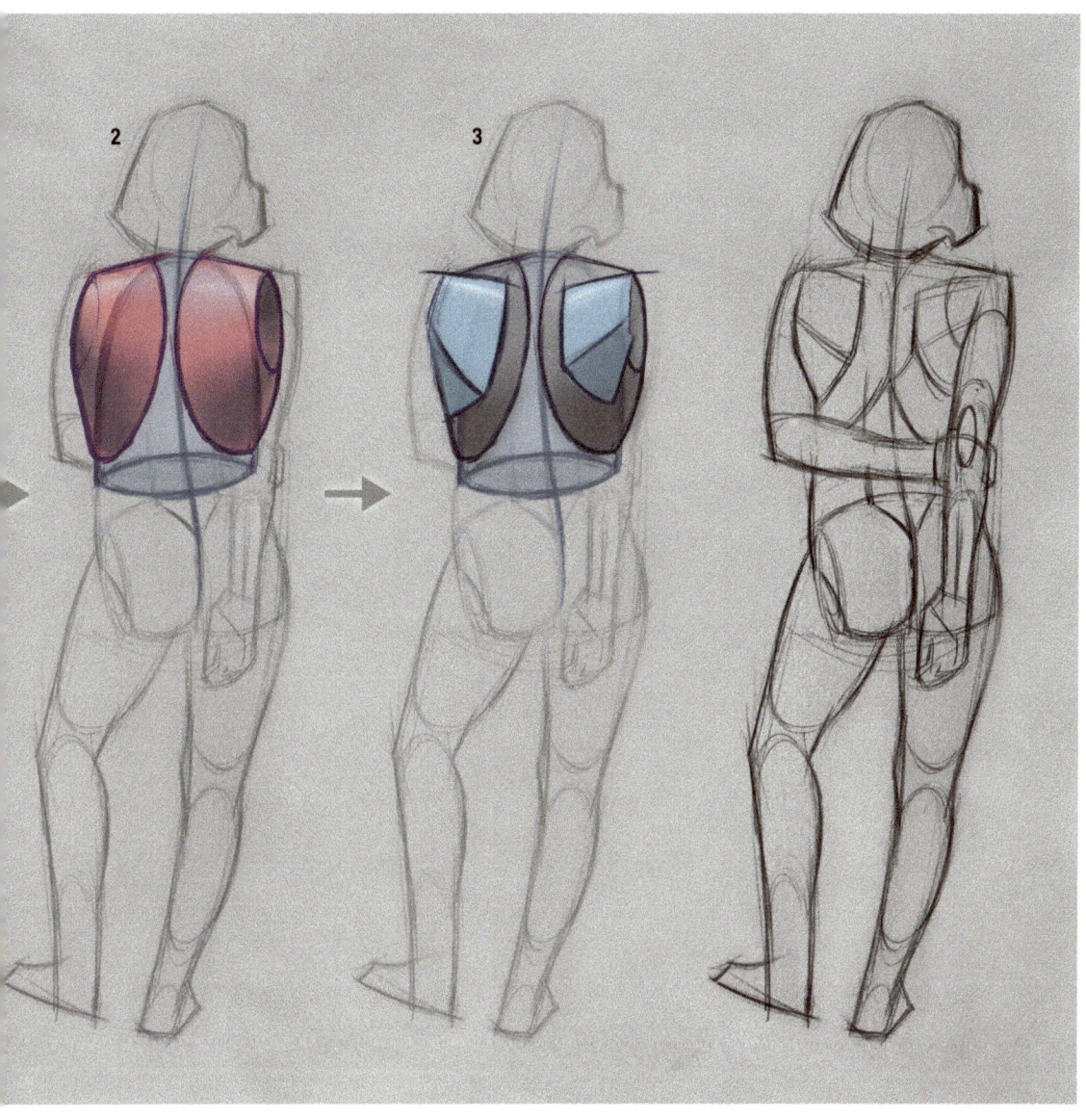

surrounding the scapula and shoulder, I could better see and recognize them on a model. If you are new to life drawing, I recommend that you first study and copy this diagram and then draw from life as much as possible. Once you gain some experience drawing from life, complement your practice with anatomy studies. Start by studying the skeleton first and then the muscles.

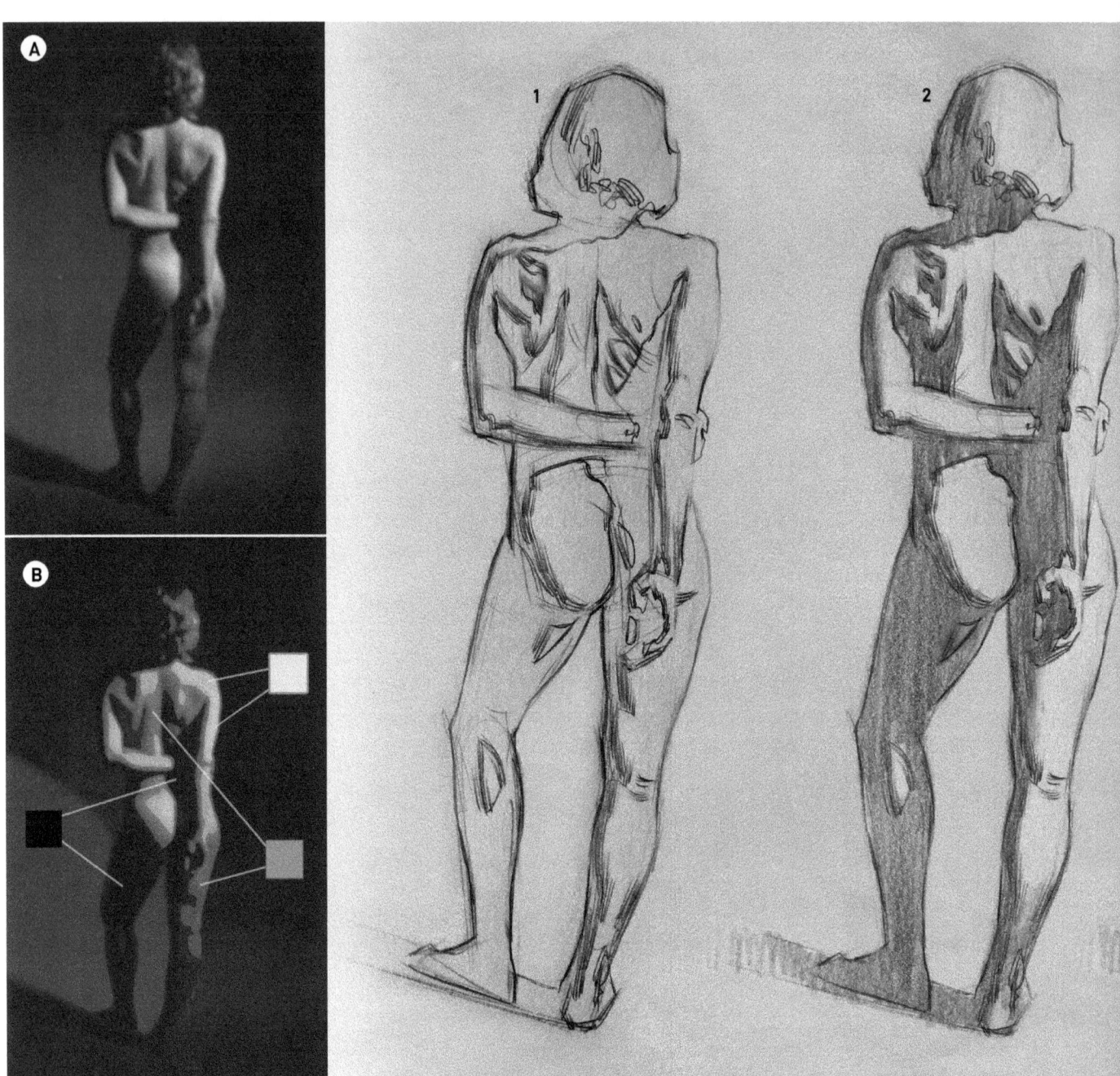

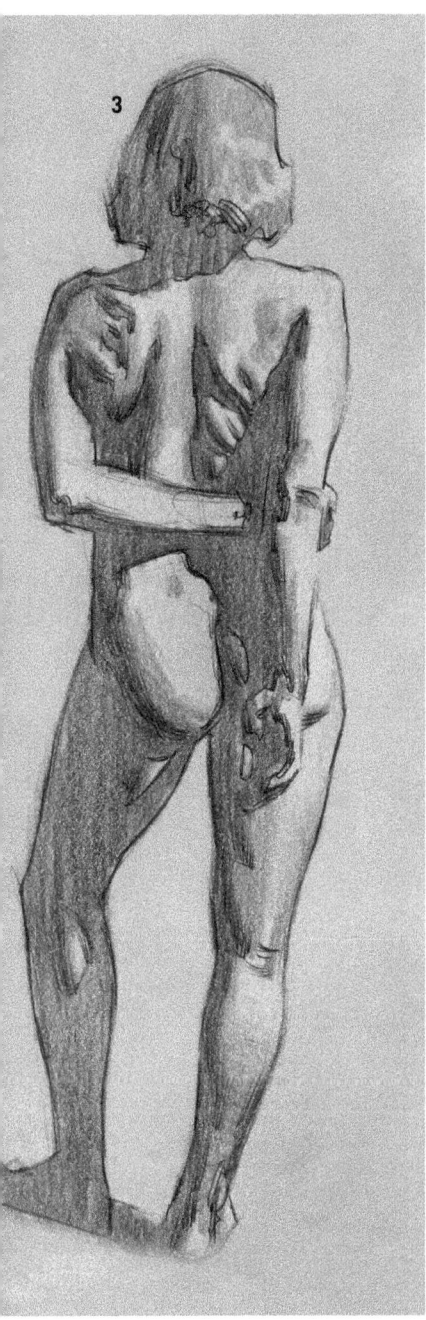

Part 2: Starting the Shading Process

Observation Notes

The lighting on this pose is done well, which makes the shadow shapes and value shapes **(B)** very clear. When I squint at the model **(A)**, the shadows group into one large mass or shape. The brightest values can be seen at the right shoulder and upper arm which are closest to the light. The left glute also groups with the light value. This leaves the figure in light, which can be grouped into a halftone value.

Drawing Process

1. Begin by defining the shadow shapes and also start to introduce some edge variation at the core shadow.

2. Next, fill the shadow shapes with a medium dark tone, which establishes a clear two-value system.

3. Finally, add halftones, starting with the areas close to the core shadow and areas farther away from the light, such as the legs and left shoulder.

Part 3: Shading and Resolution

1. Continue to add halftones, leaving only the bright areas of the right arm and left glute. Soften core shadow areas and make them slightly darker to create the illusion of form and reflected light.

2. With the time remaining, add lighter halftones in the bright areas to create highlights. To increase the contrast and make the values more dynamic, reinforce and darken the cast shadows. You can also add dark accents in the occlusion shadows where the upper arm comes in contact with the torso.

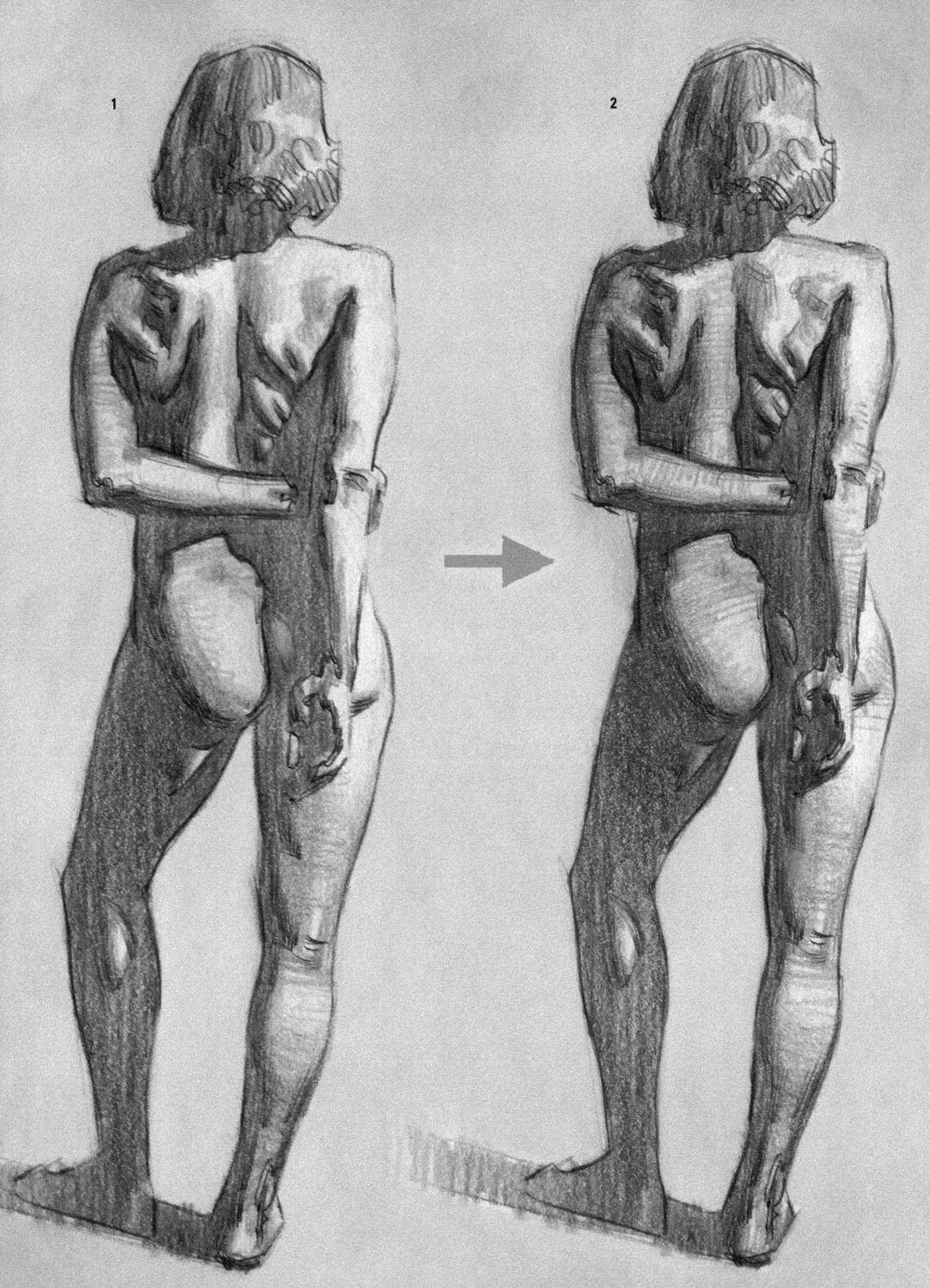

SIDE VIEW AND PERSPECTIVE

Side View Techniques and Strategies

Side view poses are challenging because they often have less information, such as anatomy and details, than other views. Because there is less information available, it becomes more difficult to communicate the pose or get a clear read. A side view can often feel flat and uninteresting.

To help me draw side views and get a clear read, I use a combination of techniques and strategies.

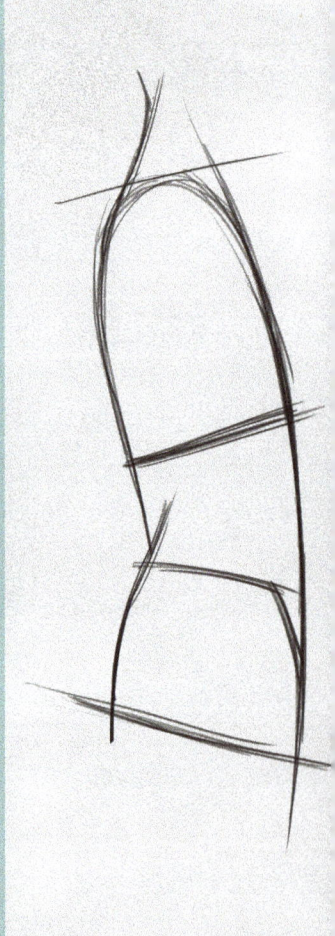

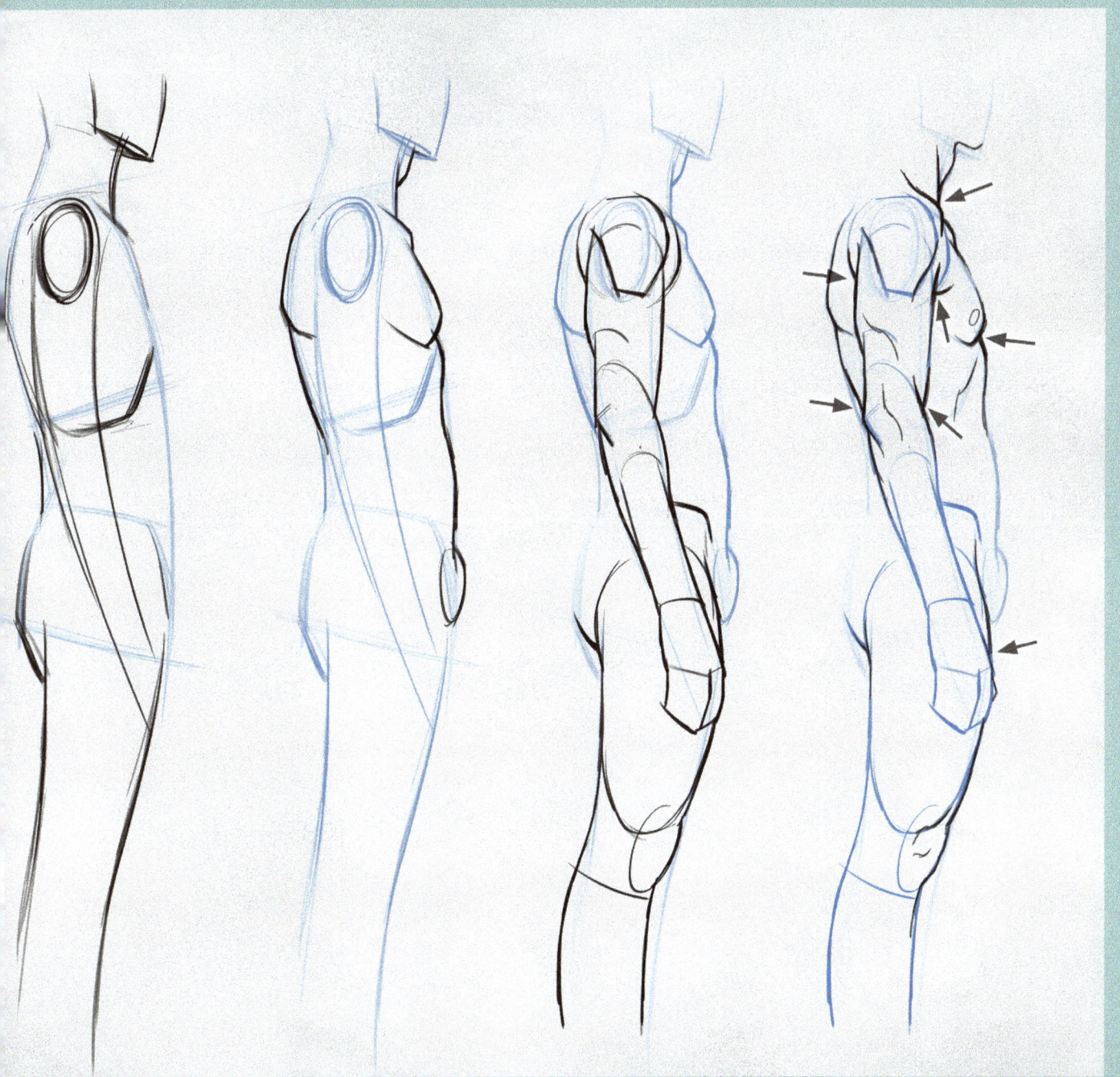

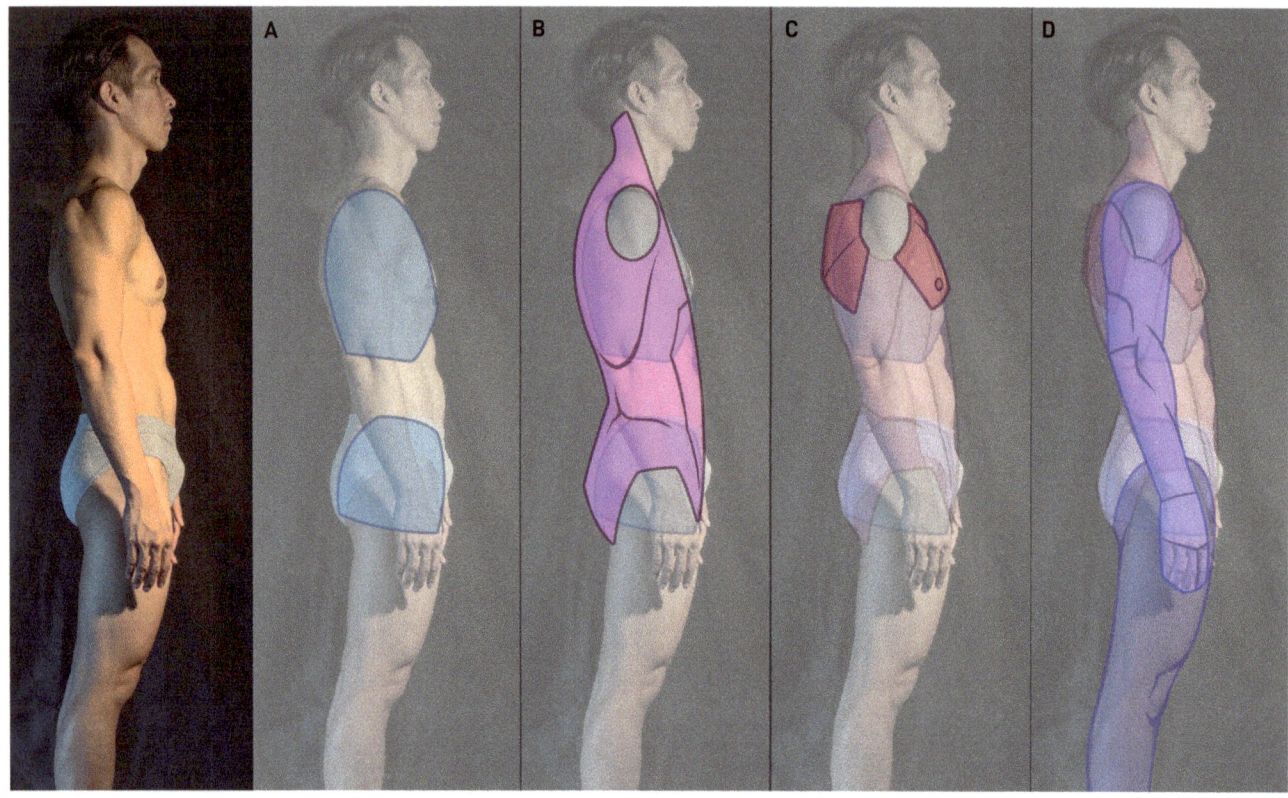

TECHNIQUE 1: STACKING LAYERS

A side view pose is a series of layers of anatomy and forms. Each layer gives us an opportunity to create overlaps, which help suggest depth. The layers of anatomy are:

A. The rib cage and pelvis.

B. The deep muscles, which include the abdominals, latissimus dorsi (lat) muscles, and trapezius.

C. The scapula and the pectoralis (pecs), or chest muscles. Females would also have breasts as the top layer of the chest.

D. The limbs, which also have their own layers of form that can be used to create more overlaps.

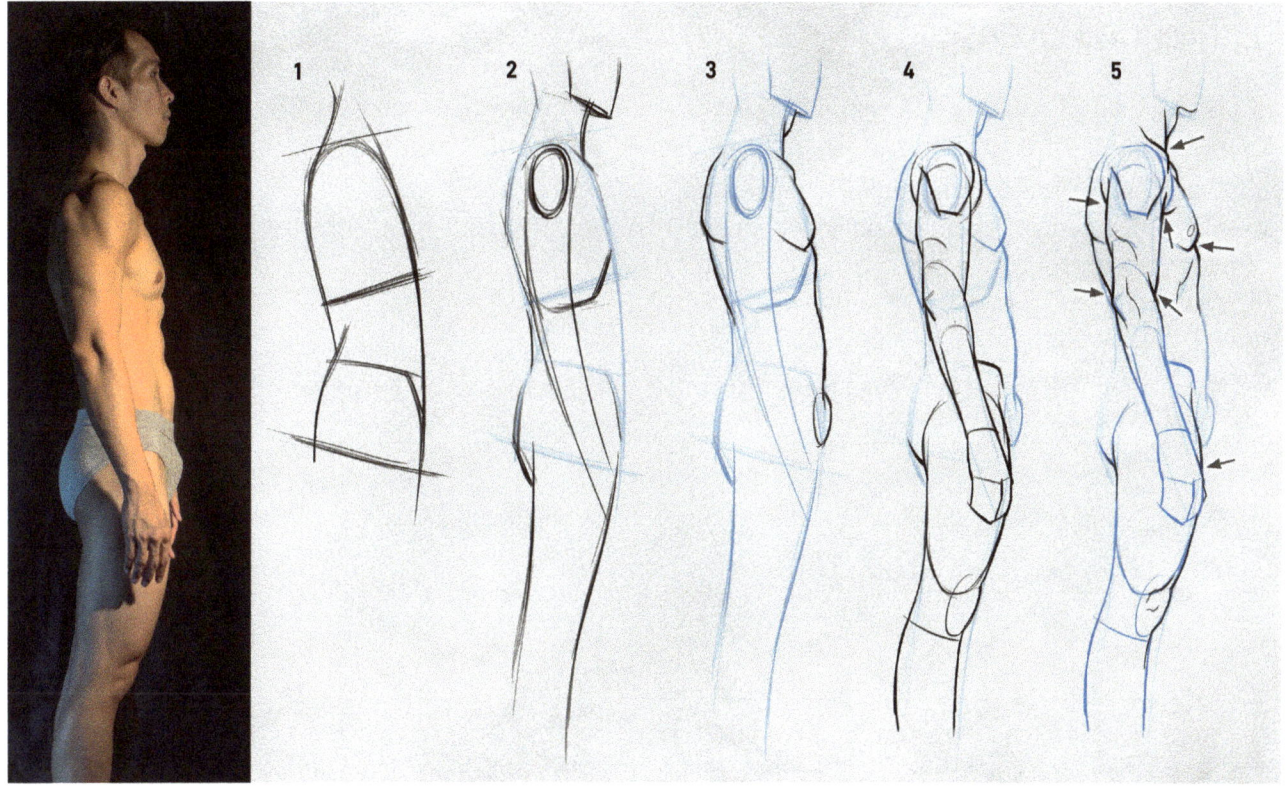

When I draw, I construct my forms and anatomy with the layers in mind.

1. Block in the shape of the rib cage and pelvis, and also define the pinch in the back.

2. Refine the rib cage shape and describe the gesture of the limbs.

3. Block in the abdominals, lat muscles, and then the scapula and chest muscles.

4. Construct the limbs with cylinders, compound shapes, and cross sections.

5. Emphasize any overlapping forms to help suggest depth.

TECHNIQUE 2: OVERLAPS

The layers of anatomy and form naturally overlap. When forms overlap they create depth. In my drawing, I consciously emphasize overlaps. One way is by using "T" intersections, which are T-shaped accents anytime two forms intersect. The more overlaps you create, the more depth you will suggest. Whenever possible, you can invent overlaps if you really want to push the feeling of depth.

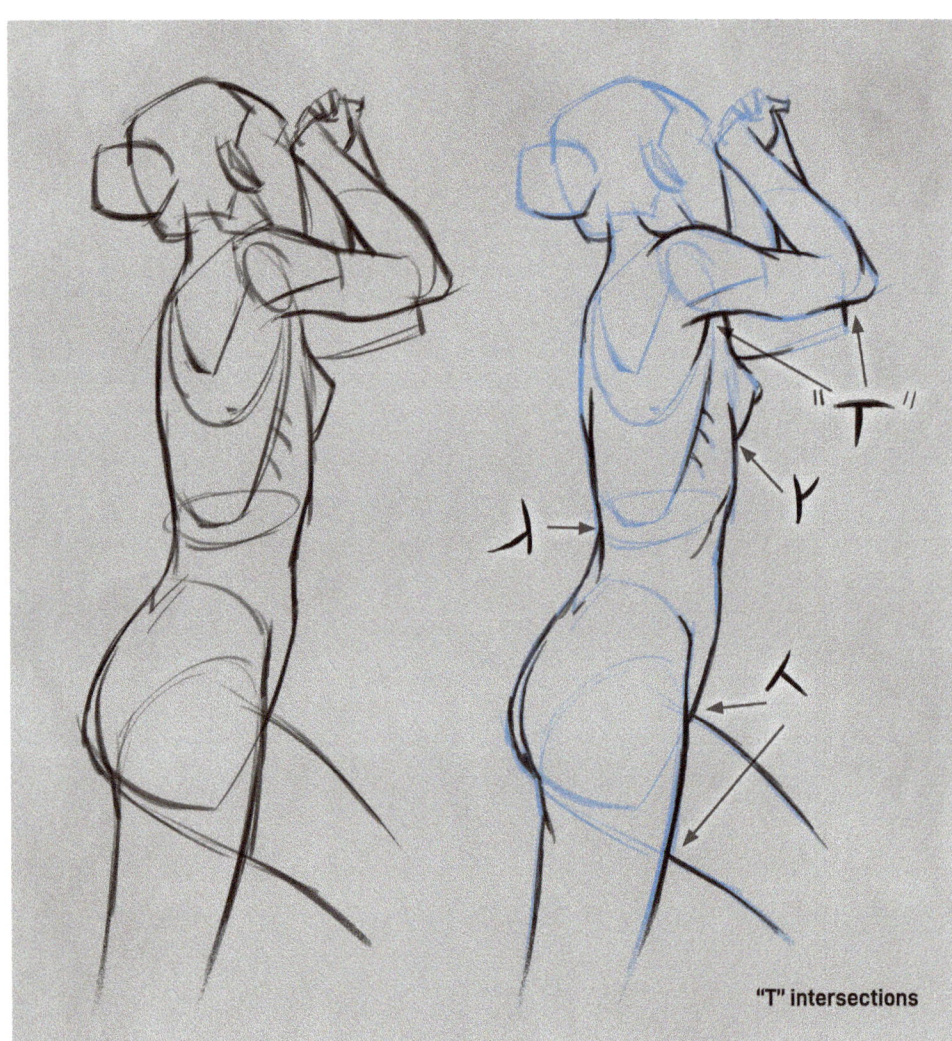

"T" intersections

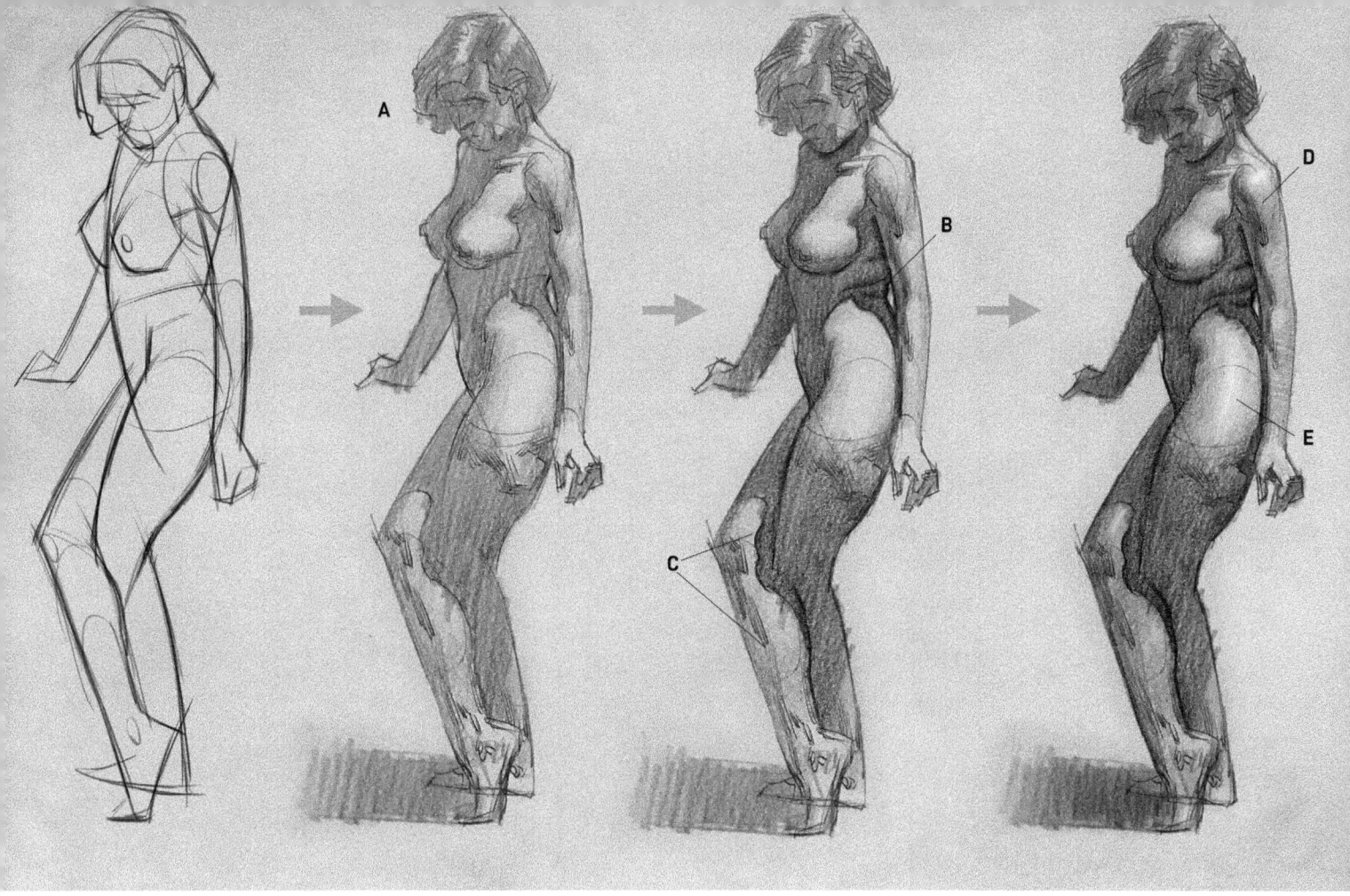

TECHNIQUE 3: VALUES AND TONES

For longer poses, you can also use shading to create depth and overlaps. In terms of value, dark objects will recede and light areas will come forward. In the above example, when I fill the shadow shape with a tone and create a two-value, light-and-dark pattern, the forms in shadow recede and the forms in light come forward **(A)**. To create more depth in the shadow, you can add dark accents, such as pinching forms in the torso **(B)**, the armpit, and where the right leg makes contact and overlaps the left leg **(C)**. When you add halftones and start to model the form, you can create a three-value system with lights and highlights. Because the highlights are the brightest part of the figure, they appear to come forward and make the halftones recede. This can be seen in the shoulder muscle, as the highlight makes the shoulder muscle come forward and appear to be in front of the arm and torso underneath **(D)**. This is also seen in the left hip and leg, as the highlight makes the form come forward and the halftones and shadows recede **(E)**.

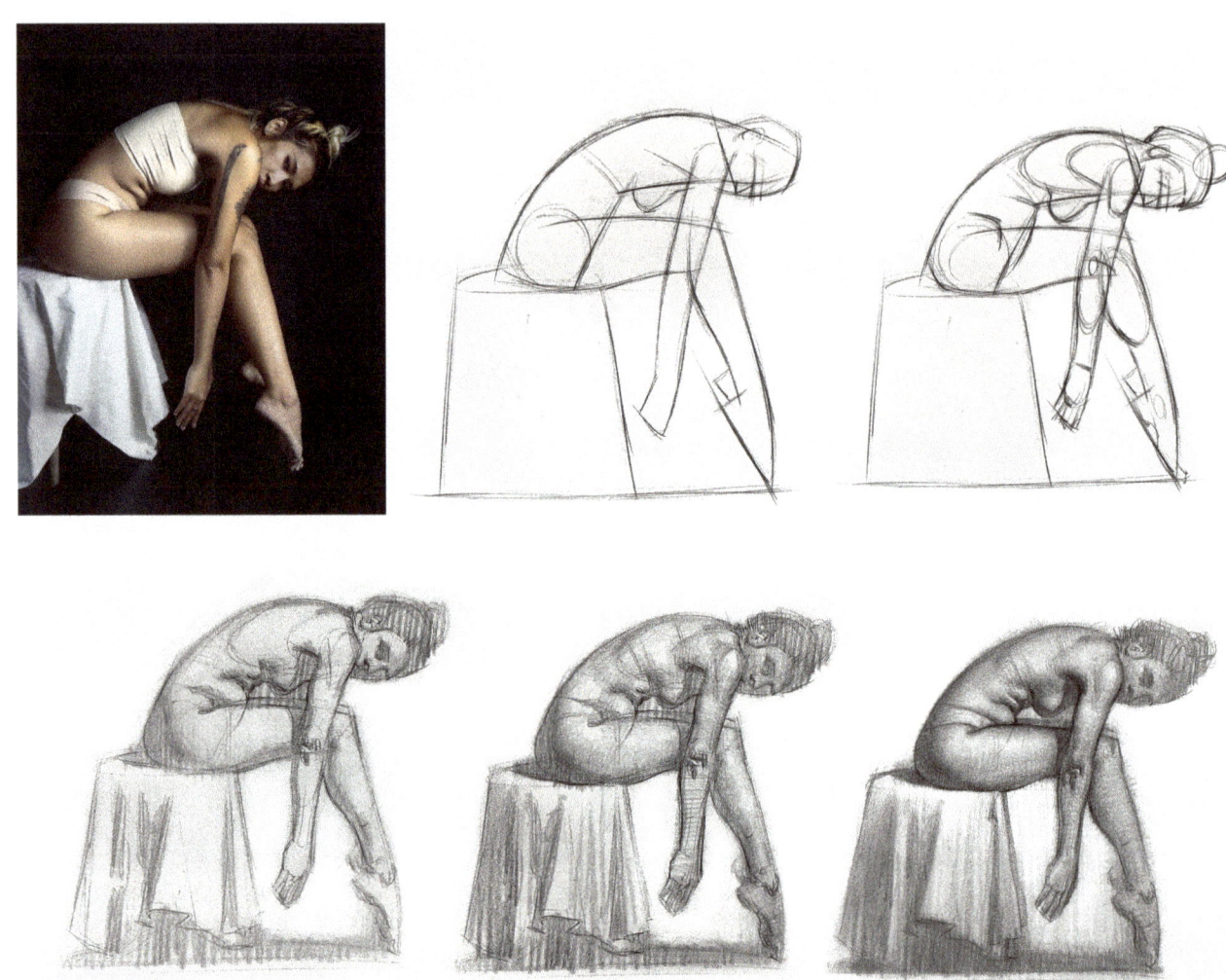

Example 1: Side View, Bending Forward, Female

Observation Notes

The first things I look for are the layers of anatomy (see opposite). The upper part of the rib cage **(A)** can be partially seen, which helps me to visualize its shape. The underwear line follows the top of the pelvis **(B)**, which helps me to visualize its shape. The next layer is the muscles. The lat muscle **(C)** is directly in front of the rib and follows its shape. The abdominals **(D)** are between the ribcage and the hips. The large gluteus medius muscles **(E)** create a layer of anatomy above the upper leg and pelvis.

The next layer is the scapula and the muscles surrounding it **(F)**. Below the scapula is the breast **(G)**. The scapula and shoulder also overlap the head **(H)**. The leg **(I)** is beneath the arm and can be used for overlaps. Finally, the arm **(J)** is closest to the viewer and visually sits above all the other forms of the body.

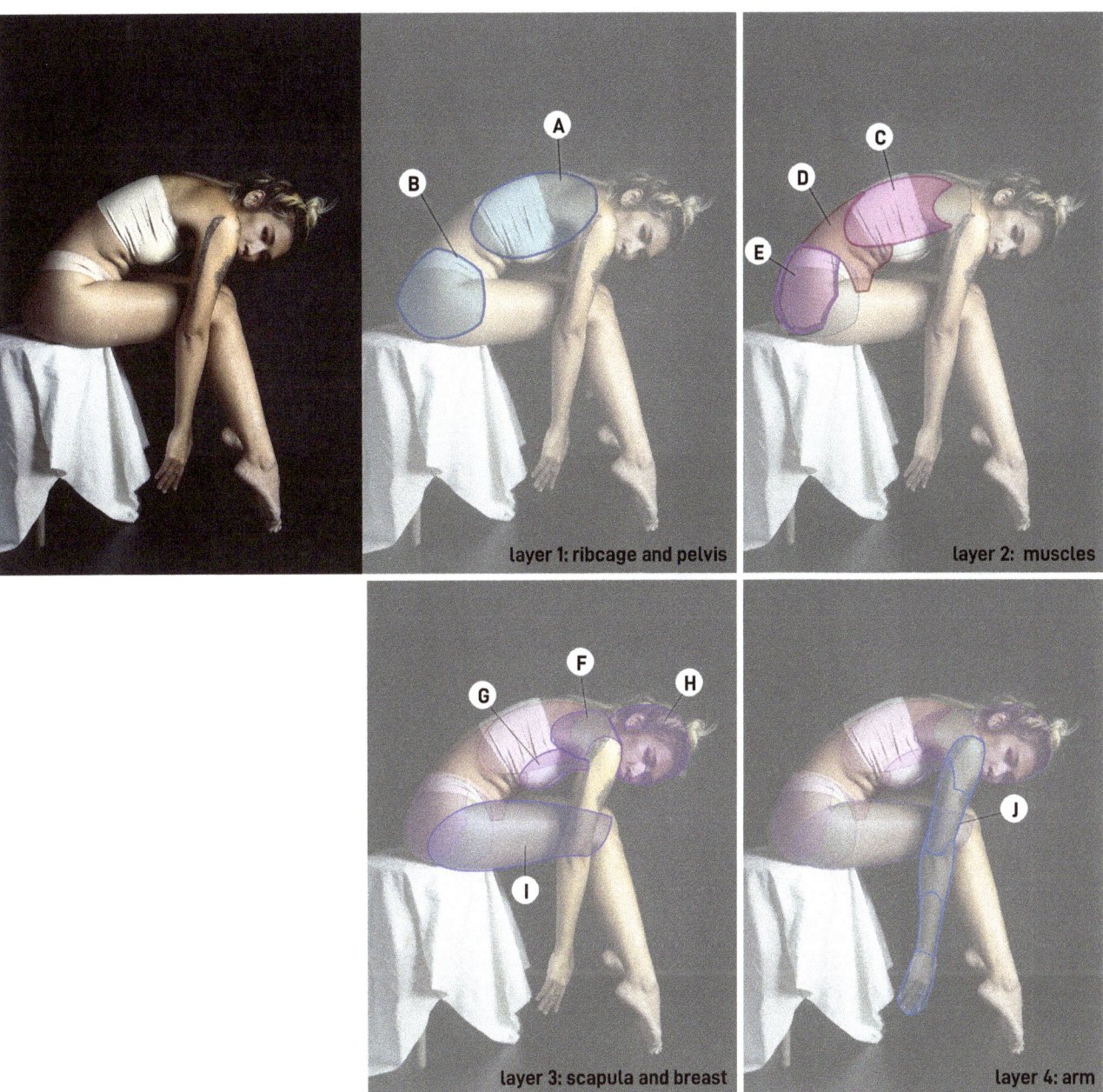

layer 1: ribcage and pelvis

layer 2: muscles

layer 3: scapula and breast

layer 4: arm

SIDE VIEW AND PERSPECTIVE

133

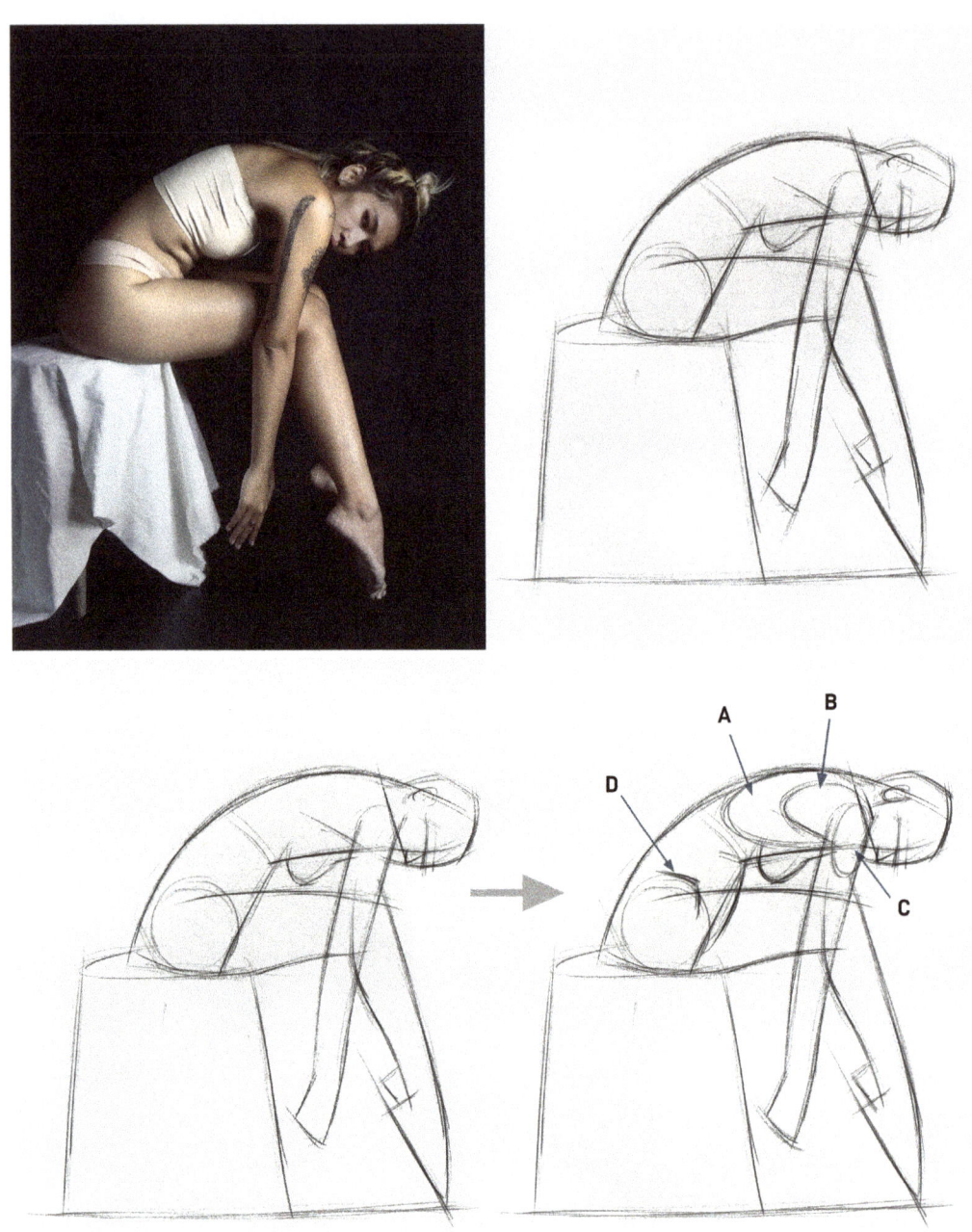

Part 1: The Lay-in

Start drawing by defining the torso and limbs as 2-D shapes. Define the shape of the ribcage, pelvis, and abdomen. Lightly lay-in the gesture of the arm and legs, which will help you make a mental game plan for the areas of overlap.

The second layer to add is the muscles. In the upper body, indicate the lat muscle **(A)** and then block in the muscles around the scapula **(B)**. Also indicate the shoulder muscle **(C)**. At the hips, block in the iliac crest **(D)**, which will create a layer between the torso and the upper leg.

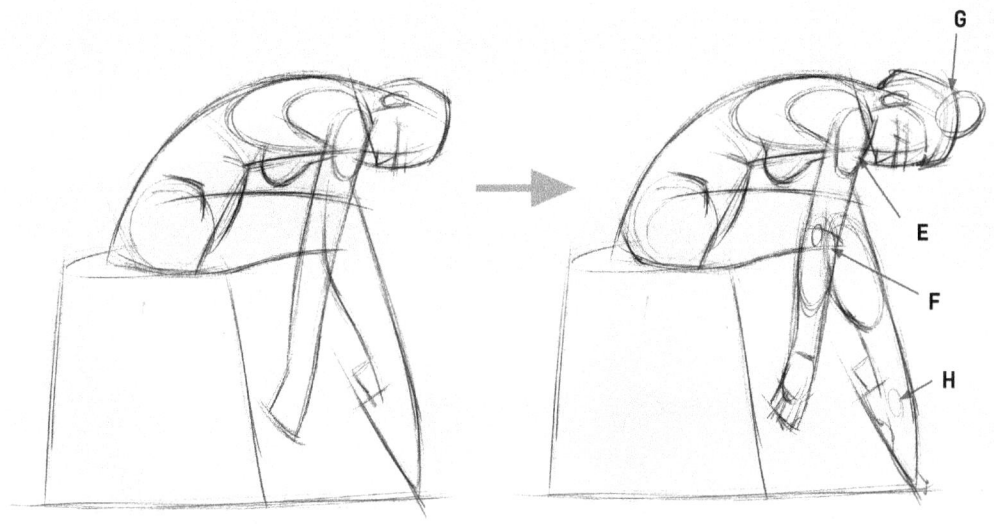

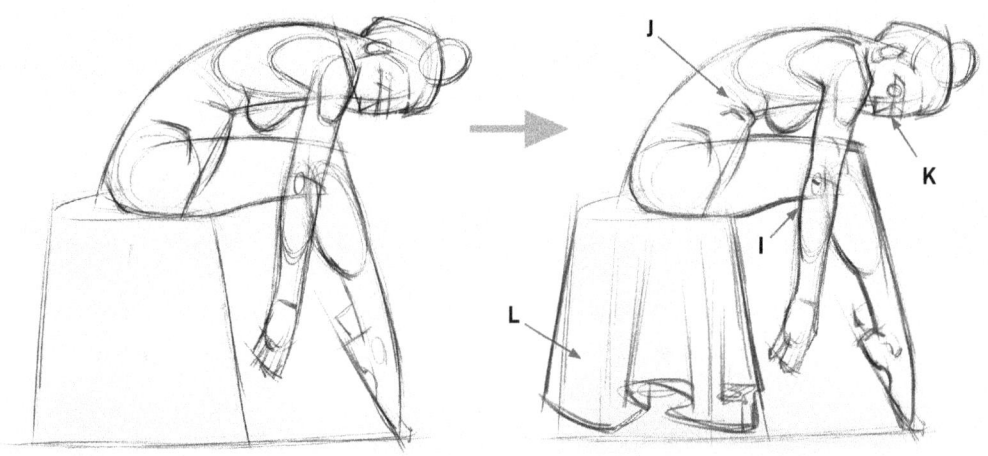

Refine the shoulder muscle shape **(E)**. Block-in the forearm with an oval shape, separating and blocking in the elbow joint **(F)**. Block-in the hair shape **(G)** to create more overlap opportunities. Refine the feet and ankle joint **(H)**.

To complete the lay-in, refine the shape of the arm, especially where it overlaps the leg **(I)**. Indicate details at the abdomen **(J)**. Indicate the facial features **(K)**. Add background shapes and details like the folds of the fabric **(L)**.

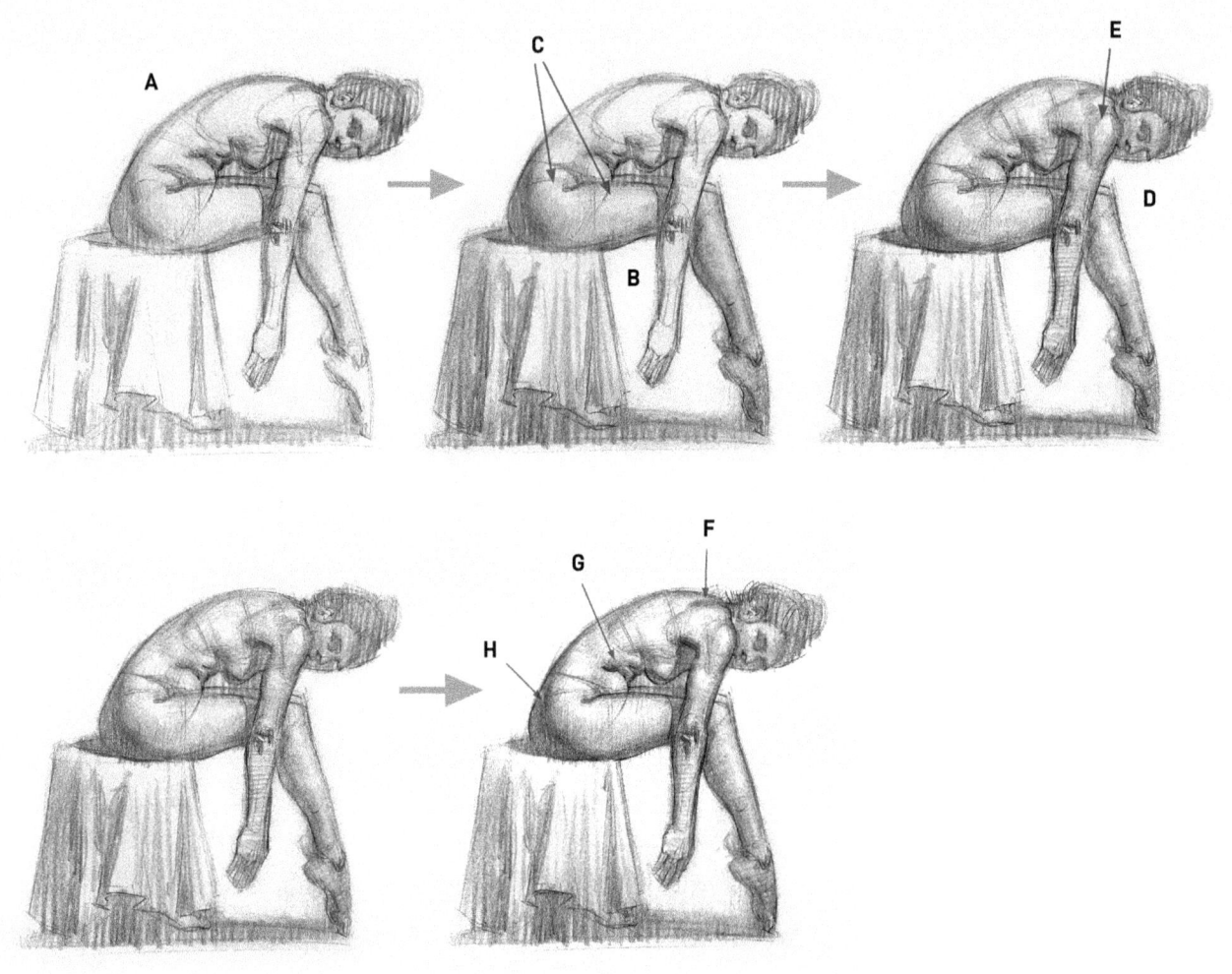

Part 2: Establishing Values

Massing in the shadow shape creates a two-value pattern, which starts to make the forms in shadow recede and the forms in light come forward **(A)**. To establish three values, start adding halftones at the legs and lower body **(B)**, leaving light areas around the side of the leg and hip **(C)**. Add tones to the upper body, especially at the arm, upper back, and face **(D)**, leaving a highlight area at the top of the shoulder **(E)**.

Part 3: Modeling Form and Highlights

Darken the contour at the upper torso **(F)** to make the scapula and shoulder come forward. Add anatomy and details at the abdomen **(G)**. Darken the core shadow around the hip **(H)**, which helps make the hip and leg come forward.

Darken the shadow at the arm and breast **(I)**. Darken the skin that makes contact with the underwear line **(J)** which makes a subtle area of overlap. Add dark accents at the contour of the thigh **(K)**.

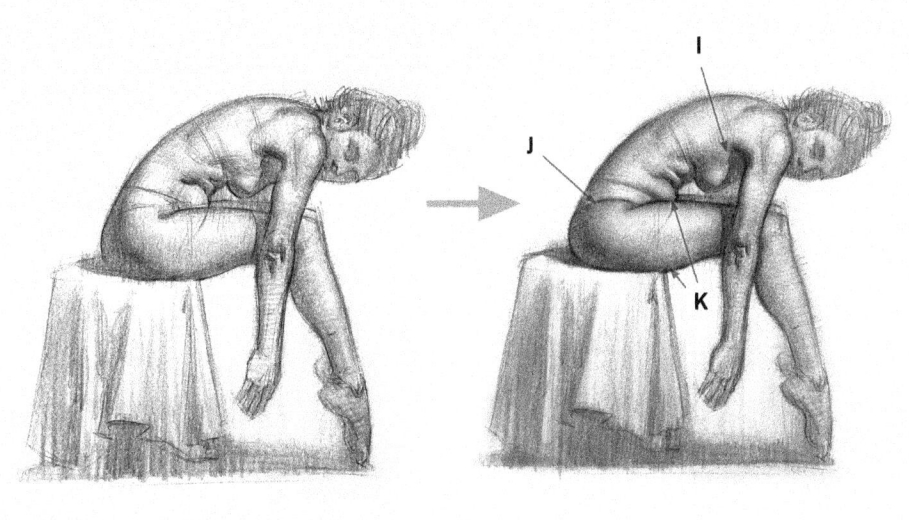

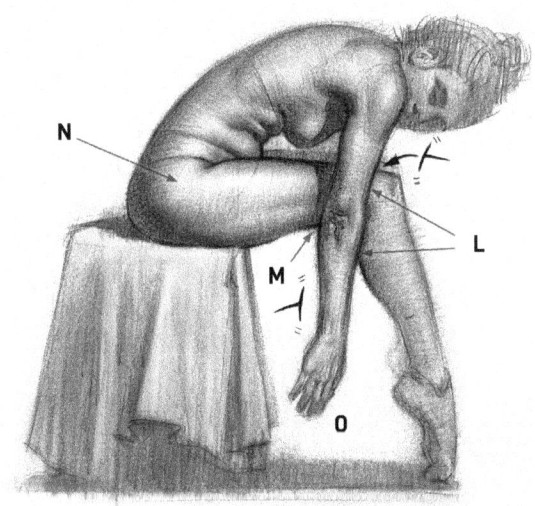

Part 4: Accents and Finishing Touches

The last marks are dark accents and finishing touches. For example, there are "T" intersection accents where the front of the arm overlaps the knee and calf **(L)** and where the back of the arm overlaps the bottom of the thigh **(M)**. Erase a highlight at the hips and upper leg **(N)** to make these forms come forward and also to create another layer of anatomy. If there is time remaining, add detail to the hand **(O)** to help the entire arm come forward from the leg.

*Note: These steps don't have to be followed in this exact order. It's okay to add dark accents before the highlights. Or, if you add "T" intersections before shading, that's okay too. The important thing is not the order of the marks, but that the marks add to the drawing and help communicate the read.

How to Draw the Figure in Perspective

Drawing the forms of the figure in perspective is challenging. A pose with extreme foreshortening can be very intimidating and frustrating, especially for anyone new to figure drawing. In my drawing classes and workshops, how to draw in the figure in perspective is one of the most requested topics.

Perspective drawing is a complex science, and an expertise on the subject is not necessary to start drawing the figure from life. In this chapter, I share some ways I apply perspective to the figure, as well as tips and techniques. First we must understand the fundamental concept of position.

DEFINING POSITION AND EYE LEVEL

"Position" refers to where a form is in 3-D space and how it occupies that space. Position is defined by the direction the form is moving relative to the viewer's eye level and vantage point. In general, a form is either moving toward or away from the viewer.

Eye level is an imaginary horizontal line that is level with the center of your eyes. Forms can be above, at, or below eye level.

The figure is capable of an infinite range of movement. In figure drawing, however, there are only six positions that require perspective. These positions are:

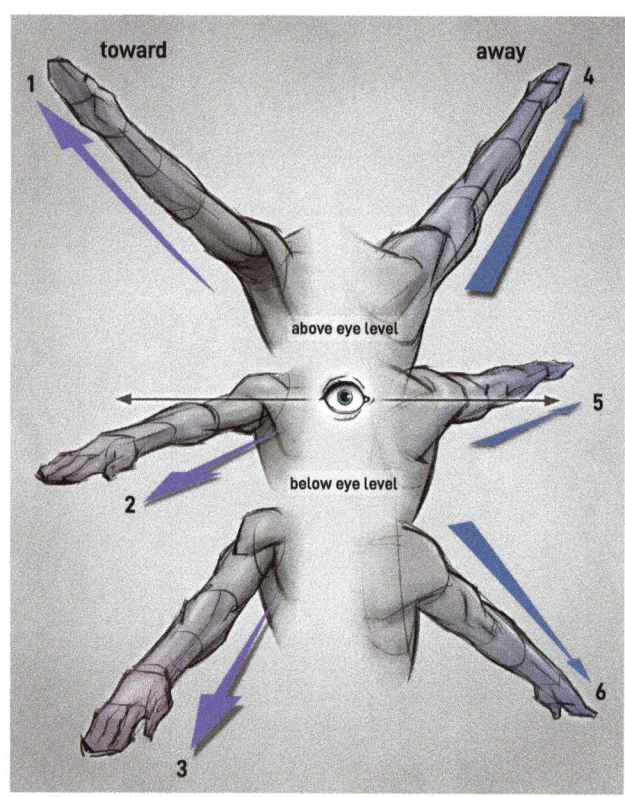

1. Toward and up (above eye level)
2. Toward, horizontally (at eye level)
3. Toward and down (below eye level)
4. Away and up (above eye level)
5. Away, horizontally (at eye level)
6. Away and down (below eye level)

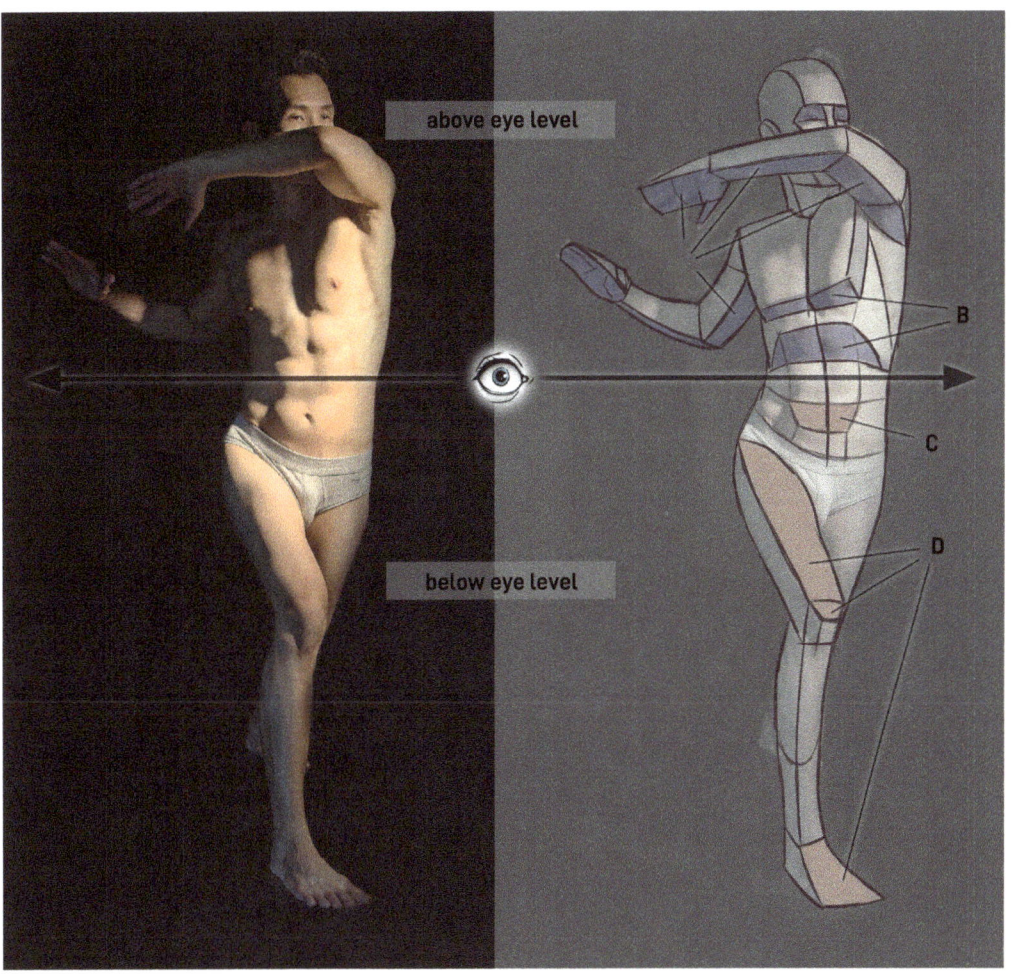

PERSPECTIVE DRAWING TOOLS

To draw the figure and its forms in any position and suggest perspective, I use a series of drawing tools and techniques that are based on form drawing, which is drawing with 3-D shapes like cylinders, cubes, and cones, to simplify the complex forms of the figure.

Tool 1: Box Forms
To see and communicate eye level, visualize the figure as geometric 3-D forms, especially box-like forms, and look for their sides, also known as "planes." If you see undersides of forms, the form is above your eye level. If you see the top of the form, the form is below your eye level.

In this pose, the arms and head are above eye level, so their undersides are clearly seen **(A)**. The underside of the chest and rib cage **(B)** can also be seen. As forms below go below eye level, you can see their top planes. Here, the top plane of the lower abdomen **(C)**, along with the thigh and foot **(D)**, are easily identified.

Tool 2: Cross Sections
A cross section is an imaginary cut or section of a form. For example, cylinder forms are elliptical in shape and the curved outer edge of the ellipse communicates the position. Determining which cross section I use depends on which of the six positions I want to communicate.

To help see the direction of a form, visualize the forms as cylinders. In this example, the torso is moving upward and toward the viewer. This means the cross sections will curve down **(A)** because the form is above eye level. The model's left arm is also moving toward the viewer, but downward and below eye level, so the cross sections will curve up **(B)**. The model's left leg is moving toward the viewer, but mostly at a horizontal plane, almost parallel to eye level. This means the cross sections will curve outward to the left **(C)**. The model's right leg is moving downward, below eye level and slightly away. This means the cross sections will curve down **(D)**. Similarly, the model's right arm is moving away from the viewer and slightly down, which means the cross sections will also curve down **(E)**. When you draw the figure, you can use cross sections to help communicate the many positions of a form and suggest perspective.

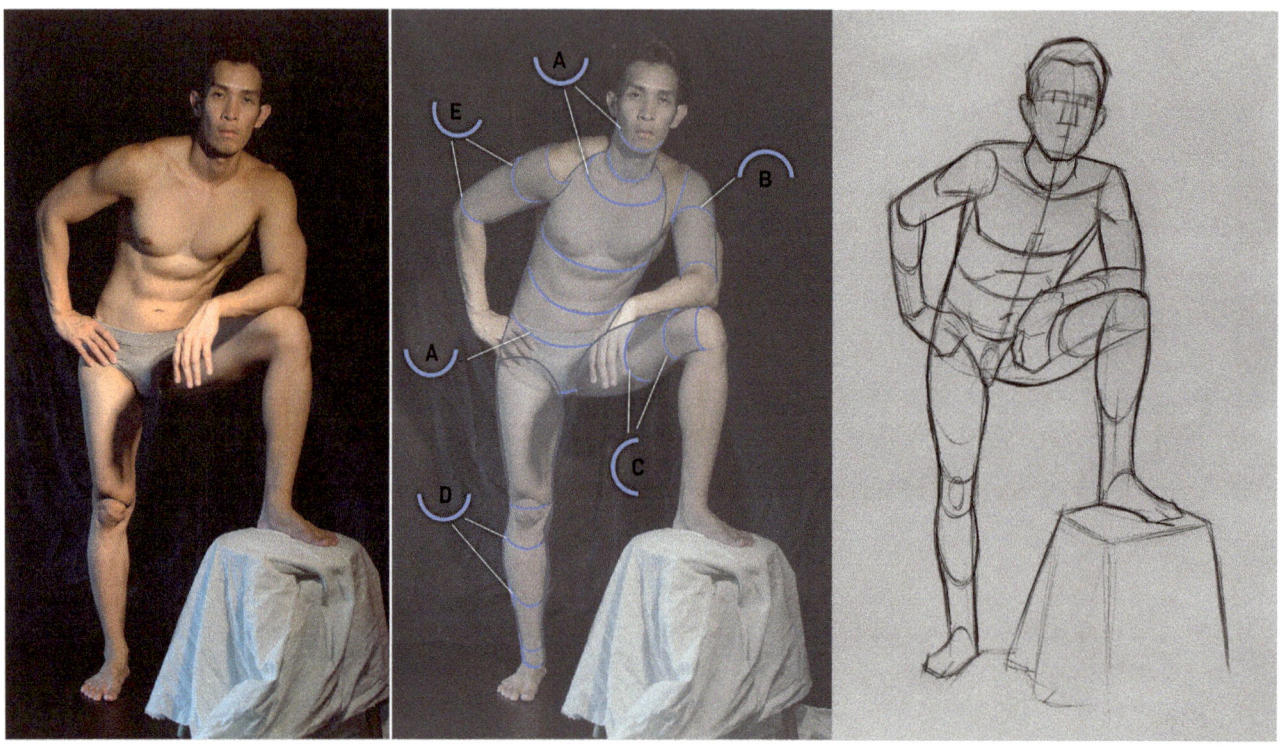

Tool 3: Overlapping Forms

As in a side view, take advantage of the naturally overlapping forms of the body. For example, if the model is bending forward, the head will overlap the shoulders, the shoulders will overlap the chest, the chest will overlap the stomach, and so on. When I draw foreshortened poses, I take advantage of as many overlaps as possible, and I even exaggerate. I will also invent overlaps, if needed, to help me get a better read.

In this pose, there are many overlaps available to use to suggest perspective. In the torso alone, the three sections of the rib cage, abdomen, and hips clearly overlap each other **(A)**. The breasts add another layer of overlap **(B)**. The head clearly overlaps the neck **(C)**, but the hair can also be used to create overlaps **(D)**. To draw foreshortened poses like this, use or emphasize as many overlaps as you can. How many more overlaps can you see?

Tool 4: Tapering Forms

Tapering forms suggest perspective, especially forms that are moving away from the viewer. The more dramatic the perspective in the pose, the more I exaggerate the taper.

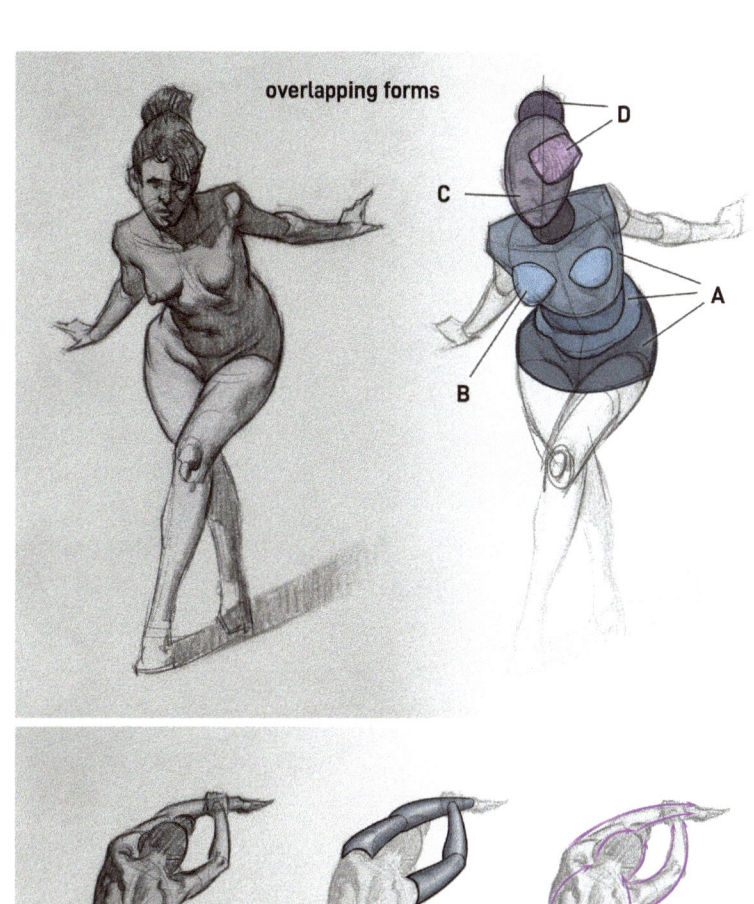

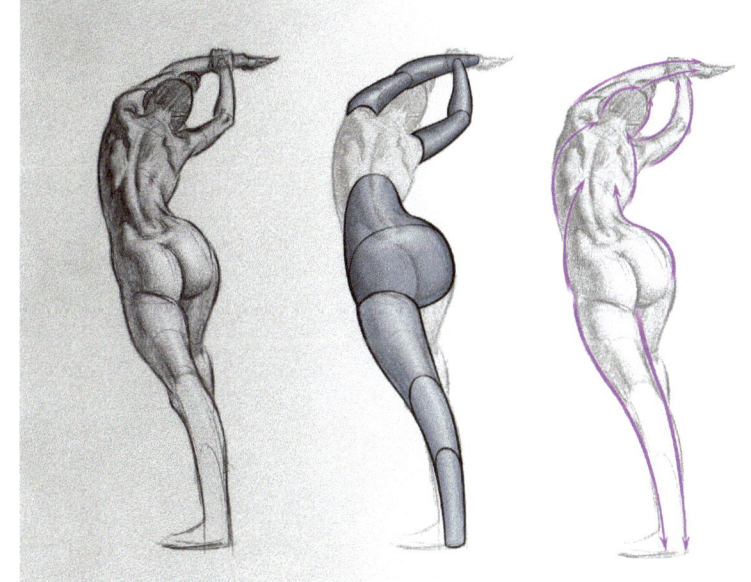

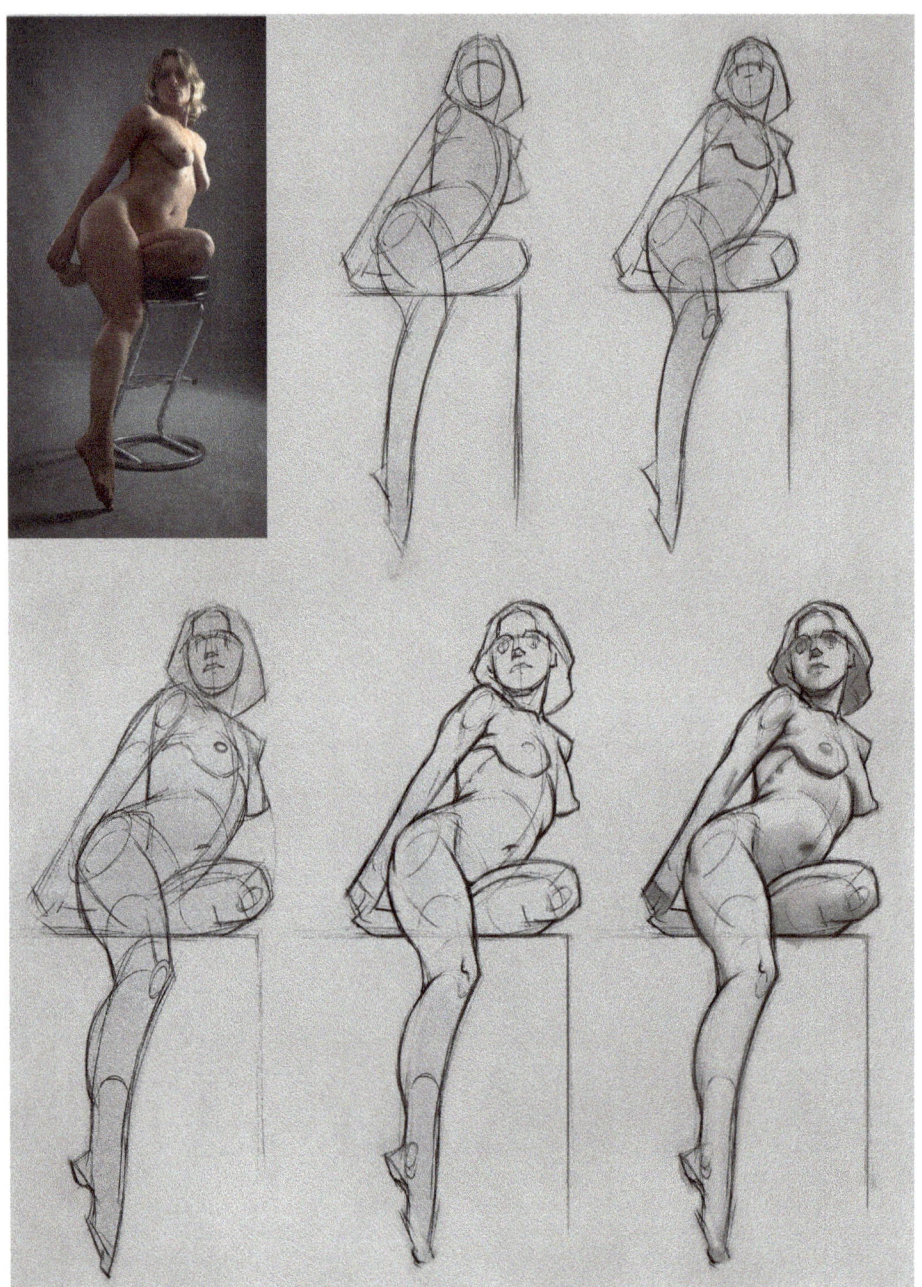

EXAMPLE 1: LOW ANGLE, UP-VIEW

A low-angle pose such as this is common in life drawing because the model is often on a stage. In this example, the model is sitting on a high stool and leaning away.

Observation Notes
Because an up-view is more challenging to draw, I take extra time to observe the pose, look at what the forms are doing, and think of what perspective drawing tools are available to me. The first thing I notice in this pose is the dramatic action and movement. Since the model is leaning back, the body and its forms are moving away from me in an upward, curved motion **(A)**.

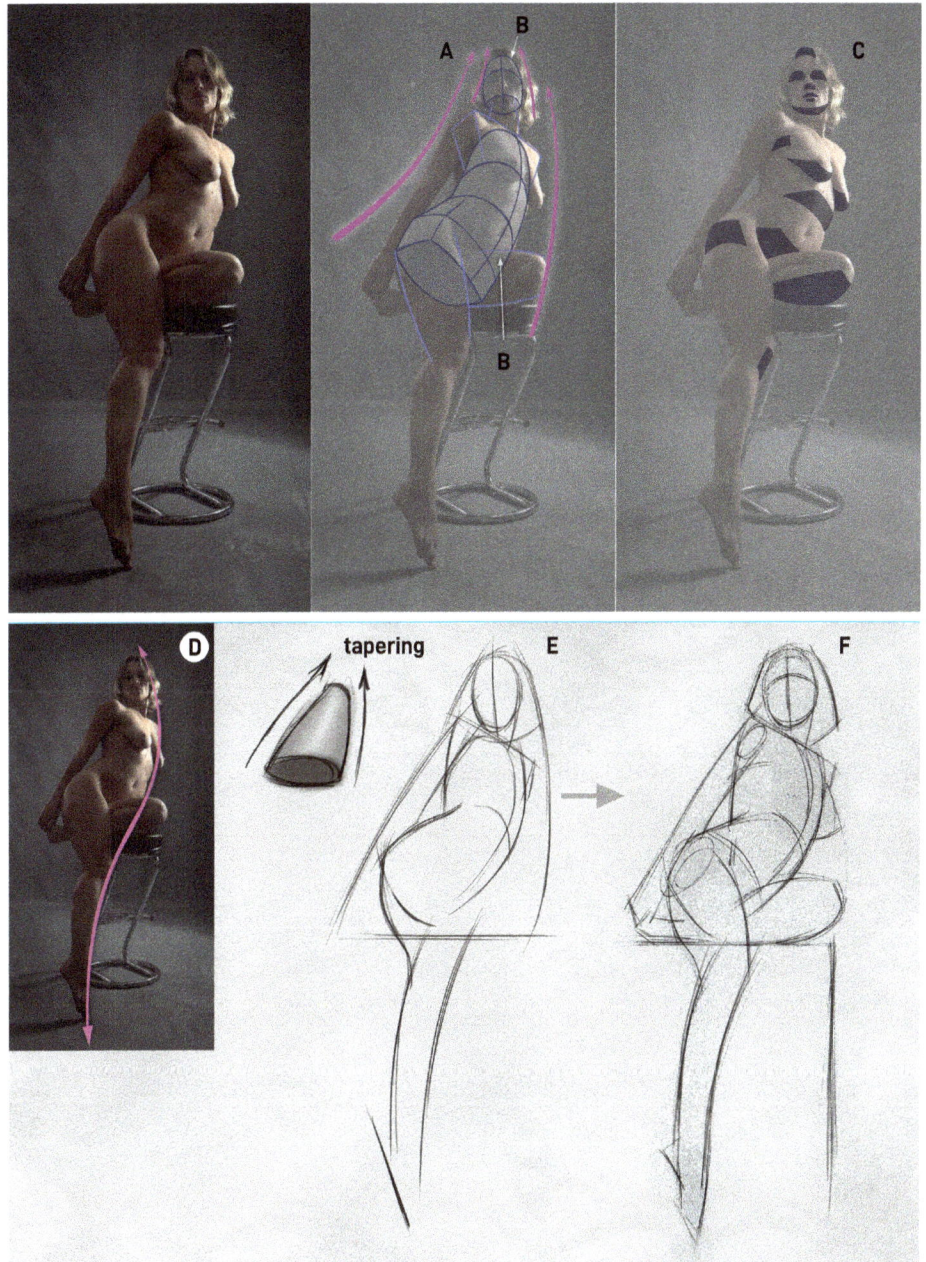

To draw this, I know I will use tapering forms as much as possible, especially when drawing the torso and the head **(B)**. The second thing I look for in an up-view are the underplanes, which are the undersides of any forms. The most noticeable underplanes in this pose are in the head, breasts, abdomen, and left leg **(C)**.

Part 1: Gesture and Shape
This pose has a very clear stretch and action **(D)**. Begin the drawing with the gesture and an outer shape that looks like a triangle or tapering cone **(E)**. This is how you will draw the sections and forms. Next indicate the head and define the shape of the torso, separating its sections. Loosely block in the gesture of the limbs. Block in the legs as two overlapping shapes **(F)**.

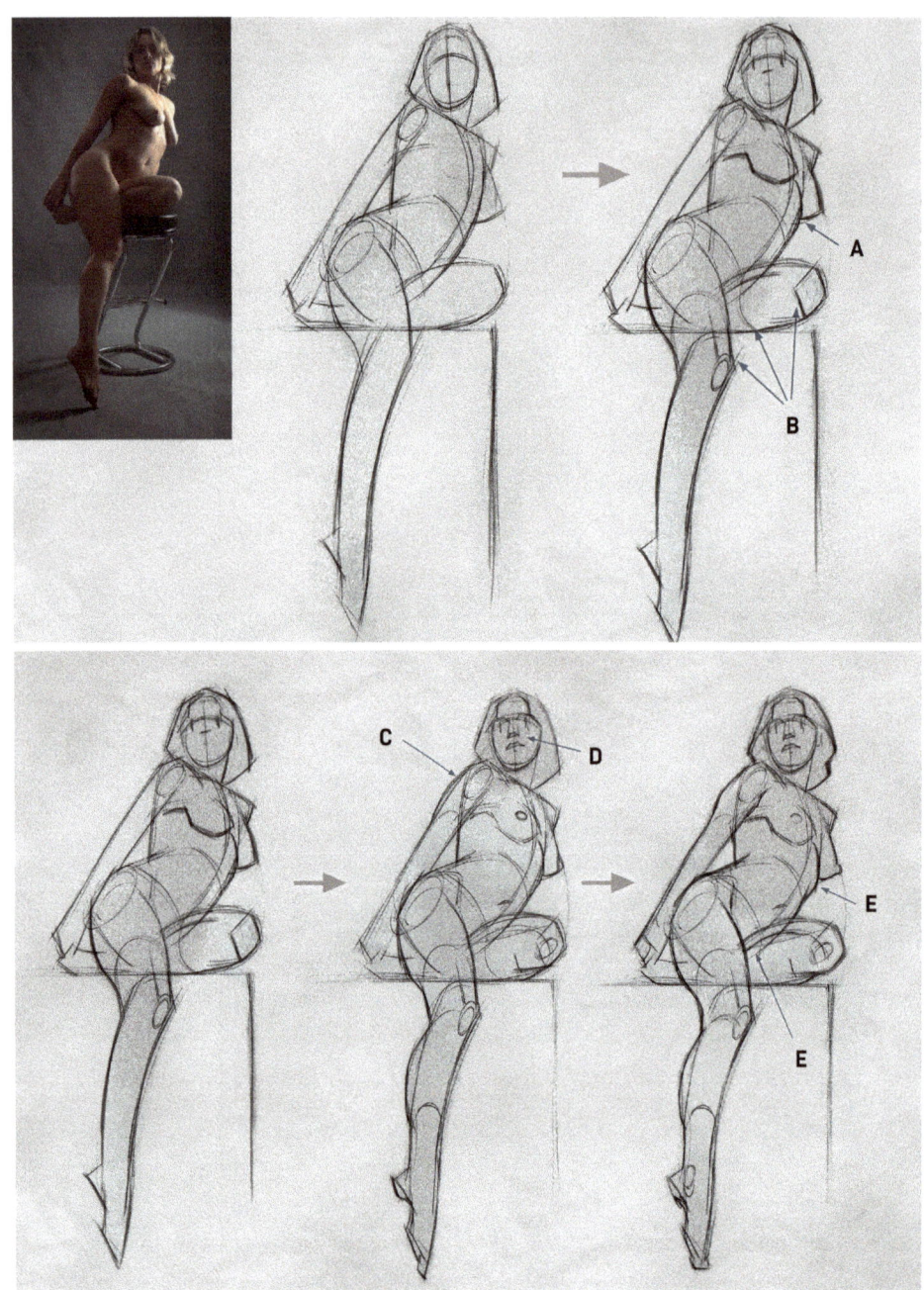

Part 2: Construction, Part 1
Block in the shape of the breasts and draw them in a way that describes the curve of a cylinder **(A)**. This creates a cross section that helps define the position. Start to construct the legs with cylinders and ovals. This adds thickness, volume, and cross sections that you can use to define the position **(B)**.

Part 3: Construction, Part 2
Continue to add construction to the arms **(C)**. Indicate the features, using the underplanes of the eye sockets, nose, and upper lip to emphasize the low-angle view **(D)**. Complete the lay-in by refining the contour of the torso and legs **(E)**.

Part 4: Overlaps, Accents, and Tone

These next steps help the drawing communicate perspective and a low-angle view. First reinforce overlaps by adding dark accents at "T" intersections: the overlaps to the legs, the hip, and the many layers of form around the armpit, breasts, and shoulders. Also accent and define the overlaps of the clavicle, neck, and jaw, which pushes the head back and behind the chest and torso **(F)**.

With the time remaining, you can add tones and edge variation. Because this pose is an up-view, use tone mostly on the overlapping areas, which are occlusion shadows, and especially on the underplanes **(G)**.

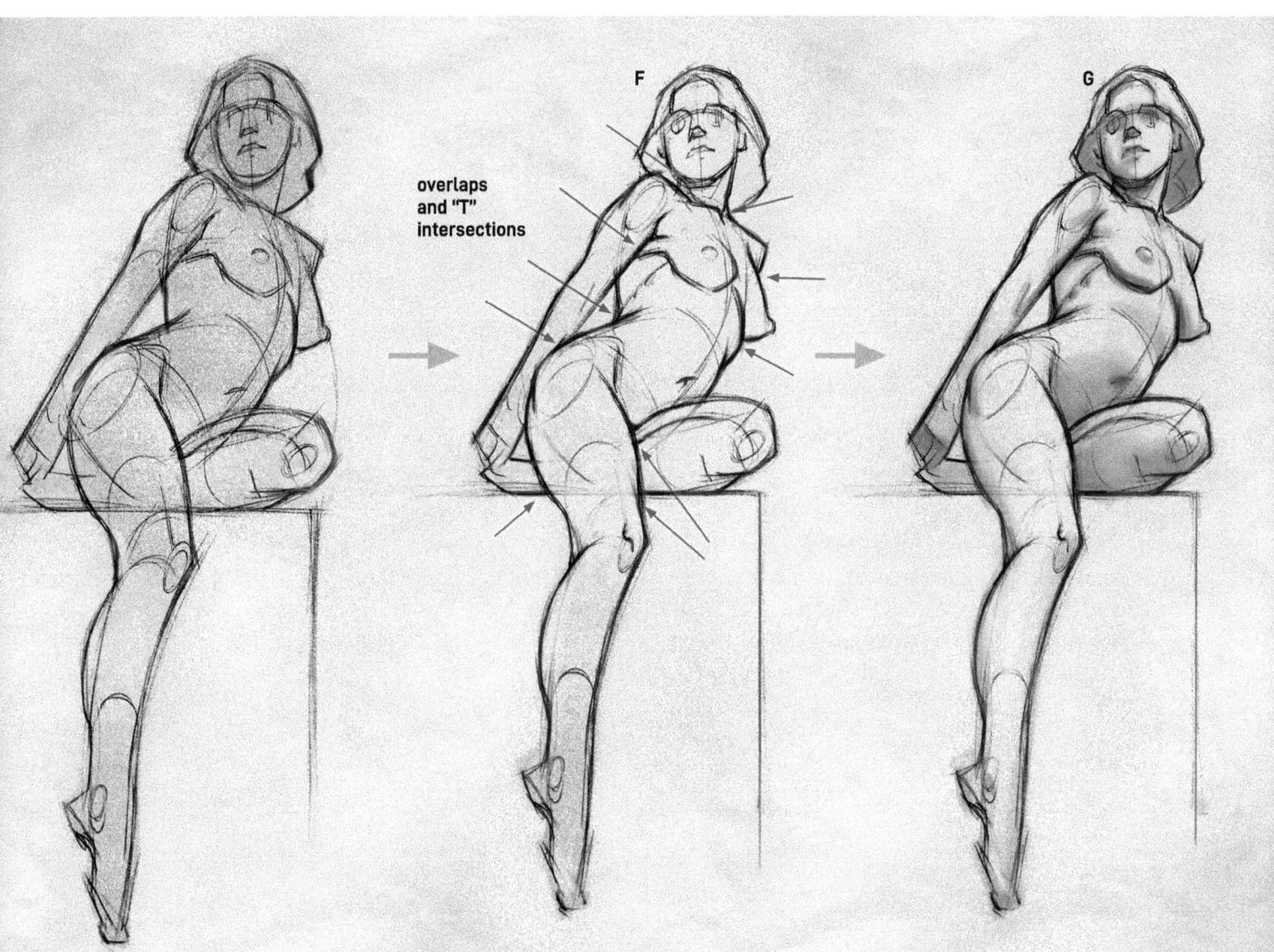

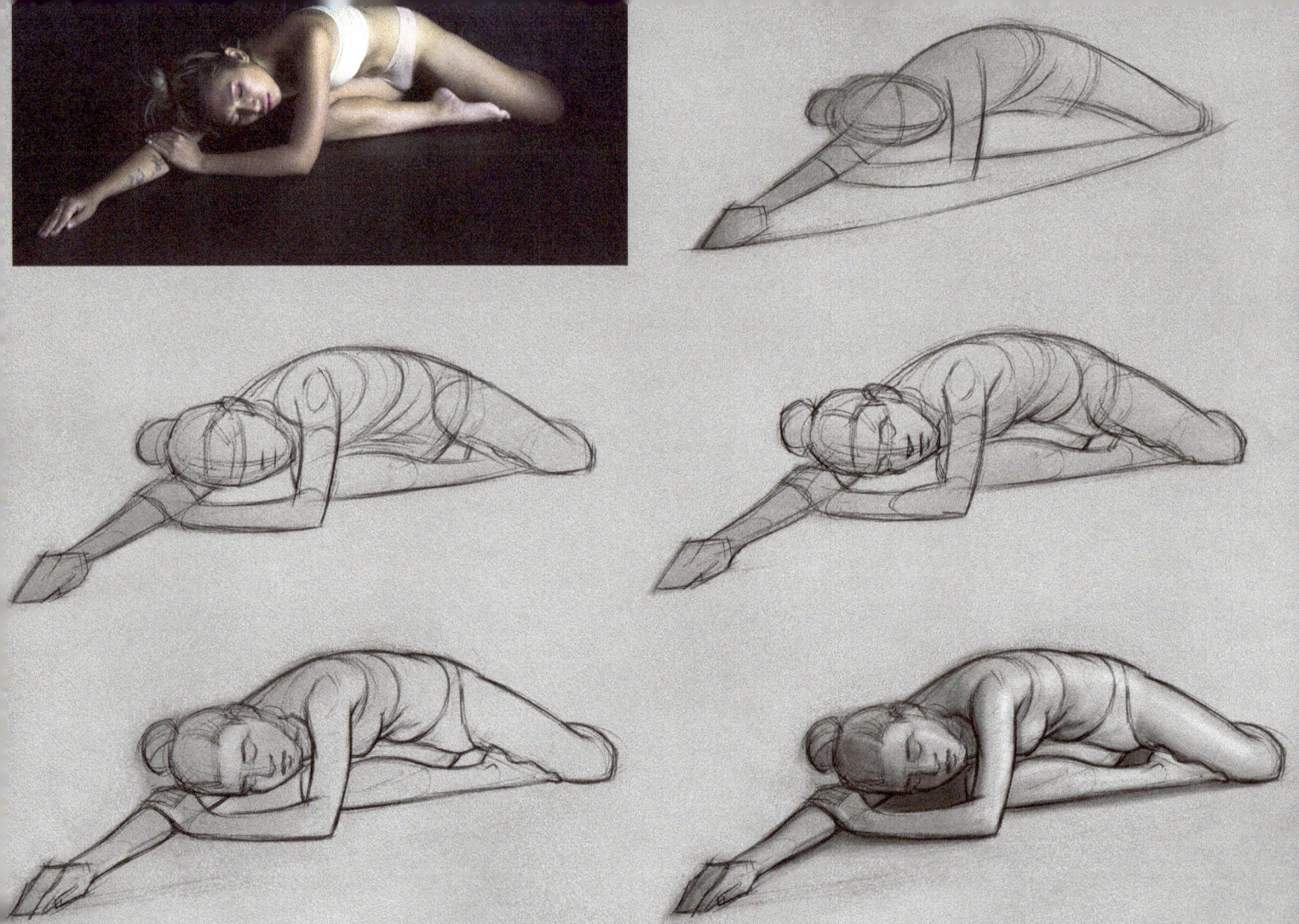

EXAMPLE 2: HIGH-ANGLE RECLINING

Reclining and seated poses are common for longer poses, and they usually come at the end of a life drawing session. If the head and upper body of the model are coming toward you (or away), then the perspective will be a challenge. These poses take much more thought and care to get a good read with natural-looking proportions.

Observation Notes

The first thing I see in this pose are the tapering forms. The torso and lower body as a whole are foreshortened, and the forms are naturally tapering **(A)**. The tapering cylinder of the right arm also suggests perspective **(B)**. The second tool you can use in this pose is overlaps. For a pose with this much perspective, use as many overlaps as you can. Here the overlapping layers are clear. The head and right arm are clearly in front of the torso **(C)**. The left arm and shoulder are on top of the torso **(D)**. The sections of the torso have clear overlaps **(E)**. The legs are also another layer you can use **(F)**.

Part 1: Gesture and Shape

The action line in this pose runs along the torso and extends all the way from the fingertips through the body to the left knee **(G)**. Relate the hand to the knee to create movement and help with the proportion **(H)**. Draw the gesture of the head shape and pinch side of the torso **(I)**. Next block in the shape of the legs by following the gesture of their contour **(J)**. Use tapering lines to block in the gesture and shape of the arms **(K)**. Simplify the hands into triangular shapes **(L)**.

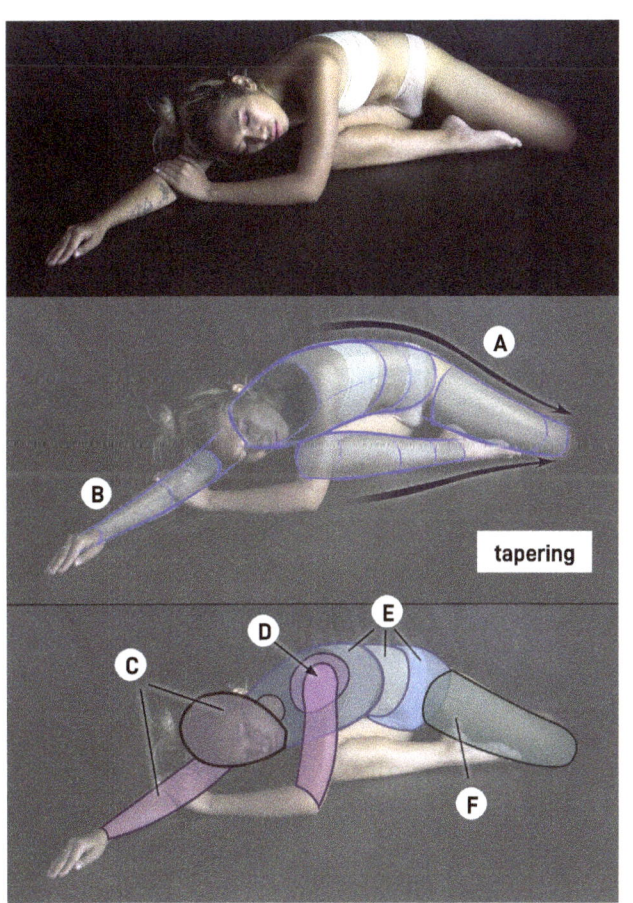

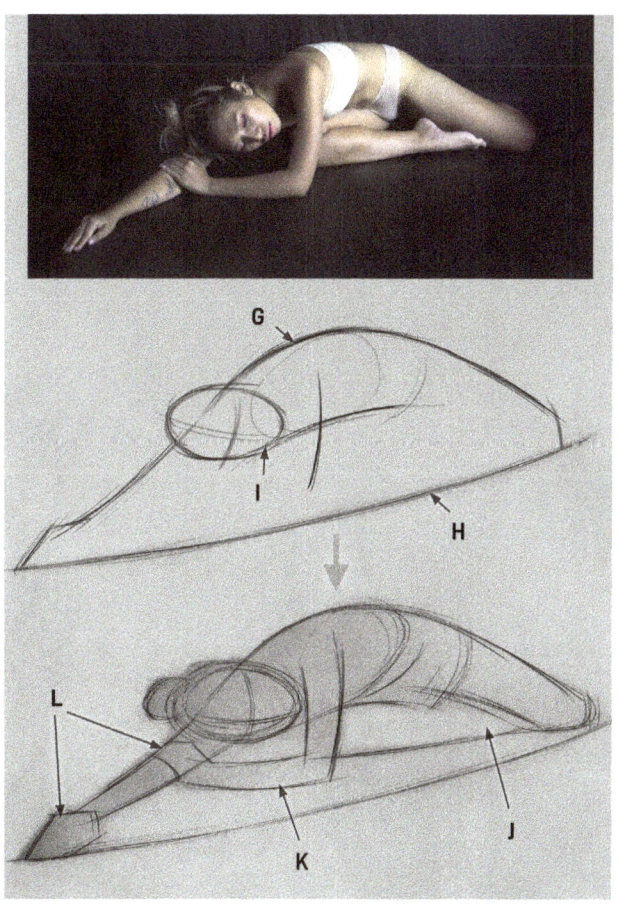

Part 2: Construction, Part 1

The gesture drawing gives you a lot of movement and a good 2-D shape to work with **(A)**, but to communicate the perspective you need to add construction to the figure.

Start construction by indicating the features and adding some details to the head **(B)**. Next add cross sections to the arms to add volume and define their position **(C)**. For the torso, separate the sections **(D)**. Construct the legs with cross sections, and also block in the foot **(E)**.

Part 3: Construction, Part 2

To complete the lay-in, add anatomy and details to communicate perspective. Start by adding anatomy to the shoulder **(F)** and then the forearm and hand **(G)**. In the torso, add the shape of the breasts and then folds and overlaps in the abdomen **(H)**. Add sockets and details to the facial features to help communicate the head's position **(I)**, and also add detail to the foot **(J)**.

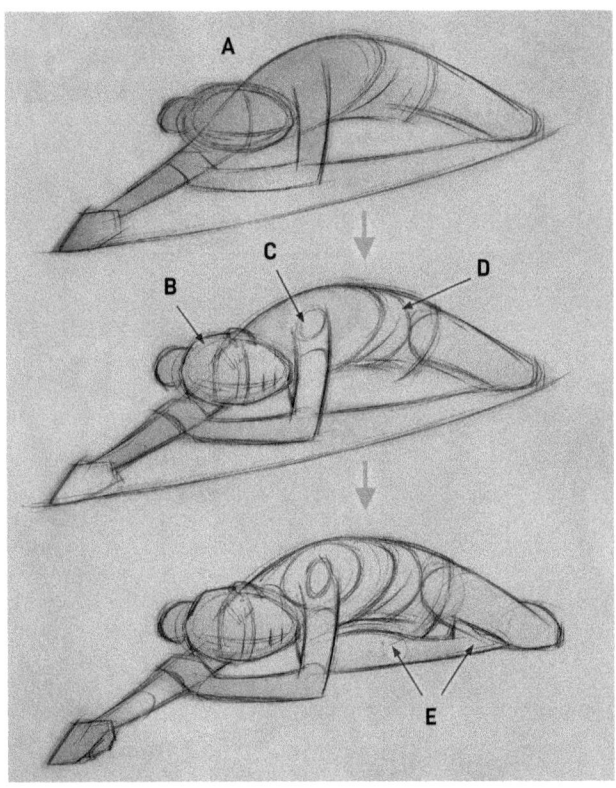
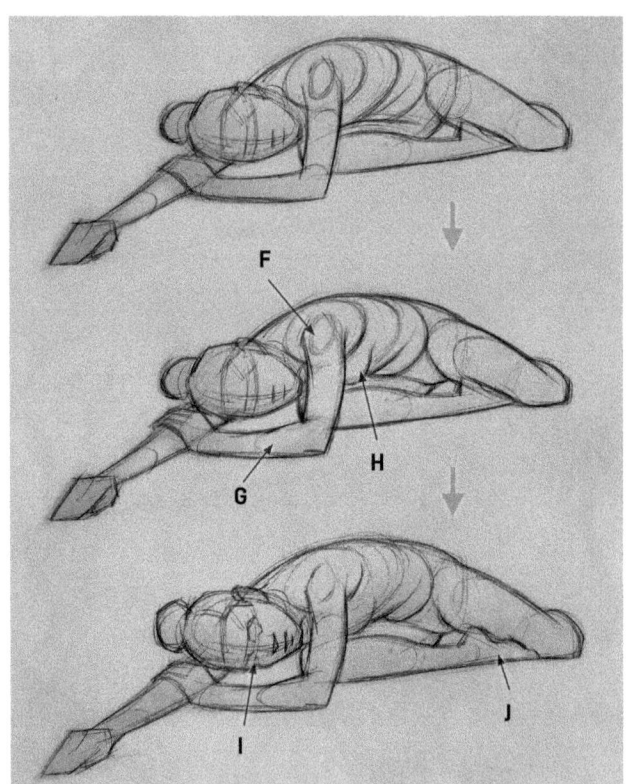

Part 4: Overlaps and Accents

For foreshortened poses like these, emphasize and exaggerate any overlaps. Start with the overlaps in the abdomen and the right leg and calf **(K)**. Next emphasize the arm overlapping the torso and leg **(L)**. Also add dark accents where the head and hand overlap the extended arm **(M)**. To create more depth, exaggerate the overlaps in the contour, especially where the abdomen connects with the hip and the hip connects with the leg **(N)**. At this point, you have completed the lay-in as a line drawing. The last tool you can use to create more perspective and depth is shading.

Part 5: Shading

If you have time remaining, add medium dark tones in the overlapping areas, especially around the abdomen, chest, and right leg. Next add tone at the left sides of the forms, the top of the left shoulder, and the front of the face **(O)**.

Darkening the cast shadows adds contrast and helps ground the figure **(P)**. To add even more volume and depth, you can also add highlights where the forms are facing the light source **(Q)**.

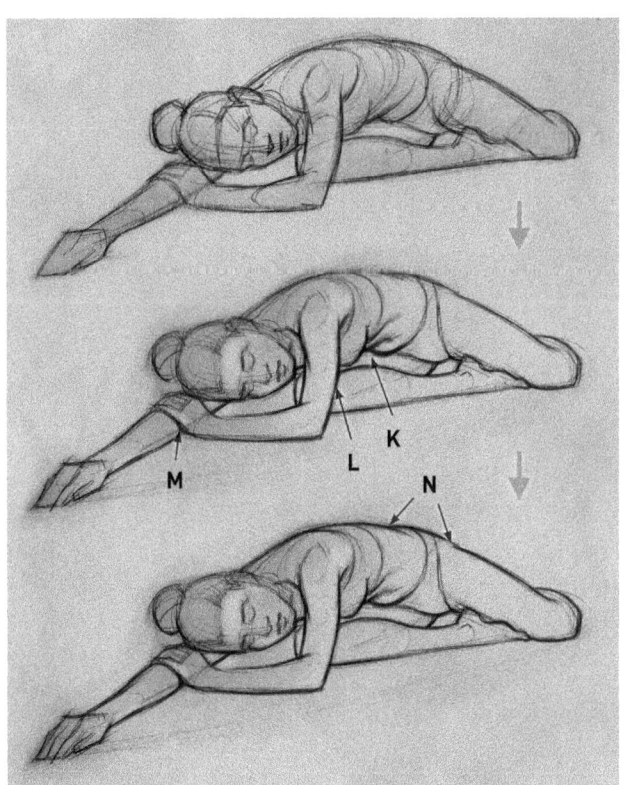

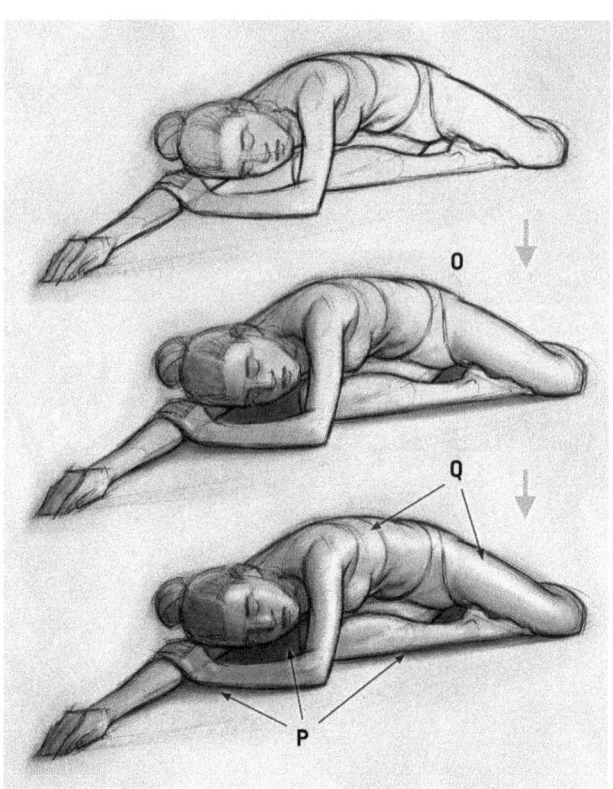

CHAPTER 5

EXERCISES AND SELF-STUDY

Recommended Exercises

I was recently teaching a live drawing workshop where I met a very motivated student. This young man asked me one of the smartest questions I've ever heard from a student: *"What exercises should I do?"*

I was shocked at the simplicity of this question. I realized that this student echoed something I had asked my mentors and teachers many years ago. It was a question I asked myself when I began my life drawing journey. Because it seemed so long ago, and because of all the thousands of hours of drawing I had done and the decades of professional experience, I had forgotten how much practice and exercise I had done myself when I was first learning figure drawing. To this young student, thank you for the reminder.

These homework exercises are divided into three parts: drawing from life and observation, dexterity exercises, and old master studies. Each homework exercise has several assignments. They don't need to be done in order because the exercises complement each other, but if you want to learn the material in this book, the obvious starting point is to draw the figure from life.

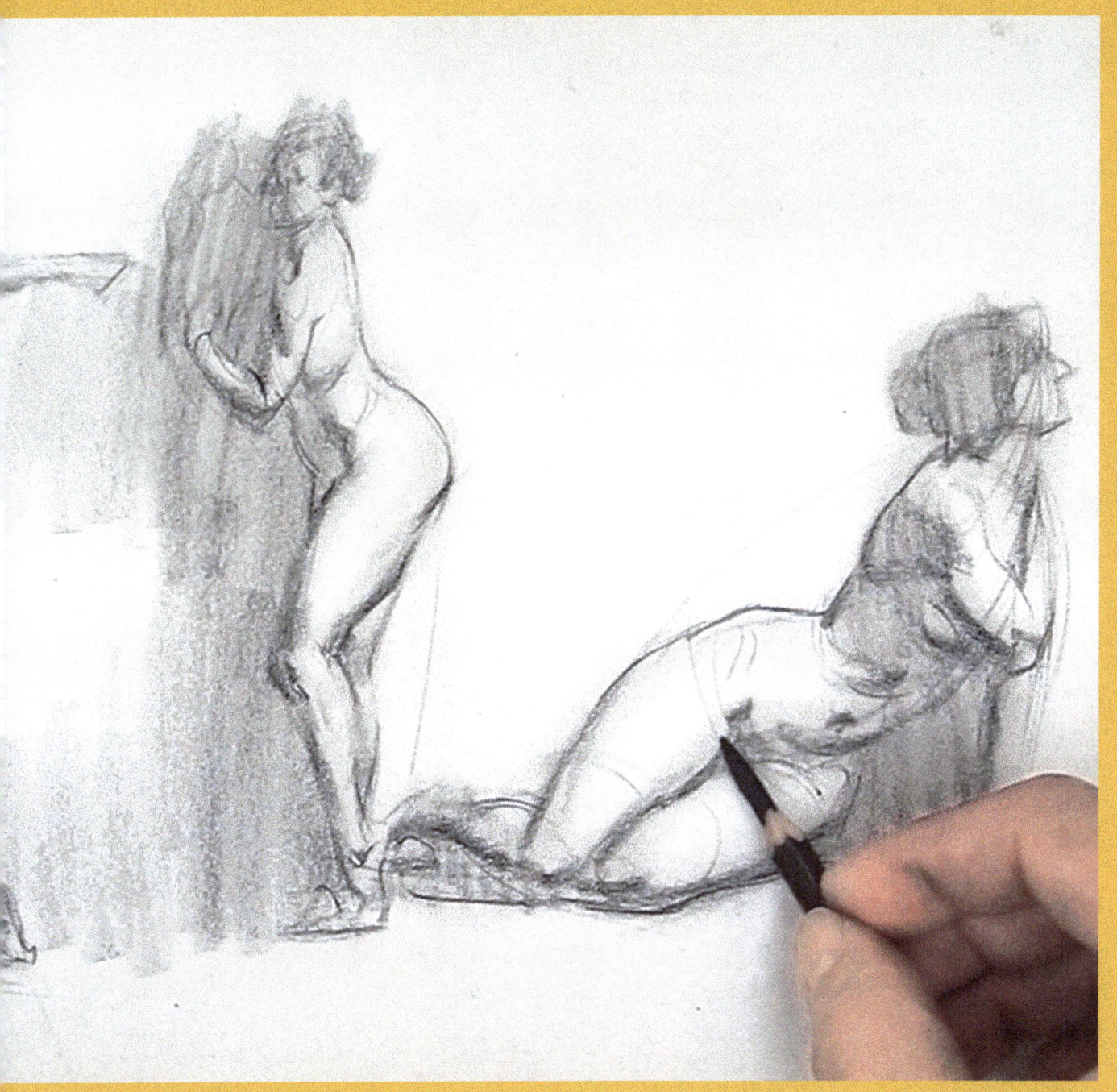

PART 1
Drawing from Life and Observation

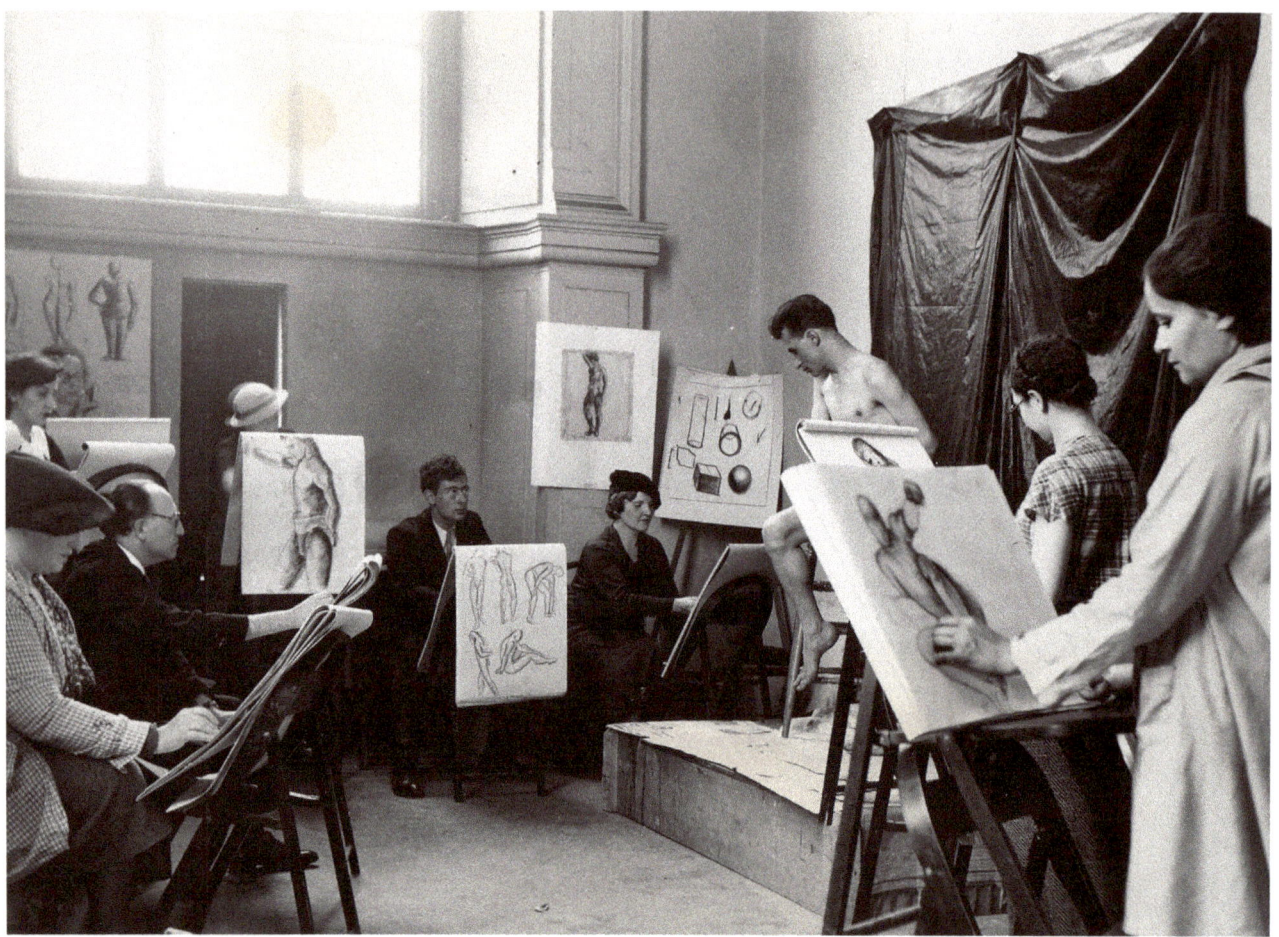

Adult art class at the Brooklyn Museum in 1935. Federal Art Project. Archives of American Art.

Your first, and most obvious, homework assignment is to draw from life and draw as much as possible. For me, "as much as possible" means at a minimum I would complete at least:

- 1 sketchbook page a day
- 1 full 18" x 24" (46 x 61 cm) page a day

If you follow even 20 percent of the exercises in this chapter you will easily accomplish that. From my experience, one page a day, consistently, every day, is better than seven pages in one day. Consistent practice and repetition is the key to rapid growth and learning.

EXERCISE 1: DRAW FROM LIFE

Now that you have this book, it's time to put it into action. If you haven't already, go to your local life drawing workshop and put in some work.

Assignment 1: Find a local life drawing workshop
If you've never drawn from life, this assignment may be the most difficult. Getting started is often the hardest part. Fortunately, life drawing workshops are everywhere, at least in the Western world. If you are in the United States and live near a major city, you can definitely find one. Following is a short list of the places I suggest looking at to find a local life drawing class. When I have moved to a new city or have traveled, this is where I start my search.

1. Local Art Schools
Most colleges and universities offer art classes and many have life drawing class. The classes will most likely be instructed, so you may have to register and become a student. Many schools that teach realism or illustration offer uninstructed drawing workshops organized by student groups or graduates. If any of these is not available or enrolling as a student is not possible, simply contact the drawing professor, current students, or graduates. Here's a hint: look for students carrying around 18" x 24" (46 x 61 cm) drawing boards. If you see them, you know you are in the right place.

2. Online Searches
Many drawing groups post their events online. One of the best sites to search is Meetup.com. Meetup is where event organizers can post and share their event. Meetup is global, so if you are outside the United States, this may be a good online resource. To search, visit www.meetup.com.

The second online resource I suggest is the figure drawing directory by Artmodelbook.com. This website is run by a former life drawing model. He has compiled a wonderful list of local life drawings in the United States and Canada. For more, visit www.artmodelbook.com/figure-drawing-directory.htm.

3. Local Art Stores
Your local art store is a great resource for events. If you're drawing every day, you will be going quite often, so next time you're buying new pencils or newsprint, check the bulletin board for flyers. Life drawing workshops and classes will be posted there. Talk to staff—they are artists too. If you see a customer buying an 18" x 24" (46 x 61 cm) drawing board and some newsprint, talk to them too! They are going where you want to go.

Some of the large art stores even host their own life drawing workshops and classes. Look for flyers and posters and ask the staff about life drawing workshops.

4. Cafes and Bookstores
Like the art store, bulletin boards at your local coffee shop or bookstore will have local events. Cafes and bookstores often host local social groups, and there may be drawing/art groups there. Talk to the barista or staff as well.

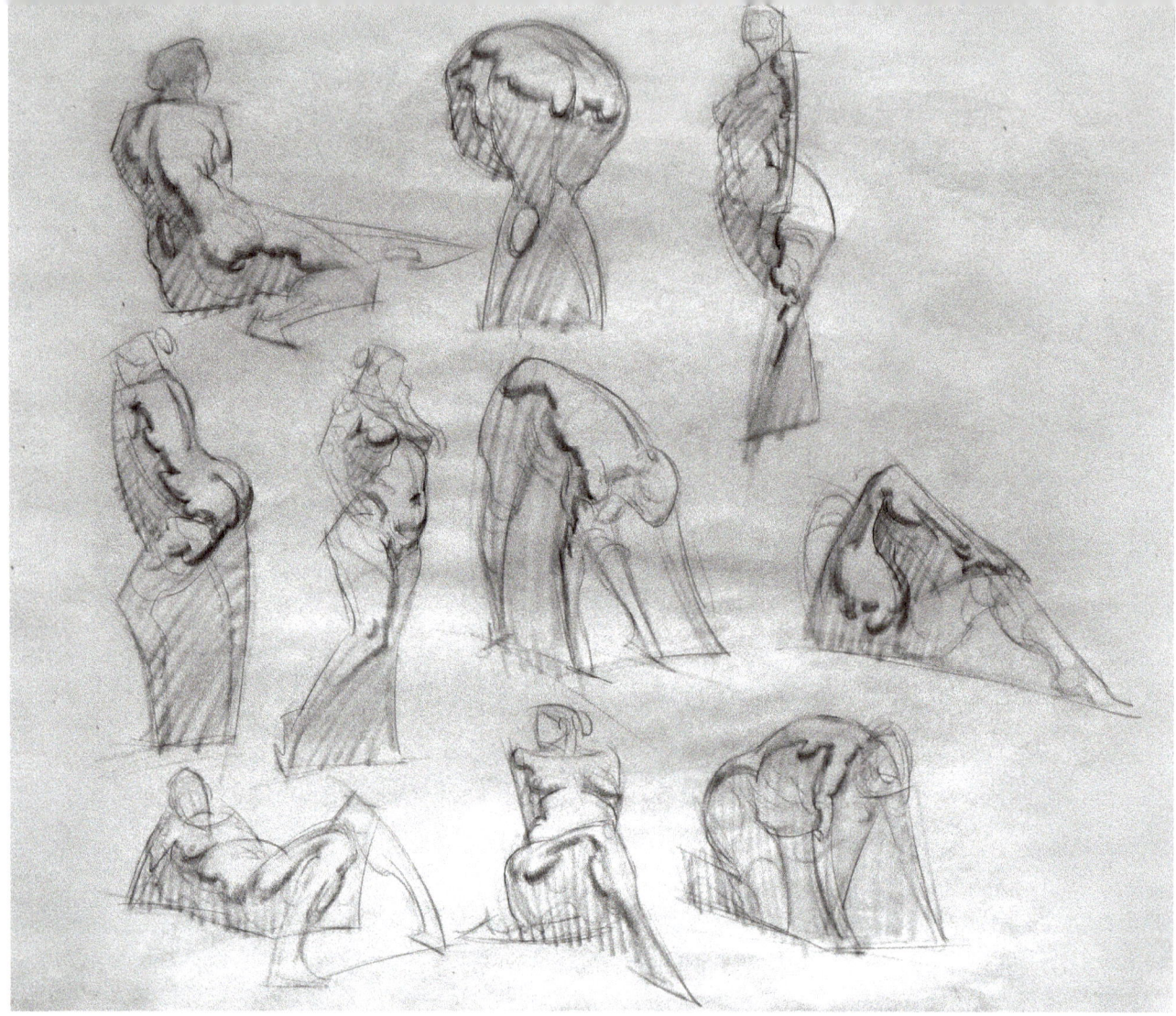

Assignment 2: Go to at least one life drawing session per week

Now that you've found a local life drawing session or have already gone, the next goal is to go as often as possible. When I was first exposed to this information, figure drawing became so much fun and so rewarding. It can be fun and rewarding for you too, if you practice and apply the knowledge in this book, but you have to go! When I was starting out, I went three to five times per week. Fortunately, living in Los Angeles at the time, I had a lot of access to life drawing workshops. Even if you can't go three times per week, once a week is a great routine to start.

Alternatives to a Live Life Drawing Session

Understandably not everyone reading this book lives in a major city of a Western country. The practice of drawing a nude or semi-nude model may be a foreign, or nonexistent, concept in your country or region. Culturally, nudity may be considered taboo, or even illegal. If you truly love to draw and want to learn, this should not stop you. There are still ways to learn and practice life drawing. All you need is an internet connection and your field sketching materials.

Assignment 3: Two pages of gestures
The page opposite is a full 18" x 24" (46 x 61 cm) page of two-minute poses from a life drawing session. This session was structured well and had a set of 1s, 2s, 5s, 10s, and 20s. Most life drawing sessions will have at least one to two hours for short poses and gestures poses. If you go regularly, it will be very easy to fill up pages in your newsprint pad.

Assignment 4: One page of torso studies
Torso studies as shown above are great for learning the life drawing process. Practice as many torso studies as you can every week. If you go to life drawing sessions regularly, commit one workshop session, or at least the first two hours, to only doing torso studies.

Life Drawing Video Stream

There are now life drawing video streams and timed poses available online. The life drawing I have used and recommend the most is by Drawthis. Not only does Drawthis hire experienced figure drawing models, it records in a professional studio with high-quality lighting. The structure of its timed poses is also ideal for practicing and studying the drawing process in this book. To see the streams, visit www.drawthis.com or go to YouTube and type in "draw this."

I only recommend drawing from photography or any still images for more intermediate and advanced students. Gesture, structure, and rhythm are best learned by studying a living, breathing model. That's why I recommend the Drawthis stream, because it is a recording of live model.

The other alternatives to drawing a figure model are cafe sketching and old master copies, which are also covered in this chapter.

EXERCISE 2: CAFE SKETCHING

If you don't have access to a live model, or if you are a drawing machine and can't stop drawing, the world can be your life drawing workshop if you practice field sketching or "cafe sketching." Cafe sketching is drawing people in public spaces. Cafes and coffee shops are obviously the most ideal locations. People sit in one place, there are tables, and you have drinks to keep you going. Cafes are everywhere too, so there's really no excuse not to practice. In addition to cafes, here are some of the locations where I sketch and draw people:

- bookstores
- trains and buses
- airports
- restaurants

Virtually any public gathering place is an opportunity to draw, which is why I bring my sketchbook and materials everywhere I go.

If you've already tried cafe sketching, you know that the main challenge is the speed at which you will have to draw. People aren't figure models, so they don't hold still. You may only have a few seconds before their pose or angle changes. For new students, I recommend practicing your observation and gesture. Capture the action of the pose and then take a mental picture of the person's shape, silhouette, features, and clothing. Keep observing and drawing until they move, and then resolve the sketch from memory. I'll admit, it's very tough, but keep practicing and over time your observation skills, decision making, and visual memory will improve.

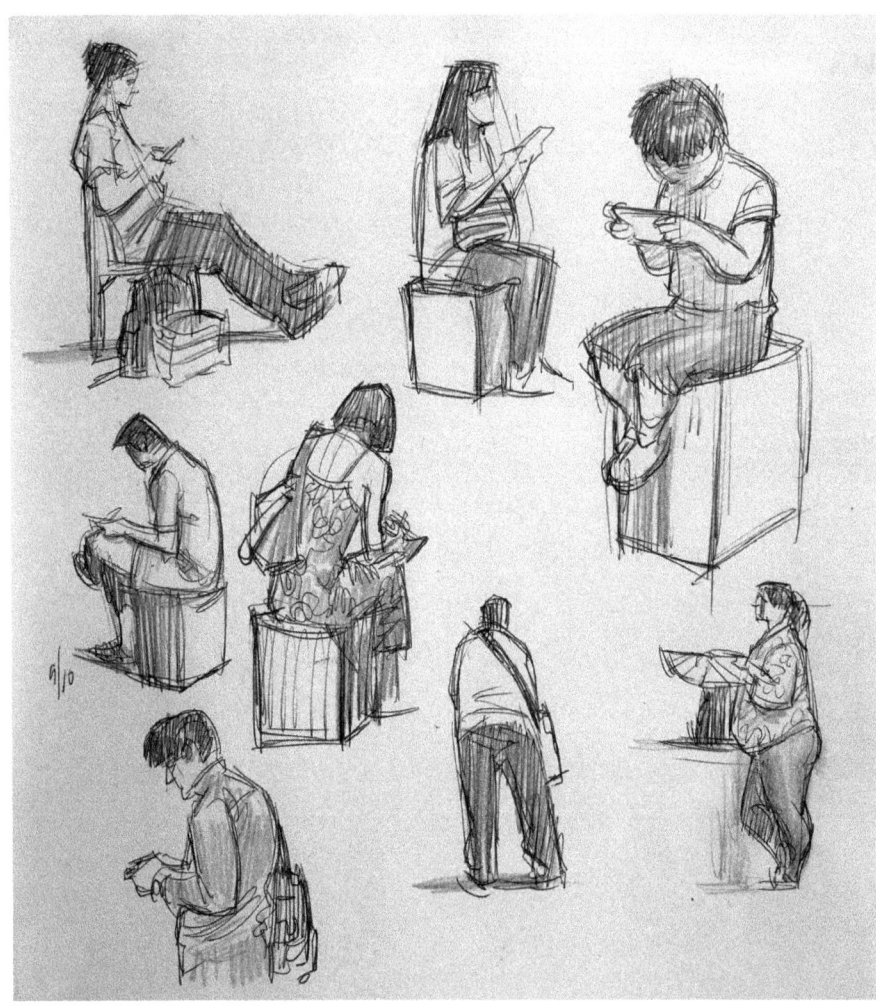

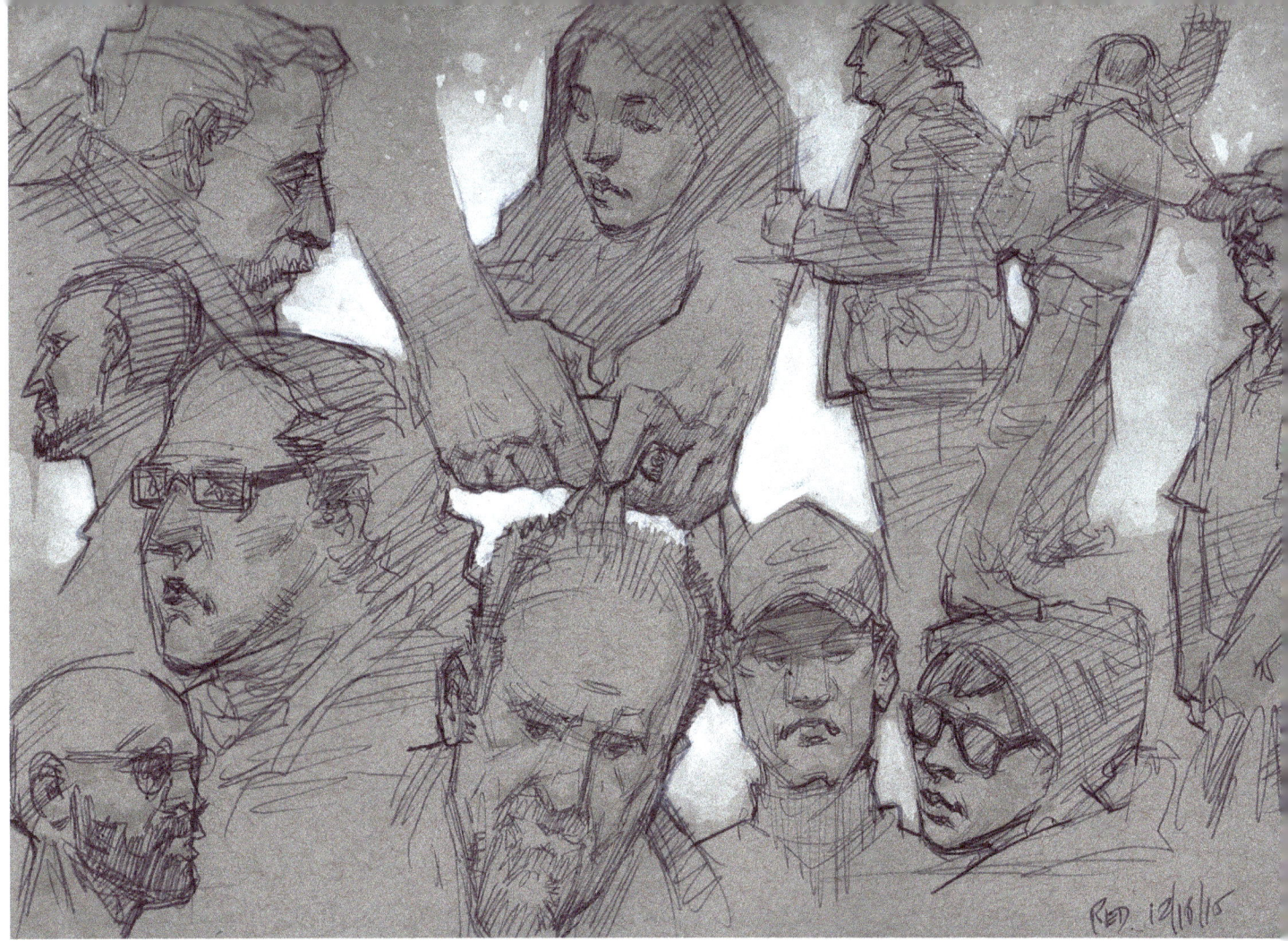

Assignment 5: One page of full figures
The sketchbook page of figures (opposite) is from a waiting area at a government office. This was a large open space, so there were dozens of people in my view. Fortunately there was seating available, and I could practice full-figure gesture sketching on the seated people before sketching the standing models, who moved a lot more.

Assignment 6: One page of heads and faces
The sketchbook page above is from a long subway train ride through Hollywood. From my seat it was rare to see a full figure, so I focused on heads and faces. For beginners, this is a great time to practice the head indication techniques from chapter 3. When I draw in the field, I try to capture the movement and shape and the placement of the features. The details and shading can be added from memory.

PART 2
Dexterity Exercises

Dexterity is defined as "skill with the hands." For life drawing, this means skill with the pencil. If you are new to the undercup grip, these exercises are even more important. Undercup is a new motor skill, and it takes time for the muscles in the hand to adapt and become comfortable with it.

The first time I started drawing with an undercup grip, my dexterity was awful. My marks were rough and inconsistent. When it came time to shade, my tones looked very bad. As someone who already had drawing experience and some ego, I was embarrassed.

Fortunately, any new skill can be quickly learned and sharpened with the right exercises and constant repetition. These exercises will help make your marks as clean and beautiful as possible. They will improve your line control, but the most challenging and rewarding skill to improve first is making clean tones.

Assignment 7

Assignment 8

Assignment 9

EXERCISE 3: TONE BOXES

This simple exercise can be a lot of fun and very rewarding. From my experience, this one exercise produces the fastest results in improved overall dexterity. To do the tone boxes exercise, simply draw a small square, about 1" x 1" (2.5 x 2.5 cm), and then use the side of the pencil to fill the box with tone. The goal is to make the tone as even and as smooth as possible.

Fill an entire 18" x 24" (46 x 61 cm) newsprint page with squares. Start with vertical, up-and-down strokes. Once you fill a page with vertical strokes, do horizontal strokes, and finally diagonal strokes. When you become more comfortable and want a challenge, try curved strokes. Do this exercise every day and you'll be amazed at how quickly your dexterity will improve. Tone boxes can also be a great warm-up before a life drawing session, or an exercise between model breaks for ambitious students.

Assignment 7: One page of boxes, vertical strokes
Start with pages and pages of vertical boxes. For variety and a challenge, reverse your stroke and go from the bottom up. It may be very uncomfortable, but the more you practice uncomfortable positions, the better your dexterity will be and the faster you will improve.

Assignments 8 and 9: One page of horizontal strokes and one page of diagonal strokes
With horizontal strokes, go from left to right and fill the box from top to bottom. For variety, do the exact opposite and stroke from right to left and fill the box from bottom to top.

For diagonal strokes, start working down to the left because this is the most comfortable angle. For variety and a challenge, do diagonal strokes down to the right. For even more challenge, do the opposite and stroke diagonally up.

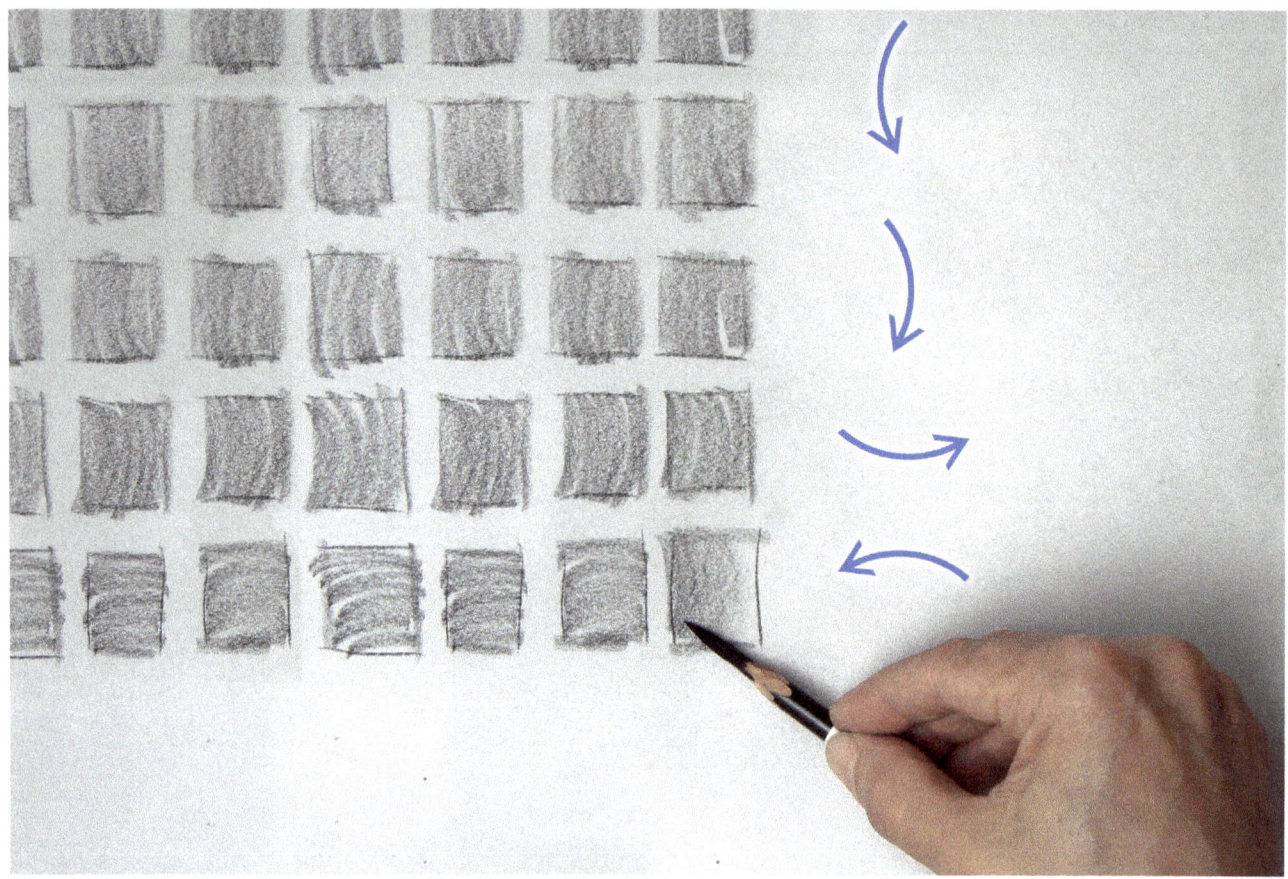

Assignment 10: One page of curved strokes in multiple directions

The most difficult and challenging are curved strokes. Downward strokes, curving out to the left and right, are most comfortable for me. Once I'm comfortable working downward, I do horizontal strokes, curving down and curving up. Fill a whole row (or multiple rows) with the same stroke, and then make a new row when switching to another stroke.

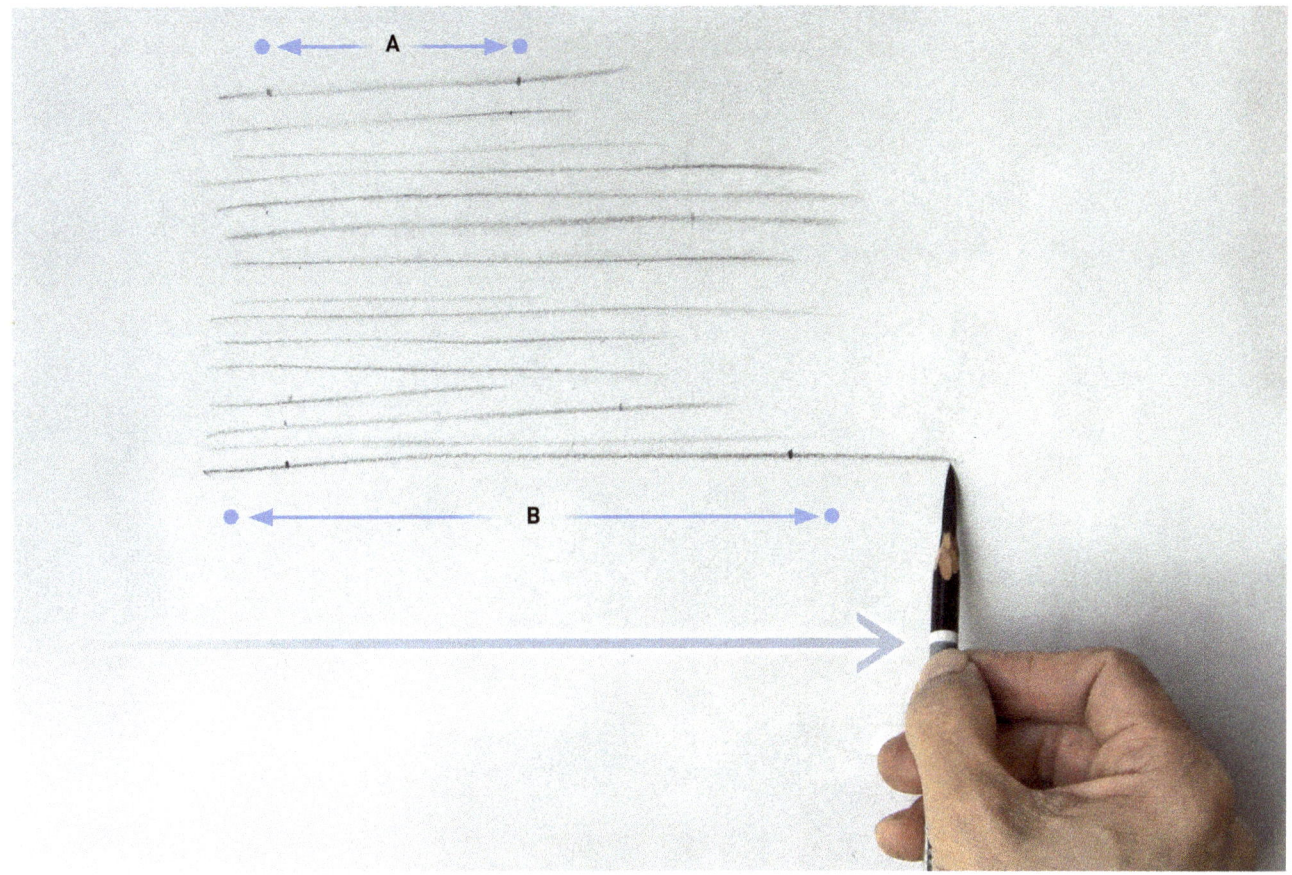

EXERCISE 4: CONNECT THE DOTS

To get better line quality fast, do the connect-the-dots exercise. I can't think of another exercise that can dramatically improve line quality in a such a short amount of time. Using an undercup grip, simply draw two dots and then try to connect the dots with a single stroke. Imagine the tip of the pencil is an arrow and the second dot is a bull's-eye. Try to hit the dot at the end of your stroke.

If you don't hit the dot that's okay. With practice, you will. What makes this simple exercise so much fun is the feeling of excitement you get when you can hit the dot with the stroke. It's very rewarding and makes practice fun.

Assignment 11: One page of straight lines
Start with a small gap between the dots **(A)**. As you get comfortable, make the dots farther and farther apart **(B)**. Eventually, try to go the entire width of your paper. As your dots get farther apart, draw with your whole arm. The more of your arm and body you use, the better and cleaner the stroke will be, and the better chance you have of hitting the mark.

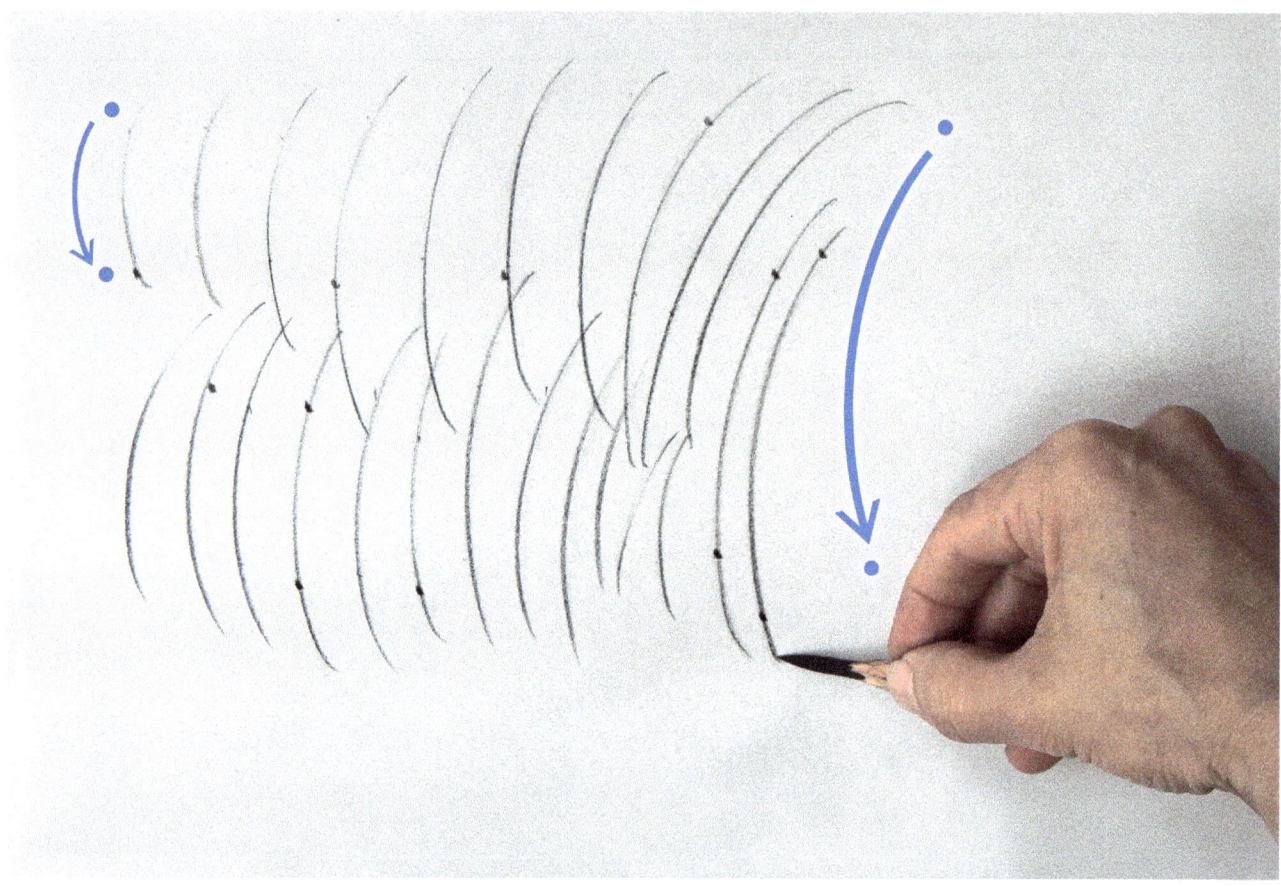

Assignment 12: One page of curved lines

For variety and a challenge, try to connect the dots with a curved line. I like to start with vertical strokes and then practice horizontal strokes.

EXERCISE 5: WRITING IN UNDERCUP

This exercise may seem a little strange, but don't underestimate writing in undercup. When I first started to seriously study life drawing I wanted to improve so badly. My dexterity with an undercup grip was still weak. My lines, and especially my tones, were so ugly. One day, as I was sketching in my sketchbook with a brush pen, I started writing some notes while still holding the pen in an undercup grip. Writing in this new grip was very stimulating, so I decided to keep writing and fill a whole page. After writing consistently, I was shocked by how much better my line quality was when I went back to life drawing. Writing forces the hand to go in many directions, angles, and curves, which of course translates beautifully to drawing strokes.

Assignment 13: One sketchbook page of undercup writing

To do this assignment, I recommend using either a brush pen (pictured here) or a long lead pencil. The subject of your writing doesn't matter. I used to write drawing notes and ideas. If you're out of ideas, just fill the page with this phrase: "I will go to life drawing every week and practice drawing every day."

PART 3
Old Master Studies

Copying the artwork of the great artists in history, also known as the "old masters," is a long-honored tradition. Every successful professional artist I know and every great drawing teacher I have had in my life has studied and admired the works of great artists in history. Some love the famous Renaissance artists such as da Vinci or Michelangelo. One of my teachers admired and studied Rembrandt. The main reason why I do old master studies, and the reason why I recommend it to my students, is how quickly these exercises help me improve.

Old master copies are almost like having a "cheat code" to drawing. These great artists are masters because they have worked a lifetime on their drawings. In their drawings and paintings, they have faced, overcome, and resolved every drawing problem possible. So when you study a masterpiece, you get to skip all the pain and struggle of countless errors and mistakes and draw only what works, what looks good, and what reads well. In a way, it's like skipping the beginner level and going straight to mastery. Pretty cool, right?

I'm always surprised at how quickly I improve after I study the old masters consistently. If you do these exercises consistently, you too will be surprised at how quickly you improve.

WHO ARE THESE "OLD MASTERS?"

What qualifies someone to be an "old master"? There are many great artists in history, and there are probably many names that first come to mind. For the purpose of realistic figure drawing, I recommend looking to the great painters from the past who are recognized and appreciated for their figures and realism. Below is a short list to start your journey:

1. Peter Paul Rubens
2. William-Adolphe Bouguereau
3. Diego Velázquez
4. John Singer Sargent

This is a very short list, but these artists are generally accepted as masters. They also have many works that feature figures and nudes. If you want more examples and are not sure who to study or where to look, start with the most famous periods of Western art: Renaissance, High Renaissance, and Baroque. Most paintings you find from these periods are good examples to study.

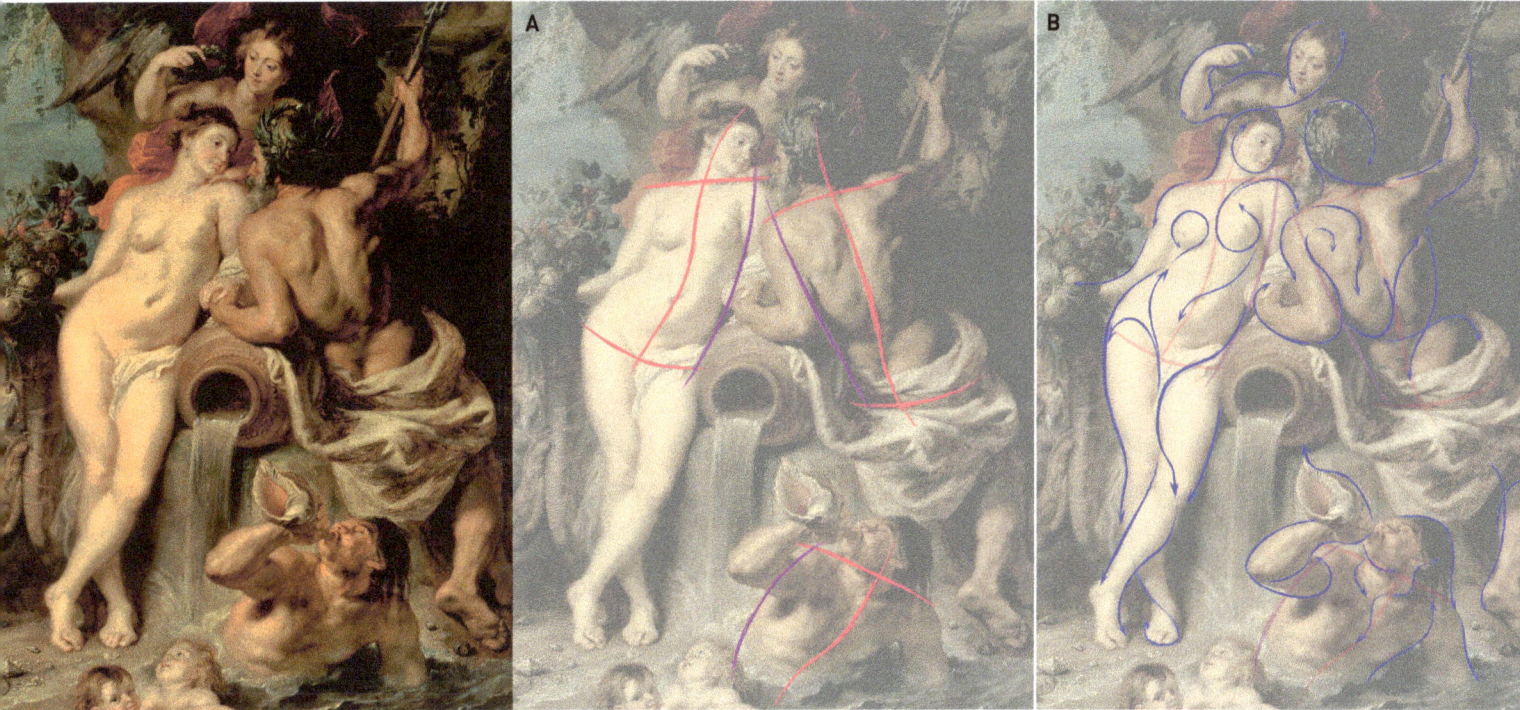

Gesture study of *The Union of Earth and Water* (1618) by Peter Paul Rubens.

EXERCISE 6: OLD MASTER STUDIES

Now that you know who to study, what to study is also important. There are many, many lessons you can learn from a great work of art. There are also many ways to approach an old master study. For the student of life drawing, I recommend that you focus your studies on the fundamentals of figure drawing and the figure drawing process.

Assignment 14: Gesture and Rhythm Study

Tracing or drawing over a masterpiece is a great exercise. Use a piece of tracing paper and colored pencils or a digital drawing tablet.

In the above example of a Rubens study, I started by tracing over the gestures in the torso, especially the action line, centerline, shoulder line and hip line **(A)**. I used another layer and traced over the rhythms **(B)**. Whenever I found a rhythm line, I tried to extend it by flowing into another rhythm line. This is how Rubens would have intended. How many more rhythms can you see?

Assignment 15: Structure and Construction Study
In this study of a Bouguereau painting, I drew construction forms of the torso **(A)**. I used box forms, spheres, cylinders, and compound forms to construct the figure. Once I had the torso, I studied the construction of the limbs using cylinders, boxes, and compound forms **(B)**. Even if there is fabric covering the figure, I try to use my imagination to construct the part of the figure that is hidden.

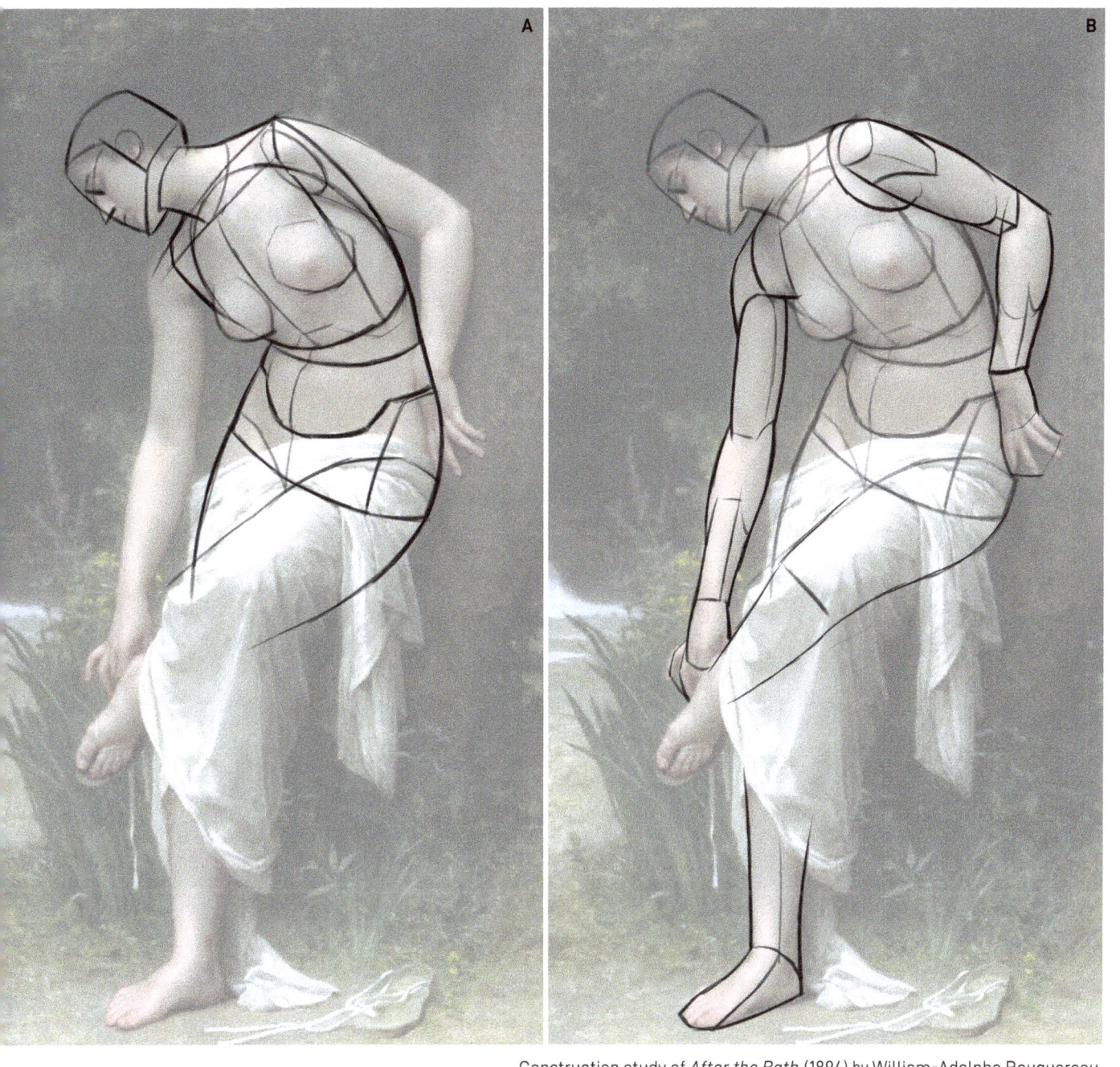

Construction study of *After the Bath* (1894) by William-Adolphe Bouguereau.

168

Assignment 16: One Page of Gesture Sketches

Another way to study a masterpiece, especially one that has multiple figures, is to copy and draw the figures in the painting. I like to imagine that the figures in the paintings are models, and I try to draw them as if they were posing in front of me. Just like a life drawing session, I use a timer to set a time limit on the drawing. Start with one- and two-minute gesture poses, and then five- and ten-minute poses. As you gain confidence and experience, do longer poses.

This example by Rubens has six figures and is a great painting to study for gesture. To mimic a life drawing session, I set a timer to one minute and treated each figure as a new pose.

One-minute gesture drawings after *Death of Adonis* (c. 1614) by Peter Paul Rubens.

Apollo in the Forge of Vulcan by Diego Velázquez, 1630.

Assignment 17: One Page of Five- and Ten-Minute Sketches

This masterpiece by Diego Velázquez is an excellent opportunity to study the figure. Not only are the figures partially nude and exposed, but the lighting is excellent and allows for clear shadows and forms. A painting like this would be great to study for five- and ten-minute poses or longer.

For this exercise, I set the timer for five minutes and started with the central figure **(A)**. As I was drawing, I tried to match the gesture, proportions, and anatomy of the original. In the last few minutes, I was able to start shading. Because the light and shadow shapes are so clear I was really able to focus on and practice my values and edges.

For the second five-minute pose, I chose the figure on the right **(B)**. In this drawing, I learned that Velázquez was very conscious of the gesture. The beautiful curved action line in the back flows from the head to the foot. Gesture was definitely a big part of the drawing. I also learned more about the head and how to construct the head from this difficult angle. Of course, the beautiful shading and anatomy of the arm was a lot of fun. If I had more time I would have slowed down and carefully observed and studied and copied the anatomy and details.

Every time the five-minute buzzer went off I didn't want to stop drawing. I was having a lot of fun trying to study and copy all the details, especially the anatomy and shading. There are many more lessons to learn from such a great painting that five minutes is not enough. A great painting like this deserves multiple studies.

WHERE TO GO FROM HERE

You now have seventeen assignments to try. Go to life drawing sessions and take this book with you. When you get stuck somewhere in the drawing process, review that chapter. When you have a free moment, do the dexterity exercises. Even if you don't do any of these assignments but simply copy the diagrams and examples in this book, you will know more about figure drawing than 99 percent of art students.

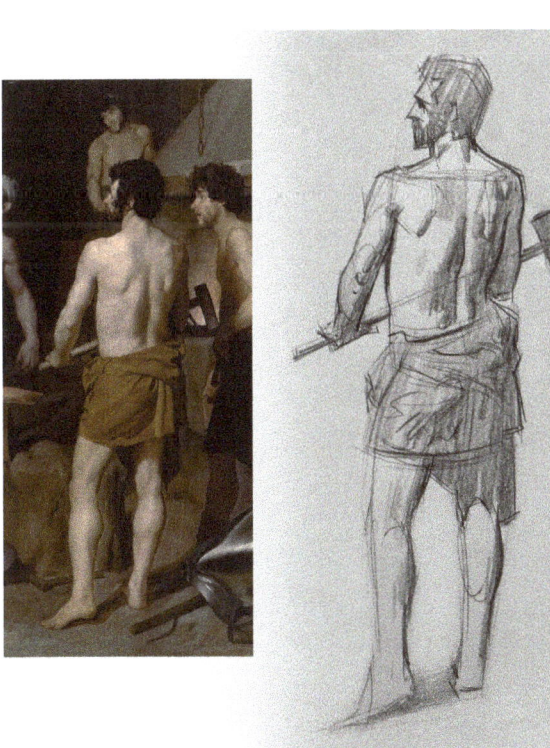

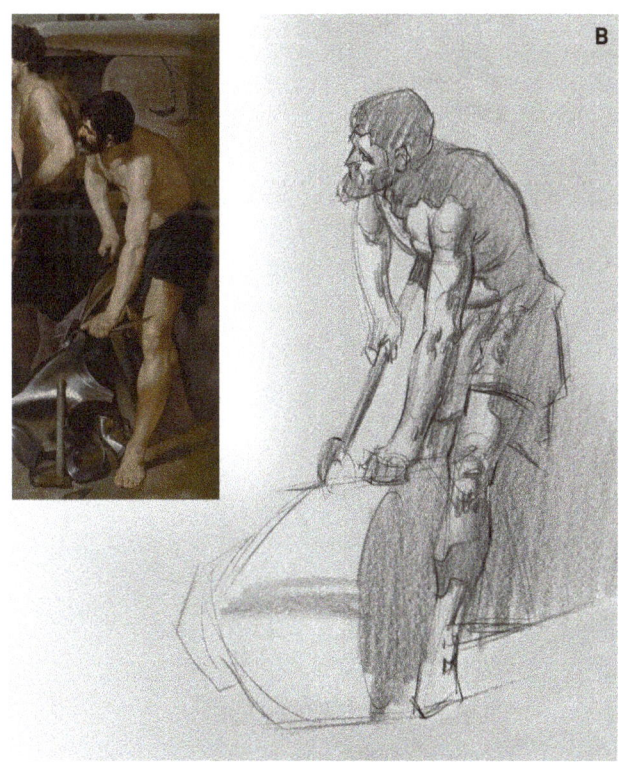

Acknowledgments

To my great mentors Steve Huston and the late Mark Westermoe: Thank you for your hard work and generosity, and for showing me and your countless other students that drawing beautiful figures is possible with the right information and the right guidance. This book is an homage to you and all that I have learned from you.

I would also like to humbly recognize and thank all the great teachers who helped to establish the American tradition of realistic figure drawing. Your books and teachings allowed a young artist like me to hope, dream, and have a career as an artist. I am especially grateful for the work of my two favorite teachers, Mr. Frank Reilly and Andrew Loomis.

To all the great teachers in Southern California: I am proud and humbled to share the same geography with you. Thank you for creating an environment where figure drawing flourishes. To Mr. Fred Fixler: Thank you for paving the way and being a mentor to so many greats. To Kevin Chen: Thank you for your generosity and for your sublime ability to simplify and teach the most complex subject matter known in the creative world.

Thank you to my students and to the readers of my work for your continued support. This book is a long time coming and I hope it will serve you in your long hours of mileage and grind.

To the editors and staff at The Quarto Group: Thank you for your guidance, patience, and constant support.

To any student who is on the figure drawing journey: Thank you. You are not alone. May this book humbly give you the knowledge and confidence to go through the ups and downs and help you reach personal breakthroughs. Most of all, thank you for keeping the craft and our shared love for the figure alive and well in this modern age.

About the Author

Chris Legaspi is a dedicated, lifelong artist who is known for his dynamic figurative drawings and paintings, and as a successful illustrator in the entertainment industry. Along with his professional work, his articles and instructional content have been featured and published in the United States and internationally in major art publications such as *ImagineFX* magazine, *3dtotal*, and *Expose*.

Along with being a proven expert in his field, with real-world experience, he is also passionate about sharing his knowledge and experience. Chris has taught at some of the top art schools in the United States, including Gnomon School of Visual Effects in Hollywood and the New Masters Academy. His design and drawing classes are some of the most popular and exciting classes offered. Along with his classroom experience, he has held workshops and lectured at the world-renowned ArtCenter College of Design and Concept Design Academy, both in Pasadena, California, and LucasArts Singapore. As a professional, his illustrations, drawings, and concept designs can be seen in blockbuster Hollywood movies, television shows, and video games. His most notable clients and projects include Warner Bros. Pictures, Disney, Marvel, *The Simpsons*, Netflix, and Bandai Namco Entertainment.

This rare combination of professional experience and teaching skill is what makes Chris such a popular and admired educator in the field of realistic art and illustration. He is working on several books, articles, and online courses, and teaching live workshops throughout Southeast Asia.

For more information and to view his work, visit:
www.drawwithchris.com
www.instagram.com/chrislegaspi_art/
www.youtube.com/user/CGArtSuccess

Index

A

Anatomical landmarks, 62–92
 head and neck, 64–83
 identifying, 62–63
 torso and limbs, 84–92

B

Ballpoint pen, 18
Bouguereau, William-Adolphe, 166
Box forms, 139
Breasts, 86–87
Brow line, 66
Brush pens, 18–19

C

Cafe sketching, 156–157
C-curves, 23–25
Centerline, 66
Chin, 66
Clipboard, 19
Clips, 17
Colored pencils, 18
Compound 3-D shapes, 43
Connect-the-dots exercise, 161–162
Construction, 37–39
Contours, 30
Copy paper, 19
Crosshairs, 66
Cross sections, 44, 139–140

D

Dexterity exercises, 158–163
Down-view head position, 81–82
Drawing board, 17
Drawing pencil, 16–17

E

Ears, 66
Edges, 51
Editing, 102
Electric sharpeners, 22
Erasers, 17, 19
Eyeline, 66
Eyes, 66

F

Felt-tip pens, 18–19
Female models, 86–87
Field sketching materials, 18–19
Finish stage, 60
Foreshortened poses, 92
Form principle, 52

G

Genitals, 86
Gesture, 27–35
 defined, 27–28
 form and function, 30–35
 long axis, 30
 rhythms, 34–35
 stretch and pinch, 30–32
 structure, 32–33
Gesture poses, 94
Graphite pencils, 18

H

Hair, 70
Hairline, 66
Head drawings
 action of the head, 71
 down-view, 81
 front view, 74–76
 hair, 70
 head indication process, 74–82
 neck structures, 72

outer shape, 69–70
side view, 79
three-quarter view, 77
up-view, 80
various up- and down-views, 82
what to look for, 66–72
Heel point shape, 20
Homework exercises, 150–171
dexterity, 158–163
drawing from life and observations, 152–157
old masters studies, 164–171

L

Layers of anatomy, 128
Lay-in stage, 56
Life drawing
anatomical landmarks, 62–92
finish stage, 60
lay-in stage, 56
lighting and modeling stage, 57
overview, 8–10
refinement and rendering stage, 59
session structure, 12–13
timed poses and progression, 61
video streaming, 155
workshops, 153–155
Light and shadow, 46–53
Lighting and modeling stage, 57
Line marks, 26
Long axis, 30
Long-lead pencil, 20

M

Male models, 86–87
Markers, 18
Marks, making, 24–26
Materials, 14–19
field sketching, 18–19
how to use, 20–23
studio drawing, 16–17

N

Neck, 72
Needle point shape, 20
Nose, 66

O

Old masters studies, 164–171
One- and two-minute poses, 94–100
Overlaps, 130

P

Paper, 17
Pencil extender, 17
Pencils
colored, 18
drawing, 16–17
graphite, 18
how to hold, 23
long-lead, 20
sharpening, 21–22
Pens, 18
Perspective drawing, 138–149
Poses
foreshortened, 92
one- and two-minute, 94–100
side view, 126–137
ten-minute, 108–111
three-to-five-minute, 102–107
timed, 61
twenty-minute, 112–124
Position, 138

R

Razor blades, 17
Refinement and rendering stage, 59
Rhythms, 34–35
Rubens, Peter Paul, 165, 169

S

Sandpaper, 17
S-curves, 23–25
Shading
 edges, 51
 examples of, 53
 form principle, 52
 light and shadow shapes, 50
 observing shadow shapes, 52–53
 process, 53
 values, 48–49
Shapes
 creating structure with, 43
 observing, 41
 three-dimensional, 42–44
 two-dimensional, 40–41
 using, 41
 why they are useful, 41
Side view poses, 126–137
Silhouette, 40
Single-edge razor blades, 17
Sketchbook, 19
Straight marks, 23–25
Stretch and pinch, 30–32
Structure, 32–33
Studio materials, 16–17

T

Tapering, 44
Ten-minute poses, 108–111
3-D shapes, 42–44
Three-to-five-minute poses, 102–107
Timed poses, 61
Tonal marks, 26
Tone boxes, 159–160
Torso drawings, 84–92
 abdominals, 84
 back view, 89
 foreshortened poses, 92
 front view, 88
 gender differences, 86–87
 hips, 84
 side view, 90
 three sections, 84
 twist, 91
 upper torso, 84
Twenty-minute poses, 112–124
2-D shapes, 40–41

U

Undercup grip, 158, 162–163
Up-view head position, 79–80, 82

V

Value block-in, 57
Values, 48–49
Velázquez, Diego, 170
Video streams, 155

W

Workshops, 153–155

www.ingramcontent.com/pod-product-compliance
Lightning Source LLC
Chambersburg PA
CBHW041923180526
45172CB00014B/1365